The Arts of Independence

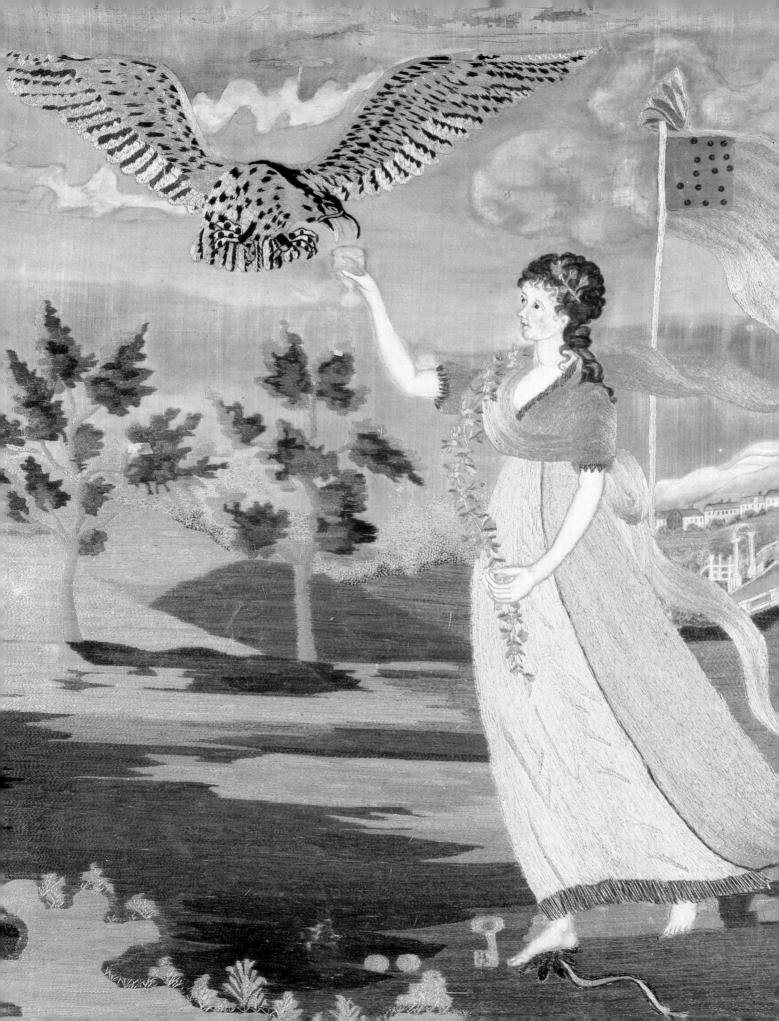

THE **DAR** MUSEUM COLLECTION

Elisabeth Donaghy Garrett

With the assistance of Gloria Seaman Allen,
Susanne Dawson, Jean Martin, and
Christine Minter-Dowd

Photographs by Arthur Vitols

The National Society, Daughters of the American Revolution · Washington, D.C. · 1985

Copyright © 1985 The National Society,
Daughters of the American Revolution

ISBN-0-9602528-5-1

Library of Congress Catalogue Card
Number: 84-62816

Designed by James Wageman
Printed by Garamond/Pridemark Press,
Baltimore, Maryland

Frontispiece, Liberty. In the Form of the
Goddess of Youth; giving support to the
Bald Eagle, 1800–1815, New Jersey or
New York.

To the memory of Robert Louis Cato, for many years Curator of the DAR Museum, who truly loved and gently tendered this remarkable collection

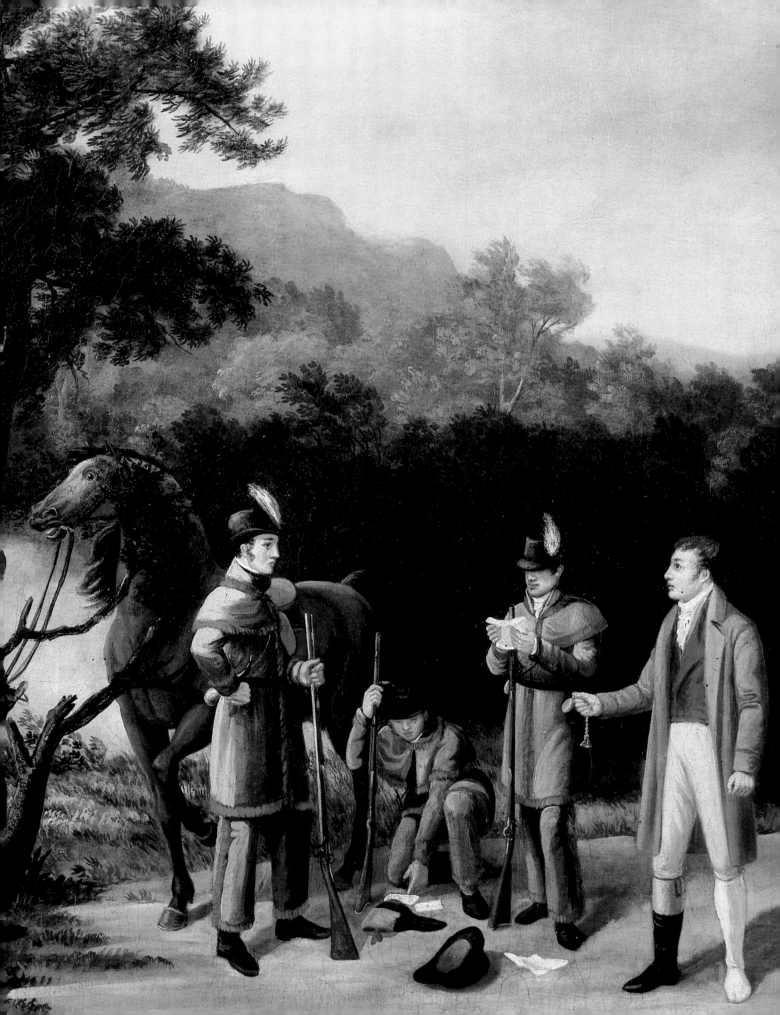

Contents

Detail from *The Capture of Major André*,
attributed to Thomas Birch. 1831.
Philadelphia.

Captions Contributed by

GSA Gloria Seaman Allen, *Curator*

SMD Susanne Dawson, *Associate Curator*

EDG Elisabeth Donaghy Garrett

JM Jean Martin, *Registrar*

CMD Christine Minter-Dowd, *Director*

Acknowledgements

In 1972, when serving as Curator General, Mrs. Walter Hughey King expressed her fondest hope to see the DAR Museum collection published for the edification and enjoyment of the membership of the DAR and the general public. Now as President General in 1985 she has realized that dream. This published catalogue of the highlights in the Museum collection is a well-deserved tribute to Sarah King's fortuitous vision and indomitable spirit.

Many other staff members at the DAR national headquarters in Washington, D.C., have helped to bring Mrs. King's inspiration to fruition. I would like to thank the present Curator General, Mrs. Gabriel Omar Saavedra, for so generously sharing the DAR Museum staff with me on this project. Gloria Allen and Michael Berry assembled materials for the planning stages of the book, and Gloria Allen, Susanne Dawson, Jean Martin, and Christine Minter-Dowd have contributed captions and affably assisted me in innumerable ways. Libbie Heck and Katharine McAulay have ably typed the bibliography. Ted Holliday, with efficiency and amiability, retrieved and returned hundreds of objects from exhibition and storage for photography and study. I have always found it an honor and a pleasure to work with him.

I would like to thank Mrs. Paul Howard Long, the Historian General, and Virginia Austin for generously sharing the DAR manuscript collection with me. Jean Jacobs, administrative assistant, and Rose Hall, editor of *The Daughters of the American Revolution Magazine*, have been perceptive in their suggestions and prompt in their assistance.

Allison Eckardt has indexed this volume with that singular excellence which she bestows on every project she undertakes. My own dear family deserves praise for the humor and resilient spirit which they maintained throughout one bustling summer.

Columbia's Daughters

O

N August 17, 1890, a notice appeared in the *Washington Post* which announced the proposed founding of a society whose purpose would be to "gather materials for history, to preserve souvenirs of the Revolution, to study the manners and measures of those days, to devise the best methods of perpetuating the memories of our ancestors and celebrating their achievements."[1] To preserve souvenirs of the Revolution, and to study the manners and measures of those days has ever been the primary resolve of the founders of the National Society of the Daughters of the American Revolution. The last two decades of the nineteenth century witnessed a renewed interest in the American past, and the founding Daughters shared that enthusiasm. Ignited by the example set forth by the Centennial International Exhibition of 1876, Americans had begun the study of colonial days and ways. Books and magazines were replete with early American history and fiction set in colonial times. Stirred as much by feminine aspirations as by nostalgia and national pride, the founding Daughters hoped to exalt the intrepid spirit of colonial women: "Especially, it is desired to preserve some record of the heroic deeds of American women."[2] Inspired by this historic feminine dedication to noble purpose, the founders were also alert to their contemporary, uniquely female role as preservers of the nation's morals: "It is pre-eminently woman's province," wrote Mrs. Daniel Manning in May, 1899, "to set in motion all those moral forces and influences that make for the higher patriotism, and to give them color, life, and equipment."[3] This "color, life and equipment" would be provided by the "relics" they hoped to collect.

1 *Emblem of America,* by Eliza Camp, 1810, Connecticut, silk, silk chenille, and watercolor on silk.

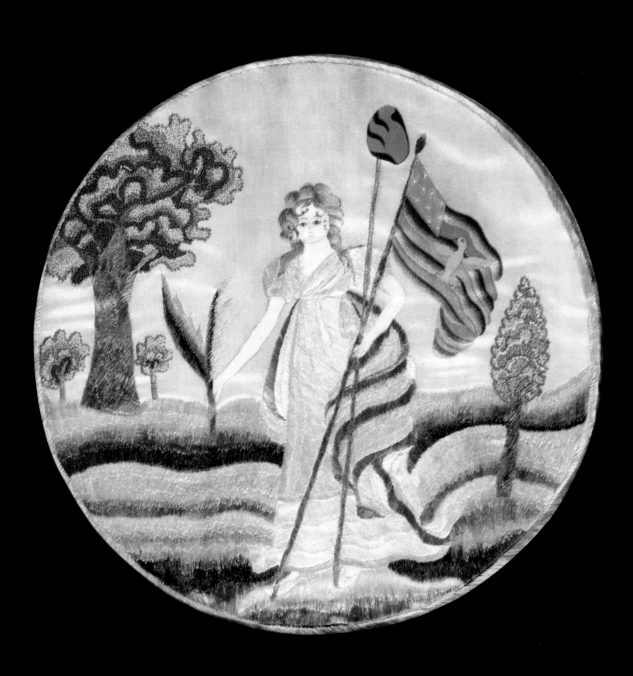

On October 11, 1890, the founding members had set as their goal, "to collect and preserve historical and biographical records, documents and relics."[4] This patriotic sisterhood had also recognized that the battlefield relic could not relate the whole story of the American Revolution, that a broader historical base was needed which included battlefield and home, men and women, the sputter of gunfire and the whir of the spinning wheel, the powder horn which accompanied J. McKee to the battlefield and the reverse-curve "sopha" which patriot Thomas McKean might come home to rest upon. "Home and Country" was adopted as the National Society's motto and in addressing the NSDAR Congress in 1892, the President-Presiding, Mrs. William Cabell, took note of the importance of domestic documents in providing a more accurate picture of the past:

> It is in old letters and journals and documents handed down through the generations that some of the most inspiring truths and incidents must be found, and Clio no longer scorns such humble means. Turning from the long and well-worn succession of kings and presidents, of battles too vast to show individual deeds of valor, of victories and defeats, diplomatic conferences and expedient bulletins, she now finds time to consult the dusty pages of family archives, the quaint inscriptions in family Bibles, and under her skillful pencil the home-life of the cottage, the diary of some young girl, the love-letters of a forgotten beauty throw their light, soft, warm, human and true, upon the splendid pages of history. To gather up these relics and to examine and perpetuate traditions as authentic as accepted chronicles, and often much more authentic, are among the duties of our Society.[5]

With the formation of the Revolutionary Relics Committee in 1890, the collection had begun. In 1899 some fifty examples of manuscripts, porcelain, furniture, silver, and pewter were temporarily deposited at the Smithsonian Institution. That same year a circular was sent out to the membership requesting funds for the construction of a national headquarters "for the preservation of its archives, and relics, as well as for its meeting-place for its annual Congresses and other sessions."[6] Patriotism, female pride, and moral leadership were again the exalted themes which the headquarters building was itself to embody. It was to be a moral anchor to windward in the buffeting winds of a rapidly changing world:

> The Continental Memorial Hall to be erected by the National Society of the Daughters of the American Revolution at the National Capital will be the first structure of its kind raised by women in this or any other country. The plan and scope of this large and magnificent monument to

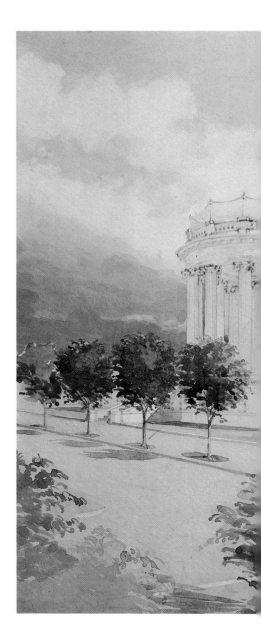

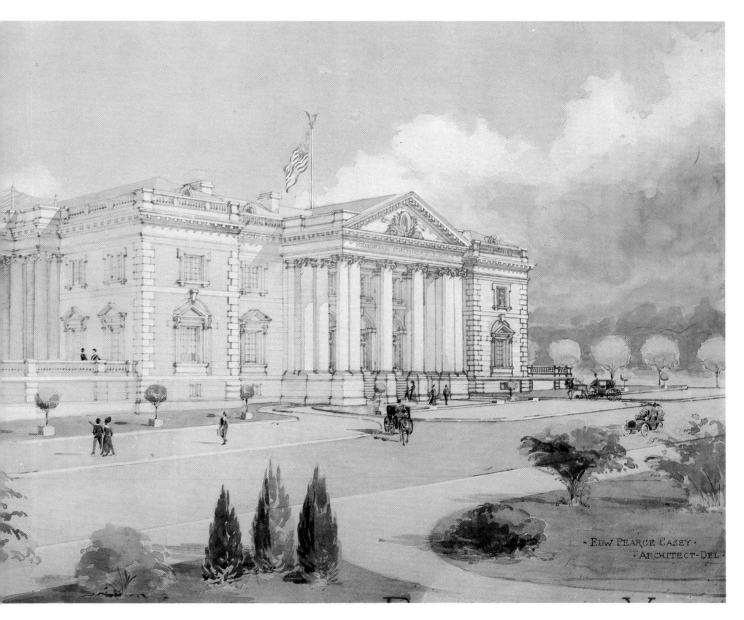

2 Edward Pearce Casey, the architect of Memorial Continental Hall, painted this watercolor rendering of the building around 1904. It documents the early years of the structure — a time of spaces yet open in Washington, a time when horse and carriage might vie for right of way with the novel automobile. Memorial Continental Hall was envisioned by the founders of this Society as an emblem of patriotism and a symbol of the purity of the ideals of the Founding Fathers. The staid, discreet classicism renounced the exuberant excesses of the age, the solid mass offered immutability in an agitated world. Portraying concepts of simplicity, antiquity, solidity, durability, and dignity, Memorial Continental Hall suggested the beneficial lessons to be learned from the study of history. The majestic entrance under the porte-cochère and up a flight of marble steps promised the entrant an elevating, ennobling experience. Concluding her remarks at the 1904 cornerstone laying ceremony Mrs. Ellen Hardin Walworth envisioned that, "This beautiful building shall arise clothed like a bride in the whiteness of purity, and as long as stone stands upon stone it shall be wedded to that majestic capitol on the hill; if the power of the government is there, on the hill, the love that cherishes and preserves government is here, and the demonstration of this love of country is in the offering we make to-day on this commemorative stone, and all it promises, to the men and women of the Revolution who were the founders of the Republic of the United States of America." EDG

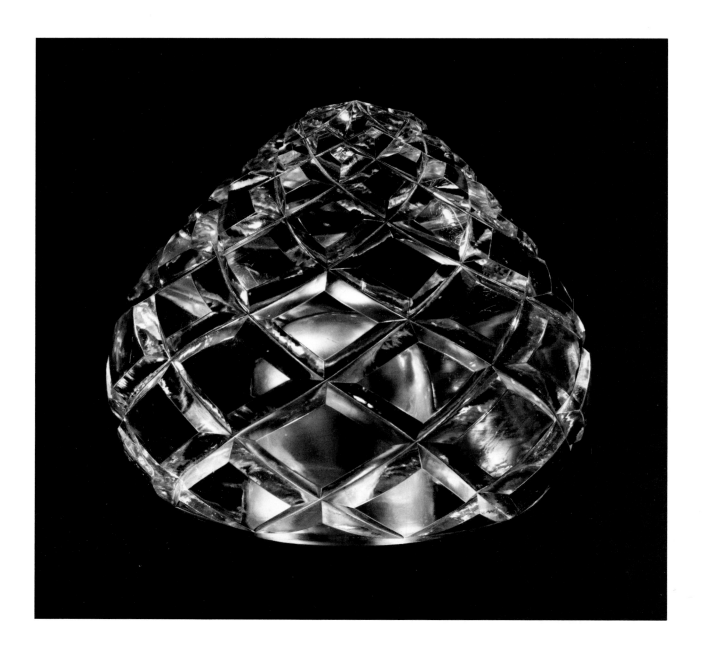

the Makers and Savers of the Republic of the United States of America reveal the mighty force of the national idea that has united and held together this body of women through the nine years of its existence as a society. This Memorial Building will be a large moral factor in the teeming materialization of the present age, to lift before the eyes of the nations the principles embodied in the National Constitution and interwoven in the National life.[7]

Land was purchased opposite the Ellipse in Washington, for this new monument was to share a symbolic and a physical rapprochement with the White House and the gleaming Capitol on the Hill. Plans were submitted and those of Edward Pearce Casey, a New York architect and graduate of Columbia University and the École des Beaux-Arts in Paris, were selected on June 4, 1903.

3 A symbol of hospitality, twenty-six cut glass pineapples crown the newel posts in the two marble stairwells in Memorial Continental Hall. EDG

4 A "collection of Historical relics" was a primary goal of the founders of the National Society of the Daughters of the American Revolution. Some of the aspirations of the incipient Society in 1890 were "to gather materials for history, to preserve souvenirs of the Revolution, to study the manners and measures of those days, to devise the best methods of perpetuating the memories of our ancestors." Early furniture and other artifacts might fulfill the didactic function of illustrating and elucidating history. To many Victorians the furniture of our forefathers was also a quiet respite from the prodigality of contemporary productions. Clarence Cook, the celebrated art critic and author on interior decoration, advocated the use of "Revolutionary furniture" in the home in his 1881 *The House Beautiful;* "the charm of it consists, apart from its usefulness …in the color given to it by age, and in the simplicity with which all its ornament is obtained. Its moldings are always good and quiet; just what is needed, and no more, to round an angle with elegance, and to catch the light agreeably, and whenever any carving is attempted, or paneling, there is a certain moderation in it that is very refreshing in these loud times." During the Victorian period the spinning wheel came to be a recognizable symbol of nostalgia for the past, and it is, therefore, befitting that the spinning wheel atop the display cases on the left was the inspiration for the design of the NSDAR Insignia. Commenting on the completion of the Society's national headquarters, Memorial Continental Hall, the *New York Times* wrote on April 8, 1909, "on the main floor is the assembly hall, the library, and the museum of revolutionary relics." The nascent collection is pictured there around 1940, fitted in among the elaborate Beaux-Arts decoration of the South Gallery. EDG

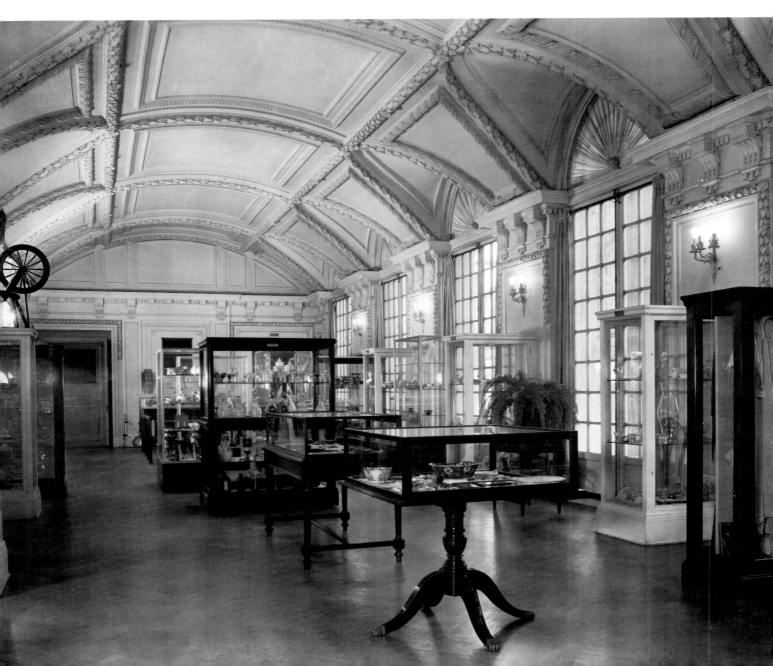

The pristine white marble building which emerged between 1904 and 1910 was heralded by *The Washington Evening Star* at its triumphant completion:

> This Valhalla is unique. It is the costliest and most impressive monument of its kind ever built by women in this country or any other. Many other halls of fame have been erected and other grand monuments consecrated to the memory of some individual heroic figure in the history of our nation, but this is the first building dedicated to all the recognized heroes of the American Revolution: men and women alike. From the artistic standpoint it is one of the finest buildings which the beautiful Capital contains, and from the utilitarian it is destined to become one of the most useful.[8]

The collection was first placed in the South Gallery of this building (pl. 4). It had soon expanded into the North Gallery as well, and, in 1950, a museum gallery was annexed to Memorial Continental Hall. Exhibit areas now include the museum gallery addition of 1950 and thirty-four State Rooms in the original building and annex. The precipitous expansion of this 50,000-object collection has been largely due to the generous gifts of members and other supporters. As heirlooms, many of these gifts have been donated with family histories which help to document their role in early American life and which impart a unique social and historical importance to the collection. A Friends of the Museum Committee was created in 1956 to secure financial gifts for museum purchases, and much of the ceramic and glassware collections have been purchased in this way. Accredited by the American Association of Museums in 1973, the DAR Museum and its marble building have achieved that destiny set forth by *The Washington Evening Star,* "to become one of the most useful." A "monument to the Makers and Savers of the Republic," the DAR Museum is a proud tribute to Columbia's Daughters, who recognized its need and envisioned its future.

5 This vignette of a late nineteenth-century doll looking into the past through a Chippendale-style looking glass symbolizes the founding of the DAR Museum collection in 1890 by a sisterhood of women who foresaw the need of preserving the tangible documentation of America's past. The white stuffed cotton quilt was made by Ann Pamela Cunningham, another foresighted woman who in 1853 founded the Mount Vernon Ladies Association of the Union to preserve Mount Vernon. During the second half of the nineteenth century the composition of American society and the visage of her landscape changed so rapidly that many citizens were alarmed. "All is now self-exalted and going upon stilts," complained one observer. Ann Pamela Cunningham's exhortation in 1874 to "Let one spot in this country of ours be saved from change," would be echoed by the founders of the National Society of the Daughters of the American Revolution. An anchor in a tumultuous sea, this patriotic sorority promised asylum from the dizzying velocity of modernization and change in American life. EDG

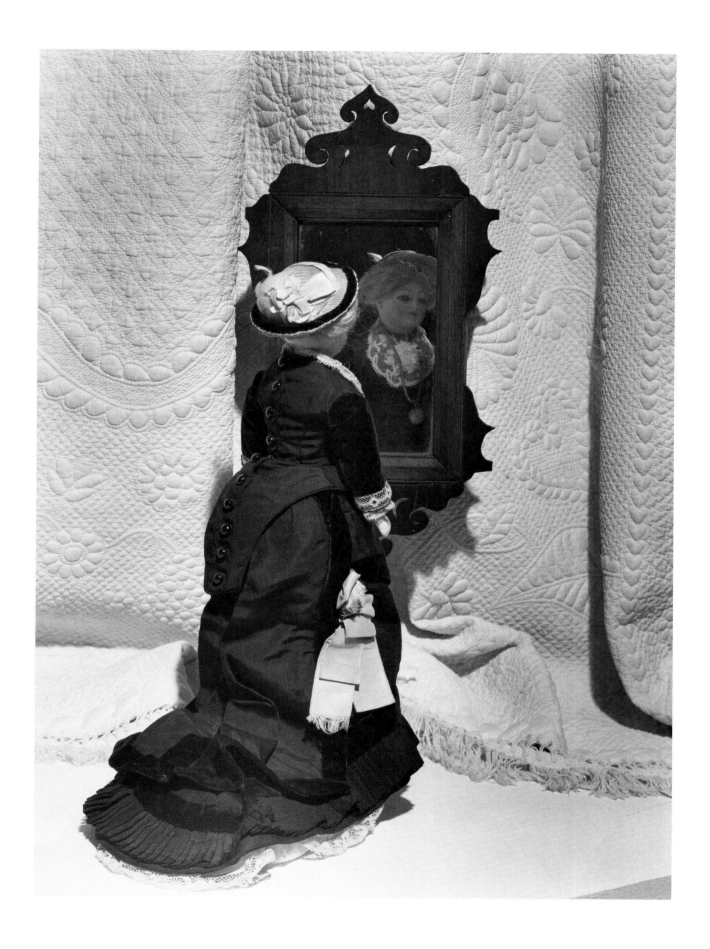

Under This We Prosper

ITH the signing of the Treaty of Paris in 1783, America had embarked on a unique and novel adventure and the whole world was waiting and watching, anxious to appraise its success or censure its failure. Optimistic, forward-looking, convinced of the perfectibility of man, and assured of their own eventual success, Americans anticipated a glorious future. "Democratic nations care but little for what has been," observed the perspicacious Alexis de Tocqueville in his *Democracy in America,* "but they are haunted by visions of what will be; in this direction their unbounded imagination grows and dilates beyond all measure."[1] The prosperity which attended the commercial expansion of the new nation confirmed such confidence. The opening up of new trade routes provided early nineteenth-century homes with all kinds of exotica and finery (pl. 8, 9). Forty-one years after the signing of the Treaty of Paris, James Fenimore Cooper might observe that in American homes in the major port city of New York were "French clocks, English and Brussels carpets, curtains from Lyons, and the Indies, alabaster from France and Italy, marble of their own, and from Italy, and, in short, every ornament below the rarest that is known in every other country in christendom, and frequently out of it, is put within the reach of the American of moderate means, by the facilities of their trade."[2] The opening up of lands west provided Americans with additional goods to be used in this international trade. Such a vast expanse of land promised copious natural resources and agrarian abundance.

6 *Eagle,* by Henry Inman, 1833, oil on board.

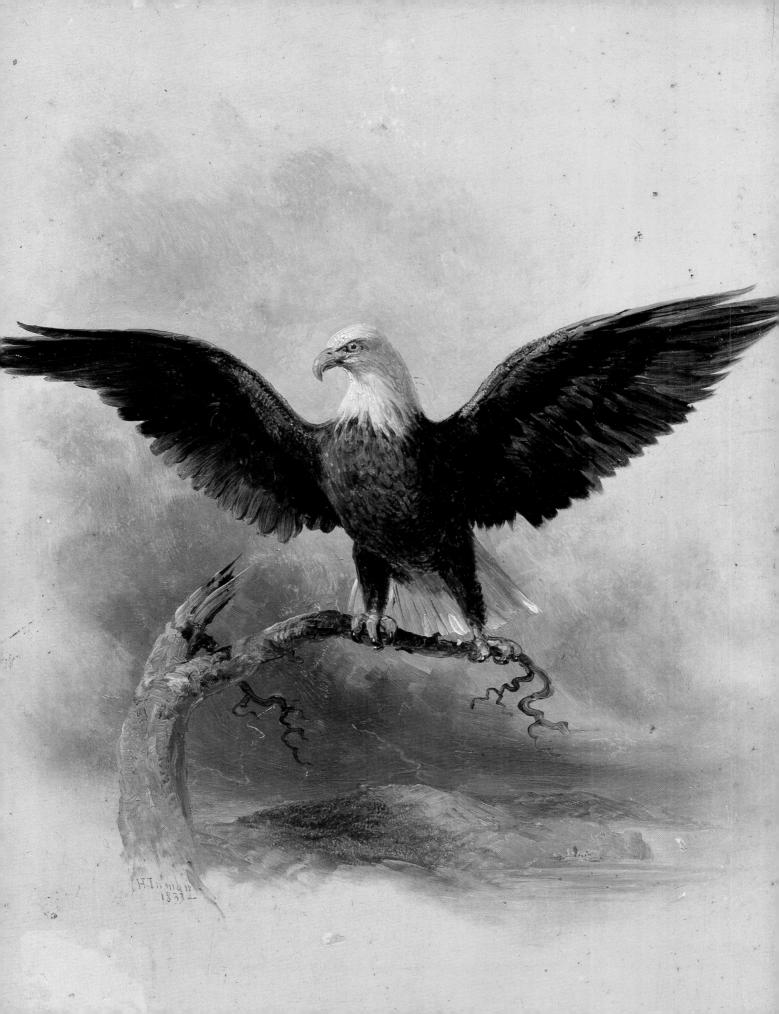

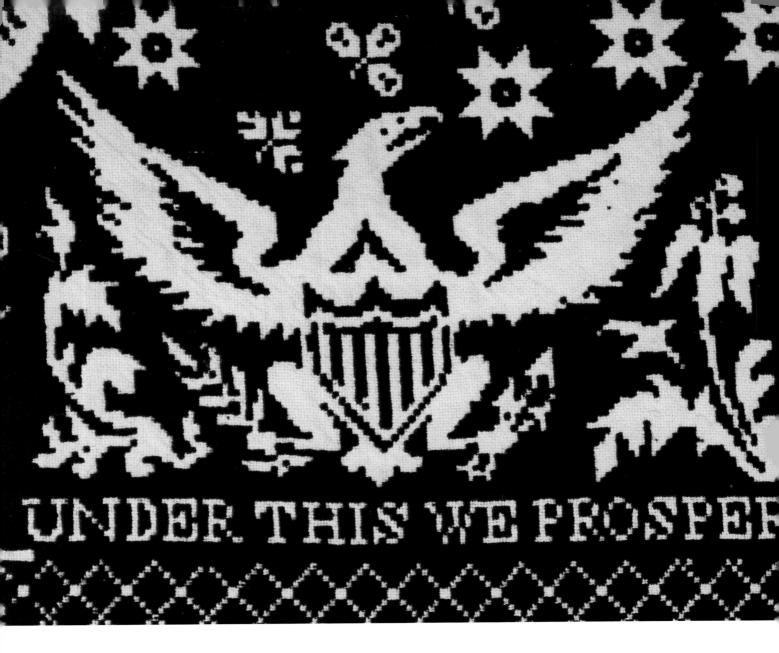

UNDER THIS WE PROSPER

Overflowing baskets of fruit and flowers, cornucopia, and bountiful sheaves of grain were carved, printed, painted, woven, stitched, and stamped decoratively on home furnishings (pl. 16, 17).

From its seventeenth-century beginnings, America had also offered a spiritual abundance — a promise of freedom of mind and the continual improvement of one's lot in life. Writing from Philadelphia in 1813, Margaret Manigault could confidently assure Josephine du Pont, on the eve of her departure from Paris to the States, that "You have a brilliant outlook for your children. I say brilliant because Fortune in this country is what the word implies. It is in no way an illusion."[3]

Equality of expectation and the "constant stimulation of hope, emulation, and ambition" promised both physical and mental well-being.[4] Henry Adams observed that every man knew that

7 Detail from a Jacquard-type coverlet, woven by James Cunningham, 1841, New Hartford, New York.

"every stroke of his axe and hoe made him a capitalist and gentlemen of his children."[5] Such "elastic and inciting liberty" ensured the elevation of character as well, and men, from the merchant to the mechanic, respected others and were, in turn, respected. Without the constricting confines of primogeniture, limited land, or established social position, American life was characterized by an invigorating fluidity and flexibility which encouraged independence. "We hear of self-made men in England," wrote Thomas Low Nichols, "In America, there are scarcely any others."[6]

The promise of America ensured that it would become an asylum for those seeking religious, political, or social freedom (pl. 10, 11). Throughout the eighteenth and nineteenth centuries German and French emigrant craftsmen brought new influences to the American decorative arts and were instrumental in setting up the iron, glass, and ceramic industries in the United States. Quaker devotion to mercantile pursuits established triangular and polygonal trade routes which contributed to American prosperity. Through family, business, and personal ties, the Quaker extended family spread to such commercial centers as Madeira, London, Barbados, New York, Newport, and Philadelphia, negating geographic distance and knitting the globe together.

Throughout the nineteenth century foreign observers, such as Aleksandr Lakier, commented that "Commerce or a passion to make money devours every other passion."[7] Amidst these rising cries of "commerce, commerce, commerce," American leaders interjected cries of patriotism and nationalism. Attempts to nourish patriotic fervor were well received and self-sustaining. The lesson was taught inside and outside the home, beginning early in life. Thomas Low Nichols remembered that "We were taught every day and in every way that ours was the freest, the happiest, and soon to be the greatest and most powerful country in the world.... We read it in our books and newspapers, heard it in sermons, speeches, and orations, thanked God for it in our prayers, and devoutly believed it always."[8] John Adams had written in 1777 of the didactic mission of the arts — painting, sculpture, statuary, medalling — in teaching history and sustaining nationalism in a nascent country.[9] That same year twelve-year-old Tommy Shippen, writing to his schoolgirl sister, would proudly alert her to the seal on the verso of his letter, "Lest you should mistake, my seal is America possessed of Liberty."[10] Painted scenes of heroic moments of the American Revolution became popular in the early nineteenth century (pl. 15) and veterans could be proud to be portrayed in military uniform (pl. 14). Newspaper advertisements for plaster busts, engraved prints, stamped silver, and transfer-printed ceramics, all decorated with patriotic symbolism, attest to the avidity with which Americans sought these patriotic wares.

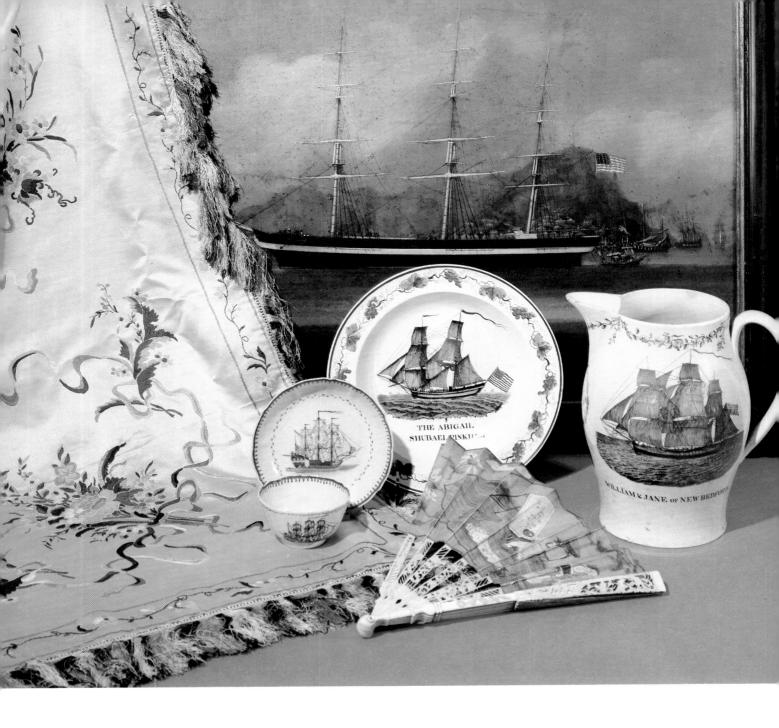

8 Under colonial government and the restrictions of the Navigation Acts, trade had been tightly controlled to maximize profits for Great Britain. These Acts stated that all goods imported into British colonies must be carried on British ships and sail from British ports. Therefore, goods from the Orient and other remote regions or even from the Continent were shipped first to London, then rerouted to their final destination. Ships operating out of colonial ports were also tightly regulated. The results were higher shipping charges, increased taxes, and long delays in the delivery of merchandise. With the signing of the Treaty of Paris in 1783, Britain's control over trade to colonial America had ended.

On February 22, 1784, only five months after the Treaty of Paris had been signed, the *Empress of China* set sail from New York for Canton. When she returned nearly fifteen months later with a cargo of porcelains, textiles, teas, and spices, she had established commercial and cultural ties with China, and the United States became a principal participant in international trade. There were fortunes to be made and lost in the China Trade as well as in trade to less remote ports in Europe, the Wine

Islands, the Carribean and on the coast of Africa. Improvements in ship design and technological innovations in navigational equipment reduced voyage time, increased safety, and lowered shipping costs. Port cities such as New York and Baltimore expanded rapidly to accommodate the growing trade. With consumer goods flowing into these ports, and with growing prosperity, the wealthy were able to acquire new and exotic goods, and even people from middle and lower socio-economic levels could increase the number and variety of their household furnishings.

Illustrated here are objects associated with such trading ventures. The silk bed cover was once owned by the Tilghman family of Maryland and Philadelphia. It was embroidered in China in the neoclassical style of the West. The cup and saucer, too, although potted in traditional Oriental form, were decorated for the Western market. The ship design was sufficiently generalized that it could be interpreted differently by the addition of extra sails, banners, or a national flag. The fan dates from the first half of the nineteenth century and has a history of ownership by Julia Dent Grant (1826–1902), whose husband had been President of the United States. The painting of an American ship at anchor in Hong Kong Harbor is labeled by the Chinese port painter, Yeuqua (w. 1850–1885), and retains its original frame. It was probably painted in the 1860's when trade with China had declined in favor of trade with Japan. The two examples of English creamware are decorated with American ships. The *Abigail Shubael Pinkham* was named after Abigail and Shubael Pinkham who lived in Nantucket in the early 1700's. The *William and Jane* sailed out of New Bedford. She was owned by Caleb Proctor, who commissioned the jug for his wife. GSA

9 The nautical decoration of a three-masted ship and a seashell-seaweed border on this Chinese export porcelain sauce tureen was appropriate to the seafaring Decatur family in which it descended. Many families in the New Republic were wedded to the sea. Lucy Larcom of Beverly, Massachusetts, recalled that "The sea was its nearest neighbor, and penetrated to every fireside, claiming close intimacy with every home and heart." Ships, sailors, and the sea were in the thoughts of all residents of port towns. Sarah Eve fretted in her journal while living near Philadelphia in 1772–1773, "A most dreadful, rainy, windy day indeed. I am really afraid we shall hear of some damage done, as I think I never heard it blow harder. Alas! the poor Sailors, protect them, Heaven!"

Intimacy with the sea changed the character of many towns and many families. "It was hard to keep the boys from going off to sea before they were grown," wrote Lucy Larcom, "No inland occupation attracted them. 'Land-lubber'

was one of the most contemptuous epithets heard from boyish lips. The spirit of adventure developed in them a rough, breezy type of manliness, now almost extinct." Intrepid captains, supercargoes, pursers, and other crewmen ranged the globe with a bold trust in their country, their ships, and themselves. John White Swift, the purser of the *Empress of China*, would write with equanimity from Canton on December 3, 1784, to his father in Philadelphia, "The Chinese had never heard of us, but we introduced ourselves as a new Nation, gave them our history, with a description of our Country, the importance and necessity of trade here to the advantage of both, which they appear perfectly to understand and wish." Such audaciously adventuresome spirits would infuse a town with an enterprising mien.

The wharves were "scenes of commotion." Noise, hurry, confusion, mystery, and intense excitement filled the air. Every returning sailor was a hero and their loaded ships would sail into port amidst

tremendous anticipation. "I well remember," wrote one Salem, Massachusetts, girl, "what a delight it was when one of my father's vessels arrived from Russia or Antwerp or the West Indies or some other land, bearing rich furs and strange wooden shoes, cocoanut and yams, Guava jellies and tamarinds." Exotic flavors permeated the town and its homes. The "pervasive smell of tar and tropical fruits," "the queer spicy indescribable Eastern smell" of pepper from Sumatra, coffee from Arabia, cinnamon, cloves, and nutmegs from the Spice Islands. Trade with the world would bring changes in American costume, diet, and home furnishings, changes which were exhilarating to the witnesses: "I remember the black wharves and the slips/ And the sea-tides tossing free/ And Spanish sailors with bearded lips/ And the beauty and mystery of the ships/ And the magic of the sea." EDG

10 This teapot was made by Paul Revere for Agnes McKean whose cipher is engraved on the side. The daughter of a prosperous Boston merchant, she probably acquired this piece around the time of her marriage to Henry Swift in 1800. Its oval body with bands of reeding and bright cutting and its domed cover with acorn finial relate very closely to another teapot by Paul Revere, now in the Mabel Brady Garvan Collection at Yale.

Paul Revere is representative of a large number of silversmiths of Huguenot descent working in America. His father, Appolos, had emigrated from France as a young boy to escape religious persecution and had been apprenticed to a Boston goldsmith. Paul would naturally follow in his father's trade. Eighteenth-century Boston provided a lively mercantile milieu with an abundant demand for household goods, both locally made and imported. Paul Revere, as many

enterprising craftsmen in early America, sold both imported goods and his own wares, combining his hand skills as craftsman with business acumen as merchant. Patriot, silversmith, engraver, owner of a foundry and coppermills, Paul Revere was the quintessence of American versatility, involving himself in the myriad affairs of his Boston community. Persisting in wearing the clothes of Revolutionary days, the dynamic and conservative craftsman died at the age of eighty-three in 1818. The *Boston Intelligencer* eulogized, "Cool in thought, ardent in action, he was well adapted to form plans, and to carry them into successful execution— both for the benefit of himself and the service of others." Useful pursuits, active exertions, disinterested benevolence, and general utility— here was the stuff that a rising republic, founded for usefulness and perpetuated by civic virtue, could be proud of. EDG

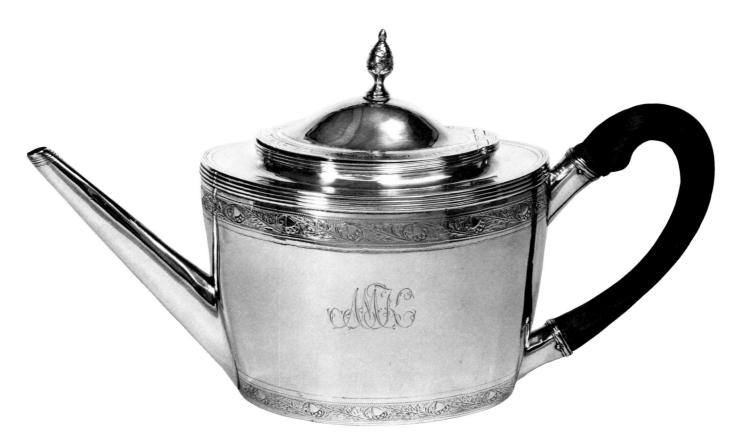

11 One of the largest and most influential religious groups to leave Europe and come to America in search of religious freedom was the Quakers. The Quaker religion originated in England in the seventeenth century when George Fox established a spiritual and intellectual organization known as the Religious Society of Friends. The basic tenets of this new religion were tolerance of fellow men, moderation in behavior, simplicity in dress, dedication to literacy, and education of youth. On May 6, 1799, the Westtown Boarding School in Chester County, Pennsylvania, was opened under the supervision of the Philadelphia Yearly Meeting. The coeducational school was exclusively for the children of Friends. Here, pupils would be taught religion, reading, writing, arithmetic and other useful skills which, for girls, denoted needlework.

Although her family lived in Salem, New Jersey, the dark green linsey-woolsey sampler worked by Martha Woodnutt in 1814, was a Westtown School assignment. It shows seven different methods of darning which Martha had mastered by the age of fifteen. Ethel Stanwood Bolton and Eva Johnston Coe, in their monumental *American Samplers,* cite another sampler which she worked at school that same year and which displayed within an oval border pious verses and a couplet from William Cowper, "The only amaranthine flower on earth/Is virtue: The only lasting treasure — truth."

While Quaker dress may have been plain, it was also style-conscious and made to last. Many of the Quaker costumes in the DAR Museum collection display skilled repairs, such as those Martha Woodnutt had learned at school, and the hems and necklines have reinforced cording for durability. The exquisitely stitched, quilted, blue petticoat and the pale blue

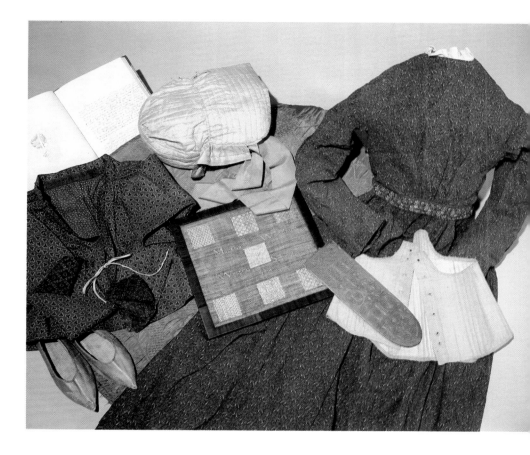

leather slippers are reputed to have belonged to the Quakeress Elizabeth Guest Evans of Philadelphia. The jacket or shortgown of four different printed fabrics illustrates the superb selection of materials and simplicity of design which resulted in the masterful interpretation of the latest fashion into a practical garment. The shortgown was worn with a petticoat by colonial women as a comfortable costume for their daily activities and chores. The gown opens down the front and closes with ties at the high waistline. The cuffs of the long, form-fitting sleeves are lined and are intended to be worn turned up. The cotton dress of brown sprigged with red and cream leaves, has a very different profile with its contrasting waistband to which are gathered the bodice and skirt. The shoulder seam, cuffs, and neckline are all piped with self fabric. The white neck ruffle is a later addition.

The cotton corset also displays fine hand stitching in the handsewn channels for stays, the six unevenly spaced eyelets for laces, and the overcast stitching on the edges. The chip-carved busk with scalloped top does not belong with this corset, but it would have been used to stiffen a corset and illustrates another method of enforcing the upright posture of young ladies in the new nation. The yellow silk "rain bonnet" was made to protect the Quaker caps which all Quaker ladies wore.

The friendship book belonged to Elizabeth Margaret Chandler (1807–1834) the youthful Quaker authoress. It is filled with watercolor pictures, poems, and selections of prose written by her friends and relatives between 1824 and 1830, the year Elizabeth Chandler left Philadelphia for the Michigan Territory, taking with her this legacy of friendship. JM

Images of America as an Indian princess or a Greek goddess leading the world aright were combined with a screaming eagle to remind Americans of a propitious past and a brilliant future. But no symbol of fealty was as pervasive as the image of George Washington. "First in war, first in peace, first in the hearts of his countrymen," Washington was the personification of republican virtue.

History taught, art reiterated, that this great American experiment had succeeded. The trials had proved great, but so had the triumphs. A people who had transformed a "howling Desart" into a dynamic democracy could with probity write below the outstretched wings of the American bald eagle, "Under this we prosper," and Henry Wadsworth Longfellow could enjoin:

> Thou, too, sail on, O Ship of State!
> Sail on, O UNION, strong and great!
> Humanity with all its fears,
> With all the hopes of future years,
> Is hanging breathless on thy fate!
> We know what Master laid thy keel,
> What Workman wrought thy ribs of steel,
> Who made each mast, and sail, and rope,
> What anvils rang, what hammers beat,
> In what a forge and what a heat
> Were shaped the anchors of thy hope!
> Fear not each sudden sound and shock,
> 'T is of the wave and not the rock;
> 'T is but the flapping of the sail,
> And not a rent made by the gale!
> In spite of rock and tempest's roar,
> In spite of false lights on the shore,
> Sail on, nor fear to breast the sea!
> Our hearts, our hopes, are all with thee,
> Our hearts, our hopes, our prayers, our tears,
> Our faith triumphant o'er our fears,
> Are all with thee, — are all with thee![11]

12 Slavery was an incongruity in a nation founded upon the Enlightenment ideal of freedom for all mankind, but efforts to abolish it were unsuccessful for over three quarters of a century after the founding of this New Republic. And meantime the eyes of the world were watching. From the early years of the nineteenth century, Americans of many religions from many states and territories had worked toward the abolishment of slavery. Elizabeth Margaret Chandler (1807–1834) was the first female American writer to take this as her principal theme. The young Quakeress published her early work

in several literary journals until 1825 when she began to write exclusively for *The Genius of Universal Emancipation.* Her poems and letters influenced people nationwide. In 1832 she founded the first anti-slavery organization in the Michigan Territory which helped to establish the underground railway. Even though Elizabeth Margaret Chandler died of "remittent fever" at the age of twenty-six, she had paved the way for others who would bring the slaves of America to freedom in the next thirty years.

In addition to her literary legacy, several important textiles believed to have been owned by her have been handed down in the family including the two silk bags with drawstring closures and the silk pin holder illustrated here. The oval cameo medallion of white jasper with a black relief figure by Wedgwood is inscribed, "AM I NOT A MAN AND A BROTHER?" In the summer of 1787, Josiah Wedgwood directed William Hackwood to model a medallion appropriate to the abolitionists' cause. According to David Buten, former Director of the Buten Museum of Wedgwood, "Thousands of these medallions were made and distributed free of charge to anyone concerned with the issue, and the wearing of the medallions set as hatpins, bracelets, rings, and buckles became quite the fashion." A very similar figure has been transfer printed on the circular silk pin holder. These purses and the pin holder were probably also sold to help fund the efforts of the abolition movement. Many tracts were published in England by the Ladies Society for the Relief of Negro Slaves, several of which were found in a similar bag now in the collection of the Victoria and Albert Museum. These objects bear eloquent testimony to the efforts of men and women, worldwide, who championed freedom for all. JM

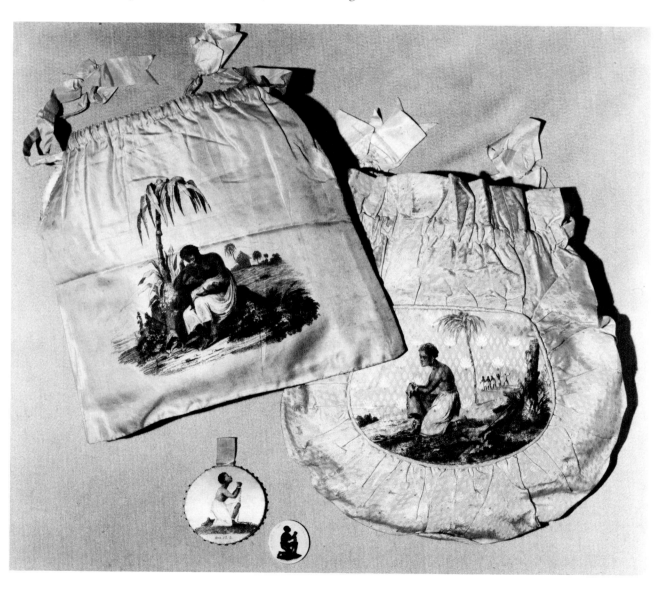

13 Freemasonry, a secret, benevolent, fraternal society whose members support sound moral and social virtues, was very active in the New Republic. John James Audubon, Paul Revere, General Lafayette, fifty of the fifty-six signers of the Declaration of Independence, and other prominent men in early American history were members. With origins in seventeenth-century England, the Society of Ancient, Free, and Accepted Masons had expanded by the 1730's to Ireland, Scotland, and America. Masonic Grand Lodges were flourishing in each of the original states by the end of the American Revolution, and in the opening years of the nineteenth century the Society, like the nation itself, prospered and expanded into new territories.

Masonic symbols, with their classical emphases, are found on a wide range of decorative arts made during the century between 1720 and 1820, often in combination with patriotic symbols. The Jacquard coverlet, woven in Dutchess County, New York, for one M. Haxtun around 1825, combines the American spread eagle, stars, and Independence Hall with the Masonic twin pillars (strength and stability), a lock (importance of Masonic secrets), and the square and compass (the Masonic code of conduct). The coverlet was undoubtedly woven to commemorate a fellow Mason's triumphal tour of the prospering new nation for the corner block reads, "AGRICULTURE & MANUFACTURES ARE THE FOUNDATION OF OUR INDEPENDENCE. JULY 4 1825 GNRL LAFAYETTE."

The thick-bottomed firing glass in the center of this picture would have been used in the celebrations following Lodge meetings when members would gather for liquid refreshment. Beverages were called "powder," glasses were "cannons," and to drink from a glass was to "fire" it. "Cannons" were "fired" after a toast was given and the emptied glass was banged on the

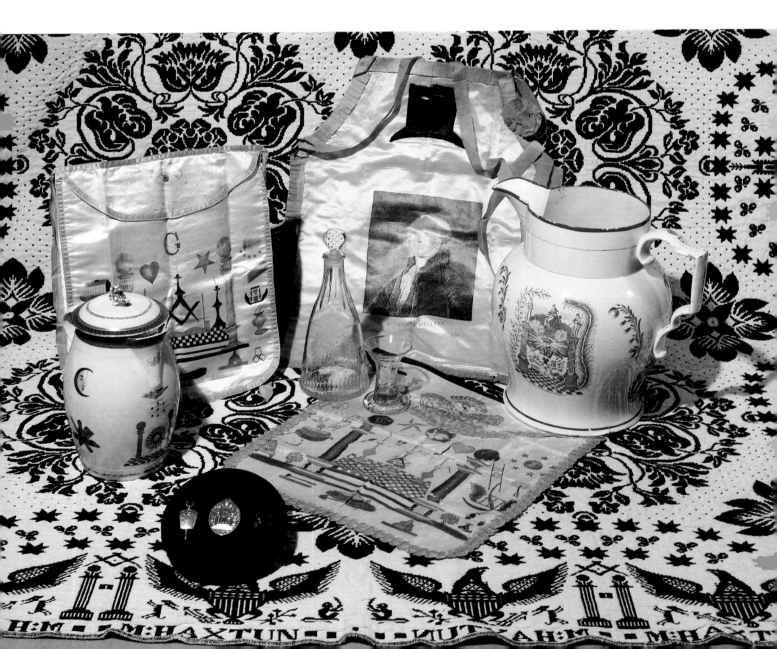

table for emphasis. Made to withstand such hard usage, the glasses have an unusually thick foot.

The three silk Masonic aprons were worn like a badge and were derived from the aprons worn by eighteenth-century artisans to protect their clothing. A piece of newspaper dated 1831 worked its way from underneath the black top hat on the bib of the center apron. It had apparently been used to stiffen the hat when the apron was worn in 1832 to a celebration commemorating the one hundreth birthday of the most famous of all American Masons, George Washington. The Masonic motto transfer printed on the presentation jug at the right, "UNITED FOR THE BENEFIT OF MANKIND," suggests why this fraternal Society would have had such appeal in a new nation imbued with esteem for civic virtue. JM

14 Prior to the American Revolution, the American colonies had been involved in a number of military conflicts. However, the majority of these battles were fought by career soldiers and assisted by Britain's well-supplied standing army. The War of Independence forced into action local militia corps who were inadequately trained and sparingly outfitted. Among the American foot soldier's belongings one might expect to find was a powder horn. Often made from horn, these powder containers are sometimes highly individualized, as owners engraved their names and the date for identification. Frequently, maps, scenes, and sayings accompany the engraved signatures. The 1777 powder horn pictured in the foreground belonged to "J. McKee" and warns that "The Red Coat Who Steals The Horn Will Go To Hell From Whence He's Born"!

The Revolutionary soldier would also carry a water container or canteen, frequently made of wood, as

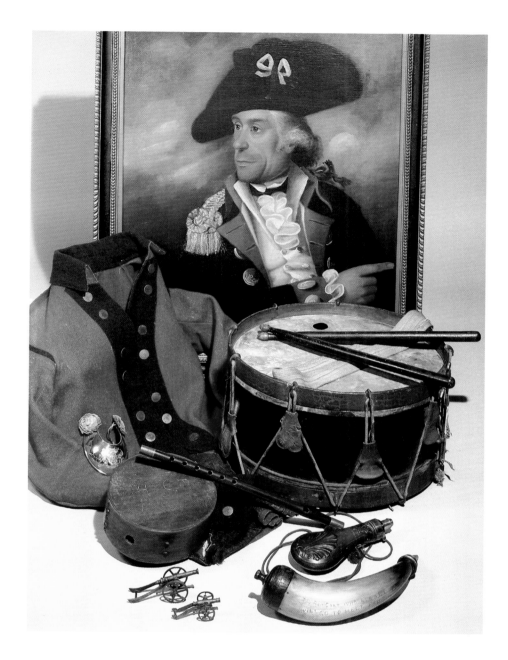

the example illustrated. The movement of foot soldiers was slow and difficult and marches played by the corps' fife and drum players most certainly encouraged a troop's pace. Pictured is an eighteenth-century cherry fife and a nineteenth-century drum.

Those soldiers who distinguished themselves often rose in rank. In this oil portrait Christopher Marshall is wearing a captain's uniform, the epaulette on the right shoulder verifying his

rank. Marshall had been a minute man at Bunker Hill and served as Adjutant, then Captain in the Tenth Massachusetts Continentals led by his brother Colonel Thomas Marshall, hence the number 10 engraved on each button of his uniform. Christopher Marshall was later assigned to West Point and was present at the execution of Major John André and the surrender of both General John Burgoyne and General Charles Cornwallis. SMD

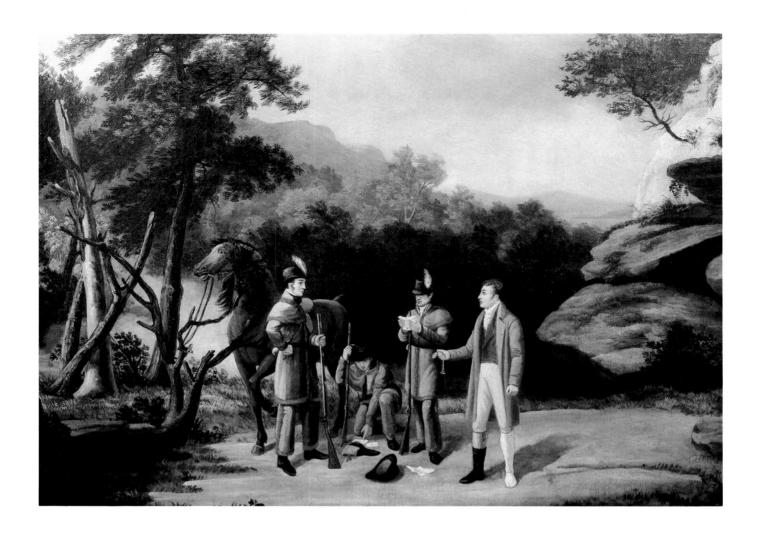

15 Historical painting was one way of renewing patriotic fervor and romanticizing the heroic moments of a victorious war. The capture of Major André was one of the most portrayed incidents. Thomas Sully and Asher Durand both painted scenes similar to this one and engravings after a painting by Stothard were advertised in the *Pennsylvania Packet* in 1797. Major John André, Adjutant-General of the British Army in North America, had been entrusted by Sir Henry Clinton with the correspondence between the British headquarters and Brigadier General Benedict Arnold. On September 21, 1780, André met the traitor Arnold just south of West Point to finalize arrangements for the betrayal of West Point to the British. Two days later, having changed his costume for a civilian disguise, and carrying the treasonable papers which included plans of the fortifications at West Point, accounts of orders issued by George Washington, and a pass signed by Arnold, André was captured at Westchester, New York. According to one legend, which is illustrated here, the three Americans who apprehended André, John Paulding, Isaac van Wart, and David Williams, refused his gold watch as proof of his being an English gentleman and not a soldier. They searched and found the papers, purportedly in a boot. Paul Svinin had thought Thomas Sully's rendition of this scene his finest painting and admired the feeling, power, and patriotism of the three American heroes "examining the papers found in the British officer's boot." The three American militia-men turned André over to the American army and on October 2, 1780, he was hung as a spy at Tappan, New York.

The inscription, T. Inch 1831, scratched into a rock in the lower left, is believed to be what remains of the signature of Thomas Birch (1779–1851), the English-born son of a painter and engraver who had moved to Philadelphia with his family in 1794. In accord with this attribution to Birch is the dramatic, romantic landscape setting in which the smaller human drama is taking place. In *The Capture of Major André* Thomas Birch has synthesized the two forces which influenced American art in the early years of the Republic —nationalism and romanticism. JM & EDG

16 America as an Indian princess and American agriculture as the goddess Ceres flank a serene setting bathed in a golden light. Lofty mountains, navigable waterways, and abundant crops set forth the American promise of peace and plenty. Although the exact purpose of this small (10 by 7¾ inches) painting is not known, it is possible that Henry Inman (1801–1846) was working with a design for a banknote engraving. Whereas a barter and exchange economy had sufficed for much of the eighteenth century, the rapidly expanding and increasingly sophisticated commercial world of nineteenth-century America relied more and more on currency. Competitive banks printed their own notes, patroniz-

ing the best artists for designs. Around 1813, Paul Svinin observed that, "Both for the sake of beauty and particularly to make counterfeiting more difficult, every bank engages the best engravers to cut the plates, and pays very generously." Replete with patriotism, optimism, and agricultural abundance, Inman's design would have been ideal for notes of the Farmers' Bank. Svinin continued, "the notes issued by the Farmers' Bank bear the image of Ceres with all her attributes, agricultural tools, etc." This painting and plate 6 were formerly owned by the Virginia primitive artist, John Toole (1815–1860), and descended in his family. EDG

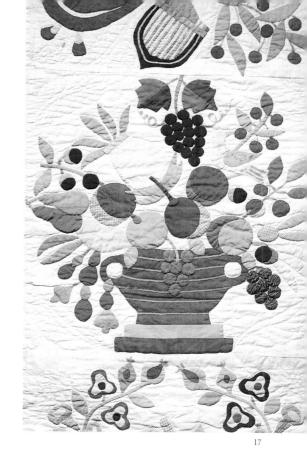

16

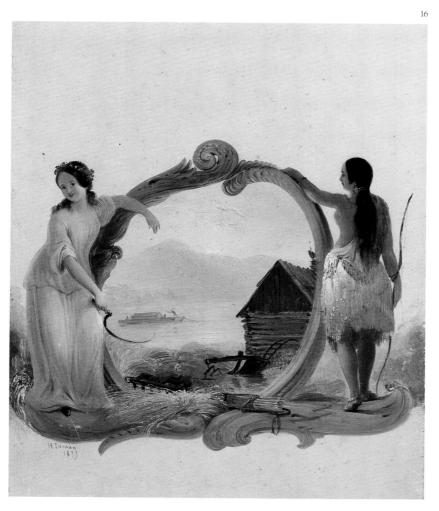

17

17 The iconography of plenty is here colorfully appliquéd on an album quilt by Carmelia Everhart of Carroll County, Maryland. A profusion of fruits and flowers spill out of a vessel which—with its swelling bowl, double handles, and stepped platform base—closely resembles silver sugar dishes in the Empire style of the 1830's and 1840's. Although the American diet was often repetitive and unimaginative, it was also abundant. Foreign observers were astounded by the amount of meat consumed by Americans of all classes, and markets in the large port towns were amply supplied with fruits and vegetables. The duc de la Rochefoucauld Liancourt exclaimed in 1799: "There is not a family, even in the most miserable hut in the midst of the woods, who does not eat meat twice a day at least, and drink tea and coffee; and there is not one who drinks pure water; the proverbial wish of having a *chicken in the pot,* is more often accomplished in America." EDG

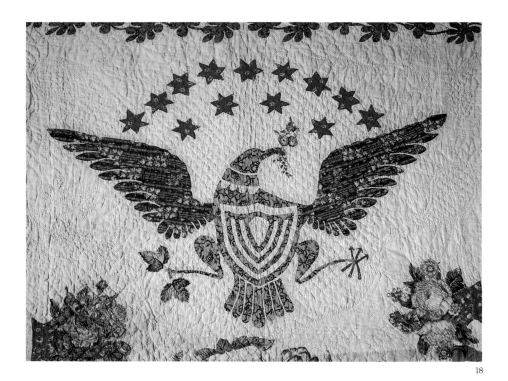

18

have made the quilt around 1815. A Markey family genealogy, published in 1917, mentions this quilt, "decorated with a superb spread-eagle copied from a china plate or possibly from the Washington pitcher." The Washington pitcher was an English transfer-printed jug with a Washington mourning scene on one side and the Great Seal of the United States on the reverse which, like the quilt, was still owned in the family. The reverse positioning of the eagle, which actually faces left in the Great Seal, lends credence to this suggestion, although there were many other possible design sources for the eagle. EDG

18 Thirteen states had been brought together in the War of Independence and the bald eagle became the symbol of that union by act of the Continental Congress in 1782, with the adoption of the Great Seal. Here, a victorious eagle, appliquéd on a bed quilt, holds leaves which look more like autumn maple leaves than the laurel branches of the Great Seal, and arrows which resemble eating utensils, but the victorious glint in his eye was ensured by the glass bead his creator, Anna Catherine Markey, stitched on. Anna Catherine Hummel Markey, of Frederick, Maryland, is believed to

19

19 With the approval of the bald headed eagle for the Great Seal of the United States in 1782, the popularity of the eagle as a decorative motif soared. The bird of freedom was represented in innummerable mediums, including paper cutwork or papyrotamia. Primarily an art form practiced by ladies, the cutting required sharp scissors and steady hands. The first step in executing the design entailed pinning a sheet of heavy paper to a board onto which a pattern was drawn. Secondly, a special penknife was used to excise unwanted paper. Once removed from the board, the design was further trimmed. Papyrotamia pictures were usually mounted on dark paper and framed. Frequently, details were painted with watercolors and ink. This artist has highlighted the American flag and the threatening serpent which the eagle unperturbedly holds in its beak. The word "VICTORY" is triumphantly cut out below. A very similar example, now in the collection of the IBM Corporation, replaces victory with "LIBERTY". The fact that the eagles in these two examples are identical suggests that the pattern for this eagle was widely available.
SMD & EDG

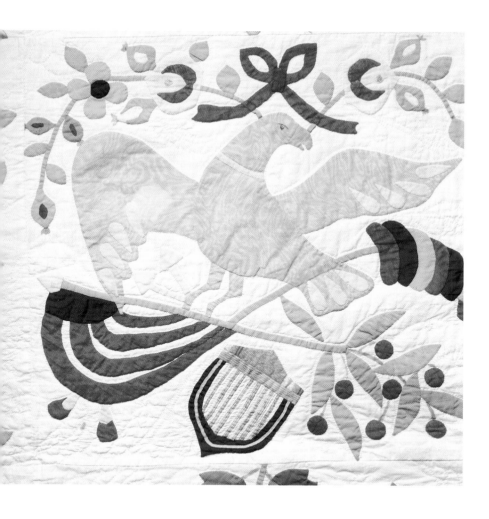

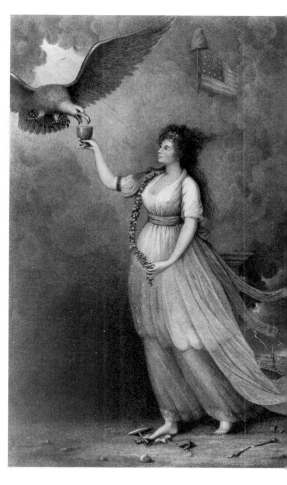

20 When Carmelia Everhart appliquéd this watered silk eagle on her Maryland album quilt she equipped him with many of the standard accessories—American flag, shield of the United States, and Phrygian liberty cap. She also gave him a piercing painted eye. Carmelia Everhart of Manchester, Carroll County, Maryland, probably appliquéd the bed cover, from which this eagle is a detail, shortly before her marriage in 1859. Family history received with the piece relates that she did not quilt it until 1907, by which time she was seventy-two years old. (See also pl. 17) EDG

21 In this print, "LIBERTY. In the form of the Goddess of Youth; giving Support to the Bald Eagle," a Grecian-gowned symbol of America offers sustenance to a dramatic eagle. Striding over the Order of the Garter and the Key to the Bastille, she promises to lead the world in the way of civic virtue and humanitarian rights. As David Ramsay had expressed it in 1794, "America's purpose is to prove the virtues of republicanism, to assert the Rights of Man, and to make society better." Engraved by Edward Savage and published in Philadelphia in 1796, the print was tremendously popular and was much copied by schoolgirls in their silk embroideries and by Chinese copyists in reverse paintings on glass. The DAR Museum also owns a silk embroidery of Liberty (see frontis.) worked by a schoolgirl who replaced the background view of Boston Harbor with a view of Trenton, New Jersey, and the triumphal arches through which Washington passed enroute to New York to take the oath of office as first President of the United States.

The public was so familiar with this print of Liberty that in commenting on the paintings exhibited in the Columbian Gallery in November, 1802, the New York *Morning Chronicle* would write: "No. 6. Liberty, as the goddess of youth, giving nourishment to the Bald Eagle &c. &c. The print taken from this has had so extensive a circulation as to preclude the necessity of any other observation. The following lines refer to the subject: Welcome, fair Goddess! to this western shore,/ Where chains can bind, and sceptres sway, no more;/ Beneath thy foot th' infernal key be trod,/ Which erst, doom'd slavery, at the tyrant's nod:/ Bid eastern climes adieu-they spurn thy sway;/ Here feed thine Eagle in the blaze of day:/ So shall the bird of Jove uphold thy name,/ And ne'er Columbia yield to Roman fame." EDG

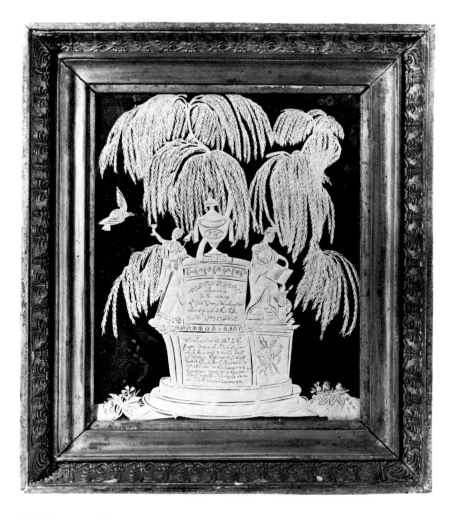

22 This beautifully executed cut-work or papyrotamia picture memorial to George Washington was probably made between 1820 and 1830. Liberty, offering support to the bald eagle, and Virtue or Truth announce the mission of America to spread concepts of justice, equality, and liberty throughout the world, by paper if possible, by sword otherwise. The picture is set against a mirrored backing, which clarifies the details. The frame is original. George Washington received the adulatory tributes of his people in life as in death. Eliza Susan Morton Quincy recalled that while Congress met in New York City, the great man, "lived in a large house in Cherry Street, and always received the highest proofs of affection from the citizens. On one occasion, when he was ill, I remember seeing straw laid down in the adjacent streets, and chains drawn across those nearest the house, to prevent his being disturbed by carts and carriages." EDG

23 Examples of ceramic forms produced in England for the American market in the early nineteenth century are the two jugs and the oval plaque, all transfer-printed with portraits of Washington. The pearlware jug on the left was made by Richard Hall & Son of Staffordshire, England, to commemorate the triumphal American tour of the Marquis de Lafayette in 1824 and 1825. Transfer-printed portraits of Lafayette, "THE NATION'S GUEST," and Washington, "THE COUNTRY'S FATHER," decorate opposite sides. According to family tradition, the pitcher was purchased by the donor's great-great-grandfather, Micah Thayer, at the cornerstone laying of the Bunker Hill Monument in Boston in 1825. It probably was actually purchased as a souvenir of that event shortly thereafter. The creamware jug, with its transfer print of Washington "ASCENDING INTO GLORY," was based on an engraving by John James Barralet (1747–1815) entitled, "Apotheosis of Washington," which was published by Barralet and Simon Chaudron, the head of a silver shop and entrepreneur in Philadelphia. A proof print was on view in their respective shops in December 1800: "Proof print on View. The subject General Washington raised from the tomb, by the spiritual and temporal Genius...assisted by Immortality. At his feet America weeping over his Armour, holding the staff surmounted by the cap of Liberty, emblematic of his mild administration, on the opposite side, an Indian crouched in surly sorrow. In the third ground the mental virtues, Faith, Hope and Charity. To be seen at Messrs. Shaudron's No. 12, Thirdstreet, at J. J. Barralet's corner of 11th and Filbert-streets, where the books lie for subscriptions" (Aurora, Dec. 19, 1800). The transfer-printed portrait of Washington on the creamware plaque, which is believed to have been made at the Herculaneum Pottery in Liverpool, was based on an engraving after a portrait by Gilbert Stuart.

French merchants courted American consumers with items such as the gilt-bronze shelf clock surmounted by the bronze bust of General Washington. A bronze bas-relief inset at the base of the clock depicts the Surrender at Yorktown. The 1849 bronze bust of George Washington by the American sculptor, Clark Mills (1810–1883), attests to the longevity of this hero's appeal. In that year Colonel John A. Washington permitted Clark Mills to cast a bronze bust from the Houdon original of 1785 at Mount Vernon. This was one of three cast by Mills at his foundry in Muirkirk, Maryland.

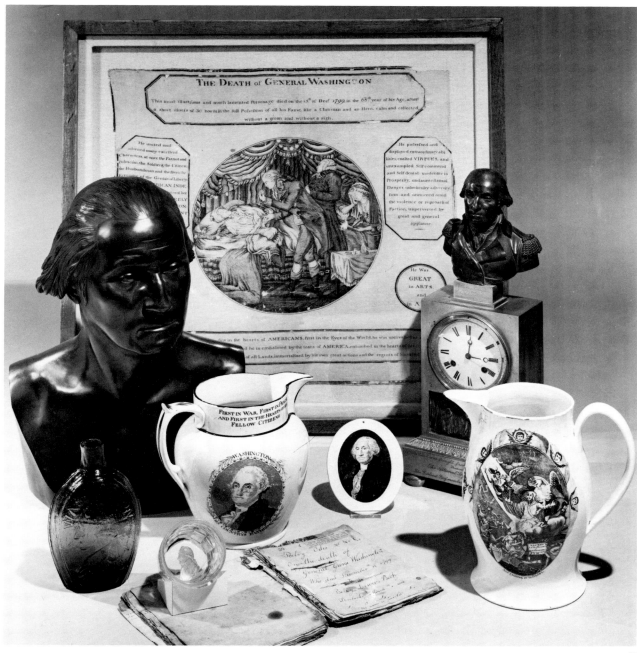

American glass companies entered the trade in patriotic wares with items like the blown-molded whiskey flask by the Keene Glass Works of Keene, New Hampshire. Washington is portrayed on one side, Andrew Jackson on the other. The Pittsburgh glass company of Bakewell, Page and Bakewell produced tumblers with a sulphide portrait bust of Washington in the bases between 1824 and 1825.

The extended period of mourn-ing which followed Washington's death in 1799 resulted in objects such as the printed handkerchief with a center medallion portraying Washington on his deathbed sur-rounded by written tributes. The deathbed scene was derived from an engraving by Pember and Luzarder of Philadelphia in 1800 entitled, "Washington in his last Illness attended by Docrs. Craik and Brown." One young patriot, fourteen-year-old Betsy Lewis, transcribed memorial poems and tributes into her copybook while away at school in Dorchester, Mass-achusetts. At the top of the page illustrated here she has pasted a newspaper clipping on the death of this great man. Images of Washing-ton would continue to be popular. National celebrations and political campaigns would often result in re-calling the Washington legend.
SMD

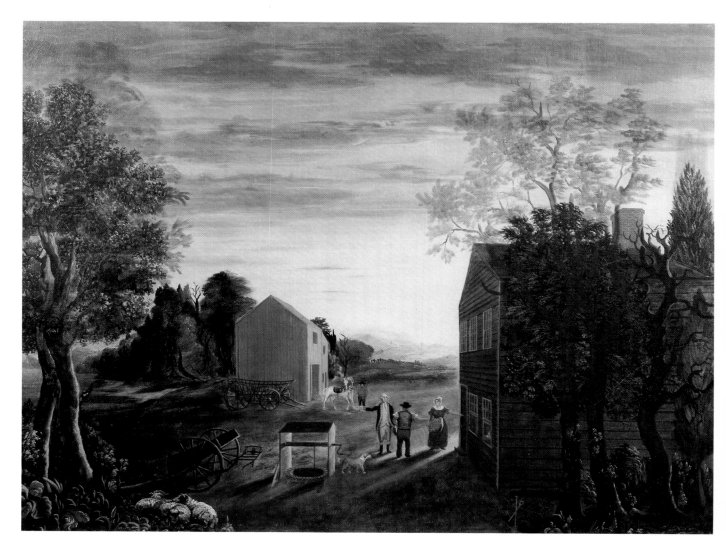

24 In this genre scene set in Revolutionary War days, General Washington has hastily dismounted at a farmhouse to ask directions to Valley Forge. The farmer and his wife seem to be motioning to Washington to come inside for rest and refreshment, while the General, pointing in the opposite direction, is perhaps saying that he must travel on before the setting sun removes all visibility. The overmantel painting was removed from a farmhouse on Providence Road near Media, Pennsylvania, and it is possible that Washington did actually stop there for assistance. Painted many years after the event, the painting would then immortalize the most important day in the history of that farmhouse. Hypothetical or factual, the painting was hung over the mantel where the glow of the fire would light it while warming the gathered family.

The image of Washington, in paper and paint, was common to American homes in the nineteenth century. Thomas McKean had "1 Picture Genrl Washington" and "1 Picture Thos Jefferson" in the North Parlor of his Philadelphia home in 1814, along with the "Sopha" (pl. 127) which is now in the Museum collection. Paul Svinin, a Russian traveling in the States between 1811 and 1813, observed that "every American considers it his sacred duty to have a likeness of Washington in his home, just as we have images of God's saints...Washington's portrait is the finest and sometimes the sole decoration of American homes." For most Americans living in the early nineteenth century, Washington was a secular saint and the personification of the New Republic. His image, on walls throughout the land, preached reverence and patriotism to youth and adult alike. One manual on child care advocated that, "In every home in our land, the altar of patriotism should stand beside the altar of religion. Mothers should teach the first lesson in history in one word—Washington."

This painting has been attributed to David L. Donaldson, an artist working in the region. Donaldson named his own son "Washington" in yet another example of the veneration of the father of this country. EDG

25 In this small painting, George Washington is depicted as commander in chief, the light-blue ribbon across his chest distinguishing his military position. The image of Washington as America's first commander in chief was an early representation, to be followed by Washington as president, Washington as statesman, and, finally, Washington as the allegorical symbol of the nation. On the back of the portrait's modern frame is written the penciled inscription, "W. J.

Williams." Previous owners had attributed this portrait to William Joseph Williams (1759–1823) based on this inscription. Although Williams did execute a portrait of Washington in the Masonic regalia of the Washington-Alexandria Lodge around 1793, there is little conclusive evidence to support the association. It appears that the portrait was not drawn from life but derived from published engravings, and it could quite possibly be of French origin. SMD

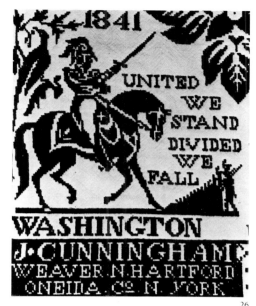

26

26 James Cunningham was a professional weaver who wove coverlets, tablecloths and other textiles in his shop in New Hartford, Oneida County, New York. A native of Scotland, he worked in partnership with Samuel Butterfield until 1835. He favored the use of patriotic slogans and symbolic references to the United States and continued to use the mounted military figure of Washington as a corner motif until late in the 1840's, when it was gradually supplanted by the arms of the State of New York. Cunningham wove this double weave coverlet for Almira Farmer, whose name is woven in the head border. The daughter of Simon and Hannah Farmer, Almira was born in Herkimer County, New York, on February 19, 1825. On April 7, 1841, at the age of sixteen, she married Jerome Jay Johnson of the same county and continued to live in this area until her death in 1891. Undoubtedly woven for her dowry, the coverlet descended in the family until it was given to the Museum by her great-great-grandson. An identical coverlet by Cunningham, illustrated in *The Treasury of American Design,* vol. II, was made for Betsy L. Farmer in 1842. Genealogical research reveals that Betsy was Almira's maiden aunt. GSA

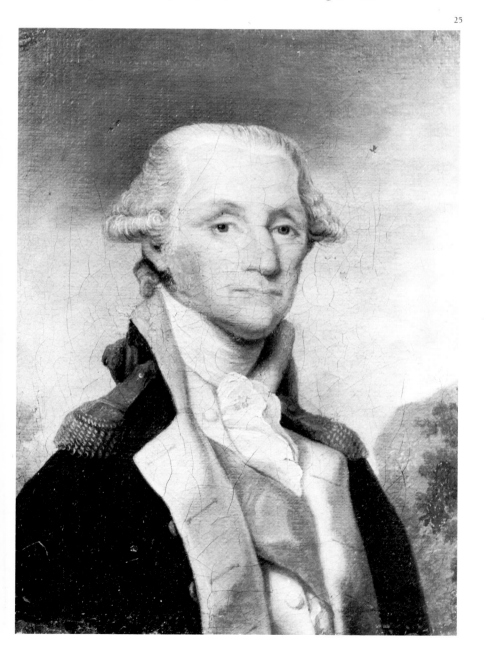

25

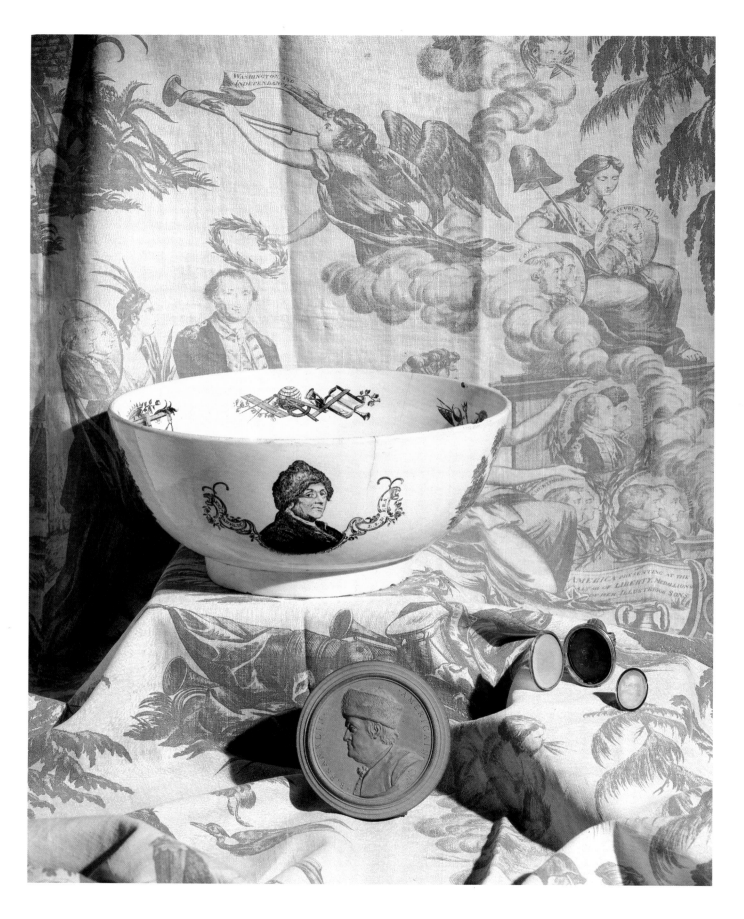

27 Benjamin Franklin as an American icon was reproduced in a variety of forms and on a number of surfaces for purchase by American, and even French, consumers. Franklin's death in 1790 and the centennial of his birth in 1806 correspond in time to the period of heightened interest in producing wares for an expanding American market. Images were sought for the glorification of the new nation. Along with those of George Washington and General Lafayette, Franklin's image was immediately recognizable, and his accomplishments as inventor, writer and statesman were well known.

A fur-hatted Franklin appears on a variety of objects in this illustration. On the terra-cotta medallion by Jean Baptiste Nini (1717-1786) and in the printed textile medallion Franklin wears a tailored fur hat quite unlike his usual shapeless one of the American frontier. The style of hat worn by Franklin in these medallions makes allusion to one worn by and associated with Jean Jacques Rousseau. Nini was thus making a visual connection between an American and a French philosopher.

Also in the French tradition is the very small intaglio image on the watch seal. It resembles the profile busts found on medallions modeled at the Sèvres porcelain factory in 1778 and painted on Sèvres porcelains in 1789. The transfer-printed image of Franklin on the creamware bowl shows Franklin wearing his more natural loose-fitting fur cap and spectacles. The image was engraved in France in 1777 and soon became the accepted image of this American statesman. GSA

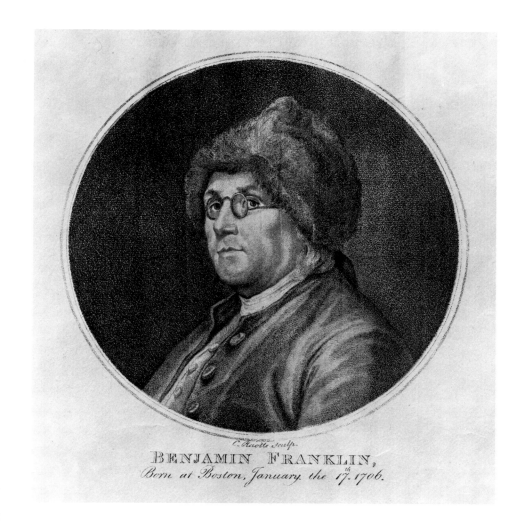

BENJAMIN FRANKLIN,
Born at Boston, January the 17.1706.

28 The likeness of Benjamin Franklin, bespectacled and wearing a fur hat, is similar to the transfer print on the English creamware bowl illustrated in plate 27. The image had tremendous popular appeal and was therefore copied directly or altered slightly and issued by a number of printers in America, England, and France. The original drawing of Franklin was executed by Charles Nicolas Cochin (1715-1790), and the first version was engraved on copperplate in 1777 by Augustin de St. Aubin. In 1784 St. Aubin's print was copied by John Norman and published in the *Boston Magazine*. Norman (c. 1748-1817) was a London engraver who came to try his fortunes in the New World. Arriving first in Philadelphia around 1774, and probably not finding much support in that city of patriotic fervor, he moved to Boston around 1780, where his reception enabled him to be one of the publishers of the *Boston Magazine,* and in 1789 he brought out the first Boston directory. Another American version of the Franklin portrait was engraved by William Harrison, Jr., who was likewise born in England and was engraving in Philadelphia by 1797, the year of his Franklin engraving. The version illustrated here, by Louis Charles Ruotte, was probably published in England for the American market. The number of versions underscores the ready availability and tremendous appeal of prints in late eighteenth-century America. GSA

Faces of the Family

IGHTEENTH–CENTURY Americans demanded that the beautiful also be useful, and by 1837 Francis Grund would still perceive that, "The Americans are yet occupied with what is necessary and useful."[1] As painting served little productive purpose, neither the art nor the artist received much encouragement. Eighteenth-century American artists were artists in spite of, not because of, living in the New World.

John Trumbull (1756–1843), the historical, portrait, miniature, religious, and landscape artist from Connecticut, complained that in America painting was generally regarded as "frivolous, little useful to society, and unworthy of a man who had talents for more serious pursuits."[2] With resignation, he pronounced, "I would sooner make a son of mine a Butcher or a Shoemaker, than a Painter."[3] Boston's John Singleton Copley (1738–1815), censured, "The people generally regard it [painting] no more than any other usefull trade, as they sometimes term it, like that of a Carpenter[,] tailor or shew maker, not as one of the most noble Arts in the World. Which is not a little Mortifiing to me."[4]

Perceived as artisan-craftsmen, American painters or limners, as they were sometimes styled, often served the community in a number of different ways. Versatility was essential. Among the artists represented in the DAR Museum collection, for instance, Joseph Badger began as a house painter; Christian Gullager advertised painted flags, drums, signs, fire buckets, and cornices; James Peale had worked as a chaisemaker and a saddler; Jacob Eichholtz as a coppersmith.

The skill of painting was sometimes learned within the family, through the generational perpetuation of a craft in the master-

29 *Mary Lightfoot*, by John Wollaston, c. 1757, oil on canvas, Charles City County, Virginia.

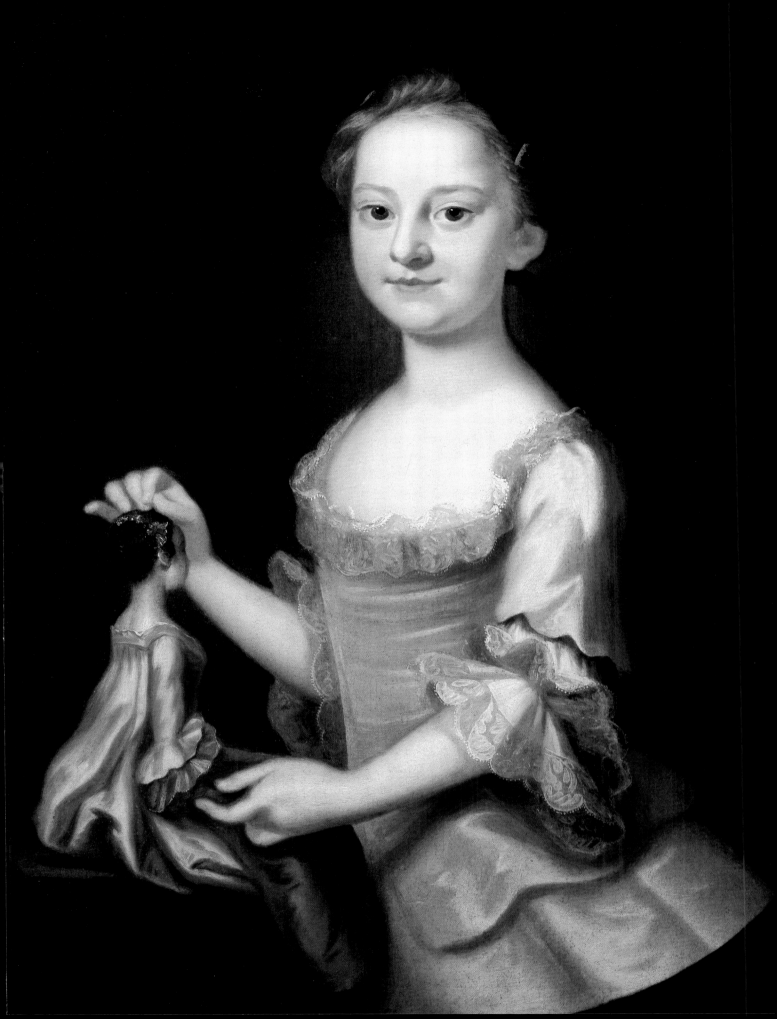

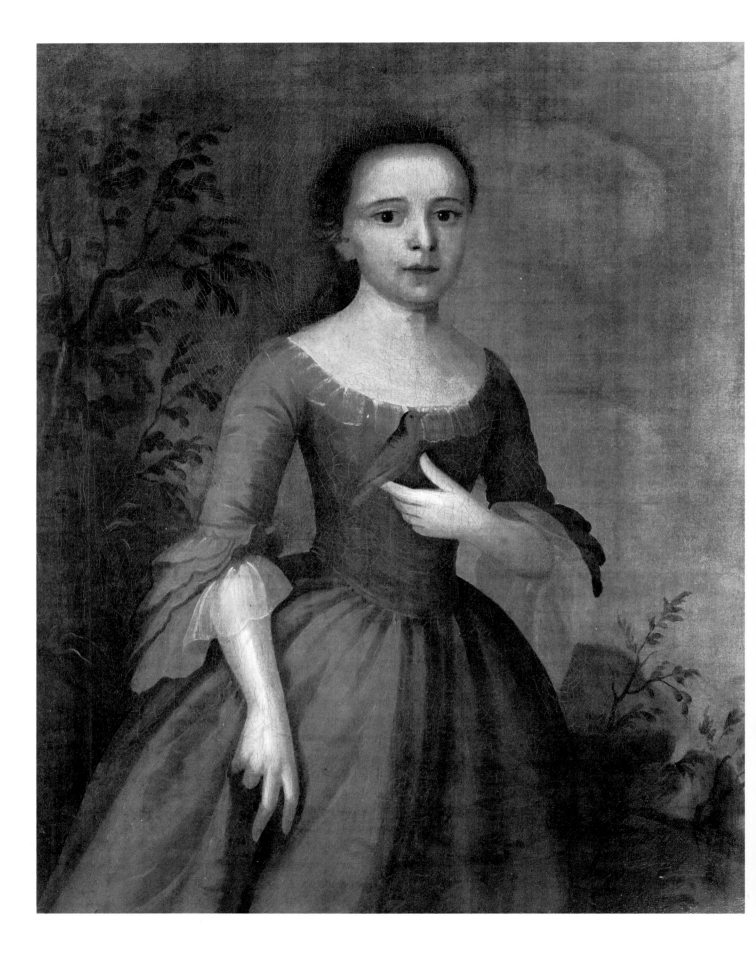

30 Rebeckah Barrett was one of eleven children born to Deacon Samuel and Mary Shedd Barrett. Her father was a sailmaker and a member of the Ancient and Honorable Artillery Company. He was deacon of the New North Church and later became a judge of the court of common pleas for Suffolk County, Massachusetts. Rebeckah was painted by Joseph Badger (1707/8–1765), a house painter and glazier who worked as a limner in Boston between 1740 and 1765. The bird on her finger could be a symbol of the transience of life, although Badger frequently portrayed his youthful subjects with a bird or squirrel.

The pose and the landscape in this portrait are similar to those in the artist's 1760 portrait of his three-year-old son, James, which is now at the Metropolitan Museum of Art. Both paintings are clearly derivative of English portrait traditions, and each child appears as the miniature adult children were then esteemed. Although Joseph Badger depicted his subjects with some realism, there is little movement or sense of placement in space. In spite of this, he portrays an innocence and honesty which was much sought after by eighteenth-century Bostonians. Both artist and subject died in 1765. Little Rebeckah was but eight years old. JM

apprentice tradition. Joseph Badger's sons advertised their capabilities in "painting and glazing in all their branches" in 1766.[5] James Peale learned painting from his elder brother, Charles Willson Peale, and Ralph E. W. Earl from his father, Ralph Earl. But most American artists in the eighteenth and early nineteenth centuries were self-trained. In 1837, Francis Grund observed that, "there is, in America, no deficiency of talent either for drawing or painting; but there is little or nothing done for their encouragement. The education of an American artist, with the only exception of a few, not very competent drawing-masters, is altogether left to himself, and to the chance he may have of visiting Europe and studying the old masters,"[6] After sitting for his likeness, Chester Harding (1792–1866), a one-time chairmaker and sign painter, was consumed with a desire also to paint a portrait:

> At length my admiration began to yield to an ambition to do the same thing. I thought of it by day, and dreamed of it by night, until I was stimulated to make an attempt at painting myself. I got a board; and, with such colors as I had for use in my trade, I began a portrait of my wife. I made a thing that looked like her. The moment I saw the likeness, I became frantic with delight: it was like the discovery of a new sense; I could think of nothing else. From that time, sign-painting became odious, and was much neglected.[7]

He was ultimately able to devote himself exclusively to portraiture.

Many artists in early America were, however, not able to subsist on painting pictures alone. They diversified their talents, offering painted chairs and signboards, full-size and small-scale likenesses, and they further supplemented their incomes by offering to teach the basics which they had themselves often just mastered. David Boudon advertised his capabilities as both painting and drawing master and versatile artist in the *Maryland Gazette* on November 5, 1807, promising "that if by subscription he can procure a sufficient number of scholars to form an academy, he offers to teach with rapid success. He also paints MINIATURES at moderate prices. Likewise PROFILE PORTRAITS, colored on vellum at three dollars each."[8] Many itinerant artists traveled widely in search of clients. Reuben Rowley and Ruth Henshaw Bascom painted in rather narrow geographic areas—the Chenango and Susquehanna valleys of New York, and the Franklin County region of Massachusetts, respectively—while others, like David Boudon and Edward Greene Malbone, covered the Eastern Seaboard and more. Miniaturist Philip Parisen stated in the New York *Daily Advertiser* on July 15, 1791, that he had received extensive patronage for his "striking likenesses" in fourteen states.[9] Portraits were the staple of the artist's trade.

In seventeenth-, eighteenth-, and early-nineteenth-century America the portrait was a recognizable sign of social and economic distinction. The richness of the costume and the elegance of the accessories in the portrait were obvious indicators of status and prestige. Although social distinctions were professedly less important in America than in any country in the world, they were in fact still important. James K. Paulding directed in 1819, "In the eyes of the law, let all men be equal, but not in the drawing rooms or in the assemblages of well-bred people." [10] If the portraits hanging on drawing room walls denoted social distinction, then ancestral portraits added the element of time—social distinction of long standing. When John Adams countered John Taylor's challenge to his view on American aristocracy, he pointed to Virginia to document his belief that ancestral portraits and other heirlooms were obvious symbols of distinction in society:

> I should be highly honored and vastly delighted to visit with you every great planter in Virginia. I should be pleased to look into their parlors, banqueting rooms, bedchambers, and great halls, as Mr. Jefferson and I once did together the most celebrated of the gentlemen's country seats in England. Should we there see not statues, no busts, no pictures, no portraits of their ancestors? no trinkets, no garments, no pieces of furniture carefully preserved, because they belonged to great grandfathers, and estimated at ten times the value of similar articles of superior quality, that might be bought at any shop or store? What are ancestors, or their little or great elegance or conveniences, to the present planter, more than those of the fifty-acre man, his neighbor, who perhaps never knew the name of his grandfather or father? Are there no natural feelings, and, consequently, no natural distinctions here? [11]

Like silver engraved with the family coat of arms or Chinese export porcelain decorated with armorial devices, the portrait connoted lineal distinction. Willed to the next generation, these portraits served the didactic function of instilling filial piety and intimating obligation to uphold family honor. Francis Wells had perhaps looked daily upon the "Picture of Cap.t Wells," "d.o his Wife," "d.o his Grandfather," "d.o his Grandmother," and "d.o his Uncle," which hung on the walls of his Boston home in 1767.[12] Many of the portraits in the DAR Museum collection descended in the families of their original owners.

Further, in preserving a likeness, the portrait offered a kind of permanence to a most impermanent life—something which would have appealed to the eighteenth-century mind as well as to vanity. In a transient world, the portrait provided a record of a life, a union, a family, which could at any moment be severed by death.

31 The frills of Rachel Marshall's elaborate cap do not soften the sternness of her expression. Straightforward and direct, the portrait displays the American demand for a plain truthfulness. Rachel Harris was baptised in Boston in 1743, and at the age of twenty-three married Christopher Marshall, whose portrait by the same unidentified artist is also in the collection (pl. 14). When the *Columbian Centinel* published her death notice on November 25, 1829, Rachel Marshall was eighty-six years old, having outlived her husband by a quarter century.

The pendant portraits were probably painted around 1790. The original frames are each stamped, S. WADE. This was quite possibly Simeon Wade, who was listed as a housewright in the 1789 and 1798 Boston directories, underscoring the versatility of the artisan-craftsman in the eighteenth century. The *Columbian Centinel* tersely recorded, on May 3, 1806, the death of Simeon Wade, a carpenter in Boston, by an accident, when he was forty-nine years old. EDG

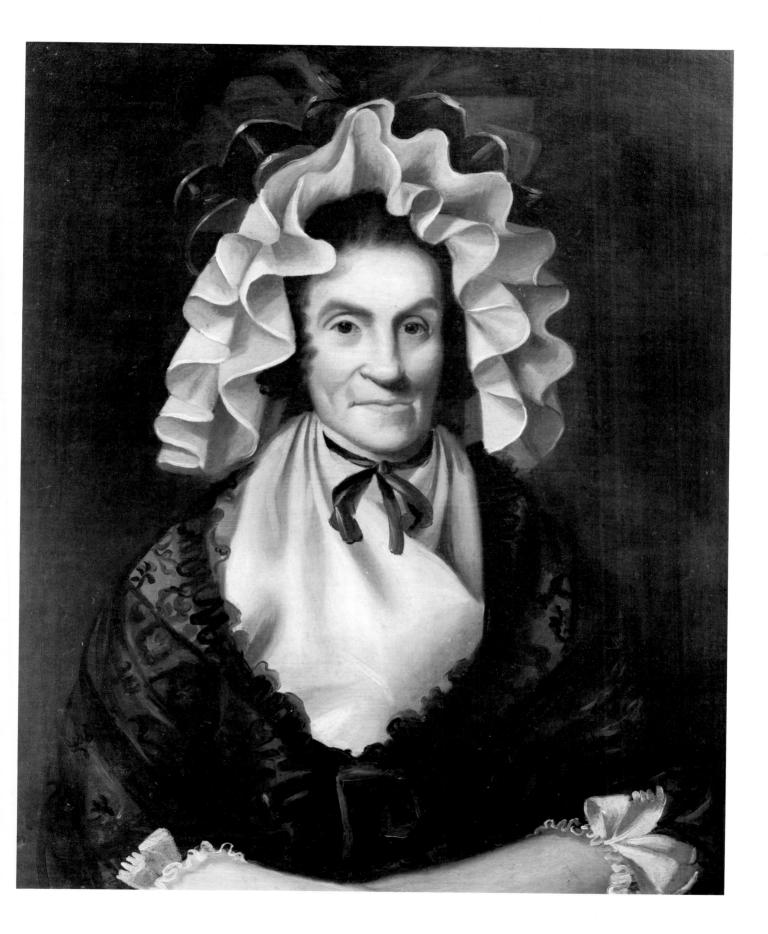

The James and the Humphrey Courtneys (pls. 32–34) sat for James Earl that they might be recorded as a family and one can visualize the Knowltons (pls. 43, 44) gathering at the parental homestead to have their "copies" taken by Ruth Henshaw Bascom at the very moment that the family was to be dispersed through the marriages of two of the children.

The miniature portrait provided tangible, portable evidence of a life held dear. Women might wear the miniature of a loved one as a ring or a brooch, on a necklace or a bracelet. Sarah Anna Emery recalled that in early nineteenth-century Newburyport, Massachusetts, "The strings of gold beads so general in my mother's girlhood were then deemed old-fashioned; necklaces and chains had taken their place; often a miniature painted on ivory set in gold was worn on the chain. Both my Aunt Peabody and Bartlett had good likenesses of their husbands, which were fine paintings."[13] The miniature portrait offered emotional sustenance to those separated in the vicissitudes of life. One sweetheart or wife, in Revolutionary War times, must have been relieved when, on October 12, 1775, Charles Willson Peale, "finished the Officers Mi[niatu]re...and set it in a mettal Bracelet."[14] On March 4, 1792, Mrs. Samuel Cary of Chelsea, Massachusetts, wrote to an adventuresome son who had begun business life in St. Kitts, elaborating on the emotional value and the virtues of a miniature:

> You wrote me some time ago to request one of the minia-
> ture pictures. I would be happy to gratify you with mine,
> but no consideration could prevail upon me to part with
> your father's for numberless reasons. He has, perhaps, the
> same reason for refusing to part with mine. If my purse
> would allow of a little trifling in that way, I would sit again,
> and request yours in return. Although absence nor time can
> efface you from my mind, yet to look on the pictures of
> those we love excites the tenderest and most pleasing emo-
> tions, and makes them, if possible, more dear and amiable
> to our hearts and affections. In the absence of friends we
> contemplate only their virtues; those, too, heightened
> greatly by the loss of their company and conversation. We
> look on the little representation, forget their faults, and
> think them all perfection, as certainly we would wish to
> appear to one another.[15]

Traveling in the States between 1811 and 1813, Paul Svinin observed that, "In every city there is bound to be a miniature portrait painter," but he appended, "none may lay claim to the name of a good artist."[16] With the progressive democratization of American society in the first half of the nineteenth century, the demand for portraits was vastly increased, and so was the number of artists seeking to supply that demand. A general knowledge of

32 Humphrey Courtney was a prosperous Charleston merchant when he had his likeness recorded by James Earl sometime between 1794 and 1796. Pensive, relaxed, and boldly self-confident, he is portrayed surrounded by the tangible evidences of his success. The mahogany vase-back armchair in the fashionable Federal style is upholstered in dark red leather with brass-headed nails outlining the seat contours. His right elbow rests on a Federal demilune card table of lively figured mahogany with inlaid lightwood stringing and oval paterae. An elaborate silver writing set is on the table. All in the latest style, these possessions, his expensive costume and genteelly powdered hair are obvious status symbols. In his left hand Humphrey Courtney holds an opened letter which family tradition believes to be the receipt for the first bale of cotton shipped from Charleston. This tradition led to the exhibition of the painting in a New Orleans International Cotton Exhibition at the end of the nineteenth century.

Humphrey Courtney was born in Devonshire, England, in 1763, and

came to Charleston as a young man apparently fired with ambitions of self-made success. In 1790 he married Elizabeth Chardon Courtney, of no relation, and died on December 4, 1824, at the age of sixty-one, after a successful career as a merchant.

Charleston was a prosperous and cosmopolitan town when Humphrey Courtney arrived and an encouraging nursery for his ambitions. Exports of rice, indigo, tobacco, and cotton accounted for a large merchant aristocracy. "Every Tradesman is a Merchant, every Merchant is a Gentleman, and every Gentleman one of the Noblesse," quipped an observer with the pen name "Mentor" in the *South Carolina Gazette*. The portrait of Humphrey Courtney hangs as a bold endorsement of this upward mobility in the New Republic. Humphrey Courtney, handsome, self-assured, proud, and successful merchant gazes steadfastly from a canvas rich with a wealth of finery, a canvas which relates the saga of young America, this "world of living and active men." EDG

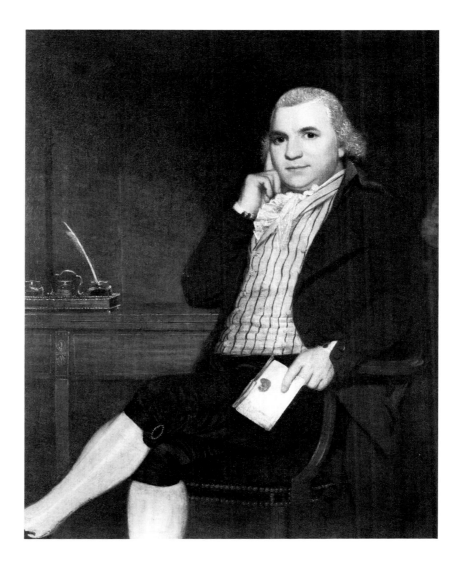

what was available spread to the middle class through newspapers and magazines, public exhibitions, galleries, and museums. Emulation was a motto in democratic America. "By-and-by," muttered the celebrated American artist, Gilbert Stuart (1755–1828), "you will not by chance kick your foot against a dog kennel, but out will start a portrait painter." [17] If the demand for portraits and the number of artists had escalated, the quality of the paintings, by these largely self-trained artists, was not proportionately increased. John Neal, a journalist, penmanship teacher, and miniaturist from Maine, observed in 1829:

> We have certainly, either by nature…or by accident, something that appears like a decided predisposition for painting in this country…Painters, if not too numerous to mention, are much too numerous to particularize. They are…more than we know what to do with. If you cannot believe this, you have but to look at the multitude of portraits, wretched as they generally are, that may be found in

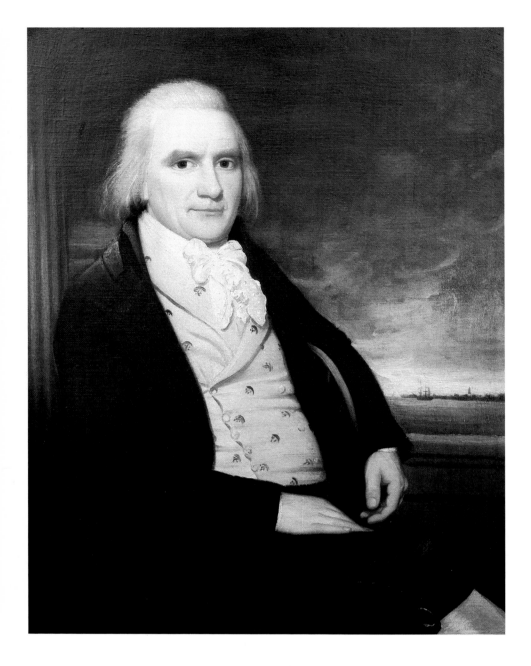

or were next door to each other on Meeting Street.

At about the age of forty-eight, James Courtney, his wife, daughter, and son-in-law had their likenesses recorded by James Earl. Earl, who is also believed to have been a Loyalist sympathizer, had arrived from a stay in England in 1794. Two years later he was dead, the victim of a yellow fever epidemic that ravaged Charleston. The *South Carolina State Gazette and Timothy and Mason's Daily Advertiser* appraised, "TO an uncommon facility in hitting of the likeness, may be added a peculiarity in his execution of drapery, and which ever has been esteemed in his art the NE PLUS ULTRA, of giving life to the eye, and expression to every feature."

One person who was not satisfied with this expression to every feature was Humphrey's wife, Elizabeth Chardon Courtney, who, according to family tradition, burned her unflattering portrait. The group of three surviving portraits are rich documentation for the esteem that Charleston felt for Earl. It would be interesting to know if the James or the Humphrey Courtneys decided first to sit for Earl, or if it was a family decision.

One wonders whether they each paid their own bill. Among the debts due the estate of James Earl at the time of his death was fifteen pounds, four shillings, six pence, owed by James Courtney. What this sum represented has not been documented. Humphrey Courtney's portrait is considerably larger and more detailed than those of the James Courtneys and obviously represents a larger financial outlay. Does this relate a comparative statement on the wealth of father and son-in-law, or was it just the bravura of youth? Within one generation, the three Courtney portraits have always hung together. EDG

33 James Courtney is seated in a windsor chair, the ubiquitous and esteemed chair of all classes, before a harbor view which alludes to the source of some of his success. James Courtney was born in Exeter, England, in 1747, and came to Boston at the age of twenty-one, where he married Elizabeth Coburn (pl. 34). A Loyalist sympathizer, he moved with his family to Shelburne, Nova Scotia, in 1775.

In 1789 they moved to Charleston, where their daughter, Elizabeth Chardon Courtney, married Humphrey Courtney (pl. 32) the following year. Beginning in 1794, both James and his son-in-law are listed in the Charleston directories, James alternately as a tailor and merchant, Humphrey as a merchant and wine merchant. For at least a dozen years they either shared a common business address

34 Elizabeth Coburn Courtney was the daughter of Seth Coburn, a Boston merchant importing British and East India goods, and Elizabeth Scott Coburn. She was also the niece of John Coburn, the Boston silversmith. Born on November 1, 1752, she married James Courtney (pl. 33) on October 7, 1773. The rich dress fabrics, high-style upholstered mahogany armchair of probable English manufacture, and rich gold jewelry attest to her position in society. Even the mourning pendant, suspended from a gold chain, is in the very latest style. She died in 1813, at the age of sixty-two, and was buried in St. Michael's Churchyard with her grandchildren. EDG

every village of our country. You can hardly open the door of a best-room anywhere, without surprizing or being surprized by, the picture of somebody, plastered to the wall and staring at you with both eyes and a bunch of flowers.[18]

In advertising their art, American portraitists in early America consistently stressed three points. First, verisimilitude. Originality was not a concept treasured by American patrons at that time, but a skill in copying, in conforming to the original, was. Realism was the measure of success in a painting. Frances Trollope, attending the

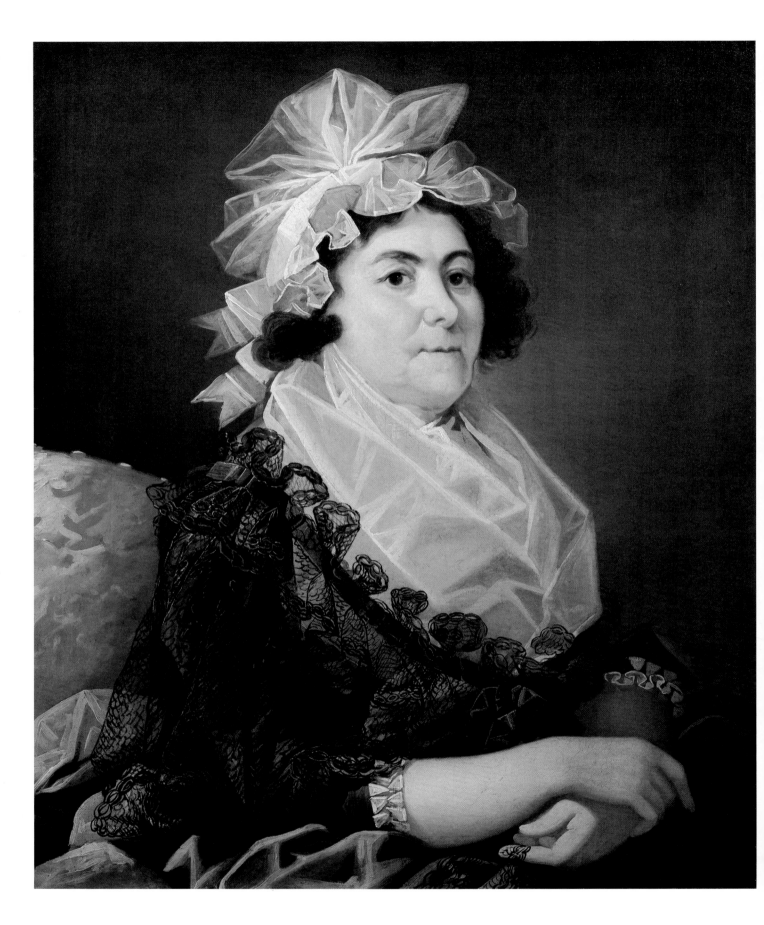

nineteenth annual exhibition of the Pennsylvania Academy of The Fine Arts in Philadelphia in 1830, noted, "From all the conversations on painting which I listened to in America, I found that the finish of drapery was considered as the highest excellence, and next to this, the resemblance in a portrait."[19] Artists consistently advertised "striking likenesses," and often reinforced this promise with a guarantee. Edward Greene Malbone stated in the Philadelphia *Federal Gazette* on April 30, 1798, that "He expects no money from his employers unless they are perfectly satisfied with his Likenesses."[20] A second point was expeditious service. First, the sitter would not have to pose for a lengthy time. Samuel Folwell, "Miniature and Profile Painter from Philadelphia," advertised in the *Charleston City Gazette and Advertiser* on March 7, 1791, that the "time of sitting, [was] four minutes."[21] Secondly, the work would be completed by the artist "with all possible dispatch." The third point was economy. In the competitive jostling for clients, artists promised their work "at moderate prices," and they could further adjust the pricing. An artist might offer to paint the picture on cardboard, vellum, ivory, or canvas, in a price scaling analogous to the cabinetmaker offering the choice of pine, cherry, walnut, or mahogany in making a piece of furniture. He could further reduce the price by working in silverpoint, crayon, or watercolor instead of oil. Size would be an important pricing factor, as would the amount of time invested. Frontal portraits cost more than profile likenesses because they demanded more skill and required more time for completion. A Maine artist, William Matthew Prior (1806–1873), could work in a more expensive modeled style, but "Persons wishing for a flat picture can have a likeness without shade or shadow at one quarter price."[22] John Colles, advertising in the *New York Gazette, and the Weekly Mercury,* on November 9, 1778, promised the benefit of all three features—verisimilitude, expeditious service, and economy:

> Miniature Profiles, No. 20, Golden-Hill, opposite the Sign of the Unicorn; J. Colles, Having had the honour of taking off the Profiles of many of the Nobility in England and Ireland, begs leave to inform the ladies and gentlemen in New-York, that he takes the most striking Likeness in Miniature Profile, of any Size, at so low a price as Two Dollars each, framed and glazed: A specimen only (which may be seen at Hugh Gaine's) can furnish an idea of the execution. Hours of attendance from 10 o'clock in the morning till 4 in the afternoon. It requires only a moments setting.[23]

The miniature could be carried on the person, but the portrait was to hang on the walls of interiors, interiors from the clapboarded farmhouses of Maine to the brick plantations of Virginia. Portraits were regarded as particularly appropriate to dining rooms

35 Hannah Morgan Stillman is portrayed in middle age as a plump lady with a clear gaze directed at the viewer. Hannah was the wife of the Reverend Dr. Samuel Stillman, pastor of the First Baptist Church in Boston, and the mother of fourteen children. She was deeply interested in charities and good works and in 1800 founded the Boston Female Asylum, known today as the Boston Society for the Care of Girls. The artist, Christian Gullager (1759–1826) was born in Copenhagen, Denmark, and studied at the Royal Academy of Fine Arts in Copenhagen. By 1786 he was in America. He married at Newburyport, Massachusetts, and moved to Boston, where he worked until 1797. JM

as they would not retain the odor of food and were not distracting to the eye, and portraits hung in the hall, stairwell, parlor, and bedchamber of early American homes. Ann Grant commended the family portraits which hung in the best bedchamber of an Albany, New York, home in the opening years of the nineteenth century,[24] while Tom Shippen was delighted to report, in 1783, on his bedchamber at Westover, the Byrd estate in Virginia, which was "hung with a number of elegant gilt framed pictures of English noblemen and two of the most beautiful women I have ever seen (one of whom [hangs] opposite to the bed where I lay)."[25]

These faces of the family provided decoration and imposed a respect for ancestors on those who could write that "no matter where we sit in the room they are watching and their eyes seem to move whenever we do."[26] The calm, direct gaze of the sitters speaks to us today of the early American aesthetic which demanded clarity, order, stability, rationality, and dignity whether in painting, furniture, interior decoration, architecture, or philosophy.

36 Although the miniature portrait has its roots in the classical world, it was sixteenth-century England which developed the art. By the eighteenth century, a miniature likeness painted on ivory, cardboard, or vellum could be readily commissioned, and by 1800 the American consumer found this portrait form both desirable and affordable. Designed as a memento, the miniature served to remind the owner of the portrayed, while its size insured that the piece could be easily worn or carried in a wallet or pocket. Setting a lock of the sitter's hair into the back of the miniature frame reinforced the owner's association with the subject.

The miniature of a gentleman of the Carter family (center), attributed to Philippe Abraham Peticolas (1760–1841), holds a lock of hair on the reverse, set with the gold cipher "RLC". Peticolas was a Frenchman who came to the United States to work as a miniature painter and teacher of music and drawing.

Another artist who advertised his willingness to teach drawing and painting was David Boudon (1748–1816), a native of Geneva, Switzerland. In 1813 in Washington County, Maryland, he painted John Van Swearingen's profile portrait on vellum (bottom center), a medium Boudon offered "at three dollars each, all warranted likenesses". His peregrinations in search of patrons took him through South Carolina, Georgia, New York, Maryland, Pennsylvania, Virginia, North Carolina, the District of Columbia, West Virginia, and Ohio.

Rhode Island-born Edward Greene Malbone (1777–1807) likewise worked the Eastern Seaboard, taking hundreds of miniature likenesses from Providence south to Savannah and Charleston, where he painted Ralph Izard Jr. (top left) around 1800. Further, Americans traveling in Europe might commission miniatures while abroad. The

much painted beauty, Alice DeLancey Izard, of Charleston, patronized George Engleheart (1750/3–1829), a leading miniature painter in London, while she and her husband were in that city between 1771 and 1777 (top center). Baltimore's Commodore Joshua Barney is believed to have commissioned the French artist Jean Baptiste Isabey (1767–1855) to capture his likeness on one of his trips to the Continent (top right).

This sampling of miniatures from the Museum's collection provides an interesting chronology of costume and hair style, from Alice Izard's Georgian bouffant to Martha Van Swearingen Shafer's classical curls (bottom left), from Enoch Huntington's republican queue (bottom right) to John Van Swearingen's democratic sideburns. SMD

37 This sensitive portrait of Mary Lisle Gamble is attributed to the Peale family of artists, and may be the work of Charles Willson Peale. In composition and style it relates very closely to a portrait Charles Willson painted of his wife in 1816, of which the artist wrote, "I believe it is the best portrait that I have ever executed." That portrait is now in the Museum of Fine Arts, Boston.

In technique, the portrait of Mary Lisle Gamble, which is painted on paper and mounted on canvas, relates to a group of paintings worked by Charles Willson in the years between 1808 and 1810. Mary Lisle Gamble was the daughter of John Lisle, an Irishman who settled in Philadelphia. She married Archibald Gamble, an engineer, in 1777. The portrait has a history of continuous ownership in the family until it was given to the Museum in 1959. CMD & EDG

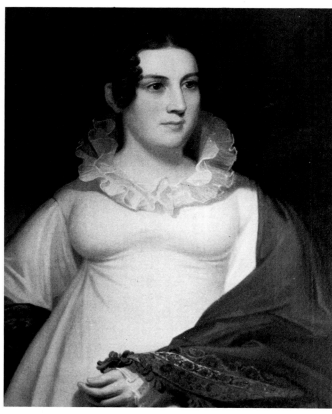

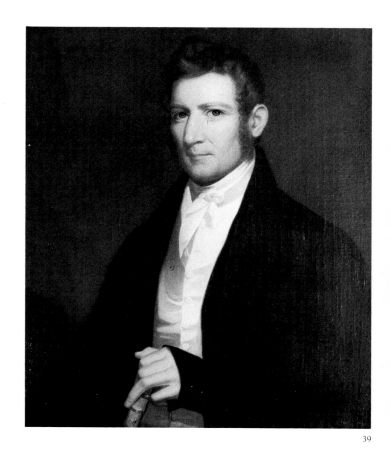

38

39

38 During the early years of the
New Republic, allusions to the
ancient republics of the classical
world were manifest in politics,
architecture, painting, furniture,
silver, costume, and nomenclature.
By 1819, when Sarah Humes Porter
was painted by Jacob Eichholtz,
one might live in a town of Grecian
title, abide in a templed house of
Greek inspiration, relax on a sofa
of classical design, insist on a
Roman hairstyle and a Grecian
gown, and answer to a classical
name. When a lady's skin should
be white, somewhat translucent
and slightly sparkling to suggest the
marble of classical statuary, pearl
powder would be a necessary cos-
metic. Full, rounded contours were
essential to promote the analogy,
and Victorine du Pont could write
to Margaret Manigault in 1798, "the
women eat heavily to fatten
themselves."
Benjamin Henry Latrobe, the

celebrated architect and proponent
of the Greek Revival style, lost all
reserve upon observing a classically
coiffed and garbed "Nelly" Custis at
Mount Vernon in 1796, for she had
"more perfection of form, of
expression, of color, of softness,
and of firmness of mind than I
have ever seen before, or conceived
consistent with mortality. She is
every thing that the chissel of Phi-
deas aimed at, but could not
reach."
 Sarah Humes Porter was the
daughter of Samuel Humes (pl. 40)
and Mary Hamilton Humes (pl. 41)
of Lancaster, Pennsylvania. In 1819,
the year of this portrait, she mar-
ried George Bryan Porter (pl. 39)
and later followed him to Michigan
when he was named Governor of
the Michigan Territory. After his
death in 1834, she returned to Lan-
caster with the portraits and built a
house on Duke Street. In 1836 she
again sat for Jacob Eichholtz, this

time in the demure black dress of a
widow. Eichholtz's bill and a now
unlocated portrait of George Bryan
Porter in middle age suggest that
she also commissioned a pendant
posthumous portrait of her
deceased husband. EDG

39 Four portraits in the DAR
Museum collection suggest the
efforts of two related Lancaster,
Pennsylvania, families to record
themselves in paint (see also pl. 38,
40, 41). At the age of twenty-four,
George Bryan Porter commissioned
Jacob Eichholtz to paint four por-
traits of his late father, two of his
mother, and one of himself. Four
years later, in 1819, he again sat for
Eichholtz, this time with his new
bride (pl. 38). The price for this
portrait, illustrated here, and its
pendant was $30.00 each.
 George Bryan Porter became
Attorney General of Pennsylvania

and in 1831 was appointed Governor of the Michigan Territory by Andrew Jackson. The pendant portraits and a portrait of Andrew Jackson (pl. 42) were taken out West. Following George Porter's premature death at the age of forty-three in 1834, the paintings were brought back to Lancaster.

Jacob Eichholtz had been trained as a coppersmith and was not able to devote himself to painting until middle age. Mostly self-taught, Eichholtz diversified his *oeuvre* with historical and landscape paintings in addition to portraits, but it was primarily his "good hard likenesses" which were much in demand amongst his Pennsylvania patrons. EDG

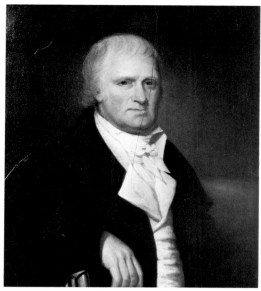
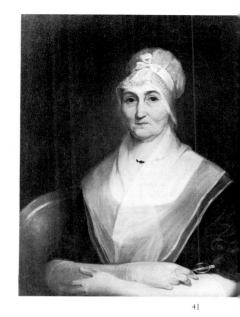

40 41

40 Samuel Humes of Lancaster, Pennsylvania, was Sarah Humes Porter's father (pl. 38). This portrait on a mahogany panel has been attributed to Jacob Eichholtz and is believed to be the one mentioned in Eichholtz's ledger book on June 5, 1810. Humes, his wife, and five of their grown children were portrayed by Eichholtz. Samuel Humes served as the Treasurer of the Sun Fire Insurance Company from 1798 to 1822, and was assistant burgess of Lancaster in 1803 and 1804. EDG

41 Mary Hamilton Humes of Leacock Township, Lancaster County, Pennsylvania, was the mistress of the much-painted Samuel Humes family. The portrait is believed to be the 1810 pendant to her husband's (pl. 40). Mrs. Humes' black crepe dress and white muslin cap and fichu were the conventional costume of grandmothers in the early nineteenth century. Marianne Silsbee regretted that at her grandmother's Salem, Massachusetts, home, "There were no chests of finery to be peeped into, no laces, no silks or satins. Born of a plain,

Puritanic family, Canton crape was the grandmother's only wear, with muslin round-eared cap, and white kerchief folded over the front of the dress: a charming costume for a handsome old lady, but I never ceased to wish that she had worn brocades in her youth, and had preserved them for her grandchildren." EDG

42 This portrait of Andrew Jackson has a history of having been painted for George Bryan Porter (pl. 39) and was owned by Porter descendants until 1929, when it was sold to a Chicago collector. The portrait is attributed to Ralph E.W. Earl, a son of the noted portrait artist, Ralph Earl. In 1818, Ralph E.W. Earl had married Mrs. Jackson's niece and, following Mrs. Jackson's death in 1828, he became part of the Jackson household, and was buried at Jackson's home, the Hermitage outside Nashville, Tennessee, in 1838. Numerous Jackson likenesses were executed by this portrait artist. Andrew Jackson is here depicted as the elder statesman. SMD

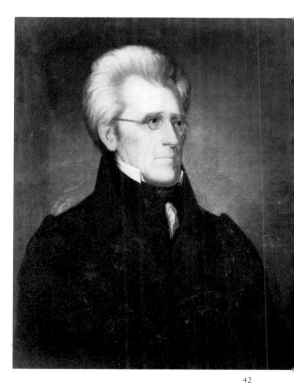

42

43 Joseph Knowlton, a son of Dr. Joseph and Relief Stratton Knowlton, was one of several members of his family to be painted by Ruth Henshaw Bascom in March 1830 (see pl. 44). Unlike the portrait of his sister, Frances, which is cut out and applied to a background, this likeness was left uncut. A reference in Mrs. Bascom's diary on March 9 probably refers to this — "put Mr. Knowlton's [portrait] in frame not finished." SMD

44 The profile likenesses of Frances Knowlton and her brother Joseph (pl. 43) were taken by Ruth Henshaw Bascom (1772–1848) between March 4 and March 9, 1830, at the Knowlton home in Phillipston, Massachusetts. In Mrs. Bascom's manuscript diary, now in the collection of the American Antiquarian Society, in Worcester, Massachusetts, portraits of Frances, Joseph, another sister, and Dr. Knowlton are all mentioned. On March 4, 1830, Ruth Bascom wrote, "Thursday very pleasant, spent the day and night at Dr. Knowlton's. Painted on Frances' copy. Sketched with her mother's and Joseph's testimony. Frances to village after her sister (Goulding) who came and slept here — to have her copy taken." And on Monday, March 8, she continued, "I past the day and night at Dr. K's finishing the two daughter's likenesses. . . ."

Frances was to marry John White Chickering on November 9, and brother Joseph would marry Harriet Bowker on June 16, 1830. It seems probable that their parents gathered the family together, at the threshold of its being dispersed, with the desire of preserving the family circle at least on paper. For this portrait Ruth Bascom posed Frances against a paper background and traced the profile shadow on paper. She then colored the picture in pastel crayons, cut out the finished profile, and mounted it on a sheet of grey background paper. SMD

45 Serenely beautiful Chloe Cushing appears lost in sad reverie in this portrait by Reuben Rowley, and reminds one of Timothy Dwight's appraisal of New England women as being of "A gentle and affectionate temper . . . gilded with serenity." Although only twenty-one years old, she had already learned the painful experience of the transience of life which so many mothers had to grapple with in the eighteenth and

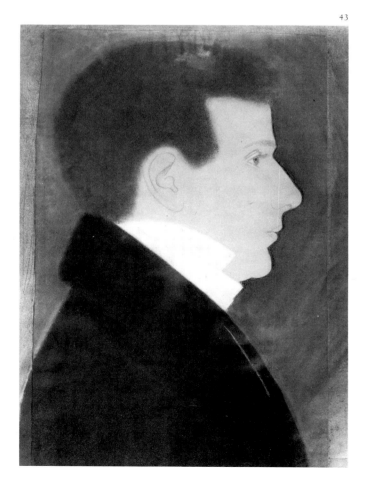

43

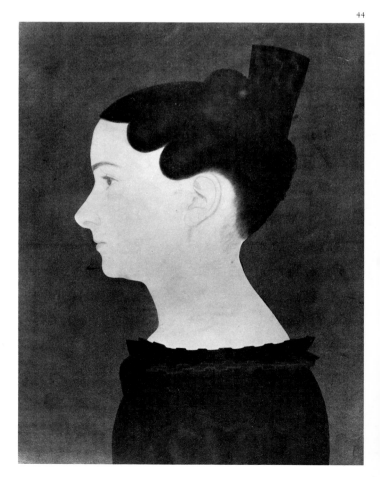

44

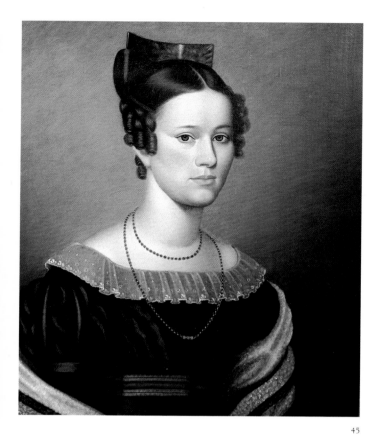

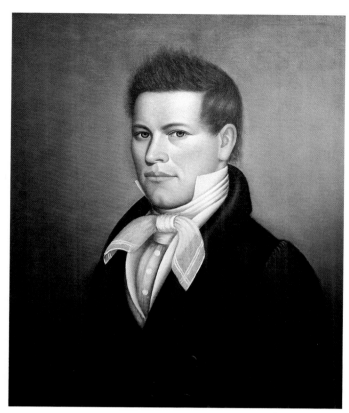

nineteenth centuries. Her first child, Ansel, had died one week after his birth in July 1825. At the time of her portrait, Chloe Cushing was two months pregnant with her second child. She would ultimately bear four children, three of whom grew to adulthood.

Her tortoise-shell comb, classical hairstyle, handsome dress, sash, shawl, and gold chain, suggest that by 1826 ladies in Ithaca were able to keep abreast of the fashions. Sarah Anna Emery in her *Reminiscences of a Nonagenarian* detailed these fashionable requisites: "The hair was worn high, often the back hair having been divided, half fell in curls on the neck while the remainder was wound round the comb; at other times it was wholly braided and twisted into a crown upon the head, the front hair clustered in short curls over the forehead or on the temples.... The string of gold beads so general in my mother's girlhood were then deemed old-fashioned; necklaces

and chains had taken their place."
EDG

46 Lucas Cushing and his beautiful bride Chloe (pl. 45), sat for their portraits in 1826, three years after their marriage. Inscribed in black ink on the reverse of the portrait is, "Lucas Cushing/ In the 24th Year of his age/ Taken in Jany 1826 at Ithaca. By R. Rowley." Reuben Rowley was an itinerant artist who traveled the towns along the Susquehanna and Chenango valleys in New York State in search of commissions. Lucas and Chloe Cushing are the quintessence of Rowley's style as described by Agnes Halsey Jones, "Rowley's portraits present the sitters wide-eyed and gentlefaced, and they are executed in a sculptural style."

Lucas Cushing was born in Worcester, New York, on May 19, 1802, to parents of New England origin. Following his marriage in 1823, he was in Ithaca, Berkshire, and Canisteo, New York, before emi-

grating to Ulysses, in Potter County, Pennsylvania, in 1835. Lucas was perhaps attracted by the fruitfulness of the soil, the healthy climate, the easy communication, the ready availability of building supplies, and the active market for produce which Potter County advertised. A yet stronger incentive was undoubtedly family ties. Preliminary research reveals that members of the Cushing family were already established in Potter County by 1833, emphasizing the complex network of family interrelationships which characterized eighteenth- and early nineteenth-century America.

Lucas Cushing and his young family probably traveled to Ulysses via the Erie Canal, docked at Dansville, New York, and then finished the move overland. Lucas opened a store and in the 1850's was operating the Temperance Hotel. It was at his home that the First Baptist Church of Coudersport was organized in April 1869. EDG

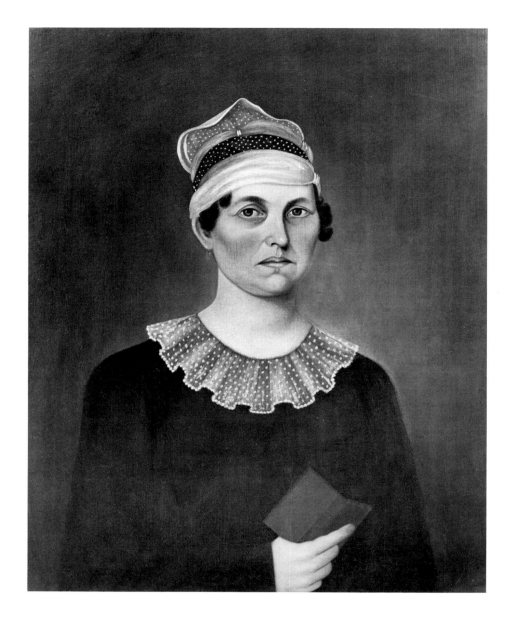

47 The resolute character of America's country folk is delineated in the determined facial features of this unidentified Maine woman. The 1823 portrait has been attributed to the itinerant deaf-mute artist John Brewster Jr.

In America, geographic and social mobility meant that life was tenuous. Any reverse in fortune or removal from city to country necessitated a change in lifestyle. When fifteen-year-old Mary Palmer moved with her family in 1790 from their home in Boston to a farm twenty miles out of town, she had to learn to milk cows, make butter and cheese, card wool and cotton, hatchel flax, and spin fine threads. She recalled: "We learned to spin, borrowing wheels of our good-natured neighbors, who seemed pleased to teach the city ladies their craft."

Conscious of the permutations of life, parents preached the need for self-reliance to their children. In 1787, Thomas Jefferson counseled his daughter Martha to prepare for her own life in rural Virginia: "It is a part of the American character to consider nothing as desperate; to surmount every difficulty by resolution and contrivance. In Europe there are shops for every want; its inhabitants, therefore, have no idea that their wants can be supplied otherwise. Remote from all other aid, we are obliged to invent and to execute; to find means within ourselves, and not to lean on others."

More than eight decades later Catharine Beecher would exhort mothers to endow their daughters with physical and mental strengths that would enable them to surmount "The Difficulties Peculiar to American Women." Many did, and when Ellen Rollins reviewed the setting of her New Hampshire youth in the 1830's she could write: "As I look back, what strikes me most in that old country living is its simplicity, its earnestness, its honesty, and its dignity. The men and women seemed to grapple with their inherited burdens. They were a race of born athletes and wrestlers with the soil; the natural outgrowth of it." American folk portraiture visually confirms this strength of character. EDG

48 This portrait of Phebe Steiner Reich is signed on the reverse, "Alexander Simpson/Frederick Town/November 1821." Alexander Simpson was a little-known artist working in Maryland. Phebe Steiner, a daughter of Christian and Hannah Steiner, was born May 11, 1774, in Fredericktown. She is referred to in her mother's 1818 will as Philipina, but all other documents record her as Phebe, a nickname she obviously preferred. In 1794 Phebe married John Reich, a Fredericktown blacksmith, and they had ten children. John Reich's parents, as well as hers, had emigrated from Alsace in 1764 and had settled in this Maryland town, where they apparently prospered.

In this portrait Mrs. Reich is seated in a green windsor armchair. The 1842 inventory of her estate lists "14 blue block seat chairs" and another "dozen block seat chairs," which were probably windsors. A windsor side chair which descended in the Reich family and is now in the Museum collection has a yoke crest and an oval-shape saddle seat. The original green paint can be seen beneath a later layer of black. The Reichs lived comfortably and among the other possessions listed in this inventory are cherry and walnut tables, a walnut wardrobe, "A desk and drawers," and a corner cupboard. The most highly evaluated pieces of furniture were the two beds and bedding at $12 each and an eight-day clock appraised at $10.

Among the niceties were rag carpets in both the front and back room, pairs of "small" window curtains, one pair of plated candlesticks, and a looking glass. A spinning wheel and reel stood ready in the kitchen, and a "lot of milk crocks" and a "churn" suggest the role of Phebe's four cows — "Cherry," "Rose," "Star," and

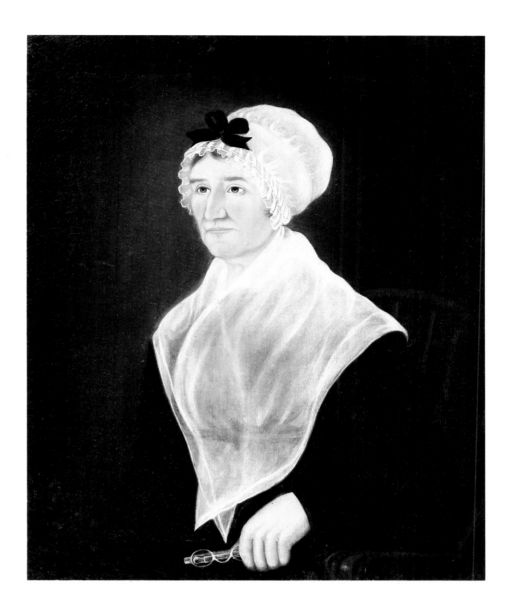

"Nanee." The details of this inventory and Phebe's neat personal appearance suggest that she was a notable housewife. EDG

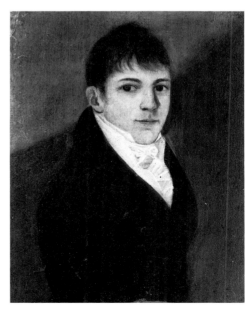

49 Inscribed in ink on the stretcher backboard of this small oil-on-paper portrait is "Benjamine Stone's" in an early nineteenth-century hand. "Benjamine" was the son and namesake of Benjamin Stone and Elizabeth McLellan of Brunswick, Maine. The simple, direct portrait is representative of innumerable likenesses which hung on the walls of middle-class homes in democratic America. CMD

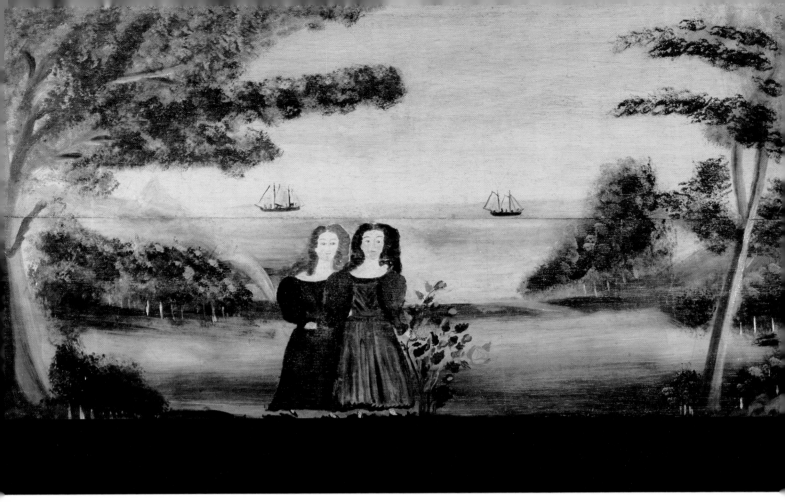

50 Wallace Nutting, the noted antiquarian, artist, author, cabinet-maker, and student of the early American home, designed the paneling for the New Hampshire State Room at the DAR Museum around this overmantel painting. "I advise," he wrote around 1930, "the use of the painted panel that is offered and which will mark the size of the fireplace opening." The overmantel painting had been removed from the French homestead in Piermont, New Hampshire, a town on the Connecticut River, in the 1920's.

The panel on which the scene is painted is constructed of two pine boards with "fishtail" joints. The sides are beveled into the original molded frame. An unknown primi-tive artist has portrayed two young girls in a landscape setting in which the leaves appear to be sponge-painted, a technique frequently employed by folk artists. Boats ply the river in the background. Rural interiors were often made colorful through the talents of itinerant artists and the inventive efforts of housewives. The sedate, urban interior mandated chromatic accord, but the country interior seemed to delight in a riotous medley of pattern and color, once paint, wallpaper, and textiles became widely available. EDG

51 The Emery children of Albany, New York, were portrayed around 1854. According to family tradition, their parents devised the idea of a portrait of their four children while traveling in England, and had the children painted on their return. The painting illustrates the growing awareness of the stages of child-hood in the nineteenth century.

Assuming that the portrait was painted in 1854, eight-year-old Josephine appears as the young lady with the feminine attribute of flowers. Six-year-old Horace, the young student, holds a book, undoubtedly proud of his nascent reading abilities. He has received the short haircut and tailored suit of boys. Four-year-old Charles holds a hoop, a standard attribute of young boys. Both he and his two-year-old brother George display the curls and frocks of infancy. EDG

Cycles of Life

THE only certainty in early America was the uncertainty of life. Self-assured and secure in his business world, Humphrey Courtney (pl. 32) would, in his domestic world, have to submit to the humbling and painful lesson of the uncertainty of life. On Monday, October 1, 1804, the *Charleston City Gazette and Advertiser* solemnly recorded:

> Died, on the 22nd instant, of the prevailing fever, Master James Courtney, only son of Mr. Humphrey Courtney, of this city, aged 5 years and 3 months; and, on the 23rd, the day following, Miss Eliza Courtney, his eldest daughter, aged 10 years and 2 weeks.
>
> Their truly distressed parents had resorted to Sullivan's Island, to preserve the blooming health of a lovely family of children; but, deprived of their dwelling by the late dreadful storm, they were obliged to return to the city, where they have lost the two eldest of these rivets of conjugal affection.[1]

By the time of her death at the age of 77, Elizabeth Chardon Courtney had buried these two little children, a twelve-year-old daughter, a promising eighteen-year-old son, and her husband.[2]

This grim lesson in humility was taught in many early American households for death was not particular. Prominent Americans buried their closest of kin as did those who lived further away from the eye of historical scrutiny. Medicine was primitive, epidemics common, and old age seldom meant an easy retirement amongst one's children and grandchildren. Colonel Landon Carter of Sabine Hall in Virginia felt the death of his little daughter Sukey in

52 A grouping of mourning art in silk, ink, watercolor, and oil paint.

CAROLINE L. NEWCOMB. 1817.

April 1758, a "Severe stroke indeed to A Man bereft of a Wife and in the decline of life because at such periods 'tis natural to look out for such Connections that may be reasonably expected to be the support of Greyhairs and such an one I had promised myself in this child in Particular."[3] Distraught over the death of his beloved daughter Mary, having buried his wife, and all his children but one, Thomas Jefferson wrote to his friend, Governor Page, expressing his grief over the ravages of an insatiable grim reaper:

> My evening prospects now hang on the slender thread of a single life. Perhaps I may be destined to see even this last cord of parental affection broken! The hope with which I had looked forward to the moment when, resigning public cares to the younger hands, I was to retire to that domestic comfort from which the last great step is to be taken, is fearfully blighted.
>
> When you and I look back on the country over which we have passed, what a field of slaughter does it exhibit! Where are all the friends who entered it with us, under all the inspiring energies of health and hope? As if pursued by the havoc of war, they are strewed by the way, some earlier, some later, and scarce a few stragglers remain to count the numbers fallen, and to mark yet, by their own fall, the last footsteps of their party.[4]

53 In 1813 Ann Elizabeth Folwell advertised in a Philadelphia newspaper that her husband Samuel would be available to teach drawing to students enrolled in her embroidery school, by which time Samuel Folwell was an established artist and teacher. In 1793 he had opened "A Drawing School for Young Ladies" in Philadelphia where his pupils were instructed in pencil work and painting upon satin, ivory, or paper. In addition, he continued to accept commissions to paint miniatures and mourning lockets and to fashion devices out of hair. It appears that Folwell designed needlework for his wife's pupils and then painted the image on satin in varying shades of grey wash. After a schoolgirl had completed the stitching, he painted in the faces, sky, and other details and lettered the memorial inscriptions. Folwell translated the style of personal mourning lockets into needlework memorials for public display in the home.

In this example, a classically robed figure, seated in a sylvan setting, quietly contemplates a tomb or monument to the departed. The landscape, which may suggest Paradise or the Garden of Eden, is dominated by the willow tree, a symbol of Christian righteousness. In contrast to earlier expressions of anguish over death and a morbid iconography, mourning, in the neoclassical period, became serene and reflective. GSA

54 Watercolor painting became increasingly important in the academic curriculum of young ladies in the early nineteenth century. Technology and trade made elaborate needlework skills less requisite for the accomplished miss, but the lesson learned in perseverance, deemed an inestimable virtue in a woman, remained a constant. Perseverance was taught by copy work, whether done in laborious stitching or painstaking brushstrokes. Nancy Hyde bridled under such discipline, writing from a girls' school in Hartford, Connecticut, in 1792, "Employed in painting. These pictures have been a continual source of perplexity, and have given me more anxiety of mind, than I should have thought it possible for

half a yard of satin to effect."

The copy skills of the young lady who painted this picture are obvious. With exacting brushwork she has simulated a number of needlework stitches achieving a *trompe l'oeil* triumph. This painted memorial picture refers to needlework mourning pictures in its composition and theme as well, and the bright colors are suggestive of the original brilliance of now-faded silks. The vogue for mourning pictures would persist in the nineteenth century moving from needlework to watercolor on satin to watercolor on paper, as better paper became available, to lithography and chromolithography in a progression away from exacting hand skills. Already, by the early

1820's, when this memorial was painted, the oval memorial plaque on the monument was printed and applied.

It was probably Sally F. Cheever (1806–1831) who painted this picture around 1821, when she would have been fifteen years old. This "transient farewell" to two "beauteous Babes" memorializes two infant sisters of shared name. Of the ten children born into this Danvers, Massachusetts, family over a twenty-two-year period, three died in infancy. The paper mark, "BRISTOL PAPER" with a crown between the two words, suggests the role that expanded trade and improved technology played in schoolgirl art in a new and rising nation. EDG

Eighteenth- and early-nineteenth-century accounts reveal that these people were constantly on guard, for even if death had not yet struck, its haunting shadow loomed large. The legacy that death bestowed on early Americans was uncertainty, an unpleasant feeling which pervades the pages of so many early documents. "Blessed be God," wrote Margaret Cary of Massachusetts in 1752, "we are yet a family not broken up by death.... I know not what another year may be to us, it may be the parting year."[5] The uncertainty of life crowded in upon all aspects of daily living — a sickness or a trip might prove to be the last. Preparing to assume a teaching post in the West in 1846, Lucy Larcom confessed, "I said positively that I should soon return, but underneath my protestations I was afraid that I might not. The West was very far off then, — a full week's journey. It would be hard getting back. Those I loved might die; I might die myself. These thoughts passed through my mind, though not through my lips."[6]

The constant threat of eternal separation encouraged a certain distance, a conscious reserve between parent and child. To guard against immodest attachment and to ensure self-reliance in both parent and child, little ones were often sent off to live for a time with relatives or friends. Benjamin Crowninshield wrote to his wife in 1815, *"Little Sally,* I wish it was not necessary to pack her

55 A sampler form which became popular at the end of the eighteenth century was the "family record" or "family register" which recorded the births and deaths of one couple and their offspring. In addition to chronicling one family, the genealogical sampler, like the ancestral portrait, instilled family pride, advocated family cohesion, and reminded youth of their filial responsibilities to the family. The popularity of the family register in needlework parallels the rise of family group portraits in oil on canvas. Both are decorative expressions of the emerging perception of the family as a private, close-knit domestic unit — unique, fragile, and precious. Like the oil portrait of the nuclear family, the needlework family register was a long-lived reminder of an often short-lived union. Fashionable mourning motifs were often incorporated in the family register.

From twelve-year-old Sarah Stevens' "Family Record," stitched in the greater Boston region in 1822, we learn that her father died when she was five years old, leaving a wife and eight small children, and that a ninth child was born eight months later. Genealogical research indicates that six of the children were named after their parents and both sets of grandparents in yet another example of parental recognition of the need for family solidarity. EDG

56 When a member of the Childs family, probably Caroline, stitched this "FAMILY REG'R" in Deerfield, Massachusetts, she detailed the births of eleven children in a twenty-one-year period and the deaths of four. The early practice of naming a newborn after a recently deceased predecessor was to diminish in the nineteenth century with the growing recognition of the individuality of each child. The tradition of naming offspring after their parents and grandparents would continue.

Asa and the two little Rhodas were named after their paternal grandparents, Eunice and Samuel after their parents. Deerfield records reveal that Samuel Childs, the father, was a weaver and was known as "Jimmy Shuttle," whereas his namesake was called "Lawyer Childs." The verse embroidered against the Queen's stitch background at the bottom propounds the virtue of domesticity: "Abroad in search of bliss we roam/ Yet must confess it dwells at home/ Where kindred mingle pains and joys/ And thoughts of love each heart employs." The shape of the graduated coffins echoes the outlines of the coffin-handled spoons which became popular in this romantic period of melancholy mourning. Caroline Childs died, unmarried, at the age of twenty-one, in Sullivan, New York. EDG

off; altho I do not see that it will hurt her, but perhaps make her better."[7] But when death did strike, the grief was inevitable, and often long-lasting. Innumerable diaries and letters reveal that the defenses often crumbled, and the struggle to submit to an omniscient God was often bitter. Jane Mecom wrote to her brother, Benjamin Franklin, in 1767, concerning the death of her daughter Mary, at the home of Jane's friend Kezia Coffin in Nantucket, "Sorrows roll upon me like the waves of the sea. I am hardly allowed time to fetch my breath. I am broken with breach upon breach, and I have now, in the first flow of my grief, been almost ready to say, 'What have I more?' But God forbid, that I should indulge that thought, though I have lost another child. God is sovereign, and I submit."[8]

With the rise of Romanticism in the late eighteenth century, mourning became a fashion, but death itself had not yet loosened its tenacious grasp. When eighteen-year-old Caroline Newcomb worked her fashionable and somber mourning picture at Sarah Pierce's Litchfield Female Academy in Connecticut (pl. 52), in 1817, she could record the deaths of six brothers and sisters on the headstone behind the grieving woman. A seventh would die later that year.[9]

The composition of families was constantly changing through both deaths and births. Wives of child-bearing age could expect to give birth about every two years, and the difference between the ages of the first- and last-born could span more than two decades. The mention of the latest confinement is sometimes interspersed with chatter about the grandchildren in women's letters of the period. Noah Childs (pl. 56) would have been twenty-one when his sister Caroline was born in Deerfield, Massachusetts, in 1790. Families were often large—there were eleven children in the Childs family—and the numbers were often swelled by the presence of grandparents, a sick relative, a niece or nephew, servants, and perhaps a child who had been indentured to the family to learn a trade or develop useful skills. Contemporary documents reveal that this constant flux in numbers, these continual comings and goings were often annoying to both the master and the mistress of the household.

Her duty, however, was to surmount such difficulties and to create a well-regulated atmosphere that was at once morally and physically sustaining. The housewife's task was to create order and

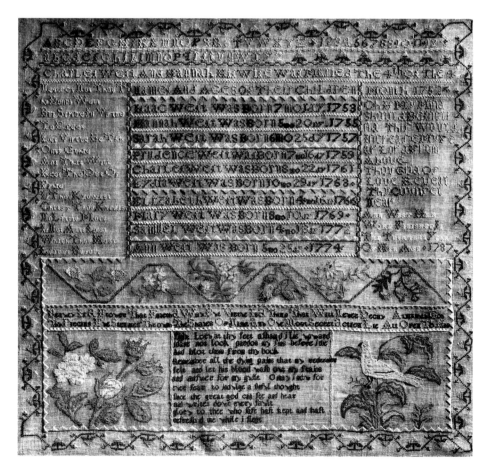

57 The earliest example of a genealogical sampler or family register in the DAR Museum collection is Ann West's 1787 sampler, which was worked at a school in the Philadelphia region. Needlework, like all art, displays regional characteristics. The horizontal composition, compartmented divisions, and sawtooth borders had appeared in Philadelphia samplers as early as the 1730's. Ann has here recorded the births of ten children in two- and three-year intervals. From the records of the Philadelphia Monthly Meeting it appears that by the time Ann West's sampler was "Finished In the Thirteenth Year of Her Age," she had already lost her father, her brother Isaac, and four of her sisters. One wonders what emotions this young Quaker girl felt as she stitched this memorial to the temporality of life, the certainty of death, and the omniscience of a formidable God. EDG

58 The pictorial image of the symbolic tree-of-life, laden with labeled circles or "fruit," was familiar to many youths in a didactic new nation. Children could easily comprehend the organic concept of growth from a life-giving trunk and the format was, therefore, used in teaching many precepts. The Dedham Historical Society in Norfolk County, Massachusetts, has in its collections a child's printed handkerchief of around 1810, entitled, "DISSECTED EMBLEMS, suitable for the INSTRUCTION of YOUTH of all AGES. Designed to impress upon their minds a Love to Virtue, and Hatred to Vice." The dissected emblems are cutaway views of a stunted and leafless tree weighted with the fruits of vice in juxtaposition to a sturdy and verdant tree displaying the fruits of virtue. Ethel Bolton and Eva Coe, in their book *American Samplers,* picture a "tree of life" sampler which graphically details Chapter 22, verse 2, from *The Book of Revelation:* "In the midst of the street of it, and on either side of the river, *was there* the tree of life, which bare twelve manner of fruits, *and* yielded her fruit every month: and the leaves of the tree *were* for the healing of the nations."

In the first two decades of the nineteenth century in New England, and particularly in Middlesex County, Massachusetts, this tree-of-life composition was adapted for needlework and watercolor family registers. Lucretia Bright probably worked her tree-of-life family record at an as-yet unidentified school in Middlesex County around 1820. The tree narrates her parents' marriage on December 27, 1797, and the births of six daughters and one son, beginning with the rather prompt appearance of Susan six months later on June 20, 1798, through the birth of Elizabeth fourteen years later. Lucretia was born in Watertown, Massachusetts, on August 30, 1807, and died, unmarried, at the age of twenty-one. EDG

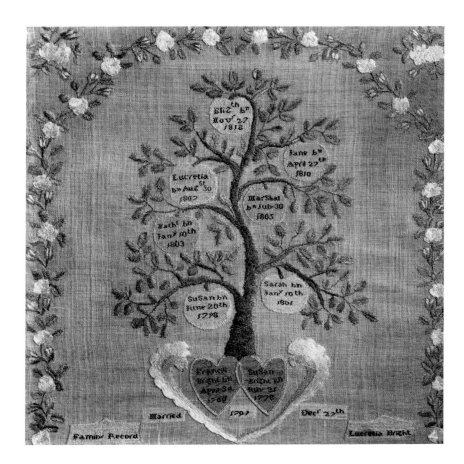

comfort. To be a notable housewife was not an easy assignment, but one which demanded both managerial skills and physical strength. The production, preparation, and preservation of food was enormously time-consuming, and the number of cooking and serving vessels and the quantities of eating and drinking wares in the DAR Museum emphasize the importance of food in the early household. Textiles were a woman's particular province, a measure of her worth and an indicator of her potential or actual success as a housewife. Henry Wadsworth Longfellow evoked a picture of the beautiful Evangeline as:

> Silent she passed the hall, and entered the door
> of her chamber.
> Simple that chamber was, with its curtains of
> white, and its clothes-press
> Ample and high, on whose spacious shelves were
> carefully folded
> Linen and woollen stuffs, by the hand of Evangeline
> woven.
> This was the precious dower she would bring to her
> husband in marriage,
> Better than flocks and herds, being proofs of her
> skill as a housewife.[10]

The volume of textiles and sewing equipment in the DAR Museum collection underscores the centrality of the needle in a woman's life in the eighteenth and nineteenth centuries. Many of the sewing demands were basic and essential, but embroidered petticoats, quilted bed covers, appliquéd table covers, and needleworked book covers attest to the complaisant efforts of many wives to decorate the home and gratify the eye of husband and children.

The diligent housewife worked hard to present the family possessions to advantage — the linens were "snow-white," the pewter "polished until it shone like silver," the furniture brasses "curiously bright," the mahogany "rubbed with a brush and bees-wax until one could see one's face in it."[11] European observers of the American scene frequently remarked that American women were good housewives and their houses neat and clean. Traveling

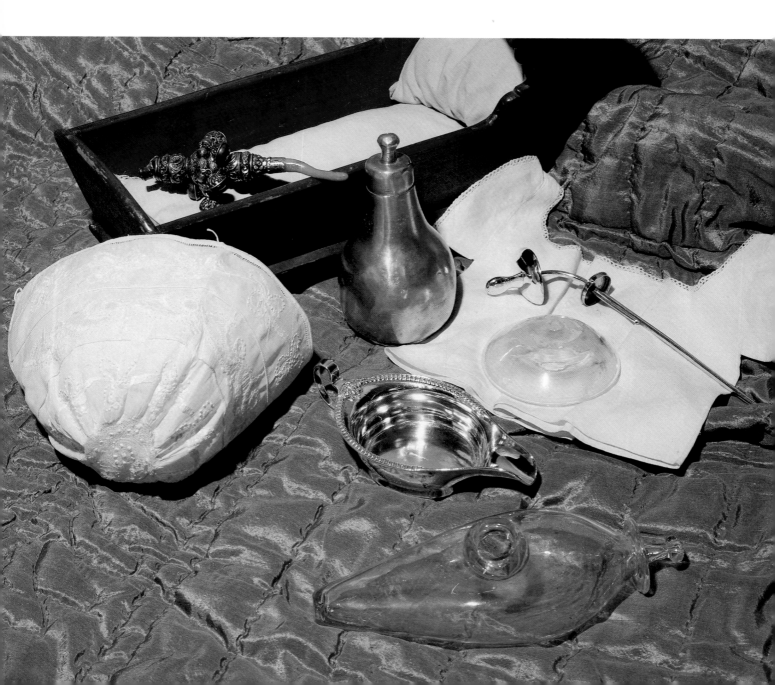

in Massachusetts in 1788, J.P. Brissot de Warville observed, "Neatness and cleanliness without extravagance are the visible signs of this moral purity, and these qualities are to be seen everywhere in Boston, in the dress of the people, in their houses, and in their churches."[12] He admired the houses en route to New York State, "Their neat and tidy appearance gave every one of them a sort of beauty,"[13] and visiting a Quaker farmer outside of Philadelphia, he wrote, "I confess I was charmed by the family as well as by the cleanliness and neatness of the house itself."[14]

American women were also esteemed good mothers. Foreign observers, particularly the French, even felt that American mothers spent too much time with their children. Thomas Jefferson, however, portrayed the frantic social life of a Parisian belle and then contrasted, "In America, on the other hand, the society of your

59 In many early homes there was a new infant about every two years for the duration of a wife's childbearing years, and the demands of preparing a layette, childbirth, and child rearing were strenuous. After the birth of her second child in 1756, Esther Burr worried, "When I had but one Child my hands were tied, but now I am tied hand and foot. (How I shall get along when I have got ½ dzn. or 10 Children I cant devise)." Almost one hundred years later, on Sunday, November 25, 1855, Ellen Birdseye Wheaton wearily noted the birth of her twelfth child, "another little girl was added to our number, and then a confinement of some weeks ensued....It was a great trial to me, to have another child, so that at times, I was very much unreconciled to it, but I dont doubt we shall love her, as much as we have any of the others."

And yet, the joy of a first-time mother is a constant, and Betsy Lewis might pick up her old school copybook (pl. 65) and pen a poem on seeing her firstborn, Elisha, asleep in his cradle. Confinement was faced with trepidation. Thomas Jefferson sought to ease the fears of his daughter Maria who was expecting her sixth child, advising her to "have good spirits, and know that courage is as essential to tri-

umph in your case as in that of a soldier." Maria Jefferson Eppes died in that childbed.

Pewter, silver, and glass nipples were miserable but necessary substitutes for a mother's warm breast. There was "1 silver nipp & drawer," undoubtedly similar to the example illustrated, in Captain William Tyng's Boston inventory in 1653. Pewter "sucking bottles" could be purchased at the sign of the *Crown and Comb* near the Prison in Queen Street, Boston, in 1756. American glass "nipple shells," perhaps like the round example here, were of assistance to nursing mothers. A silver pap boat, such as this one made by Harvey Lewis of Philadelphia around 1815, might be used to feed pap — a soft or semi-liquid food made of bread or meal moistened with water or milk — to an infant or a convalescent mother. In 1820 the *Examiner* described an infant which had been "swaddled, and papped, and called beautiful like its father."

A possible gift to a newborn was a coral and bells or whistle and bells in gold or silver. A combination whistle, rattle, and teething stick, these were a luxury item much prized in early America. This English example once had a gold wash and dates from around 1836. Sometimes a child's only plaything,

the whistle and bells were often hard used, as is documented by the one John Stamper took to the Philadelphia silversmith Joseph Richardson, in 1748, for mending of the socket, a new piece of coral, and six new bells. One hopes that these loosened bells were never swallowed. Visiting in New Orleans in 1849, Charles Lyell observed a regional variation: "I remarked, at a jeweler's, many alligators' teeth polished as white as ivory, and set in silver for infants to wear round their necks to rub against their gums when cutting their teeth, in the same way as they use a coral in England."

It was generally conceded by late eighteenth- and early-nineteenth-century observers of the American scene that American women were involved and conscientious mothers, sometimes to the exclusion of other preoccupations or distractions. Brigadier General Henry Bouquet complained to Ann Willing as early as 1761 that in America, "The ladies...are commonly involved and buried in the details of their families, and when they have given you the anecdotes of their days work, and the pretty sayings of their children, with a dish of tea, you may go about your business, unless you choose to have the tale over again." EDG

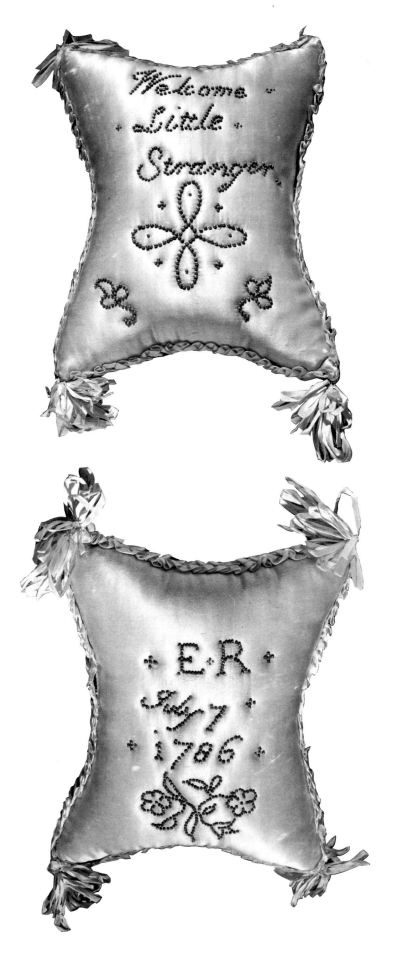

60 A cream-colored satin pincushion stuck with hand-wrought pins was a frequent gift to a newborn. This beautiful example retains its original folded silk edging and tassels. Anna Green Winslow noted in her diary on December 30, 1771, "My aunt stuck a white sattan pincushin for Mrs. Waters. On one side, is a planthorn with flowers, on the reverse, just under the border are, on one side stuck these words, Josiah Waters, then follows on the end, Dec^r 1771, on the next side & end are the words, Welcome little Stranger." EDG

61 On the reverse of the "Welcome Little Stranger" pincushion are the initials of Elizabeth Rea Rhodes, the daughter of Captain Zachariah and Betsey Rea Rhodes, who was christened on September 10, 1786, at Trinity Church in Boston. Her father had served in both the army and the navy during the Revolution and later worked as Surveyor and Inspector of Revenue for the Port of Pawtuxet (Pawtucket), Rhode Island. The cushion descended in the family.

The birth of her brother two years later was perhaps yet more heralded, for the birth of a daughter was not always as auspicious as that of a son. Edward Shippen wrote his father in June, 1760, advising him of the birth of a daughter, "My Peggy [Margaret Francis] this morning made me a Present of a fine Baby [Peggy Shippen], which tho' of the worst Sex, is yet entirely welcome."

Infants' clothes were often secured with pins. In June 1860 Caroline Richards recorded another practice: "Mrs. Annie Granger asked Anna and me to come over to her house and see her baby. We were very eager to go and wanted to hold it and carry it around the room. She was willing but asked us if we had any pins on us anywhere. She said she had the nurse sew the baby's clothes on

every morning so that if she cried she would know whether it was pains or pins." EDG

62 The miniature portrait of Charles Fenton of Pennsylvania or New Jersey was painted around 1819. Charles is portrayed with a book in his hands — the emblem of diligent boys and dutiful sons, and he had probably only recently exchanged his loose, baby frock for the skeleton suit which little boys received around the age of four in Federal America. This suit consisted of long trousers, and a short, attached jacket over a wide, ruffle-collared shirt. Mary Lee wrote to her husband from Boston one Thursday evening in May, 1821, concerning the suit she was making for their four-year-old son Hal: "I am to be employed tomorrow making Hal's new clothes. He is much pleased with the idea of being made a big boy, which he fully expects his boy's dress will make him." Three days later she updated the report: "He has appeared today for the first time in his boy's dress, and much strutting we have had, I assure you — I thought it had a good effect in keeping him still at church, but for the rest of the day I cannot say much."

The constant demands on mothers to make, wash, repair, and alter children's clothing were sometimes staggering. Ellen Birdseye Wheaton complained from Syracuse, New York, on April 21, 1850, "I can only say that since the second week, in March, I have been preparing garments, for children['s] summer wear, having shirts altered & made, for Charles, and having dresses made, and fixed till I am at times, almost bewildered. I began this work, earlier than usual, this season hoping much to get the main part of my sewing done, before the extreme heat of summer, but oh! it seems at times, as tho' it could never be done." EDG

husband, the fond cares for the children, the arrangements of the house, the improvements of the grounds, fill every moment [of a lady's day] with a useful and healthy activity."[15] Timothy Dwight had nothing but praise for the women of New England who, "perform in an exemplary manner the various duties of life. They are almost universally industrious, economical, attentive to their families, and diligent in the education and government of their children. They are to a great extent excellent wives, mothers, and daughters."[16] A mother taught her daughters a thorough knowledge of housewifely skills, and instilled in both sons and daughters moral strengths and amiable virtues. Before a child was sent to school, his mother had often taught him to recite hymns and prayers and to read the Bible.

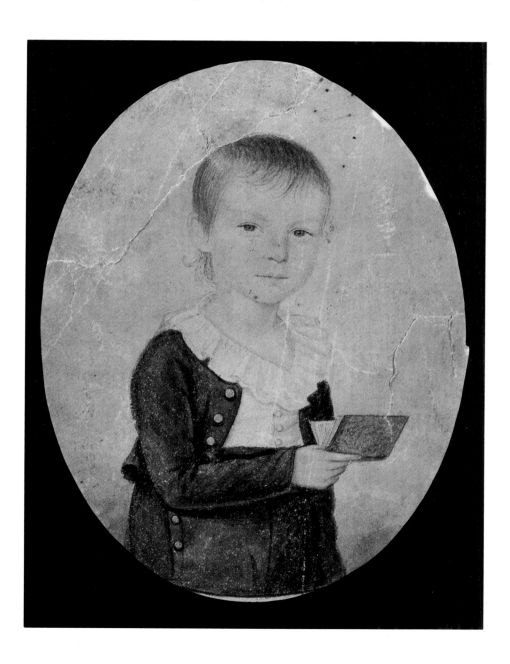

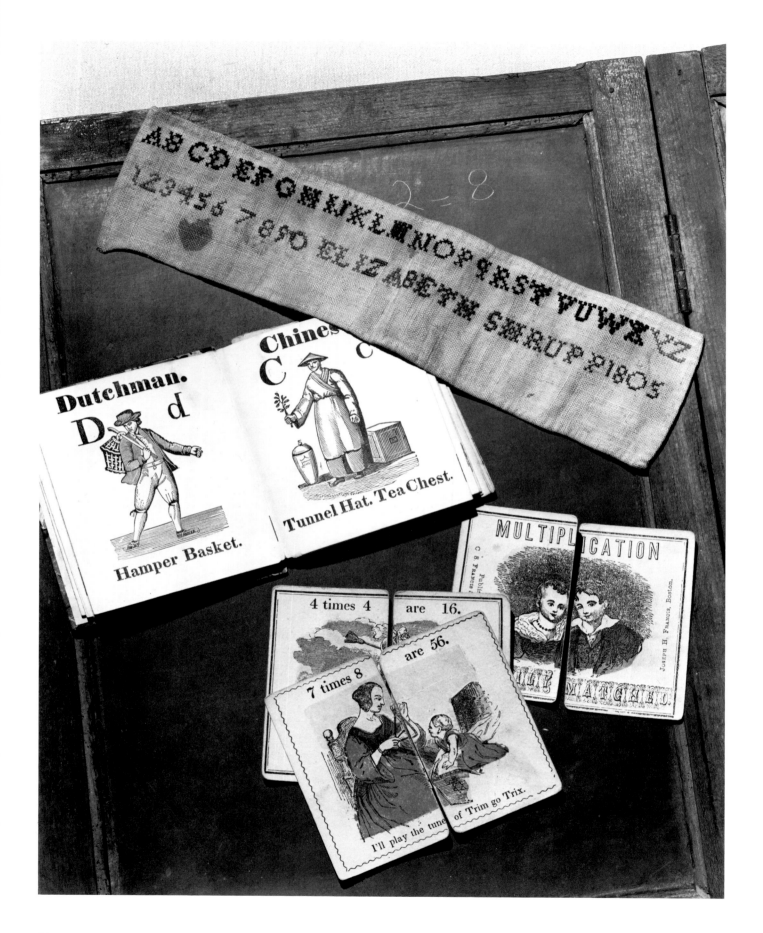

The boundary lines between childhood and adulthood, home and school, or home and work were amorphous and easily crossed in the eighteenth and early nineteenth centuries. The different stages of life flowed naturally into each other. The apprenticeship system offered a boy the chance to evolve slowly over a period of usually seven years from dependent childhood to young adulthood with acquired skills which enabled him to work independently, with no awkward, intermediary stage. Most girls worked closely beside their mothers until they were married and, thus equipped, moved easily from childhood home to bridal home. Like their brothers, young girls were given responsibilities early in life. Lucy Larcom of Beverly, Massachusetts, was grateful that she had been taught at home

> how to do everything that a woman might be called upon to do under any circumstances, for herself or for the

63 The increasing availability of juvenile books, "flash" cards, and educational games in the early nineteenth century demonstrates the growing recognition of the malleability of a child's mind, and mothers played an augmented role in the molding of these minds. Children in upper-class urban families were given a basic education at home before being sent to school. Offspring in families of the middling sort or those located in more remote geographic settings, where formal training was not always available, might well receive their schooling at home. Mary Palmer reminisced of her teen years in Framingham, Massachusetts, at the end of the eighteenth century: "Among others of her numerous avocations, my mother taught her children to read and write. Hampden, Edward, Amelia and Sophia were just old enough to be taught by her, and we girls, who were old enough to take care of household affairs, tried to let her have time for it; as there was no school kept in that town then, except in winter."

Some twenty years later, by then Mrs. Royall Tyler of Brattleboro, Vermont, Mary Palmer Tyler regretted that this rural Vermont setting and a lack of finances prevented her from providing her younger sister with a finished education: "Sophia had now become of great use and comfort to me, in helping to teach and tend the little ones. And it has ever been a painful recollection to me, and was to my husband, that we had it not in our power to give her such advantages of education as she ought to have had; but there were no young ladies' schools here then, and we could not afford to send her from home."

Catharine Beecher was grateful for the guidance her mother and her aunts offered her which gave her elementary instruction in reading, writing, arithmetic, spelling, and geography, and technical skills in sewing, knitting, drawing, painting, and housewifery. But she lamented, "oh, the mournful, despairing hours when I saw the children at their sports, and I was confined till I had picked out the bad stitches, or remedied other carelessness, or had completed my appointed 'stent'!" Caroline Richards, who was brought up by her grandmother in Canandaigua, New York, wailed a similar complaint, "I am sewing a sheet over and over for Grandmother and she puts a pin in to show me my stint, before I can go out to play."

The sampler was one way of teaching a daughter the alphabet and numbers as well as a vocabulary of stitches, and some simple samplers were worked at home under such guidance. A verse on an 1823 sampler acknowledged, "Thanks to my mothers tender care/ Who these materials did prepare/ And taught my hands to sew." Visiting New Orleans in 1819, Benjamin Henry Latrobe, the eminent architect and engineer, effused: "A Lady showed me today a Sampler worked by her daughter of 8 Years old. a b c d, &c. 1 2 3 4 5. A B C D, and so on, and at the end, that most affecting address of Christ, Suffer little Children to come unto me &c. &c. The Sampler was so well worked and the Stitches were so well counted, and so *little drawn*, that of the sort of thing it was really worthy of admiration, and accordingly I did admire it."

Caroline Richards was quite pleased with the sampler she was working under her grandmother's watchful and demanding eye in 1854 and said: "I am making a sampler, too, and have all the capital letters worked and now will make the small ones. It is done in cross stitch on canvas with different color silks. I am going to work my name too." EDG

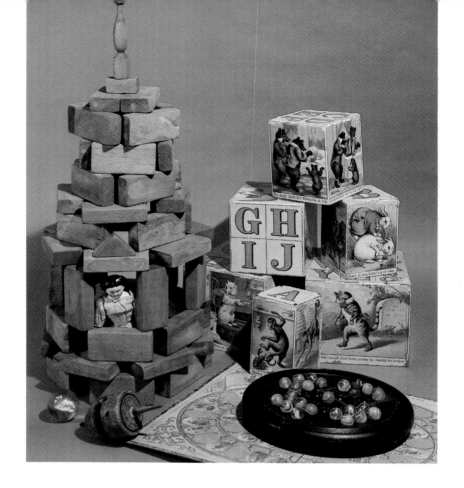

64 During the nineteenth century, American manufacturers busily developed children's games which were at once instructive and entertaining. Alphabet blocks were suitable for a young child's play, while a moralistic game such as "The Mansion of Happiness" taught pious lessons to the older child. Developed by a clergyman's daughter and published by W. and S.B. Ives in Salem, Massachusetts, in 1843, this board game stressed life's virtues and vices. Those players who succeeded in landing on virtue squares advanced to win the game.

Tops and marbles, though age-old toys, reached new heights of popularity in the Victorian era. Marbles were entitled according to their composition — "agates" were made of veined stone, "alleys" of alabaster, and "taws" of brown marble. Later, glass factories would manufacture marbles. A particularly handsome example of a glass-type marble is this large clear-glass example with the encased white sulphide of a lamb.

In 1886 Gene Schermerhorn recalled his boyhood play on 23rd Street in New York City some thirty-eight years earlier: "Marbles were played in a great ring four or five feet across marked out on the smooth hard dirt; not in the miserable way they do now — a little spot of bare earth about two feet by four and three or four glass marbles, as I saw some boys playing the other day. A handfull or two of marbles were put in the ring; and then you would hear shouts of 'knuckle down,' 'fen dubs,' 'fen everything,' etc. etc. The good shots would have bags half as large as their heads, full of 'migs,' 'China Alleys' and 'Real agates.' And then a crowd of 'Loafers' from some other street would make their appearance, and everyone would grab the marbles and run, or else stand and fight and then there *would* be a time." SMD & EDG

household she lived in. It was one of the advantages of the old simple way of living, that the young daughters of the house were, as a matter of course, instructed in all these things.[17]

Within the early household there was an easy commingling of age groups with children in varying stages of development, sometimes an aunt, and often a grandmother sharing the responsibilities of the household. The emphasis was on cooperation.

Cooperation was, in fact, the essential emphasis of all life in early America. The home and its inhabitants were tied to their community, their country, the world at large, through an incredibly complex network of interrelationships that are difficult for us to comprehend today. Myriad radiating tributaries of kinship ties, friendship bonds, business links, and religious alliances were the ligaments which bound and supported the New World. What early Americans lost in the uncertainty of life, they gained in the resilience of these bonds. And it was in the home that these bonds would be synthesized into confidence and security — a confidence and security which facilitated one's headway through the cycles of life.

65 The late eighteenth century placed much emphasis on the accomplishments of the "genteel" miss. Private girls' schools and academies began to proliferate in the young republic, and here a young lady's mind was to be instructed, her hand skills perfected, and her temperament molded. Caroline King, who was born in Salem, Massachusetts, in 1822, recalled: "My father used to tell of seeing a sign on a house in his boyhood which said, 'Plain sewing and politeness taught within by Mrs. Bakeman.'" At these schools creativity was subservient to uniformity, originality to rote. Girls practiced hand skills by copying prints and other pictorial and literary sources.

Betsy Lewis transcribed the copybook illustrated here in ink and watercolor while attending the Ladies Academy in Dorchester, Massachusetts, in 1803. Another schoolgirl, Julia Ann Crowley, worked this sampler in "Washington City" in 1813. Several other samplers from this as-yet-unidentified District of Columbia school repeat the verse and composition and suggest that a preceptress had composed a pattern for her pupils to copy. The school sampler, with its exacting stitchery, was ample proof of assiduity, and it was often framed and taken home to be hung as "the chief ornament of the sitting room or the best bedchamber." School mistresses recognized academic diligence and good behavior with tokens such as these silver merit medallions or, later, a "Reward of Merit" printed on paper.

Young girls away at school were often homesick. Eliza Southgate counseled her sister who was in attendance at Mrs. Susanna Rowson's School in Medford, Massachusetts, "A boarding-school, I know, my dear Sister, is not like home…[but] Surely, Octavia, you must allow that no woman was ever better calculated to govern a school than Mrs. Rowson."

Some yearned for the amenities of home, but plucky Anne Jean Robbins took one elegancy with her from home when she went off to Mrs. Saunders' and Miss Beach's Academy in Dorchester, Massachusetts, in 1803: on the first morning at school, as it was later recorded by her daughter, "when seated around the breakfast-table, the other girls eating with the pewter spoons which were thought good enough for boarding-school children of that day — and really were so — Anne cheerfully pulled a bright silver spoon out of her pocket, and began to eat her breakfast. 'As long as there are silver spoons in the world' she said in an undertone 'I shall eat with one; and, when there cease to be, I will put up with some inferior metal.'" EDG

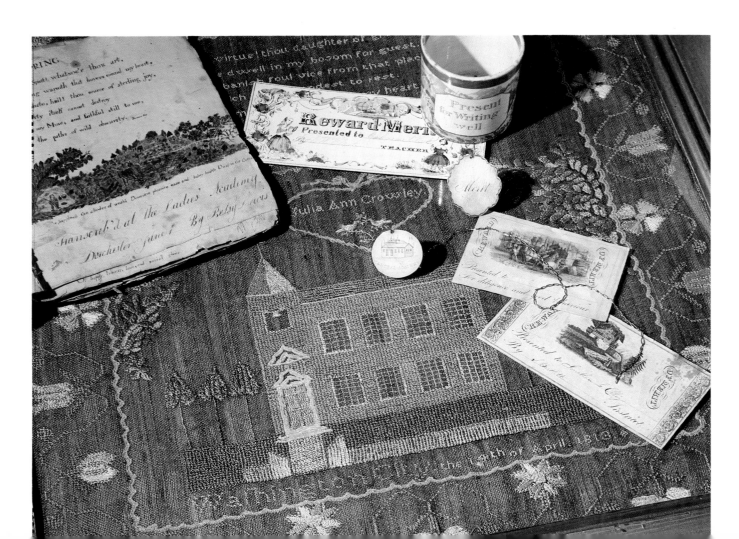

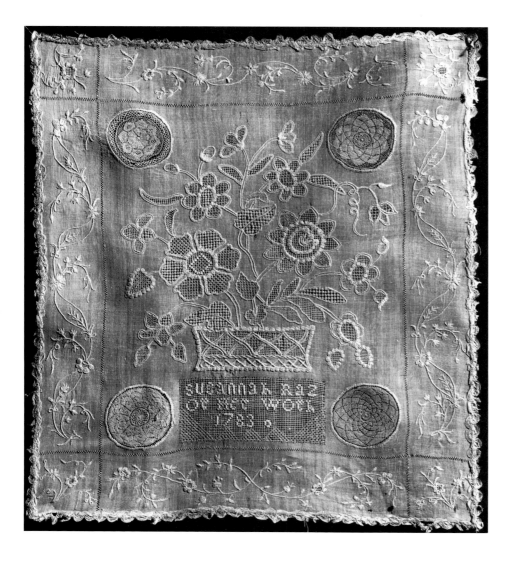

66 Susannah Razor's 1783 sampler is a remarkably well-preserved example of the Dresden-type and drawn-work samplers which were made in the Philadelphia region in the second half of the eighteenth century. The planter, flowers and leaves, and the rectangle on which she has stitched her name and date are worked in darned lace. Circles were cut out in each corner and filled with hollie-point lace. Drawn work provides a border of squares and rectangles which is filled with embroidered trailing flowers, some with darned-lace centers. The mastery of these needlework techniques would have assured Susannah the ability to ornament clothing and household textiles.

Recent research by Susan Swan, associate curator at Winterthur Museum, suggests that these now pristine-white cutwork samplers were originally colorful, with brilliant silk quilled ribbon borders and rosettes. The pink thread that secures Susannah's quilled-ribbon edging hints that this was itself once bright pink. Additionally, the sampler would have been mounted on a colored backing, and silk peeling for cutwork was advertised in the eighteenth century. Florence Montgomery in her dictionary of textiles, *Textiles in America 1650–1870*, defines peeling as "A kind of silk satin made in China," and cites the case of John Norton of Virginia, ordering "bright pink"

and "handsome blue" peeling satins in the 1770's. Susannah Razor's once-colorful and yet beautiful sampler descended in the family. EDG

67 Bia Hale stitched this earliest known view of the Baptist Meeting House in Alstead Center, New Hampshire, around 1802. Struggling with her running and satin stitches, she probably felt like Lucy Larcom, who wrote that her sisters "called my sewing 'gobblings.'" Bia's sampler displays none of the sophistication of samplers worked under the exacting eye of a sewing instructress, as was her daughter's (pl. 68). It could have been worked at home or at a neighborhood school which did not emphasize needlework skills. Yet her simple stitches have accurately captured the advanced ages of the black-garbed trio before the meeting-house and the impatience of the horse tethered to the tree.

It appears inevitable that the enormous bug will topple the cock-crowned steeple, yet the Baptist Meeting House is still standing today. Built in Alstead Center in 1802, it was moved to Alstead Village in 1828, where it was used as a church until around 1842, and then served as a three-room schoolhouse until 1954.

Bia Hale was born on August 5, 1792, the daughter of Captain Moses and Abigail Page Hale. Her father had served in the American

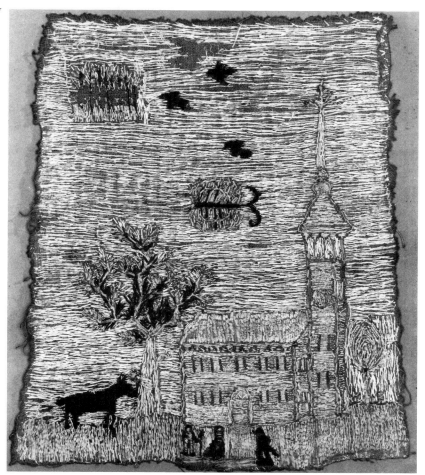

Revolution and was an active member and supporter of many institutions in Alstead, including the Baptist Meeting House. Bia married Ralph Emerson Smith on March 4, 1816. EDG

68 Anna Hale Smith of Alstead, New Hampshire, was born October 30, 1818, the daughter of Bia Hale (pl. 67) and Ralph Emerson Smith. She was named for her mother's older sister, who had died at the age of eleven in 1801. By the time eleven-year-old Anna Hale Smith completed her sampler in 1830, there had been a proliferation of ladies' academies in New England.

Although her mother had to be content with the most elementary stitches, Anna, under the careful guidance of a needlework instructress, has worked her sampler in satin, hem, French-knot, stem, flat, cross, and buttonhole stitches. In composition and motif it relates closely to a sampler made by ten-year-old Louisa Cushing from the neighboring town of Walpole, and the girls undoubtedly attended the same school. Louisa's sampler is now in a private collection.

Anna Hale Smith died, unmarried, in Alstead, at the age of twenty-three. Her sampler was obviously treasured and well cared for — a beautifully executed and colorful remembrance in yellow, cream, apricot, blue, green, black, and brown silks. EDG

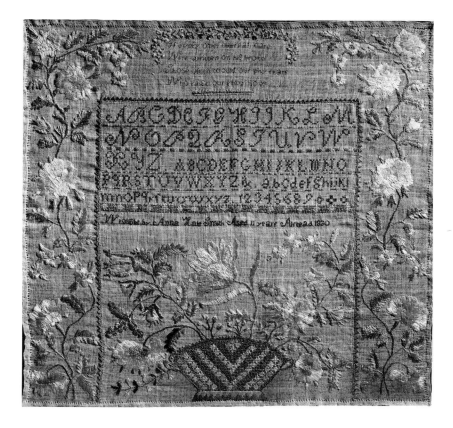

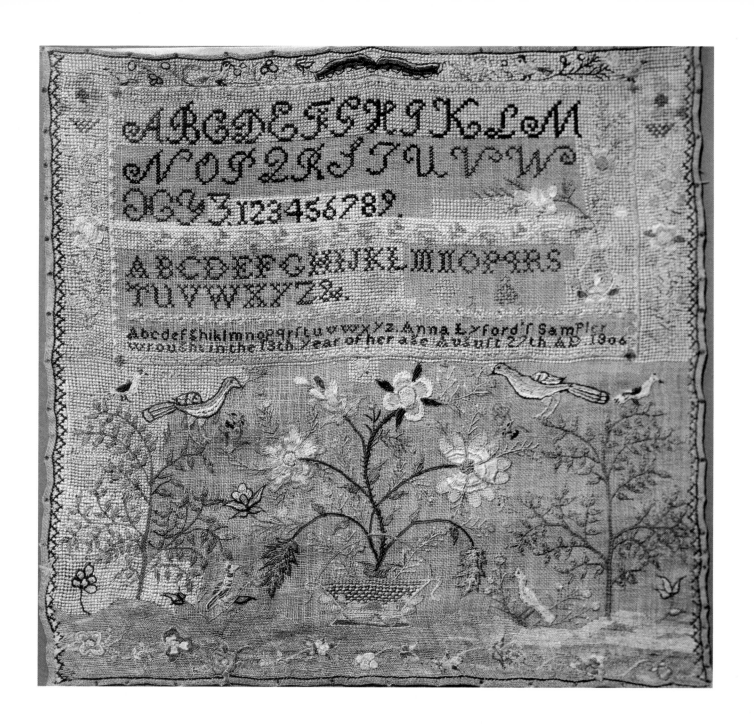

69 Anna Lyford's sampler, "wrought in the 13th year of her age August 27th A.D. 1806," was never finished. She never embroidered some of the inked-in leaves and stems, and she abandoned her ambitious attempt to cross-stitch a white background. Girls were often called home from school if family finances were short, or to help with sudden, increased household duties.

The delightful sprightliness of this sampler is characteristic of the best examples of New England needlework. In composition and motif it relates to a group of samplers which were all made by girls from Northfield, Canterbury, and Sanbornton — neighboring towns in south central New Hamp-

shire. An anecdote in the *History of Sanbornton, New Hampshire,* by Reverend M.T. Runnels, concerning Master Abraham Perkins, leads one to believe that we can discount his school as the source of these delightful samplers: "…in one of his first schools a young girl carried her knitting-work into the school-room. Being a new beginner, she supposed of course she must ask the master for directions as to her work. She accordingly went to him several times, and he directed her every time to *narrow!* This process soon brought the matter to a *point,* and when the unsuspecting girl asked for further instruction, the master advised her to apply to her mother."

Anna Lyford was born in Northfield, New Hampshire, on December 9, 1793, and married Ebenezer Morrison on February 10, 1814. Ebenezer Morrison was a tanner in Northfield, where their six sons and one daughter were born. The family later moved to Sanbornton Bridge, where Ebenezer, with two of his sons, erected a steam tannery. Ebenezer and Anna Lyford Morrison were buried in Hodgdon Cemetery in Northfield, with their daughter, Mary, who had drowned in a tanning pit in 1824, a toddler of seventeen months. At the time of the tragedy Anna Morrison had four sons, from nine-year-old Thomas to Mary's twin, Obadiah. With no daughters to help supervise the younger children, and harassed by household duties, Anna Morrison had lost her only daughter. EDG

70 Cassandanna Hetzel worked her sampler in yellow, blue, green, brown, pink, black, red, cream, and white silks on muslin in flat, satin, French-knot, chain, stem, and buttonhole stitches. The stitched inscription in the box at the lower left of the sampler reads: "Cassandanna Het/ zel a daughter of John/

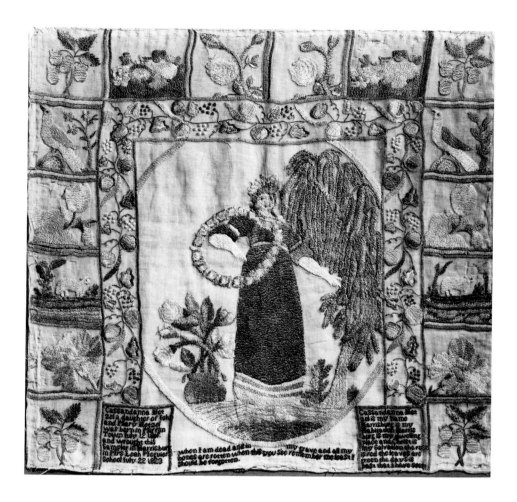

and Mary Hetzel/ was born in Mifflin/ Town July 12 1802,/ and wrought this/ Sampler in Harrisburg/ in Mrs. Leah Meguiers/ School July 22 1823." Other examples from Mrs. Meguier's School reiterate the composition of this sampler: an outer border of squares with embroidered figures, an inner trailing vine border, and a central figure or figures within a geometric shape.

The central goddess-type figure in Grecian garb and Cassandanna's name reflect the contemporary fascination with the classical world. Cassandanna and her younger sister, Selina, were hopefully pleased with the stylish names John and Mary Hetzel chose for them. James Stuart, a Scotsman traveling in Illinois in 1830, was distressed by this slavish duplication of classical names even in the backwoods of

America: "I remonstrated with Mr. Picket upon the Minerva names of the female part of his family. He defended himself on the ground, that it was now the universal custom of the country that the Christian names of the ladies should end with the letter A. His defense is, I believe, generally well founded; but it is as singular that such a custom should prevail in a new country, professing perfect simplicity of manners, as that *new* families in England should almost invariably abandon the far more beautiful and simple names of Mary, Jane, &c. and adopt the fanciful and romantic names of Theodosia, Constantia, &c. in preference to the good old names of their mothers and grandmothers." Cassandanna's father had served in the American Revolution, and the sampler descended in the family. EDG

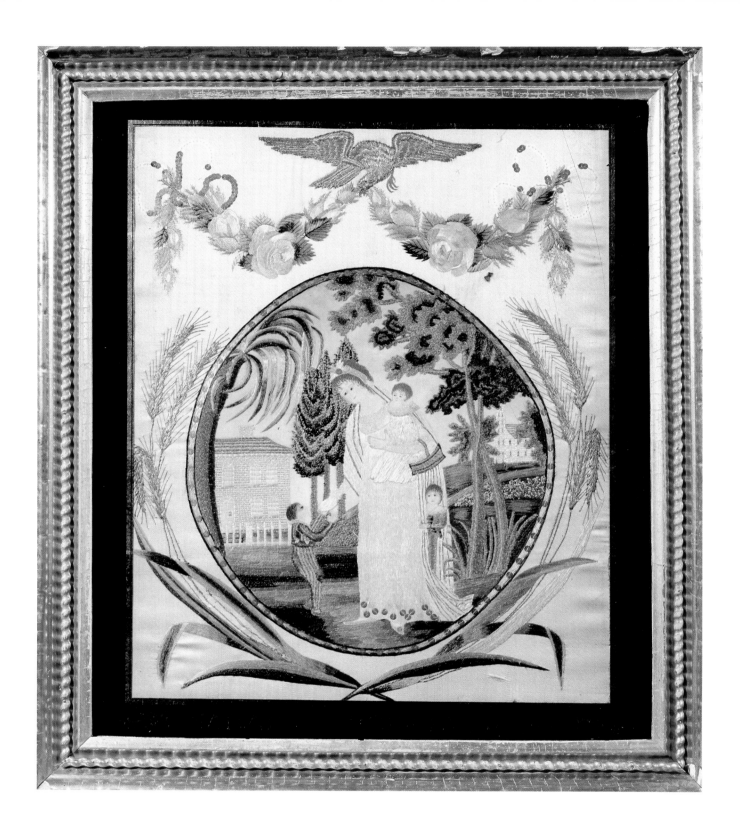

71 In 1806 Sarah Marshall embroidered this needlework picture of Charity in silk, silk chenille, and gold metallic thread on silk. Gold sequins and watercolor provide highlights and details. Sarah Marshall was born on December 2, 1791, to Elisha and Anna Carter Marshall in Windsor, Connecticut, where her father was a farmer. She worked her picture at Miss Patten's painting and embroidery school in Hartford, Connecticut, a school which educated about four thousand young ladies between 1785

and 1825. It was run by three sisters, Sarah, Ruth, and Mary Patten. In 1845, it was recalled that "The time in Miss Patten's school was divided between study, painting, embroidery, and some needlework. Each young lady had a handsome framed piece on their return home, to present to their parents; as embroidery was considered an indispensable accomplishment in those days."

Sarah's picture was copied from an English print entitled *Charity*, (pl. 72), and she would have received encomiums not only for her adept stitchery but for her faithful duplication. Prints of "Faith, Hope, and Charity," were offered for sale in New York in 1802, and Fidelity, Wisdom, and Piety were also widely distributed. These English engravings were much copied on paper and silk at ladies' academies. They were useful in instilling moral values, and the fashionably garbed personification of each virtue appealed to the sartorial inclinations of young ladies.

If the central figures were derived from English print sources, the composition was the dictate of the schoolmistress. Several other needlework pictures from the Patten school display identical compositions: a central, sequined oval framed at the bottom and sides by fronds and bearded ears of wheat, some bent; and, at the top, a spread eagle worked in gold thread supporting a floral garland which is secured at each end with a sequined bowknot.

Sarah Marshall has taken the common details of the print and rendered them more delicate and genteel. Charity's long hair has been shortened and gathered with tendrils of hair framing the face in the new, romantic style. Young Eliza Southgate had pleaded with her mother in 1800, "Now, Mamma, what do you think I am going to ask for?—a wig.... I must either cut my hair or have one, I cannot

dress it at all *stylish*.... At the assembly I was quite ashamed of my head, for nobody has long hair."

Sarah has taken the unattractive, shiftlike gown and common red shawl and refashioned them into the stylish evening dress of New England ladies with short waist and low neck, "an under handkerchief fitted so neatly it was scarcely discernable." Sarah Anna Emery further detailed, "White dresses were worn entirely by young ladies when in full dress.... Muslins and gauzes over under dresses of satin, with rich trimmings of lace, ribbon, spangles, bugles etc., were the mode for evening attire."

Charity's bright-eyed young son, hiding in the folds of her costume, has been given the short, face-

framing haircut of young boys in the New Republic and a stylish skeleton suit. The nondescript stone building in the print has been remodeled into a center-hall Georgian brick residence with arched window, fanlighted doorway, door knocker, and neat picket fence. Sarah Marshall's needlework picture is in its original gold, beaded frame and was undoubtedly proudly displayed at her parents' Windsor home. Justly treasured, it was handed down in the family. EDG

72 This mezzotint entitled *Charity* was the design source for Sarah Marshall's needlework picture (pl. 71). It was published by P. Stampa in London in 1802.

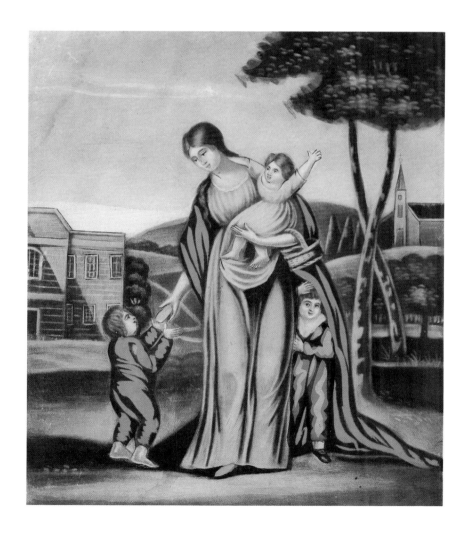

73

Charles Varles' *Complete View of Baltimore* of 1833 listed the "Misses Rookers" under his section on private schools for young ladies and elaborated, "The seminaries of learning for young ladies are numerous, especially those called boarding schools, and are well supported. They are kept by both ladies and gentlemen of great respectability, assisted by teachers of the first rate talents." EDG

73 This early nineteenth-century embroidered and watercolor picture, *View Near Exeter,* by Rebecca Rooker, and its accompanying print (pl. 74) are an extremely rare example of a needlework picture and its print source remaining together. Both were handed down in the Rooker family.

Rebecca was born on October 1, 1793, one of twenty-one children of James and Mary Berry Rooker of Birmingham, England. Early in the nineteenth century, Rebecca and her older sister Harriet came to Baltimore, where they opened an academy for girls. The Misses Rookers English Seminary for young ladies is listed in William Fry's *The Baltimore Directory for 1810,* and seems to have closed by 1837.

74 This English colored engraving by William Cartwright was the print that Rebecca Rooker copied when she stitched and painted her *View Near Exeter* (pl. 73). A print could be folded, as this one has been, and carried in a pocket or workbag for easy reference. The leitmotiv of crumbling ruins was a recurrent one in the romantic period, its emphasis on decay echoing the concurrent theme of death and the transience of all life. Among the images of crumbling ruins in the DAR Museum collection, are those painted in a school copybook, penned on a cotton bag (pl. 75), and printed on a porcelain plate (pl. 157). This reiteration of motif horizontally across a style period lends a certain veracity to the objects.

The emotive power of ancient, moldering ruins might have intrigued the American romantic, but ruins were not indigenous to this bright, new American landscape. Nathaniel Hawthorne complained of the dilemma of writing romance under such uninspiring conditions: "No author, without a trial, can conceive of the difficulty of writing a romance about a country where there is no shadow, no antiquity, no mystery, no picturesque and gloomy wrong, nor anything but a commonplace prosperity, in broad and simple daylight, as is the case with my dear native land....Romance and poetry, ivy, lichens, and wallflowers need ruin to make them grow."

74

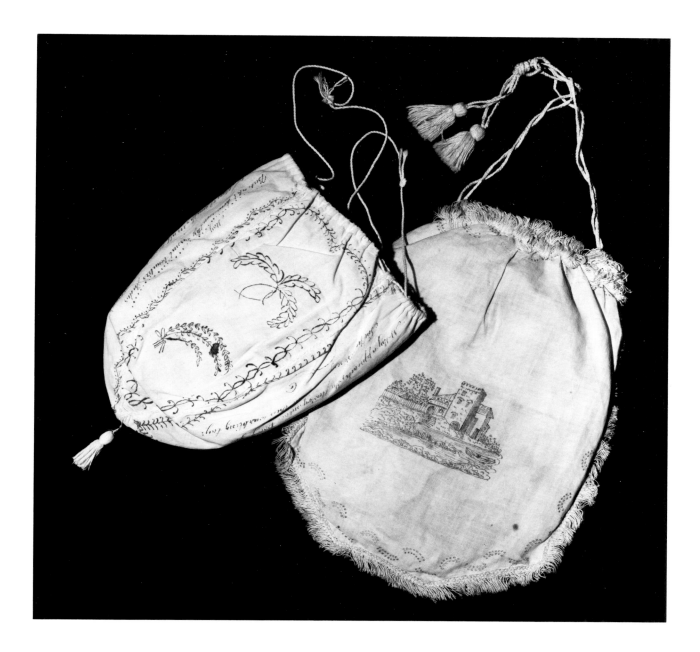

However, one romantic miss, Abby May, had been filled with powerful, melancholy reflections upon seeing the emotive fallen stones at Fort Ticonderoga in July 1800: "the ruins, much more magnificent then I supposed existed in our new country, built of stone, and the stone alone remaining...we alighted, I paced over the stones awestruck...the heaps of stones on which soldiers used to cook — the ditches, now grass grown, and forsaken graves!! all, every thing makes this spot teem with melancholy reflections." EDG

75 Drawstring bags were carried by ladies in the early nineteenth century and replaced the hip-hung pockets of the previous century (see pl. 88). The cream color would have blended with the fashionable white dress of the period. These simple but expertly stitched cotton examples were made by two young ladies from Exeter, New Hampshire, Caroline Odlin and Hannah Gilman, probably between 1810 and 1820. Hannah's pen-and-ink verses on the month of May, "verdant queen of spring," and Caroline's vignette of a turreted building

repeat the verses and motifs which schoolgirls were penning in their copybooks.

A very similar cotton example with pen-and-ink verses and floral motifs is now in the collection of the New Hampshire Historical Society. It was made by Sarah Bartlett of Campton, New Hampshire, in 1819, and suggests a regional preference for this type of bag. Contemporary documentation suggests that girls often gave these bags as tokens of friendship. Caroline Odlin inscribed hers to a friend whose name is now illegible. EDG

76 Fifteen-year-old Hannah Fox Budd worked her "South East View of the Episcopal Church & ACADEMY at Newcastle Del." in 1806, while attending the Burlington Academy in Burlington, New Jersey. Her view was undoubtedly derived from a print published between 1791, when the brick wall was laid, and 1806, the date of the sampler. In the background is the Immanuel Protestant Episcopal Church and, to the left of the brick wall, the Newcastle Academy building. Hannah Fox Budd was born April 17, 1791, in Northampton, Burlington County, New Jersey, to Joseph and Mary Fox Budd. The inscription stitched on the headstone in the foreground, "In Memory of MB 1800," commemorates her older sister, Mary, who died at the age of sixteen. EDG

77 By the end of the eighteenth century the school curriculum of an accomplished little mistress would have included English, arithmetic, history, music, drawing, penmanship, needlework, and geography, so Eliza Southgate might write from Mrs. Susanna Rowson's Academy in Boston on February 18, 1798, "I learn Embroidery and Geography." By this date Americans looked out over vastly extended horizons — west to an ever-expanding frontier, and east to an exotic world only recently opened to Americans in trade. Familiarity with international geography was essential to the wives, sweethearts, and daughters of merchants and seagoing men who, in the words of Lucy Larcom, "talked about a voyage to Calcutta, or Hong Kong, or 'up the Straits,' — meaning Gibralter and the Mediterranean, — as if it were not much more than going to the next village."

One way of teaching geography and sewing skills simultaneously was a map sampler. Although they were more common in England, map samplers were also made at

several girls' schools here in the new nation. An instance of parental guidance in these matters is recorded in a letter schoolgirl Nancy Shippen received from her mother in November 1777: "If Mrs Rogers has no objection I'd like you to work a map...Yr Papa will try to get the canvas."

Celestial and terrestrial silk globes, such as this 1822 example by Edith Stockton, were made by girls at the Westtown School near Philadelphia. At this Quaker school a girl was first required to master plain sewing, then she worked a darning sampler (see pl. 11), and finally she might attempt to work a pair of globes. One Westtown student, Rachel Cope, wrote to her parents in 1816 concerning the globes she was about to embroider: "I expect to have a good deal of trouble in making them, yet I hope they will recompense me for all my trouble, for they will certainly be a curiosity to you and of considerable use in instructing my brothers and

sisters, and to strengthen my own memory, respecting the supposed shape of our earth, and the manner in which it moves (or is moved) on its axis, or the line drawn through it, round which it revolves every twenty-four hours."

For Edith Stockton's example, eight wedge-shape sections of silk were sewn to a stuffed, canvas-covered sphere. Couching stitches outlined continents while ink inscriptions were calligraphed microscopically to identify continents, countries, and bodies of water. Several notations, such as the identity of Chatham Island as the place where "Capn Cook was killed 14 Feb 1775," indicate that the globe was useful in teaching history as well. The Museum also owns Edith's celestial globe, which displays the constellations, astrological signs, and characters from the myth "The Quest of the Golden Fleece." The celestial globe taught stitchery, penmanship, astronomy, and Latin. EDG

78 By the time Virginia Kramer worked her needlework picture in tent and fishbone stitches in 1840, the sampler was becoming a thing of the past, and her limited vocabulary of two stitches is indicative of the diminished emphasis on sewing skills in a young girl's education. The delightful naive charm of her youthful effort far outweighs the paucity of stitches.

Twelve-year-old Virginia probably worked her sampler in Pittsburgh, where she was born on March 27, 1828. In 1842 or 1843 Virginia was sent west across the Ohio River to the Canton Female Seminary in Canton, Ohio. Her 1845 diploma from this seminary documents her thorough training in "the Branches of Literature and Science...together with the Ornamental Branches following: Music, Drawing and Painting." Needlework is not mentioned, for girls' school curricula now mirrored the shifting emphasis from elegant accomplishments to academic proficiency. EDG

79

80

79 This brightly colored arrangement of fruit in a basket with a bird and butterfly was quite possibly worked by a schoolgirl to decorate the wall of her family's home. Creating still-life compositions of abundant displays of fruit and flowers was a popular feminine pastime in the second decade of the nineteenth century. Although some paintings were executed freehand, it was more typical to use stencils. Formulas for composition, preferred colors and shading were closely followed. As a result, a number of almost identical theorems survive. Individual expression and talent can be found in the manipulation of brushstrokes and the careful execution of detail, or in the addition or subtraction of elements in the composition. Easily executed, theorem painting could be done at home once a schoolgirl had learned the technique. GSA

80 The ubiquity of domestic architecture in schoolgirl embroideries of the late eighteenth and early nineteenth centuries attests to the centrality of the home in female lives in preindustrial America. Home was "centre and circumfer-

ence." Only the Sunday stroll to church or a season away at school cut through these taut perimeters. "The employments of the women of New England are wholly domestic" perceived Timothy Dwight at the end of the eighteenth century. "The business which is abroad is all performed by men, even in the humblest spheres of life. That of the house is usually left entirely to the direction of the women, and is certainly managed by them with skill and propriety." EDG

81 This transfer print from the side of a creamware teapot is entitled "The Fortune Teller" and illustrates the precept accepted by most girls in the eighteenth century that marriage was the only true, happy state for a woman. It was towards this ultimate goal that their education was directed and their temperament was molded. In 1762 Charles Carroll of Annapolis cautioned his twenty-five-year-old son, Charles Carroll of Carrollton, that a wife must be "Virtuous, Sensible, good-natured, complaisant, complying, & of a Cheerful Disposition." The Marquis de Barbé-Marbois subsequently remarked on "the extreme

docility, the obedience, and the submissiveness of American women to their husbands." But one sprightly Philadelphia Quakeress, with the help of a male cousin, composed a poem which challenged such resignation, "Good humour & gay will last the first day/ But then I'll begin for to pout/ To find at my board I've got a new lord/ To govern me in doors & out." She then defiantly directed, "No man of good nature would threaten his wife/ But submit to her will all the days of his life/ As you, my good master, must do I declare/ So sit yourself easily down in your chair/ I'll be a good wife but I will have my way/ I sometimes shall govern and sometimes obey."

Within marriage, a wife should be industrious; her duty was to economize and to preserve, to make last whatever her husband had provided. With premonitions of possible discord and perhaps with the enlightenment of past experience, the widow Deborah Leaming and the widower Jacob Spicer drew up a lengthy antenuptial agreement in which item 22 stipulated "That the said Jacob Spicer shall not upbraid the said Deborah with the extraordinary

Industry and Good Oeconomy of his deceased wife neither shall the said Deborah Leaming upbraid the said Jacob Spicer with the like extraordinary Industry and good Oeconomy of her Deceased Husband." EDG

82 The production and maintenance of textiles was one of the most time-consuming and exhaustive aspects of woman's work in the eighteenth and early nineteenth centuries. A young woman's collection of handmade textiles was a measure of her worth and an indicator of her potential or actual success as a housewife. By the 1830's, advances in textile production technology had relieved many housewives of the necessity of home spinning, but women in many rural and pioneer areas would perpetuate these homely skills throughout the nineteenth century.

Textiles were marked in cross-stitch with the maker's initials for identification purposes and newspaper advertisements document the importance of this practice in recognizing stolen goods. The *Boston Gazette* mentioned "a Damask Counterpin of a Bed, one breadth, mark'd S.P....[stolen] from a Yard near Fort Hill," and Charleston, South Carolina's *Columbian Herald* alerted its readership to "a number of Table cloths, sheets, pillow-cases, towels, men's and children's shirts —all of which are marked with the initials of the Christian name and the surname Reeves in full," which had been stolen from Mr. Reeves' house during a fire.

Washing and ironing were laborious, repetitive responsibilities which were complicated by the attendant duties of making soap, hauling water, and building a fire. But much care was taken. Indigo "blueing" or bleach was added to the water, and linens were stretched out in the sun to ensure

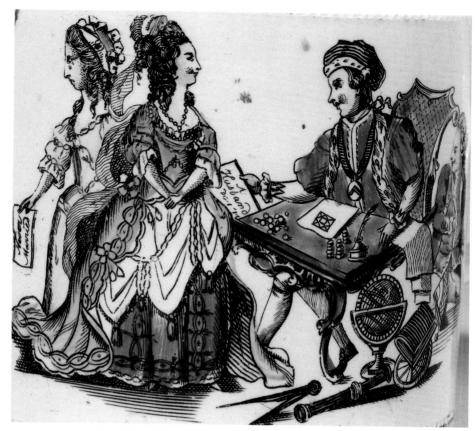

81

82

an ultimate "snowy whiteness." Catherine Henshaw, sister of the artist Ruth Henshaw Bascom (pls. 43, 44), in the early spring of 1804, shortly before Ruth's marriage, "took a delightful walk up into the orchard to see Ruthie's diaper which is whitening on the last snowbank that is to be seen."

Ellen Rollins recalled her grandmother's skillful production and solicitous care of cloth in her farmhouse in Wakefield, New Hampshire, in the 1830's, where "on long summer afternoons...[she] planted [her] little wheel by the back door, and hour after hour drew out the pliant threads which were to be woven, in the loom upstairs, into concisely patterned coverlets, tablecloths, and towels....The bureau, in the fore room, was always crammed with fine twined linens, white as snow, and scented with lavender and rose leaves." EDG

83 The German settlers in Pennsylvania brought with them skills and traditions which they perpetuated in their New World homes. Elaborate hand towels, such as Margetha Minsen's of 1797 and Anna Rutt's of 1820, were such a tradition. Proudly displayed, these show towels connoted cleanliness about the house and a fastidious care of textiles. Many observers of life in eighteenth-century Pennsylvania commented on this cleanliness and on the prosperity of its citizens. Manasseh Cutler, traveling between Bristol and Philadelphia in July 1787, wrote, "I observed the men generally wore fine Holland shirts, with the sleeves plaited, the women in clean, cool, white dresses, enjoying the ease and pleasures of domestic life, with few cares, less labour, and abounding in plenty." EDG

84 Versatility with the needle enabled a woman not only to fulfill the plain sewing demands of her household but to do fancy work as well. Elizabeth Gorton of Kent County, Rhode Island, worked and marked this crewel-worked strip at the age of twenty-six. Measuring 91 inches around the base, it could have been a petticoat border. On December 19, 1749, the *Boston*

Gazette announced the theft of a similarly embroidered border: "stolen out of the Yard of Mr. Joseph Coit, Joiner in Boston, living in Cross street, a Woman's Fustian Petticoat, with a large work'd Embroider'd Border, being Deer, Sheep, Houses, Forrest."

The Queen's stitch pinball was originally owned by Elizabeth Arnold, who was married in Newport, Rhode Island, and the attached chatelaine was made by Walter Cornell, a silversmith working in Providence from around 1780 to 1801. Engraved on the face of the shield-shape clip is the inscription, "LH to EA." The long backpiece of this clip fit over the waistband of a skirt or apron and secured the chatelaine, from whose linked chains the housewife might suspend sewing implements, keys, a watch, or sometimes decorative beads.

A housewife's keys were a symbol of her regulatory control over the household, and the keyholes which were neatly fitted into the drawer fronts of much early furniture, such as this tambour-reeded worktable, express a contemporary desire for privacy and security.

Elizabeth Peyton Patterson of Suffolk County, Virginia, worked the canvas cover to her 1783

Oxford Bible, carefully planning the spine crossbands in an allusion to the tooled leather bindings of the period. In an age when the Bible might be one of the few items to decorate the typically bare table tops in the home, Elizabeth Patterson's colorful and skillful attention to detail would not go unnoticed. Portraits of that time often depict a woman with the Bible in her lap. One was constantly reminded to direct one's affections and devotion to an immortal God rather than to mortal man, for the durable pleasures of faith could transcend a mortal's fluctuating, transitory state.

Religious faith was the primary font of fortitude. The death of Thomas Jefferson's daughter Maria compelled Abigail Adams to break the silence which had marked the estrangement of these two families. On May 20, 1804, she wrote to Jefferson offering him the religious succour which had enabled her to surmount similar trials: "It has been some time since I conceived that any event in this life could call forth feelings of mutual sympathy. But I know how closely entwined around a parent's are those cords which bind the parental to the filial bosom, and, when snapped asunder, how agonizing the pangs. I have tasted of the bitter cup, and bow with reverance and submission before the great Dispenser of it, without whose permission and overruling providence not a sparrow falls to the ground. That you may derive comfort and consolation, in this day of your sorrow and affliction, from that only source calculated to heal the broken heart, a firm belief in the being, perfections, and attributes of God, is the sincere and ardent wish of her who once took pleasure in subscribing herself your friend." "Acceptance is requital" was a motto often engraved on mourning rings, and a dutiful submission to the will of an allpowerful God was sometimes the only comfort derived from the vicissitudes of life. EDG

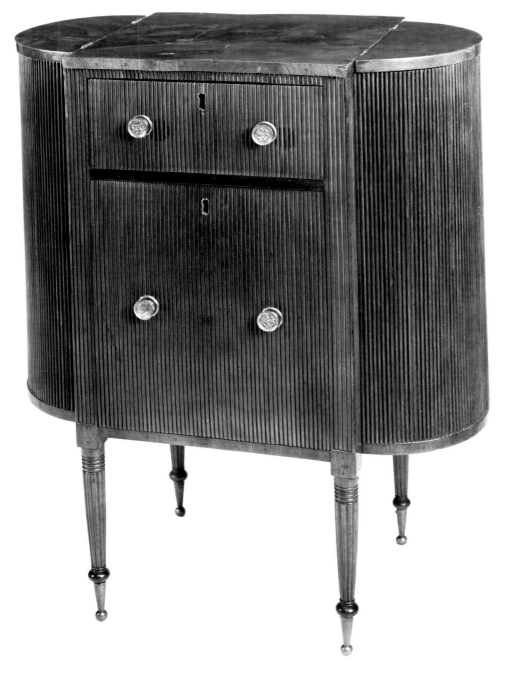

85 Ladies in the New Republic wielded considerable authority in the decoration of their homes, and cabinetmakers had to recognize this feminine persuasion. In his *Cabinet-Maker and Upholsterer's Drawing-Book* of 1793, Thomas Sheraton clearly acknowledged the ascendancy of female influence on home furnishings, for of sixty-four entries in his book of furniture forms, at least twelve were specifically designed for "a Lady's" use and many others with her comfort in mind. "A Lady's Dressing Table," "a Lady's Work Table," "a Lady's Drawing and Writing Table" all suggest the growing emphasis on luxury, comfort, convenience, and accomplishment which characterized the urban neoclassical home and its mistress.

The worktable was introduced about this time. This tambour-reeded example is thought to have been made in Philadelphia and has a history of ownership by a Quakeress, Hepsibah Gardiner Chadwick of Nantucket. The hinged ends of the top lift up to reveal deep semicircular wells for storage. The narrow top drawer is divided into nine small, square compartments for the orderly stowage of sewing implements, and the deep lower drawer would have held unfinished work. As a lady sewed, the top provided a surface for a thimble, scissors, and a candle or lamp. EDG

86 This tiger-maple worktable has a history of ownership by Mary and Almon Babcock of Rootstown, Ohio, and it descended in that family. Almon was born in Granville, Massachusetts, on November 19, 1788. He married Mary Collins of Hartford, Connecticut, in 1814, in Rootstown, where he had settled

in 1810 as a member of the Charlestown Land Company to look after his father's land.

The worktable was perhaps the product of a cabinetmaker who trained in the East and moved West, as the workmanship in this piece is particularly fine. The nicely shaped saber legs with turned-ball feet, the crisply turned urn-shaped pedestal, the finely dovetailed drawers with chamfered bottoms, beaded moldings, and inlaid ivory escutcheons, all attest to this cabinetmaker's sophistication. The Babcocks had also owned a tiger-maple four-drawer chest of drawers with ivory escutcheons and Ionic columns.

According to the donor of the worktable, "It always stood in the parlor between the windows in the old Babcock house," the conventional location of this form in the early nineteenth-century home. The table could then be moved in front of the window for daytime sewing or into the middle of the room for evening handwork, its flat top providing a surface for the candle or lamp which would be placed on it. Maria Brown, who was born in 1827, and who had similarly moved west to Ohio from the East, used part of the $100 she received from her father's estate to buy herself some handsome furniture: "I bought a walnut breakfast table with fall leaves and a drawer in which to keep the tablecloth. I also bought a cherry bureau, a cherry bedstead, and a cherry candle stand — pretty pieces, all of them. The candle stand had a bird's-eye maple drawer with cherry knobs. When evening came we used to set a candle on the candle stand and pull the stand into the centre of the room so that four people could sit around it and see to work." EDG

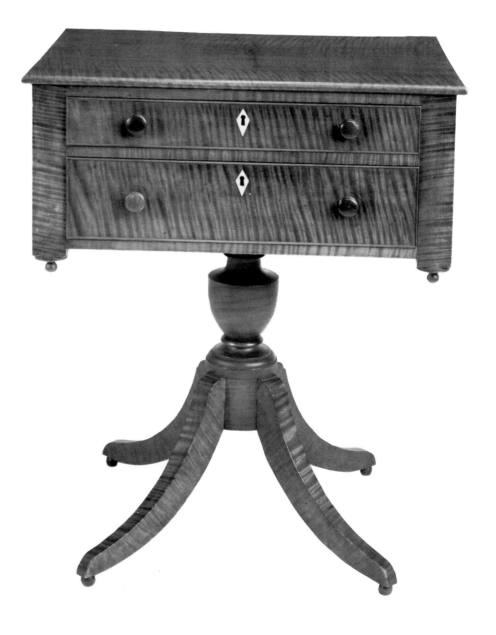

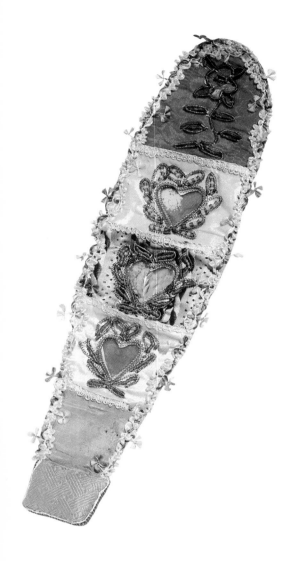

87 This decorative example of needlework virtuosity was meant either to be hung as a wall pocket or to be carried as a purse. Four small pockets are faced with varied silks and would have provided storage space for small items such as sewing accessories and dressing pins. Although the pincushion at the base is not original to the piece, there might well have been one, as it would have enhanced the usefulness of this item. The pockets fold compactly and relate in design to the multipocketed folding purses called "housewives" which were made of more humble cottons in New England in the early nineteenth century. This sophisticated version combines silks, etched mirror glass, colored glass beads, and silvered wire. It was received at the Museum with a history of having been made at a French convent in the eighteenth century. The vivid colors are an important and edifying aspect of this piece. Perhaps because it was folded and protected from the light, the quilled-ribbon and tassel edging is still bright pink, yellow, blue, and green and hints at the original brilliance of similar edgings used on American schoolgirl embroideries. The backing fabric is a sky-blue silk. EDG

88 Ladies' pockets, often worn in pairs, were attached to a woven tape, tied around the waist, and suspended over the hips in the eighteenth century. Their ample size and tape-reinforced edges and openings would have provided space and sturdy support for keys, needlework accessories and work, perhaps a letter, a small book, a wallet, and a child's toy. The bright colors of the crewel yarns would have complemented the gold, red, blue, or green quilted petticoats over which they were worn.

In the novel *Adam Bede*, George Eliot penned a picture of a young woman in her bedchamber: "Having taken off her gown and white kerchief, she drew a key from the long pocket that hung outside her petticoat, and, unlocking one of the lower drawers in the chest, reached from it two short bits of wax candle." By the late eighteenth century, the slender outlines of stylish white gowns clinging to the figure obviated such bulky pockets. Small cream-colored silk bags with delicate silk embroidered decoration and drawstring closures might now be worn over the wrist.

One Delaware mother, Ann Ridgely, wrote to her sons at Dickinson College in Carlisle, Pennsylvania, in 1796, pleading with them not to frequent taverns nor to spend their time, "among Women and Girls, from whom nothing but nonsense and affectation is generally met with now a days. A young lady visited here last week who profess'd herself 'astonish'd to find your sisters at work,' and declared, in a sweet simper, that she never had Sizars, thimble, needle or thread ab[ou]t her, for it was terrible in a Lady to wear a p[ai]r of Pockets — the French Ladies never did such a thing." EDG

89 Needlework pocketbooks were commonly carried by both men and women in the second half of the eighteenth century: the examples illustrated here were received with histories of male ownership. Pocketbooks were used for carrying currency, papers, jewelry, and other personal valuables. This grouping includes both the single-flapped envelope type and the double form which folded in the middle with pouches to either side. All are worked in wool on canvas, lined in colored worsted, interlined with stiff cardboard, and bound in wool twill tape. Three examples are worked in Irish stitch, the most common stitch used for needlework pocketbooks, in a flame, diamond, and carnationlike pattern. The fourth is embroidered in crewelwork designs. EDG

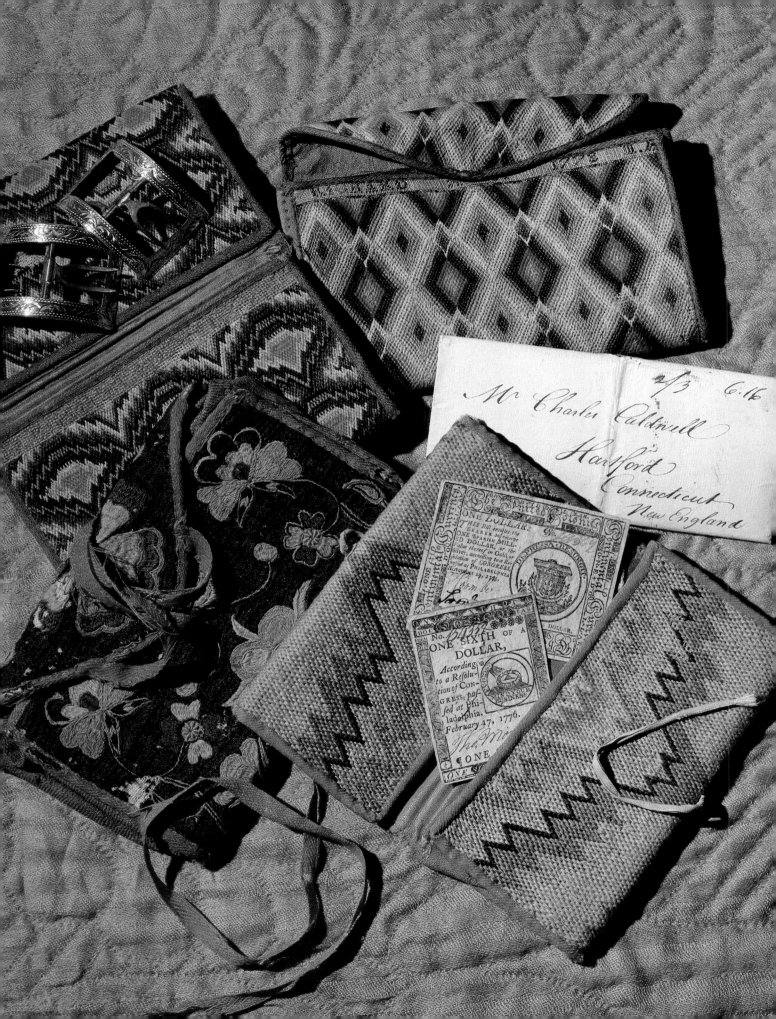

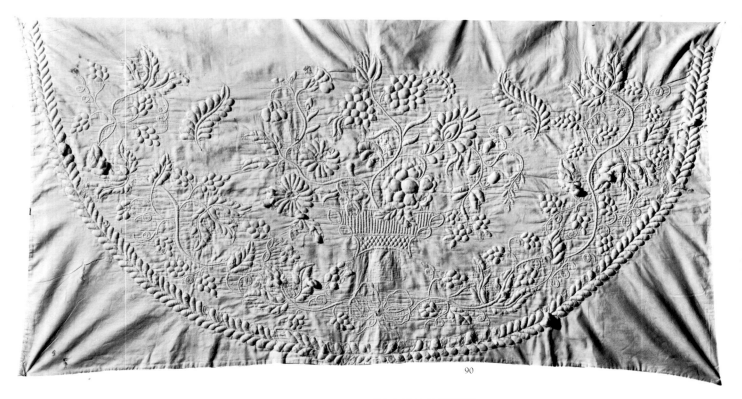

90

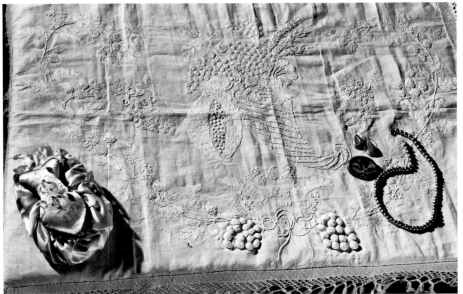

91

90 In the late eighteenth century ladies deemed it fashionable to own a semicircular dressing table which might have a worked top and to which was sewn a gathered skirt. Like the stylish miss herself, the dressing table must be draped in white. Mary Palmer Tyler described the niceties of her simple early nineteenth-century Vermont home: "we had curtains to the bed and windows, two white dressed toilet tables, and a few very common chairs." These dressing tables came to be so closely associated with women that they sometimes appear in early nineteenth-century female portraiture as a symbol of femininity.

This example was worked in hand-done Marseilles work and has both stuffed and corded areas. It was made around 1815. The high-relief surface meant that nothing that might tip could be placed on it, but a pin cushion was conventional. Pins of varying sizes enabled a lady to hold her costume together and were essential to a dressing table. Usually a looking glass was suspended above it to facilitate the toilet. Tom Shippen recorded in 1783 that in his bedchamber at Westover, the Byrd estate in Virginia, the "toilet table which stands under a gilt framed looking glass, is covered with a finely worked muslin." EDG

91 Chests of drawers and toilet tables were commonly covered with a cloth or scarf; this embroidered and tufted example was made in 1811. The lady's embroidered silk combination bag, pincushion, and needle holder is perhaps similar to the one Josiah Quincy admired at the Charleston, South Carolina, home of Elizabeth Inglis Smith on March 6, 1773: "Mrs. Smith shewed me a most beautiful white satin and very richly embroidered lady's work-bag, designed as a present for a lady in London." EDG

92 "Kittle holders" were as necessary in the eighteenth century as they are today, and nice designs were favored then as now, but the eighteenth-century example would have been all hand sewn. In 1834, Caroline Howard Gilman recalled the calico bag she had received years before as a young bride, "containing iron holders, kettle holders, wipes and dishclothes, presented me by an old aunt, who had quilted them for the occasion." EDG

93 This crewel-on-canvas hand-held fire screen is stiffened with cardboard and backed in green silk. In the eighteenth century one complained frequently of the unpleasant sensation of sitting near the fire, freezing on the side away from the flame and burning on the other. A fire screen would provide some protection from the heat while allowing one to enjoy the grateful warmth. On October 8, 1782, Lucinda Lee noted in her Virginia journal, "I have been busy to-day working a little screne, to hold in my hand to prevent the fire from burning my face. I think it will be beautiful." In the nineteenth century fire fans were more often made of pleated silk or heavy paper painted in fashionable designs. EDG

92

93

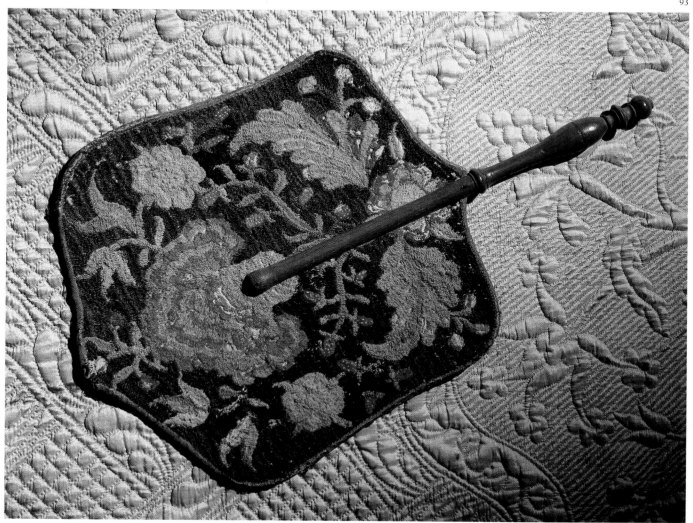

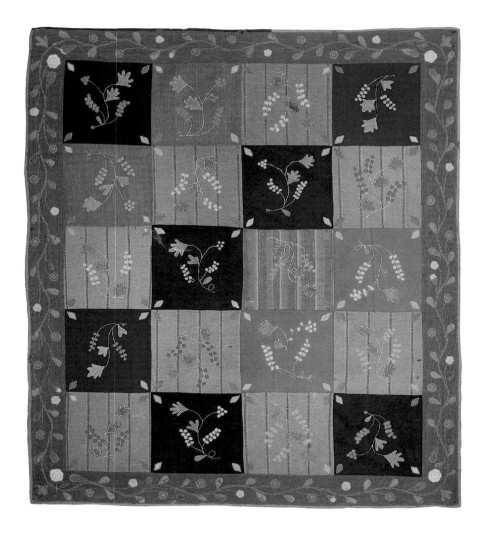

94 The creative energy, frugality, and resourcefulness of a New England housewife are expressed in this wool table cover. Twenty squares of wool clothing and bedding fabrics are contained in a 3¾-inch border. Appliquéd on each square is a vine-and-berry motif. The leaves are stitched with a couching stitch in a contrasting yarn color, while the berries are stitched with color-coordinated thread. Gold or red diamonds are appliquéd at the corners of the squares and provide an overall unified design. At each corner of the undulating floral border is a posy of grey satin. The backing fabric is a printed cotton, with a black vine-like pattern scattering across a white-dotted tan background. Using scraps of material she had around the house, the maker has created a decorative and functional cover of restrained exuberance which would have lent warmth and vitality to a New England winter interior. It demonstrates the ingenuity, thrift, and flair with which many early American housewives furnished their homes. JM

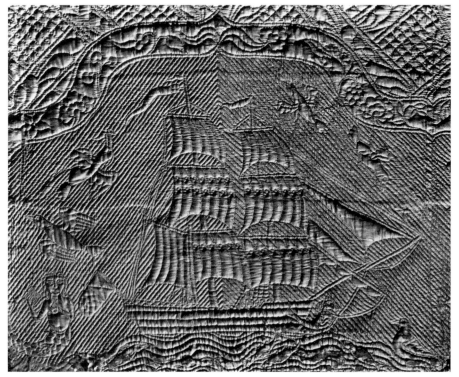

95 The nautical details of a two-masted ship and a mermaid riding the waves are from a quilted petticoat. A lion, unicorn, flowers, birds, pear tree, and anachronous pineapple tree decorate the remainder of the petticoat, which is quilted in gold thread on a gold silk ground and backed in blue and natural striped homespun. These stuffed and quilted tropical and mythical details provided both warmth and adornment. Additional petticoats might have been worn under this topmost and visible petticoat in winter months, when a hibernal layering was essential to keep warm in drafty homes inadequately warmed by open wood fires.

 Anne Jean Robbins recalled that during the winters at her home in Milton, Massachusetts, in the early nineteenth century, "We wore our

great coats in the house half the time…and even then could not have been warm without the active employments that kept us constantly busy." The grateful warmth provided by quilting ensured that the technique would be used for bed covers, petticoats, and coats. This petticoat was received with a history of having belonged to Margaret Sterling, the daughter of an import merchant in Burlington, New Jersey; she was born on April 12, 1785. EDG

96 This delightful, sure-footed, and colorful rooster is a detail from an appliqué quilt made by Laura Whitcher Adye, who was born in Vermont in 1801 and married Aner Adye, a farmer and a miller. The peregrine aspect of her married life replicated that of so many New England girls at the time. She moved south to Kentucky and, in 1839, north and west to Dubois County, Indiana. In 1875, at the age of seventy-four, she died at the home of a son, yet further west in Iowa. The quilt was given to the Museum by a granddaughter.

Two themes which distinguish early home life can sometimes be read in quilts. One is the easy commingling, within a household, of females of varying ages — girls, young women, and old women — working together. The other is the social aspect of neighborliness. A bed quilt was often a community effort, for practical reasons as well as social.

Thomas Low Nichols, who had been born in Orford, New Hampshire, in 1815, elaborated: "The quilting is mostly a feminine arrangement. Its ostensible object is the manufacture of a bed-quilt. This involves a social gathering — talk, tea, probably a little gossip and scandal, and in the evening the accession of masculinity, with more or less of fun and frolic. The upper surface of the quilt is that marvellous result of feminine industry —

patchwork; the lower stratum is more modest calico; the interior cotton or wool; and the whole is united by quiltings in elaborate figures, composed of a vast number of stitches, made by as many old and young ladies as can sit around the frame, beginning on the borders, and, as the frame is rolled up, gradually working towards the centre. The reasons for making this a social undertaking are obvious. When the quilt is in the frame it occupies a large space. It would take a long time for one or two persons to do it, and would be a long time in the way. Finally, it is an excuse for a social gathering."

A patchwork quilt was an effective way of teaching sewing skills and was thus taught at both home and school in the early nineteenth century. The quilt taught economy through the judicious use of fabric scraps, and the pattern was a visible gauge of organizational skills. Because the scraps had often been pieces and parts of family clothing,

the quilt had a powerful associational value. It could be as effective as oil portraits or photographs in conjuring up the image of the person who once wore those garments.

Lucy Larcom, who was born in Beverly, Massachusetts, in 1824, recalled: "Another trial confronted me in the shape of an ideal but impossible patchwork quilt. We learned to sew patchwork at school, while we were learning the alphabet; and almost every girl, large or small, had a bed-quilt of her own begun, with an eye to future house furnishing. I was not over fond of sewing, but I thought it best to begin mine early. So I collected a few squares of calico, and undertook to put them together in my usual independent way, without asking direction. I liked assorting those little figured bits of cotton cloth, for they were scraps of gowns I had seen worn, and they reminded me of the persons who wore them. One fragment, in particular, was like a picture to me. It

was a delicate pink and brown sea-moss pattern, on a white ground, a piece of a dress belonging to my married sister, who was to me bride and angel in one. I always saw her face before me when I unfolded this scrap — a face with an expression truly heavenly in its loveliness."

In 1908 Eliza Calvert Hall gave similar words, though expressed in a more colloquial dialect, to the central character in her novel, *Aunt Jane of Kentucky:* "I've had a heap o' comfort all my life makin' quilts, and now in my old age, I wouldn't take a fortune for 'em.... You see, some folks has albums to put folks' pictures in to remember 'em by, and some folks has a book and writes down the things that happen every day so they won't forgit 'em, but, honey, these quilts is my albums and my di'ries, and whenever the weather's bad and I can't git out to see folks, I jest spread out my quilts and look at 'em and study over 'em, and it's jest like goin' back fifty or sixty years and livin' my life over agin." EDG

97 This quilt is believed to have been made by a member of the Lumm family of Loudoun County, Virginia, and the initials "MEL" are embroidered on the reverse. The traditional pieced "Star of Bethlehem" pattern can be found on a number of quilts with Virginia histories. The DAR Museum owns a similar one from western Virginia.

This quilt is especially appealing because the quilter has carefully selected the color and pattern of her textiles to complement the design. She has used at least ten different printed textiles in a close harmony of color. In the central star she has alternated rows of blue and brown diamonds, and in places where the print contains both colors, she has used the repetition of printed motif to create a secondary design. The pieced pat-

tern has been finely quilted at the count of thirteen to fifteen stitches per inch. The outer border and the area around the large star have been quilted in a running feather-and-vine pattern, while the area around the small stars has been quilted in the shell pattern. GSA

98 This striking album quilt is appliquéd with motifs cut from madder-printed English chintz and arranged in seventy-two small squares and one large square. Almost every square is individually signed in ink. Some are dated between November 1842 and January 31, 1844, and a number have place names, with Philadelphia and Trenton being the most frequently mentioned. The central

square is dedicated to "Aunt Eliza Moore/ Trenton, N.J./ March 4th 1843." Eliza's father signed the quilt in two places and her mother in one. The remaining signatures belong to relatives, members of the Moore, Fish, Howell, and Stryker families, and to friends in the Philadelphia-Trenton region. It is not known whether Eliza Moore was about to be married or was moving away from family and friends. She has not been located in family genealogical records.

The maker, Emma Maria Fish (b. 1825), whose name is signed on the reverse, was in her late teens. She was the daughter of Benjamin Fish and Maria Moore Fish of Trenton and the aunt of quilt "presentor" Emily Augusta Fish, as indicated by the inscription in the first

97

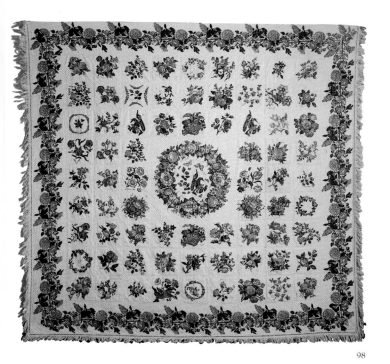

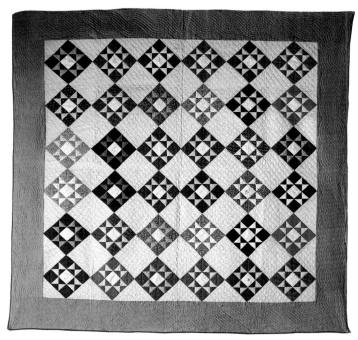

98

99

square at the upper left, "Presented by my niece Emily Augusta." Emily Augusta, born July 12, 1840, was only three years old when she presented the quilt.

Signature or album quilts came into popularity around the 1840's and parallel the contemporary fad of collecting signatures, verses, drawings, and other tokens of remembrance into albums and autograph books. Signing the quilt squares was like signing a card today — the signers were expressing their friendship for the recipient, not identifying their own workmanship. GSA

99 This album or signature quilt came to the Museum with a history of having been made by members of the Lee family in Berks County, Pennsylvania. Each of the thirty-six squares contains a neatly penned "signature" in black ink. Pennsylvania census records for 1850 confirm that the "signers" were

members of several extended families who resided in the neighboring townships of Exeter and Amity. In addition to numerous Lees, the signers also included families that were related by marriage or were close friends. The majority of signatures were those of women, then aged from seventeen to seventy years of age. Most of the men were listed as farmers in the census records. They ranged in age from thirty-four to seventy years of age and owned property evaluated at seven hundred to eight thousand dollars. A number of the signers can be identified as members of the Society of Friends and were affiliated with the Exeter or the Philadelphia Monthly Meeting.

One signature square differs from the others; in the lower center, there is a memorial inscription for "Ellen B. Brimfield/ Aged 77 years." The verse surrounding the signatures denotes her recent death: "Art is long and time is beating Funeral marches/ like muffled

drums are/ fleeting. And our hearts/ tho stout and brave. Still to the Grave." The 1850 Census lists Ellen Brimfield, "age 70," as residing with George and Elizabeth Leonard, whose names also appear on the quilt. She owned property valued at seven thousand dollars, and she was probably Elizabeth's widowed mother. Perhaps vanity caused her to report her age as seventy in 1850, for it was recorded a year later on this quilt as seventy-seven.

Family tradition states that the quilt was made for Elizabeth Moore by Aunt Martha Lee. Curiously, neither name appears on the quilt. If Martha Lee did not make the quilt, it was probably made by one or two other members of the Lee family and not by thirty-six different people. This signature quilt is similar in style to a number that were made in other counties in south-eastern Pennsylvania around the middle of the nineteenth century. GSA

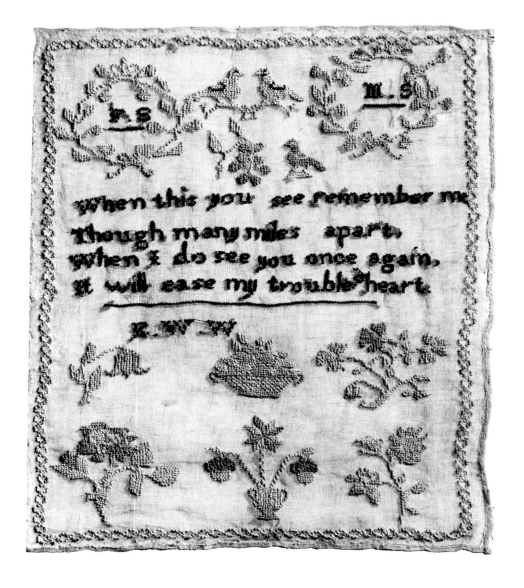

Another Culpeper County girl hoped that her father would not succumb to the lure of the West and glumly observed, "I hope he will not leave Virginia. Mamma and I cannot give up the Old Dominion. Our Culpeper papers are filled with advertisements. Auburn is for sale. It is truly distressing to see many old residences that we have been accustomed to visit set up to the highest bidder." EDG

101 The word "bandbox" first appears in New England records in 1636. In 1755 Dr. Samuel Johnson, in his *Dictionary of the English Language,* defined "bandbox" as "a slight box used for bands and other things of light weight." The earliest bandboxes were lightly constructed of wood and enlivened with paint, but by the nineteenth century cardboard boxes covered in specially printed papers or wallpaper were being manufactured by a number of paper-hanging and bandbox factories. Printed labels pasted inside the box often reveal the boxmaker. Daniel Gladding of New Haven, Connecticut, labeled the box in the background of this picture, while Joseph Freeman of New Bedford, Massachusetts, pasted his label on the lid of the large bandbox in the foreground.

Both men and women found bandboxes useful in carrying personal items such as hats, bonnets, collars, ruffles, gloves, lace, and ribbons. The size and shape of the box depended upon its function. Large bonnet boxes were essential to ladies whose heads were always covered, sometimes with very large creations. Half-round-shaped comb boxes, such as the one illustrated here, were specifically designed to hold the large tortoise-shell combs admired by ladies during the same period that the bandbox was held in esteem. This large comb, carved with the American eagle, was received with a history of ownership by Dolley Madison. The comb box is not original to it. Boxes

100 A number of objects in the DAR Museum, including this small sampler, trace the advance of Americans on the western frontier in the nineteenth century. As early as 1785 John Jay had remarked on the "rage for emigrating to the western country," and by 1817 Morris Birkbeck, a British visitor, would be alarmed that the whole country was "breaking up and moving westward." The use of the verb "breaking up" is significant because the westward migration did sever communal and family ties which had bound families closely together for generations, and if the move could be exhilarating in its challenge, it could also be deeply disturbing in its wrenching dislocation.

Eliza Woodrow, a young Quaker and member of the Crooked Run Meeting in Culpeper County, Virginia, embroidered this sampler in blue and cream silks on muslin as she was preparing to leave Virginia and move to Ohio. The verse, "When this you see remember me/ Though many miles apart,/ When I do see you once again,/ It will ease my troubled heart," was intended for her sister and brother-in-law, Mary and Francis Shinn, whom she was leaving behind and whom she hoped would soon follow her to the West.

The effects of this mobility were disturbing to those left behind as well, as homes were put up for sale and household goods dispersed.

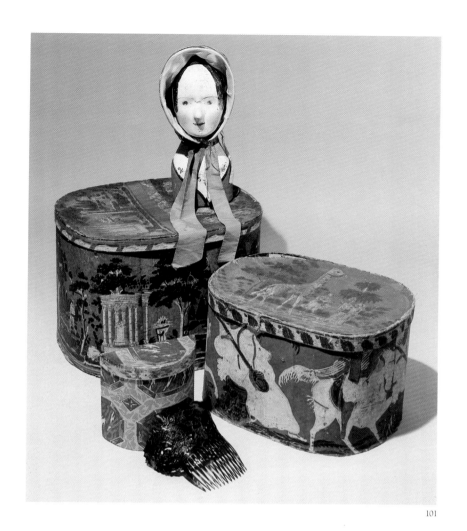

102 Gentlemen were as particular in their appearance as ladies, and expended considerable time and goodly sums to ensure proper toilet articles, genteel hairdressing, and handsome costume. EDG

might be covered with a colorful geometric print as this comb box is, or more elaborate scenes of classical ruins as Daniel Gladding's is, or mythological scenes and exotic animals as portrayed on the bandbox in the foreground. Here, the base with the lute player design and the lid with the giraffe design were not originally together.

By the mid-nineteenth century, the vogue of the bandbox had passed. When Eliza Leslie came to describe "Travelling Boxes" in her 1854 *Miss Leslie's New Receipts for Cooking,* she observed, "As bandboxes are no longer visible among the travelling articles of *ladies,* the normal way of carrying bonnets, caps, muslins, &c. is in small square wooden boxes, covered with black canvas or leather." The arrival of the locomotive would confirm the need for sturdier luggage. SMD

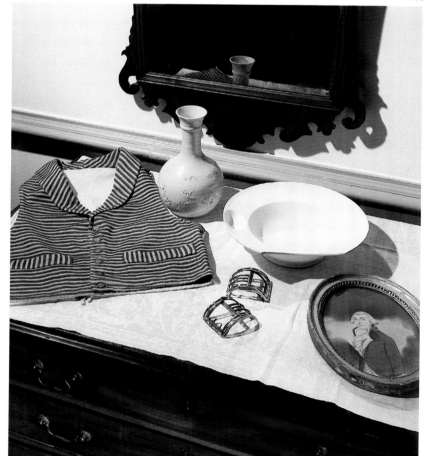

Tangible Comforts

MERICANS living in the cen-
tury between 1750 and 1850 were intrigued with objects, and
their homes reflected this fascination. Many of the tangible com-
forts which were once part of the domestic settings of merchants,
farmers, and artisans have descended to the DAR Museum, where
they reflect a picture of these people, their aspirations, and their
homes.

Permanence was an important concept in the Enlightenment
world of the eighteenth and early nineteenth centuries. Urbane
and practical patrons asked that their furniture be neat and strong
—"made to endure."[1] Solid woods, stretchers, through tenons,
and brackets were strengthening devices for which consumers
were willing to pay extra money, as they assured durability. Indeed,
the original expense of an object was weighed against the promise
of immutability. "If well kept," Gouverneur Morris assured George
Washington concerning some porcelain figures he was sending
him in 1790, "they will always be worth the cost."[2] The Enlighten-
ment paterfamilias regarded substantial household possessions as
both serviceable in his lifetime and suitable for future generations,
thus the directive to the craftsman that his work be strong and
solid. Because of the longevity of these robust objects, many early
American homes displayed a mixture of furniture styles, with a
back parlor frequently displaying "An old desk," or a back bed-
chamber "an old case of drawers." The conservative taste of Ameri-
can consumers often meant that the old and the new blended

103 Tin-glazed earthenware plate,
1737–1750, Bristol or Liverpool,
England; silver cann, c. 1765, pos-
sibly Boston; letter from Edward
Jeffrey to Ichabod Stodard ordering
cheese, cider, and towcloth, Sep-
tember 26, 1788, probably
Connecticut.

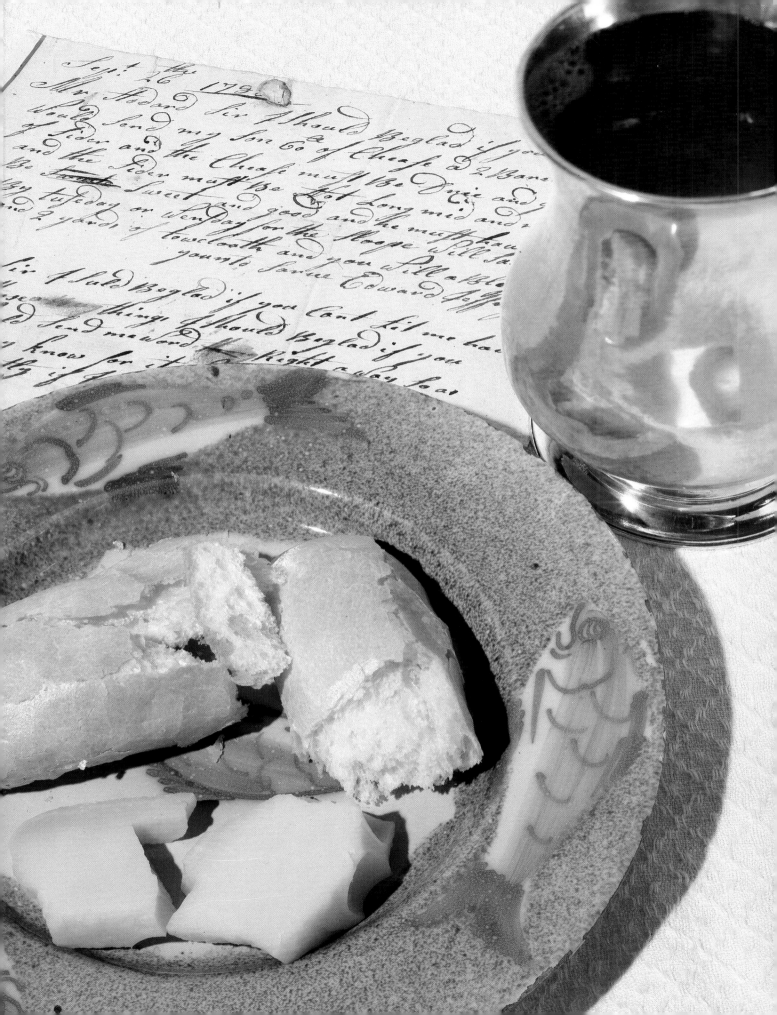

easily together. Among the household furnishings of Edward Everett Hale in 1893 were the "stately, solid and expensive" chairs, tables, and sideboards of his early nineteenth-century home which he found "as good now as they were then."[3] Paintings of early American interiors reveal that bedchambers were frequently lined with chairs purchased by previous generations. Phebe Steiner Reich (pl. 48) had "5 old Chairs" in her Frederick, Maryland, bedchamber in 1842,[4] and Emily Barnes recalled the "old-fashioned mahogany chairs" with needleworked seats which were in her aunt's Walpole, New Hampshire, chamber in the first half of the nineteenth century.[5] The generational aspect of tangible comforts meant that the notable housewife might derive emotional satisfaction in bequeathing her needlework to descendants. "To my son Gen. George Washington," willed Mary Washington in 1788, "my best bed, bedstead, and Virginia cloth curtains (the same that stands in my best room) my quilted blue and white quilt."[6] The 1782 will of John Morris of Southwark, Pennsylvania, bequeathed to his grandson "8 Mahogany Chairs the Seats of which were worked by his Mother."[7]

American interiors mirrored the conservative and measured taste of the well-bred provincial of British background. Americans were, in the words of Henry Wadsworth Longfellow, "English under another sky."[8] It was a close and suffusive alliance imparted from infancy. Lucy Larcom recalled that the spirit of her hometown, Beverly, Massachusetts,

> was that of most of our Massachusetts coast-towns. They were transplanted shoots of Old-England. And it was the voice of a mother-country more ancient than their own, that little children heard crooning across the sea in their cradle-hymns and nursery songs.[9]

Regardless of their political allegiance, Americans sustained their emotional and aesthetic dependence on England throughout the eighteenth and early nineteenth centuries. American lifestyles, architecture, interiors, furnishings, toilet, and clothing bespoke the mother country. Detailing her fashionable life in federal Newburyport, Massachusetts, in the opening years of the nineteenth century, Sarah Anna Emery wrote:

> Before the Revolution, all our idea of elegance had been derived from England, and, at this period, the country had not thrown off this allegiance. English style and mode of life were affected by our gentry, in their spacious mansions, well-stocked wine cellars, heavy family coaches, superb horses, and liveried servants.[10]

A knowledge of the latest London fashion was gained several ways. The constant business contacts between Britain and America

104 An ever-increasing number of Americans enjoyed the amenities of tea during the eighteenth century. Already, by 1740, Joseph Bennett might write from Boston, "the ladies here visit, drink tea and indulge every little piece of gentility to the height of the mode and neglect the affairs of their families with as good grace as the finest ladies in London." In many homes, however, tea drinking was at the core of family life. Moreau de St. Méry reported from Philadelphia in 1795 that "the whole family is united in tea, to which friends, acquaintances and even strangers are invited."

This eighteenth-century emphasis on sociability meant that parlors were lined with furniture for active social interchange — tea and card tables. The one exception to bare table tops in the eighteenth century home was the tea table or china table which sometimes held the tea equipage. This might include a teapot and a tea canister such as these English salt-glaze examples. Anthony Joseph Jr. advertised "Tea shells," amongst other spoons, probably very similar to this tea-filled example, in the *Pennsylvania Packet* in 1790. The small round tea cups were often referred to as "dishes of tea." As late as 1833 an Englishman, James Boardman, reported that in America "We found chests of drawers still called bureau...
sofas sittee, cups of tea dishes of tea; and a number of other things designated by names long out of fashion in genteel society in England."

That teaspoons were often displayed with the tea china is suggested by a number of contemporary newspaper advertisements for stolen silver. Taken from a Philadelphia home in 1780, for instance, were "Two Tea Spoons (Silver) almost new...with a full set of blue and white China and a large Japan'd Waiter." EDG

facilitated a knowledge of custom and mode through correspondence as well as through the importation of goods. Further, personal contacts were of inestimable importance in the dissemination of fashion and goods. Kinship and friendship bonds surmounted geographic hurdles and fashionable advice traveled in letters westward across the Atlantic and then in radiating networks between friends in the New World. Eighteenth-century letters reveal that consumers, both men and women, would often bypass nearby cities and market towns in favor of a distant, but trusted and efficacious, contact. Esther Burr wrote from Newark, New Jersey, in November 1755 to her Boston friend Sarah Prince, asking for some practical information and a fashion update:

> I want to know how a body may have some sorts of Household stuff — What is the price of a Mehogane [mahogany] Case of Drawers...in Boston, and also a Bulow [bureau] Table and Tea Table and plain Chairs with Leather bottoms and a Couch covered with stamped Camblet or China, all of that wood.

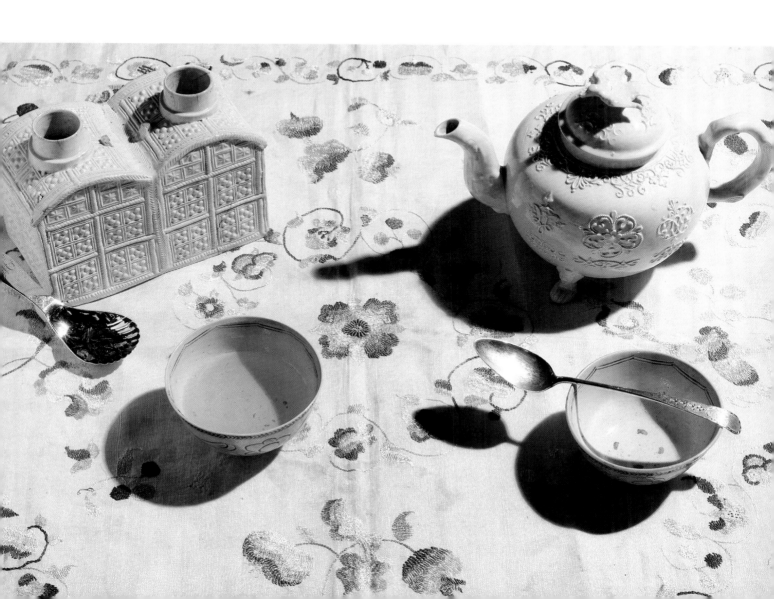

I should also be glad to know what is most fashionable
—wheather to have looking Glasses or sconcers [sconces]
for a Paylor [parlor], and what for a Chamber.[11]

Esther had recently been in neighboring New York City "driving about York Streets like Mad," and Philadelphia was close by, but she had an implicit faith in the judgment and taste of her Boston friend.[12] Perhaps, too, being a native of Northampton, Massachusetts, she preferred the Boston regional expression in furniture to that of New York or Philadelphia. The transmission of style through this type of personal correspondence was frequent and effective.

Publications — design books, newspapers, and ultimately journals — enlightened not only the American craftsman but his clientele as well. Travel at home and abroad could be instructive of fashion; and the continuous arrival of immigrant craftsmen, "lately from London," brought both English training and English templates to American towns. Finally, the openness of the early American community meant that nothing escaped the scrutiny of the curious. Neighborliness was requisite, and friends were almost as familiar with the possessions of associates as with their own. Emulation was a powerful stimulus. Benjamin Franklin commented on his advancement from a "two penny earthen porringer, with a pewter spoon," to "a China bowl, with a spoon of silver bought for me without my knowledge by my wife...for which she had no other excuse or apology to make, but that she thought *her* husband deserv'd a silver spoon and China bowl as well as any of his neighbors."[13] The new shape of a chair back or swag of a curtain, the new cut of a skirt or breadth of a bonnet left the stricken admirer the option to commission or "bespeak" a similar piece locally or to order it from abroad. In 1743 John Smibert, an artist working in Boston, ordered a silver teapot through his London agent, and several months later he acknowledged its receipt and appended:

> Sir: — I hope youl excuse the trouble I now give you, occasioned by the Tea Pott you sent which is admired by all the Ladies and so much that in behalf of one of them (who I assure you has great merit) I Must beg the favour of you to send such another one of the same fashion and size only the top to have a neat hinge.[14]

Yet for all these English influences, an American style in the household decorative arts did emerge. It had an English nucleus but, with native speech patterns, it shared a rural lisp. In general, American interiors and American furniture were simpler, plainer than their more heavily ornamented British counterparts. General Lafayette could see that in America "Everything recalls English customs, except that there is more simplicity in the homes than in England."[15]

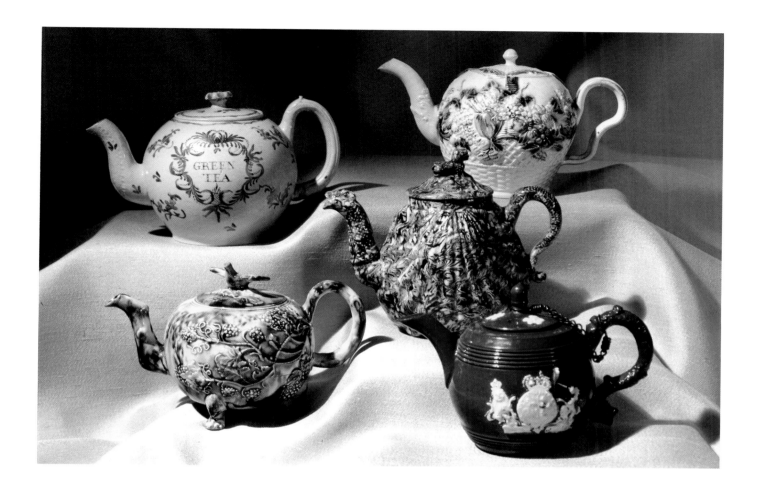

105 China tea was available in England and in colonial America in many grades and at a variety of prices. Green teas included Hyson, Hyson Skin, Imperial, and Gun Powder, and black teas were sold under names like Bohea, Souchong or Congou. All China teas came from the same plant, "thea Chinensis," and varied only in the drying process. Grade designations were given to teas of varying qualities and they were priced accordingly.

The original interest in tea was for its curative properties. As early as the mid-seventeeth century, the English had learned from the Chinese that tea "openeth Obstructions, cleareth the Sight, purifieth Defects of the Bladder and Kidneys, driveth away Pain of the Colic and safely purgeth the Gall." By the mid-eighteenth century tea was more commonly used as a social beverage.

As the serving of tea in the home grew in popularity, the need for tea wares also increased. English potters were quick to meet the demand for elegant, finely potted cups, saucers, teapots, and other tea equipage. The demand coincided with a period of tremendous technological development in the ceramic industry and rapidly changing fashions in English society. As a result, a wide variety of tea wares became available, and these varied considerably, in body type, method of glazing, and application of decoration. The teapot, being one of the largest and the most intricate objects in the tea service, lent itself to unusual forms and varied decoration. A 1776 advertisement from a Philadelphia newspaper listed some of the different kinds of English-made teapots for sale to the American consumer: "Egyptian, Etruscan,

embossed red China, agate, green, black, colliflower, white, and blue and white stone, enamelled, striped, fluted, pierced and plain Queens' ware teapots."

Illustrated here are five of a number of different types of teapots which would have been available to the consumer in the mid-eighteenth century. The body types include white stoneware, cream-colored earthenware, redware, and agate or veined ware; the glazing ranges from salt-glaze to colored and clear lead-glazes, and the decoration derives from modeling, applied sprigging, or painted enameling. Several incorporate a number of these decorative techniques. All have the low, full-bodied or bulbous mid-eighteenth-century profile and display a diverse combination of Oriental and western or rococo motifs. GSA

106 In the County of Staffordshire, England, during the 1740's and 1750's, several potteries produced tea wares molded from red earthenware and covered with a glossy black glaze. Somewhat later examples, made in the Jackfield area of Shropshire, became known as "Jackfield ware." Earlier forms, such as this teapot, often resembled salt-glazed stonewares which were being made at the same time in numerous Staffordshire potteries. They are characterized by bulbous bodies, crabstock handles, lion feet, and applied "sprig" or molded decoration.

Estate inventories and merchants advertisements show that "black" teapots were in fairly common use in colonial America, and were frequently used with tea wares of other colors. Family history states that this teapot was owned by Mary and John Hoffman of Rotterdam. By 1790, the couple had settled in Pennsylvania, and this heirloom descended in the family. GSA

107 The method of making unglazed red stoneware in England is credited to two Dutch immigrants, John Phillip and David Elers. In 1684 they were granted a patent for their pottery, which was modeled after the Chinese I-Hsing wares imported by the British East India Company. The I-Hsing red porcelain continued to have a strong influence on mid-eighteenth-century pottery. A number of Staffordshire potteries produced objects with a red, non-porous, non-glazed body. Some shapes and many of the molded or stamped decorative motifs were copied from the Chinese wares. In this example, the molded-griffin spout echoes a Chinese prototype and the method of applying the stamped ornament shows a Chinese technique in which a mold was pressed into a previously applied pad of clay. The bottom is impressed with a pseudo-Chinese mark. "Red China" was imported into colonial and post-colonial America, where it was used in limited quantity as tea and other beverage wares. Its durable, non-porous composition made it ideally suited to use for hot liquids. GSA

110

108 These two porcelain teapots, which are very similar in shape and decoration, have vastly different origins. The one on the right was made at the Lowestoft Porcelain Factory on the east coast of England. The soft-paste porcelain body is carefully handpainted with floral sprigs. Although the Lowestoft factory employed a number of accomplished "china painters," the style of painting and the characteristic lily with long stamen indicates that this teapot is the work of the so-called Tulip Painter who was active from about 1774 until at least 1780.

The teapot on the left, which is part of a tea and coffee service, has a hard-paste or true porcelain body and was made in China. The style of painting, however, suggests that it was decorated in the West. It was not uncommon for Chinese porcelain to be imported "in the white" and sold at reduced prices. Some of these whitewares, particularly tea wares and presentation pieces, were decorated by Continental and English painters, most of them working independently of the factories. A number of these painters were located in the London region. The floral and insect decoration on this service may be the work of James Giles, who advertised as a "China and enamel painter" between 1754 and 1770.

Chinese porcelain decorated in the West is just one example of the cultural crosscurrents in this China Trade. Samples of English or Continental porcelain were sent to China to be exactingly reproduced in both form and decoration. A carefully worded merchandise order placed by the Dutch East India Company around 1778 requested that the china not be decorated with Chinese motifs but "with the small flowers in the taste of Lowestoft ware." The similarity between English, Chinese, and Anglo-Chinese wares made it possible to combine pieces of varying origins in a harmonious way. GSA

The American style was a response to native conditions. The proverbial lack of servants in a country where opportunity was ecumenical, and the neglect of those domestics who did serve dictated a solid, vigorous style free of "superfluous carving," with "no work that will harbor dust."[16] Erratic temperature changes required a solid form "quite plain without any finery [veneering] or inlaid work" which might buckle and crack.[17] In ordering girandoles and a pair of pier glasses from England in 1771, Charles Carroll of Carrollton stipulated that the carving "be of a solid kind, it has been found by experience that slight carving will neither endure the extremes of heat or cold nor the rough treatment of negro servants."[18] Labor historians have also demonstrated that the apprenticeship system simply unraveled and could not be enforced in America in the face of a chronic labor shortage and an open frontier. Perhaps, it is possible to find in this dual-pronged labor problem — the shortage and neglect of servants in the home, and the breakdown of apprenticeship in the shop — some of the reasons for the plain, simple outlines of American furniture. Undoubtedly, the political aversion to ostentation was pragmatic as well. The resultant style was one described as "elegant simplicity" by some,[19] "elegantly plain" by others.[20]

Our vision had long been realist. Thomas Hooker, perched on the edge of an awesome New England wilderness in 1648, explained his use of a prosaic, unpretentious style of writing:

109 In 1776 Joseph Stansbury advertised that his shop on 2nd Street in Philadelphia had on hand a "large and elegant Stock of China, Glass and Earthen Wares," including "colliflower" teapots, sugar dishes and bowls. Stansbury's merchandise must have included cauliflower-shape wares similar to those illustrated here. Earthen-bodied beverage and table wares in the form of fruits and vegetables, such as melons, pineapples, cabbages, and cauliflowers were made at several English potteries in Staffordshire, Yorkshire, and Derbyshire between 1760 and 1790.

The idea of producing table and tea wares in natural forms had originated at the Meissen porcelain factory and had been translated by the British into a less expensive earthenware form. The decoration, too, was simpler; instead of enamel overglaze painting, the molded earthenware was partially covered with a colored lead glaze. The cauliflower form was exactly suited to this technique; the fleshy part of the body was left plain, while the leafy areas were covered in green glaze. This semi-transparent deep green glaze was developed from refined copper by Josiah Wedgwood, but the variations in green glaze seen on these pieces indicate that they are the products of several factories in the Staffordshire and Yorkshire regions. GSA

That the discourse comes forth in such a homely dresse and course habit, the Reader must be desired to consider, It comes *out of the wildernesse,* where curiosity is not studied. Planters if they can provide cloth to go warm, they leave the cutts and lace to those that study to go fine.... plainesse and perspecuity, both for matter and manner of expression, are the things, that I have conscientiously indeavoured in the whole debate: for I have ever thought writings that come abroad, they are not to dazle, but direct the apprehension of the meanest, and I have accounted it the chiefest part of judicious learning, to make a hard point easy and familiar in explication.[21]

Seventeenth- and eighteenth-century Americans weighed the success of a house, a chair, a remark by its appropriateness, for everything was viewed in the measure it related to its situation. Thus a style appropriate in England, when measured against the American scene, would require adaptations in design, material, and ornament. And this balanced measure of all things also meant that some goods were appropriate for the town house while others befit the country house. In 1754 the *Boston Evening Post* carried an advertisement for "large Sconce & pier Glasses" for the local clientele and "small Looking-Glasses of different Sizes by the Dozen, suitable for the Country."[22] Appropriateness, measure, and relationship were the dictates of furnishings and furnisher alike.

The early American studied himself in the plural — in his relation to others — and his insistence on the neat, genteel stance of his furniture and an agreeable, polite, personal posture underscores this social outlook. In the democratic nineteenth century the Enlightenment ideals of permanence, stability, balance, relationship, and order would erode. "In the newest fashion" would be the new measure of taste as a runaway cultivation of novelty grasped the country. The individual, *sui generis,* became the hero, bravura his style. It now seemed that what had been given to the few in the eighteenth century — mahogany furniture, colorful textiles, lustrous ceramics, lively wallpapers, handsome portraits, delicate meats, and sweetened tea — were now the God-given rights of the many. The Marquis de Chastellux remonstrated, "Such is the general equality of condition that those things which everywhere else would be regarded as luxuries are here considered necessities. So it is that the salary of a workingman must not only provide subsistence for his family, but also comfortable furniture for the home, tea and coffee for his wife, and a silk dress to put on every time she goes out."[23] The increasing demand for goods and the scramble for riches led the craftsman to the realization that the most expedient route to wealth was to sell more at a lower price.

110 A few little girls were lucky enough to own an English tea set in the eighteenth century. "Several compleat Tea-table Sets of Children's cream-coloured Toys," were advertised in the *Boston News-Letter* in 1771. Little Peggy Shippen of Philadelphia must have been filled with anticipation after her uncle wrote that he had sent, "a compleat tea-apparatus for her Baby [doll]. Her Doll may now invite her Cousins Doll to tea, & parade her tea-table in form."

By the early years of the nineteenth century, a particularly fortunate child might own a matched tea set of Chinese export porcelain, such as the example illustrated here, which belonged to Sophia Kendall, who was born in Weston, Massachusetts, in 1788. Her juvenile tea service boasts a teapot, cream pots, tea canister, sugar dish, spoon tray, tea cups, coffee cups and saucers, each with a pseudo-armorial device. Most children did not own china tea services, but inexpensive ceramic or pewter sets provided tea equipage for many little role-players in the nineteenth century. Stephen Walkley recalled that in the early 1830's in Southington, Connecticut, his sister Mary "would make tea sets of the acorns and their cups, using herdsgrass stalks for handles and spouts." Four-year-old Stephen was delighted with them. EDG

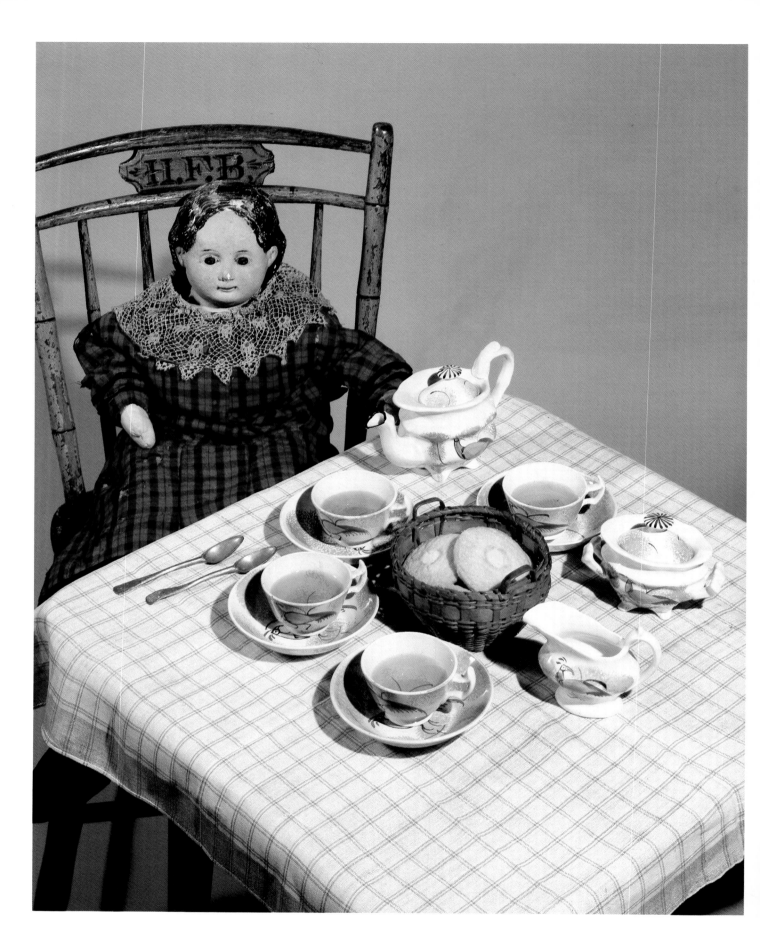

111 The nineteenth century witnessed the increased production and availability of children's toys. European potters had manufactured small tea sets from the sixteenth century in response to special commissions. By the nineteenth century, however, sets were being manufactured in great quantities in response to the ever-increasing demand for children's playthings. Though the shape and style of children's tea wares mirrored full-size sets, the decoration had juvenile appeal.

A colorful spatterware set in the so-called peafowl pattern is illustrated here. The availability of dolls also increased in the nineteenth century as new materials such as papier-mâché lowered the cost to both producer and consumer. Ludwig Greiner patented an American papier-mâché doll head in 1858. Greiner dolls, like the one illustrated here, have slightly sallow complexions, pug noses, double chins and complacent expressions. The windsor chair with its original yellow paint belonged to Hannah Fox Budd (1791–1871) of Burlington County, New Jersey, as the painted initials attest. SMD

112 Cream pots were essential components of a well-equipped tea table. The variety of form found in cream pots is suggested by the diverse names of the period — cream pot, cream jug, cream pail, cream urn, and cream ewer. Other necessary accouterments of the tea service were the teapot, tea canister, sugar dish, slop bowl, sugar tongs, teaspoons, and cups and saucers. Materials for these ranged widely from silver to pewter, from porcelain to glass. Many of these accessories were typically owned by both high- and low-income families in urban and rural areas. CMD

Furniture, ceramics, silver, and glass were made in ever-larger sets. Whereas eighteenth-century newspapers had advertised "a few sets" of tea wares of seating furniture, the nineteenth century promised to fill all orders. Eighteenth-century regularity was replaced with nineteenth-century abundance.

As listeners to the human heart, the history of these objects is of interest to us today. It might not be significant or relevant that, in the words of Dean A. Fales Jr., "an object is bought with the fact known that it was owned by the Zilch family of Buggywhip, a member of which had known the maid of the fourth mistress of Eagle Flyright, our fourth President." [24] But an object's personal history can help to delineate the home of an earlier period and its inhabitants. Resolute, steadfast, pragmatic, manipulative, our ancestors forged out a new style of life, and that spirit can still be read in the legacy of heirlooms — tangible comforts — which they bequeathed to posterity.

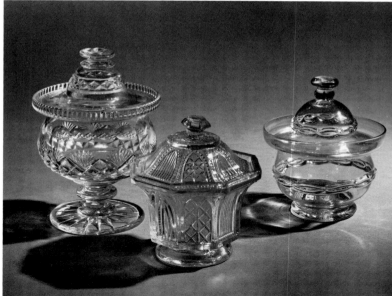

113

113 This group of four covered sugar dishes clearly illustrates the progression from early to late neoclassicism. Throughout both periods geometric forms were decorated with ornament derived from antiquity. At the extreme left and right are urn-shape covered sugar dishes in the earlier style by Joseph Richardson Jr. and Christian Wiltberger respectively. Richardson relied on beading and bright-cut engraving for the decoration of his sugar dish, while Wiltberger concentrated on outline. The robust gadrooned bodies of the sugar bowls by John McMullin, in the foreground, and Robert Sheppard and William Boyd, at the back, exemplify the heavier profiles of later classicism. Indicative of this period are the heavily ornamented bands of machine-milled silver. The ample horizontal emphases of these two pieces contrast with the slender verticality of the earlier sugar dishes. CMD

114 Efforts to produce refined glass tablewares in America before 1800 were ill-fated and short-lived. Henry William Stiegel and John Frederick Amelung received critical acclaim for their adaptations of English and Continental glass manufacturing methods and decoration, but both ended in bankruptcy. Several other glasshouses, particularly those located in the region extending from New England south to New Jersey, achieved limited success. Without protective tariffs, it was impossible for American glasshouses to produce wares which were competitive with inexpensive, high-style European imports.

In the early decades of the nineteenth century, with an expanded market fostered by the westward movement, the disruption of European trade, and government intervention in the form of trade restrictions, a number of glass factories were established, especially in New England and the Midwest. One of the earliest was Bakewell and Page of Pittsburgh. Established by 1808, Thomas Bakewell made a variety of fancy table and beverage wares with cut and engraved decoration, in addition to more utilitarian wares from free-blown or mold-blown glass. The blown sugar dish cut in the strawberry diamond and fan pattern (left) is attributed to this factory.

Thomas Caines, working in Boston, is credited with establishing lead glass manufacturing in the East. His production of fine glassware filled a need created by the interruption of trade with Britain due to the War of 1812. Caines produced free-blown, cut, and mold-blown glass. Objects with applied chain borders, as the sugar dish illustrated here (right), are usually attributed to this glasshouse.

In 1818 Deming Jarves founded the New England Glass Company, where he manufactured table and other wares from clear and colored, cut, blown and mold-blown glass. By the 1820's, working under the firm name of Boston and Sandwich Glass Company, he had perfected pressing machines for patterning glass. Designs resembling hand-cut glass could be duplicated rapidly on an assembly-line basis (center). Such technological innovations contributed to lower costs and expanded use of glassware in the American household. Now, in addition to drinking vessels, a myriad of glass tablewares became both available and affordable. GSA

115 The animated mahogany veneer of this card table would have come to life in a candlelit drawing room. Both the plain surfaces and the spiral-turned legs with "balloon" feet are characteristic of New York cabinetwork in the early nineteenth century. The top revolves on a center pivot to reveal a compartment lined with green baize on which is nailed the label of John Budd, a New York cabinetmaker. A very similar example in the Henry Francis du Pont Winterthur Museum is labeled by the celebrated New York cabinetmaker Charles Honoré Lannuier, and also turns on a center pivot to reveal a hollow compartment for the storage of card game accessories.

Indices of the social atmosphere of early homes, card tables were requisite in fashionable interiors. They were so common in New York homes in 1781, that a visiting Philadelphia miss, Rebecca Franks, would write home to her sister with some prejudice, "Few New York ladies know how to entertain company in their own houses unless they introduce the card tables.... I will do our ladies, that is the Philadelphians, the justice to say they have more cleverness in the turn of an eye than the N[ew] Y[ork] girls have in their whole composition."

Card tables, which were drawn out into the room for use, were stored against the wall. Brass casters, which were an integral part of the design of this table, would have enhanced its portability. Often purchased in pairs, card tables further provide a picture of the federal home, with its insistence on symmetry, balance, and accord. EDG

116 John Budd's engraved 1817 label from the card table illustrated in plate 115 promised, "Orders from southern ports immediately attended to." In the early years of the nineteenth century New York

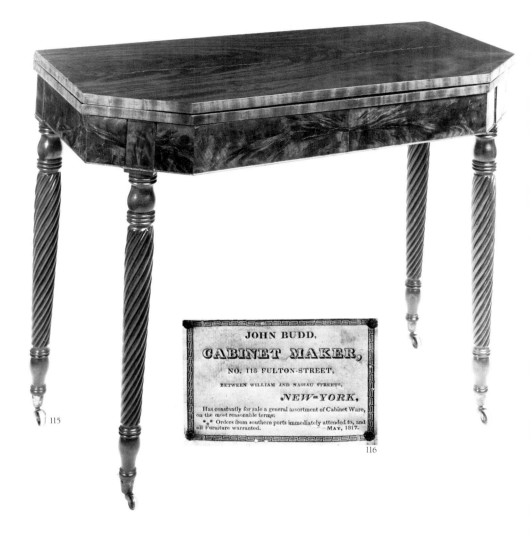

City was recognized as the stylistic center of American cabinetwork by North and South alike, and much New York furniture was shipped south. It offered stiff competition for local cabinetmakers.

Lewis Bond, an obliging North Carolina cabinetmaker, advertised that he could provide his clientele with furniture "in the New-York or English Style," referring to the French accent of Manhattan cabinetwork. And an ingenious cabinetmaker, John W. Nelson, advertised in the New Bern *Carolina Sentinel* in May 1830 that "he had just returned from New York, where he purchased a supply of the best Mahogany, and a variety of other articles, Among Wich Are: Carved

bronzed Sideboard Columns, Carved Sideboard Feet and Table Legs, Glass and Brass Sideboard & Bureau Knobs, Iron and brass Sideboard, Bureau and Portable Desk Locks, Together with a variety of other Mountings." He was now prepared to make furniture in the fashionable New York style, and at the shortest notice.

With the opening of the Erie Canal in 1825, the West could also be supplied with New York workmanship. John Budd's promise that he "Has constantly for sale a general assortment of Cabinet Ware," refers to the growing practice of ready-made goods on display to the retail market at warehouse locations. EDG

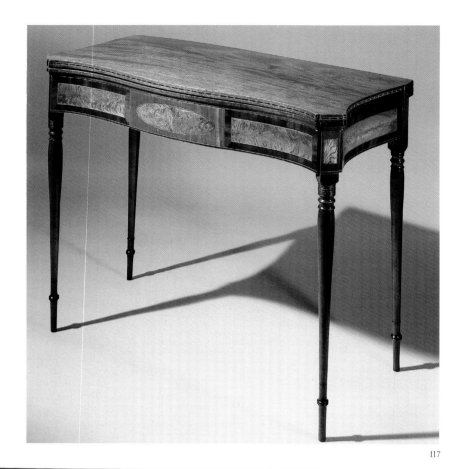

117 This delicate card table was probably made in the Boston region, as several features are found on pieces made in that city, including the three-part facade of the apron, which is composed of matching veneers. The swelled shaft of the leg and the high terminal-ring turning also suggest a Boston-area origin. During the eighteenth and early nineteenth centuries a large number of card tables were made for use in American homes. In many households, pairs of card tables were used as much for creating symmetry in the room arrangement as for card playing. CMD

118 This card table was made in the Philadelphia-Baltimore region. Although certain construction features relate it to Philadelphia cabinetwork, the running inlay of pointed ovals and diamonds is found on a large body of chiefly southern pieces. By the opening years of the nineteenth century, trade between these cities had increased, travel was easier, and cabinetmakers and other craftsmen could move from one area to another with ease. CMD

119 By the early years of the eighteenth century a dressing table and its companion highchest were considered desirable for a fashionable bedchamber. Throughout the eighteenth century the dressing table would have been covered with a protective cloth of homespun, damask, diaper, calico, or dimity. A looking glass would have been suspended above the table or placed upon it. Sarah Anna Emery of Newburyport, Massachusetts, recalled her grandmother's bedchamber with its "handsome dressing table, a fine specimen of the sculptured frames of the period, with several drawers and compartments. Over this hung a glass."

This dressing table came to the Museum through a Virginia family and could have been made in that

117

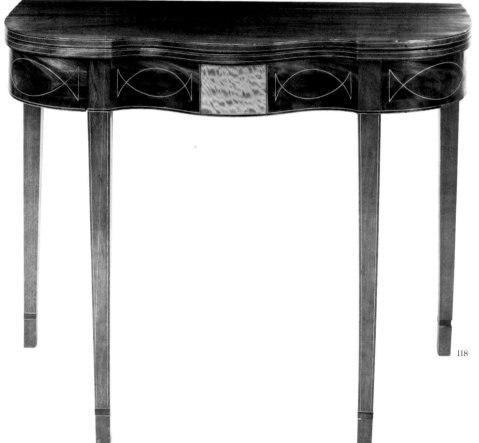

118

state. The cabriole legs of round section with blunt pad feet and the cyma-curved skirts compare closely with a walnut desk-on-frame now in the Henry Francis du Pont Winterthur Museum which is believed to be of Virginia or North Carolina origin. The cabinetmaker has carefully selected the burl walnut for his drawer fronts to contrast with the quieter walnut graining of the body. The brasses are not original and would have offended the eighteenth-century eye in being disproportionately large. EDG

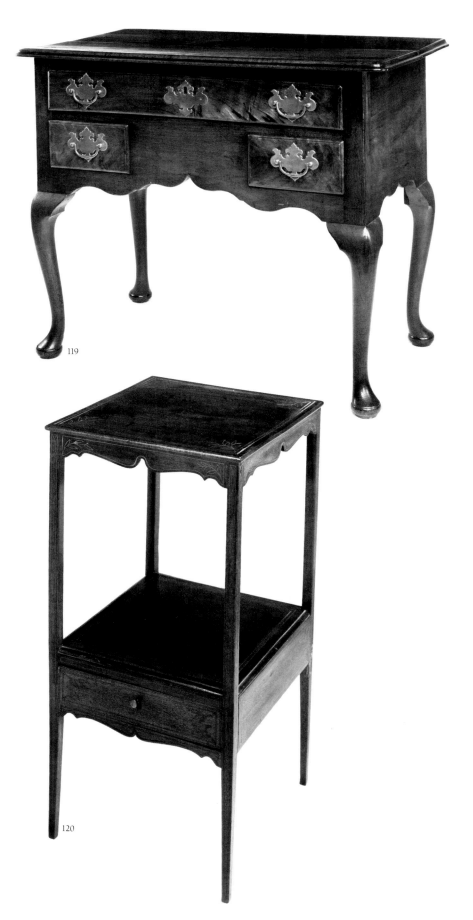

119

120 By 1800 a washstand, with a bottle and basin, had become a characteristic piece of bedchamber furniture. In Maria Trumbull's New York bedchamber in 1800 were "a large clever carpet, a bed with curtains (and very nice sheets), a sofa, some green chairs — a table, a wash stand, a large looking glass — and a picture." This delicate example would date from that period. The twisted brass wire stringing is unusual and could be a later addition. The table was received with a history of having been purchased in Wakefield, Virginia, in the nineteenth century.

The combination of woods — mahogany, white pine and tulip — are of little aid in discovering the origin of the washstand, for during the Federal period, quantities of white pine were shipped from northern ports for use by southern cabinetmakers. In addition, great quantities of furniture were sent to Baltimore, Virginia, the Carolinas, and Georgia from New England ports as well as New York and Philadelphia. The volume of this venture cargo is referred to in a letter Captain Elias Grant wrote from Richmond in April, 1803, to Elijah and Jacob Sanderson, Salem cabinetmakers and merchants: "the goods are not sold as yet.... the Reason they don't sell quick their is Ben a vessel here from New York with firniture & sold it very lo." EDG

120

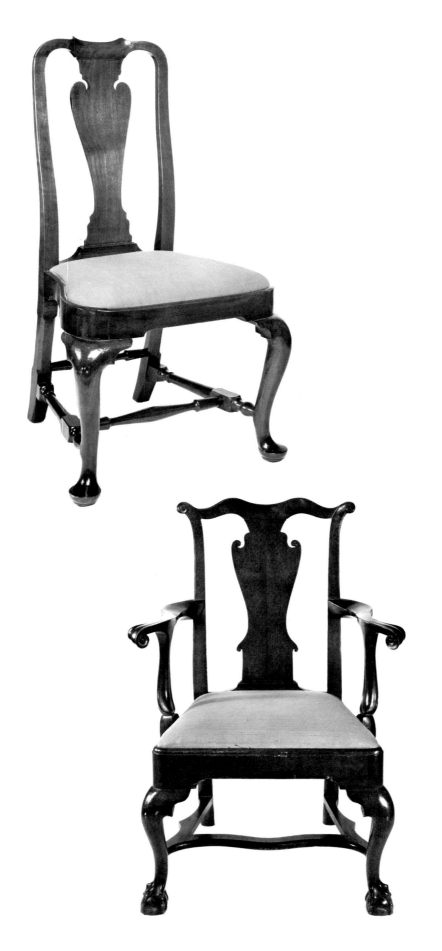

121 This walnut side chair was
probably made in the Boston
region around 1757, and relates to
other Massachusetts Queen Anne
examples. Two chisel notches in
the form of the Roman numeral II
inside the front seat rail identify it
as the second in a set of indeter-
minate number. This chair was
given to the Museum with the
information that it was "one of sev-
eral originally owned by Elizabeth
Lord Eliot who was married in Bos-
ton in 1760." In fact, Elizabeth Lord
of Lyme, Connecticut, was married,
probably in Connecticut, to Jared
Eliot, a Killingworth farmer in 1760.
However, Boston records do dis-
close his previous short-lived mar-
riage; "Mr. Jared Eliot of Killings-
worth & Eliza Walker Mar. 10,
1757." Perhaps this ill-fated Boston
bride, who lived only a short time
thereafter, brought the set of Mas-
sachusetts chairs to her new home
in Connecticut. Her successor,
Elizabeth Lord Eliot, lived to enjoy
them. EDG

122 This walnut armchair was
probably made in the greater Phila-
delphia region and displays an
interesting combination of Queen
Anne and Chippendale features.
The solid splat, serpentine arms
with scroll knuckle terminals,
incurvate arm supports, and ser-
pentine stretchers are all attributes
of Philadelphia craftsmanship in
the Queen Anne period. The
bowed, eared crest rail, squared
seat, and claw-and-ball feet deter-
mine that the chair was made after
the introduction of these
Chippendale-style elements. Per-
haps this chair was the work of a
provincial cabinetmaker who,
although knowledgeable of certain
Philadelphia design elements, was
not able to combine them in a
sophisticated way. Pine braces
encircling the inside seat frame

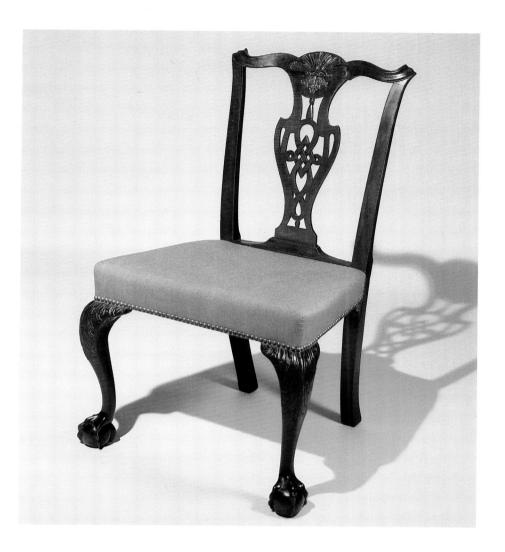

suggest that the chair was originally a "convenience chair" and was fitted with a potty. EDG

123 This handsome example of Massachusetts craftsmanship descended in the Fessenden family of Lexington, Massachusetts. According to tradition, the side chair was given to Nathan Fessenden by John Hancock, following British damage to the Fessenden family property in the Battle of Lexington. Nathan Fessenden, who fought in Captain John Parker's company of minute men, entered a claim for loss of property in this battle amounting to £ 66/10.

One of the most fascinating aspects of eighteenth-century American furniture is its regional expression. Although the basic design of this chair is derived from English precedent, the cabinetmaker has modeled a piece that answers distinct local preferences. The choice of the diamond, figure eight, and tassel splat, the character of the carving, the precise, thin skirt, the shaped rear legs, the sharp knees of the front cabriole legs, and the raked talons of the claw-and-ball feet tell us that the chair is American and, further, that it is Massachusetts. The cabinetmaker has used choice mahogany and curly mahogany for the visible parts of the chair, while local maple and white pine are the secondary woods.

In America at the time this chair was made, a client would bespeak or commission a piece of furniture. The chair would be the product of client preferences and craftsman skills. The original owner of this chair would have paid extra for every fine detail, including the choice of mahogany, all the carving, the upholstered seat, and the brass nailing. A virtually identical chair is in the Olivia Dann Collection at the Yale University Art Gallery.

Throughout the eighteenth century chairs were often ordered in multiples of six and were kept against the walls of a room when not in use. Thomas Rodney wrote to his wife Betsey from Philadelphia on March 17, 1772, "[I] hope to have Everything in Order, to Receive you, by the first of Aprill—I have bespoke Some furniture viz. 1 Dining Table; 1 Brakefast Table; Two bedsteads; one high & one Low; 6 Chairs—and 6 winsor Chairs." EDG

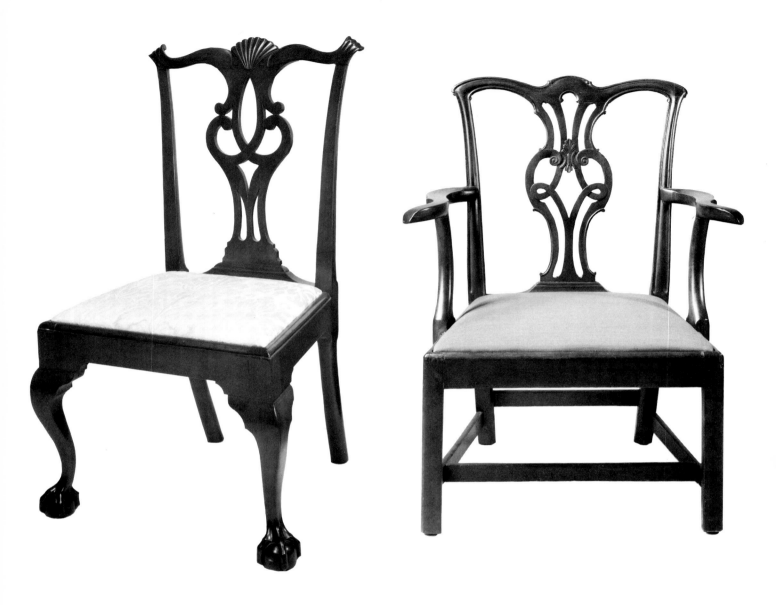

124 This side chair has been attributed to Eliphalet Chapin, a cabinetmaker in East Windsor, Connecticut, on the basis of several stylistic features. The overall design of the back, the distinctive squared claw-and-ball feet, and the profile of the cabriole legs all relate to documented examples of Chapin's craftsmanship. Before he worked in East Windsor, Chapin had served a four-year apprenticeship in Philadelphia, and the four quarter-round corner blocks inside the seat frame and the through-tenon joint which secures the side rails and the back legs are Philadelphia structural elements and atypical of central Connecticut. The chair is marked number "V" of a set which once belonged to Hope Mosely Hale of Glastonbury, a Connecticut River town near East Windsor. The chair was given to the Museum by her great-great-granddaughter. CMD

125 This armchair may have been part of the furnishings at the Governor's Palace in Williamsburg and is impressed "VIRGᴬ" on the rear seat rail. The colony provided some standing furniture for use by the governor while in residence, and it is possible that these pieces were marked to differentiate between colony-owned and governor-owned possessions. A number of similar chairs have documented histories of ownership by families in the Chesapeake Bay area of Virginia and Maryland. Recent research by Wallace Gusler of Colonial Williamsburg has resulted in the attribution of many of the pieces to Williamsburg craftsmen. Williamsburg was the political center of the Virginia Colony, and thereby a meeting place for the influential and privileged of the region; it would have been natural for political appointees to purchase Williamsburg's handsome products while in that town. CMD

126 These four rush-seated chairs are examples of the type of inexpensive seating furniture available in America during the eighteenth and early nineteenth centuries. The use of local woods, such as maple and ash, the simple joined and turned construction, and the fiber seats priced chairs such as these at about one-tenth the cost of their high-style mahogany counterparts. Thrifty, brightly colored with paints and stains, lightweight, and practical, these chairs were found in rich and modest households alike. Some were made in urban centers by professional craftsmen, others were simply turned in rural areas. Their lines generally aped those of their high-style counterparts, but in rural areas, where taste was conservative, styles were perpetuated for many years. GSA

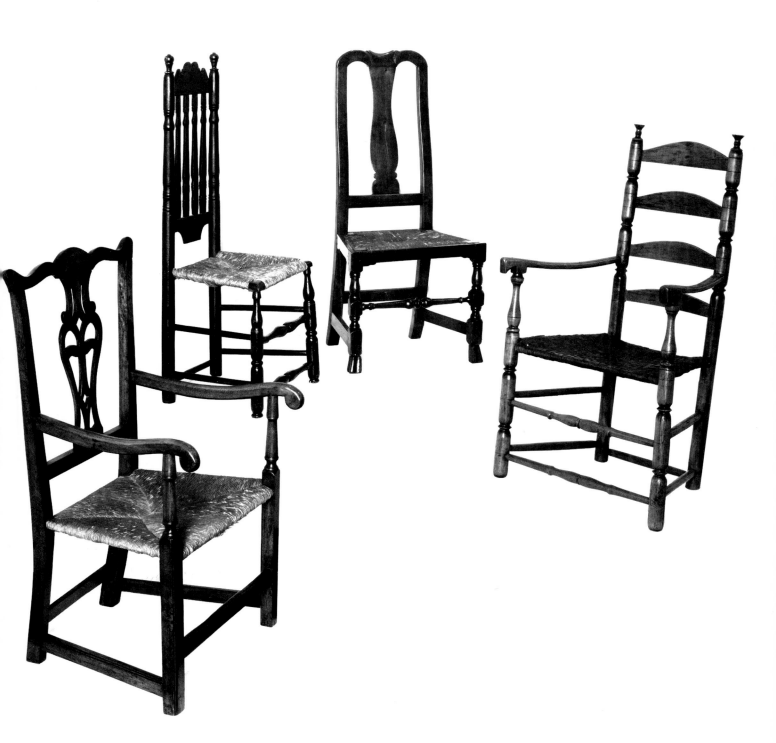

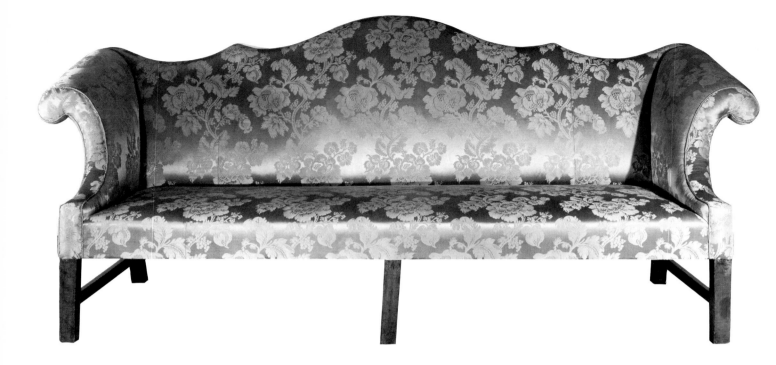

127 This Philadelphia reverse-curve sofa came to the DAR Museum in 1927 through the McKean family, with a history of ownership by Thomas McKean, a Delaware signer of the Declaration of Independence and an ardent patriot. During the Stamp Act Congress, in October 1765, McKean had emerged as one of the most adamant critics of British restrictive policies, insisting on colonial economic autonomy. The political and economic flavor of Philadelphia at that time provided fertile ground for such independent thought. That same year Samuel Morris wrote to Samuel Powell, "In the humour people are in here, a man is in danger of becoming Invidiously distinguished, who buys anything in England which our Trademen can furnish." Patronage was given to local craftsmen, but if economic independence was prized, stylistic dependence was likewise expressed; "Household goods may be had here as cheap & as well made from English patterns," confided Morris. American taste in furniture was English, and not only did English

patterns provide prototype, but many craftsmen working in Philadelphia had been born and trained in England and were thus able to provide a local product of London derivation.

Probably made sometime between 1770 and 1790, the clear, simple lines of this sofa are characteristic of the best American furniture and befit the republican reserve of one who measured time from the great events of 1775, dating his 1814 will, "of the Independence of the United States the thirty ninth [year]." An August 1817 inventory of McKean's Philadelphia home lists "1 Sopha" in the "North Parlor" which, with its sideboard and knifecases, marble top [serving table], and six chairs, was apparently a dining room, although the dining table itself might have been moved to a cooler location for the summer months. The "sopha" at $5.00 was appraised at half the value of that newer, fashionable form, the sideboard.

In 1787 Charles Willson Peale, the celebrated Philadelphia artist, had portrayed McKean's wife, Sarah

Armitage, and their two-year-old daughter, Maria Louise (1785–1788), seated on a sofa of rich red damask, outlined with bright brass nails. As Peale often used a sofa as a prop, we cannot interpret this painted sofa as documentation for the McKean's, but rather as a symbol of social and economic prestige. An expensively upholstered sofa was a luxury item owned by few before the 1820's, when technological advances reduced the price of furnishing fabrics.

A scrap of material tacked to the frame suggests that this sofa was originally upholstered in green. Small nail holes in the arms of the frame indicate that the arms were fashionably outlined in brass nails. The seat here appears uncomfortably hard and low to the ground, but originally there would have been a removable cushion, running the length of the seat, which would have added to its physical comfort as well as its visual enhancement. Additional, smaller cushions would have softened the back. EDG

128 This upholstered-back armchair or elbow chair was made in New York around 1770. The upholstery, the slight backward cant of the back, and the gentle downward slope of the arms were all designed to enhance comfort. The chair was given to the Museum in 1915 by Elizabeth Newton, who in turn had received it through the 1885 bequest of Jane V.C. Cooper of New York, with the following notation of provenance: "to Elizabeth Newton my first cousin I leave my armchair which once belonged to my great grandma Livingston,

Generals Lafayette and Washington sat in it when they visited my grandmother dePeyster at Poughkeepsie. I was the fourth generation to own it." A New York origin is further suggested by the regional constructional technique of diagonal seat braces. EDG

129 This important pair of armchairs is part of a set of twenty-four chairs and four sofas ordered by President James Monroe in 1817 to furnish the East Room of the White House, the "President's House" as it was known then. The maker of the

set was William King Jr., a Georgetown cabinetmaker. King's charge for each chair was $33, for each sofa $198. Commissions for presidential furniture had formerly been awarded to well-known craftsmen working in style centers like Philadelphia, New York, and Paris. The solid monumental design of these chairs illustrates the Empire focus on ponderous classicism. The heavy outlines of the individual pieces and the large number in the suite were appropriate, even necessary, to fill the vacuous space of the enormous East Room. CMD

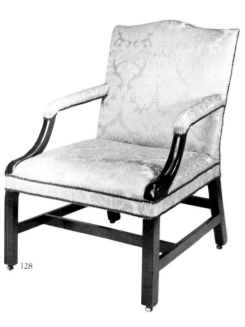

128

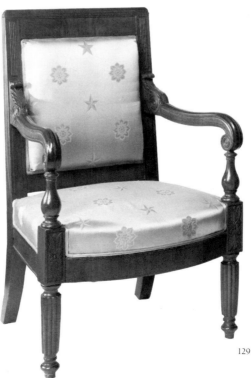
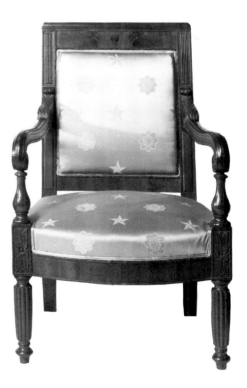

129

130 Recent examination of the secondary woods used in the interior of this maple desk reveals white pine and white cedar; because white cedar is found only as far north as New Jersey and Pennsylvania, this desk-on-frame is thought to be from the mid-Atlantic region. The Queen Anne style emphasized form and silhouette rather than ornament. The desk illustrates this focus in the arch which outlines the molding above the pigeonholes, defines the vertical divides of the end interior compartments, and shapes the apron of the frame. Another Queen Anne characteristic is the cabriole leg and pad foot. CMD

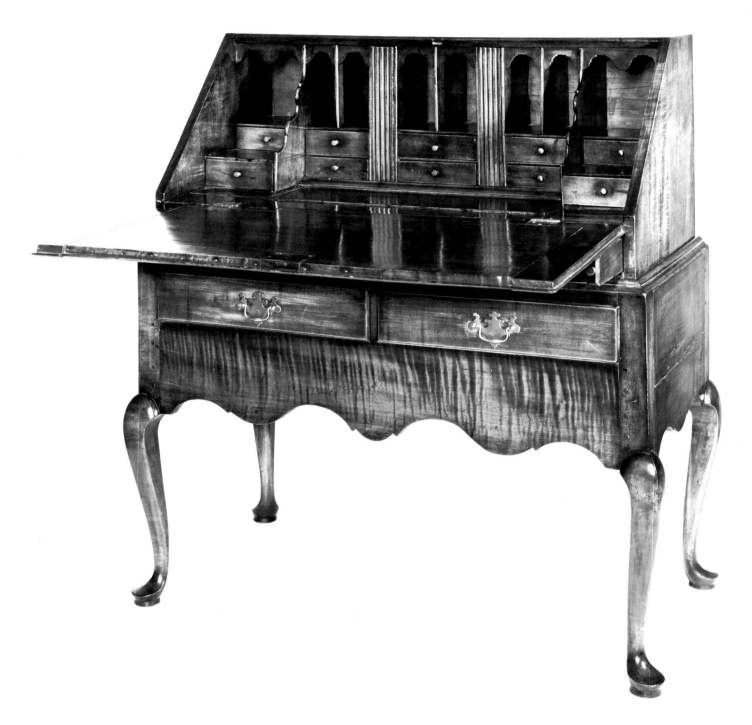

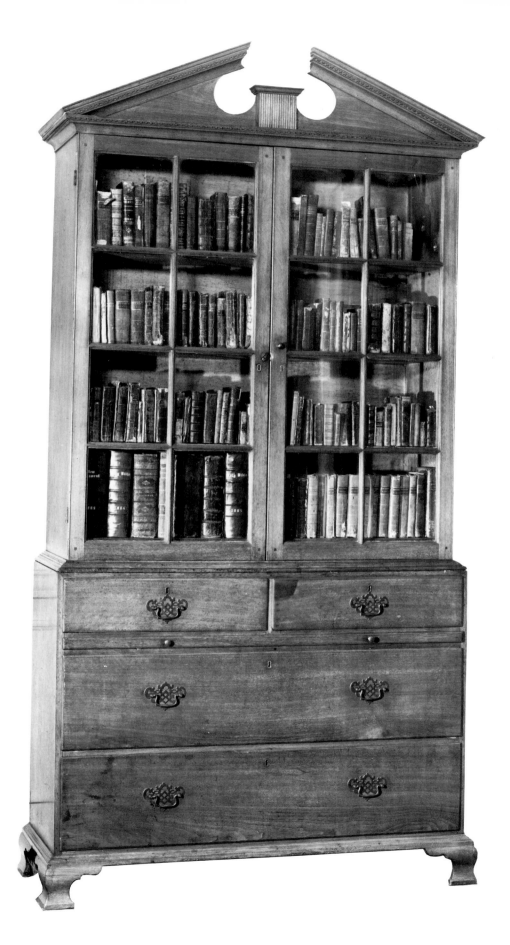

131 This important bookcase was probably made in northeastern North Carolina, an attribution which is based on its relationship, in both construction and design, to other case pieces from this discrete region. Local walnut and yellow pine additionally point to a southern origin. A pull-out writing shelf beneath the top drawer was undoubtedly used for examining folio volumes and other books. The brass pulls on this shelf are the only original ones; indentations on the drawer fronts suggest that they were originally fitted with small, round knobs. The well-proportioned pitch pediment suggests that the cabinetmaker was acquainted with English design sources, and its height of nearly nine feet hints at the scale of the interior for which it was originally designed. CMD

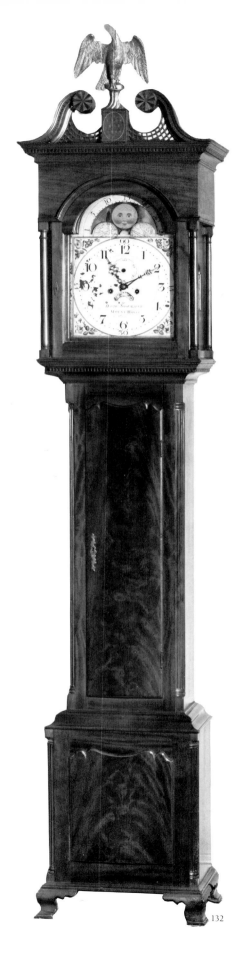

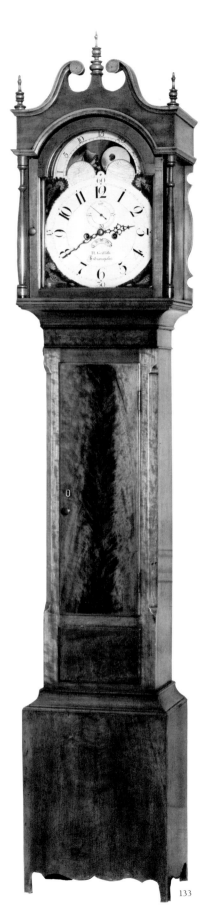

132 The enameled face of this New Jersey tall-case clock is inscribed "DAVID SHOEMAKER/MOUNT HOLLY /No. 153." The clock was probably made around 1810 and stands nearly nine feet in height. Its original owner was Joshua Burr of Vincentown, Burlington County, New Jersey. Burr, a Quaker, moved to Philadelphia in 1811 and in 1817 married Mary E. Newbold. The diversity of this Quaker merchant was detailed by a granddaughter: "He inherited from his father a grist-mill, saw-mill, chair factory, a distillery where the oil of sassafras was extracted, and a store where the employes 'traded.' I lived at my grandfather's and remember riding my horse as a child beside him as he rode over his farm daily to look after his help. He had a passion for hunting, was a celebrated shot, kept his hounds and fine horses, and enjoyed life as few countrymen of his day did." This handsome, tangible evidence of his success descended in the family until it was given to the Museum in 1971. Joshua Burr would have paid handsomely for such a clock, paying extra for such details as the use of mahogany, fine carving, "scroll" top and inlays. CMD

133 Humphrey Griffith, the maker of this clock, was born in Wales in 1791. He served a seven-year apprenticeship with a clock- and watchmaker in Shrewsbury, England, before moving to London, where he worked in the trade. In 1817 he emigrated to America, working first in Huntington, Pennsylvania, and subsequently Centreville, Indiana. In 1825 Griffith moved to Indianapolis, where he established that city's first clock- and watchmaker's shop, which he operated on West Washington Street until the summer of 1836. Appropriately, "his leading characteristics were punctuality in all things." The clock case is constructed of local cherry wood and was probably made by an Indianapolis cabinetmaker. CMD

132

133

134 The large, punch-roughened letters in the cross stile identify this chest as having been made for Mary Burt, a daughter of Henry and Mary Burt of Northampton, Massachusetts. Mary Burt was born October 29, 1695, and married Preserved Marshall of Farmington, Connecticut, on November 20, 1716. This chest and others carved with the names and initials *Esther Lyman*, T S, and *Sarah Strong* share peculiar iconographic notations: swastikas, comma-like tendrils, and stylized, fish-shape tulips. The compartmentalized units of design were originally reinforced by the use of contrasting paints or stains, primarily red and black. The back of this chest has the inset upper panel and applied lower panel characteristic of this group of so-called "Hadley" chests.

Genealogically, the chests all suggest Northampton histories. They were given to a girl before her marriage and probably held the linens and clothing which she had laboriously prepared—sheets, pillowcases, tablecloths, towels, petticoats—which would facilitate and ameliorate her life after marriage. The side-hung drawer and the lift top would have aided in the storage and retrieval of textiles. Both the cotter pins for the lift top and the iron lock are original.

All these chests have locks, and the importance of keys to the notable housewife can be readily understood. Seventeenth- and eighteenth-century inventories reveal that the household linens were often stored in the room with the best bed, a room which would have been used primarily by the master and mistress of a household. Security for such valuable linens was, thus, further ensured.

Versatility was as requisite of home furnishings as it was of homemakers. A flat top might provide a table surface, on occasion a bed. Oliver Goldsmith could pen a picture of "The whitewash'd wall, the nicely sanded floor,/The varnish'd clock that click'd behind the door,/The chest contriv'd a double debt to pay,/A bed by night, a chest of drawers by day." EDG

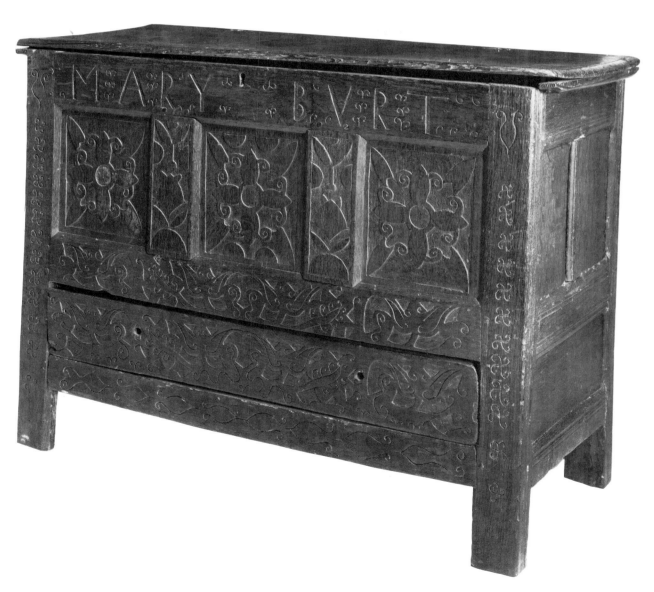

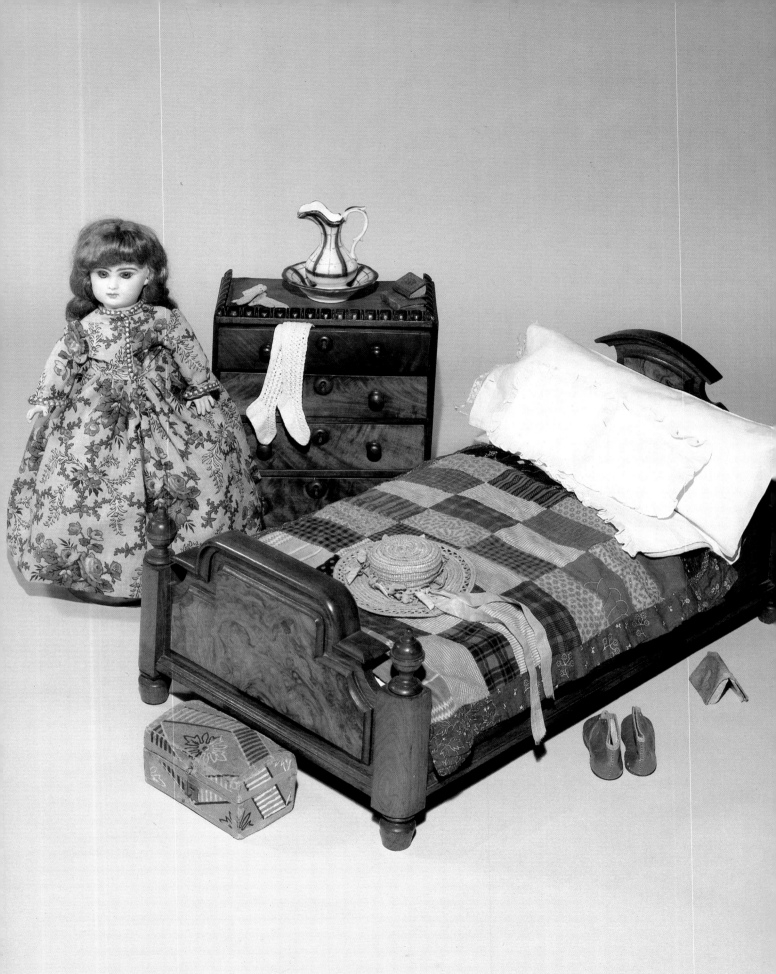

135 This nineteenth-century French bisque doll labeled by Jumeau of Paris is well supplied with a fine straw hat, cotton knit stockings, and red leather shoes. A paper-covered traveling trunk, chest of drawers, and washbowl and pitcher complement the handsome walnut bedstead with its elegant linens and pieced quilt. SMD

136 The household inventory taken when Charles Ridgely, a former Governor of Maryland, died in 1829 lists many pieces of currently fashionable painted or fancy furniture. Among those listed in the front parlor of his Gay Street home in Baltimore were, "1 Doz Green & Red chairs, 2 Green & red settees, 2 Green & gold pier tables, 2 Green & gold card tables, and 2 Green and gold lamp stands." From this group the Museum owns one of the pair of card tables. It had been purchased from the estate by a son-in-law, Henry B. Chew, and descended directly in the Chew and Green families until it was acquired by the Museum.

The period of popularity of Baltimore fancy furniture spans the years 1800–1840. During that period, Baltimore was one of the fastest-growing cities in the United States. To meet the demands of an increasingly affluent merchant class, cabinetmakers produced furniture in the new archaeological taste. Inspired by Greek and Roman prototypes as translated in English and French design books, Baltimore craftsmen combined classical forms with freehand and stenciled decoration. The resulting fancy furniture was well received in the best homes of Baltimore. GSA

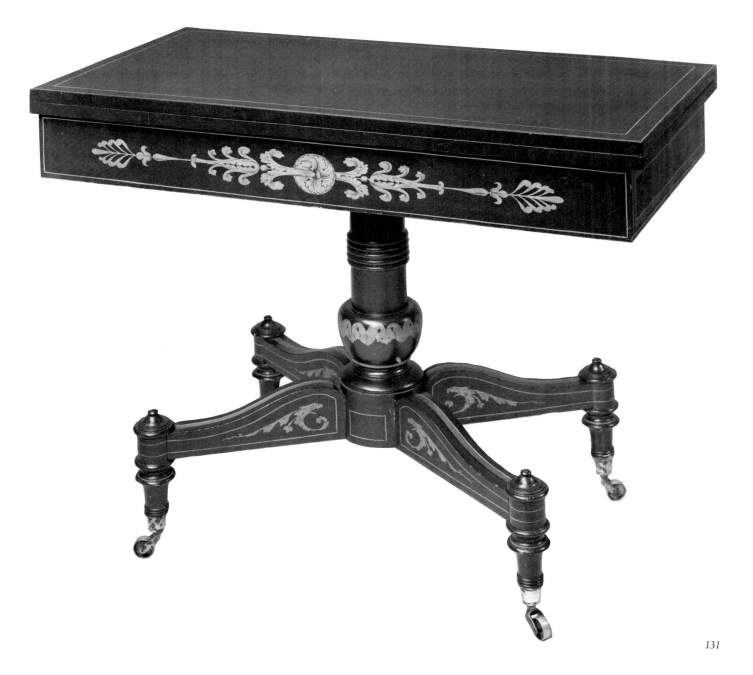

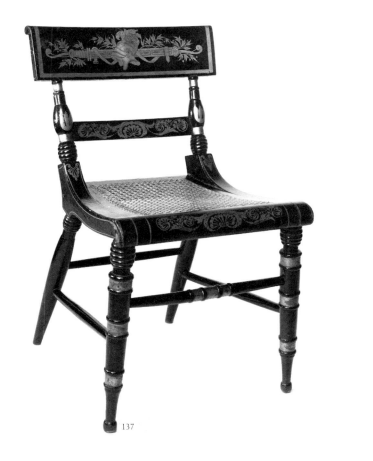

137

137 This Baltimore painted or fancy chair is significant for its strength of design and its original decoration. The stenciled and freehand gilt decoration is highlighted with touches of red. The black background provides a dramatic setting for a full range of neoclassical motifs — helmet and sheathed sword, acanthus and anthemion leafage. Gold striping and banding frames the panels and serves to strengthen the viewer's focus on each horizontal element. This chair, and an identical chair now owned by the Maryland Historical Society, have a history of ownership in the prominent Key family of Maryland. CMD

138 This whimsical pair of rush-seated maple fancy chairs was probably made in Otsego County, New York, around 1820. Gold, green, and red freehand morning glories, roses, shells, leaves, dots, and pinwheels are painted on a red-brown background and the rush seats retain much of the original light ocher paint. The pair belonged to Stephen Benton of Unadilla, New York, who had moved west from Sheffield, Massachusetts, in 1804, and operated a retail store and distillery. The chairs descended in the family of his business associate and son-in-law, Christopher Fellows. EDG

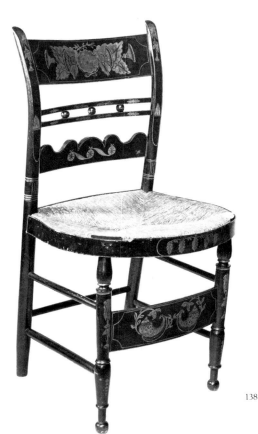
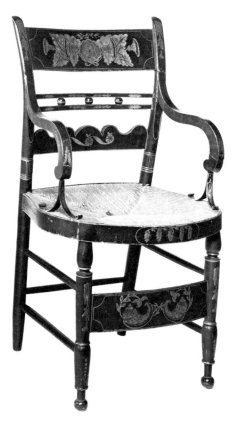

138

139 In the early nineteenth century this type of round-top, pedestal-base table became known as a center table as it was designed to stand in the center of a parlor. Each evening the family would cluster around it for devotional reading and the form became closely associated with the concept of the tightly knit nuclear family and Victorian cultural values.

The top of this New York example can be raised and lowered on a brass ratchet by means of a large handle, suggesting that the original owner wanted a piece that could either stand in the center of the room or be stowed against a wall with the top tilted. In the latter position, the twelve wedge-shape sections of flame mahogany that compose the top would have supplied a bold and lively reflecting surface in a candle or lamp-lit room.

The superb craftsmanship attests to the superior skills of the most accomplished cabinetmakers working in New York City in the early 1800's. Sleek veneered surfaces, bold simple lines, flattened ball feet, and a distinctive ormulu collar all relate to the French Empire style favored so highly in the metropolis at the time.

The table was received with a history of ownership in the Livingston family of New York; it certainly suggests that the original owner had an astute eye and an ample purse. EDG

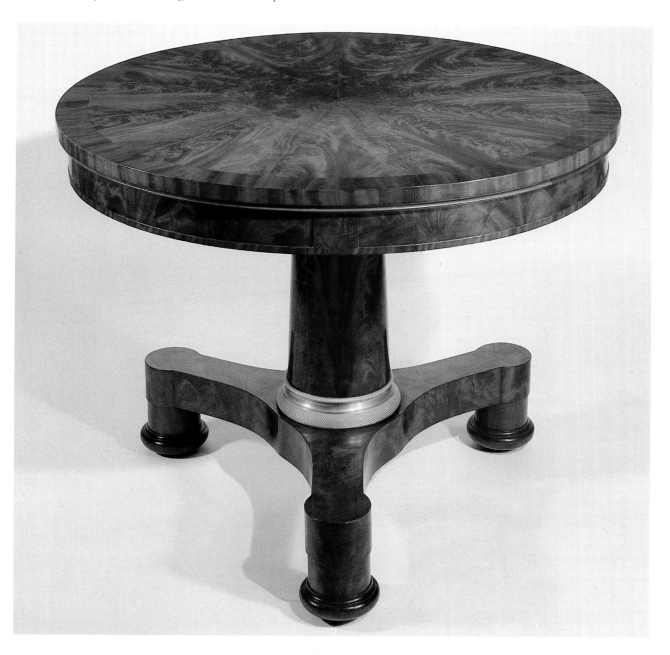

140 This mahogany hunt board or sideboard-table was made in Maryland at the end of the eighteenth century and relates to a small group of other Maryland examples. In spite of its large size and seventy-five-inch length, the table does not look heavy, for the cabinetmaker has lightened its appearance by tapering the legs and giving a serpentine sweep to the top and the front skirt. Precision of outline is detailed by a narrow stringing of lightwood which defines the upper edge of the top, and by bands of light and dark wood which trace the lower edge of the skirts and carry around the legs. The zigzag cuff inlay also helps to clarify the organization of the piece.

Sideboard-tables facilitated service in the dining room. The top was often covered with a protective cloth. Robert Roberts, the butler at Gore Place in Waltham, Massachusetts, counseled in 1827: "The side table is the place where you are to have all your dinner plates, pudding and cheese plates, and likewise the dessert plates, if there is not room on your sideboard for them. You must have a clean cloth spread upon it, as your salad and cold meats are to be placed on it, if they are not put on your dinner table." The unusually long (69½ inches) side-hung drawer which runs nearly the full length of this piece might have facilitated the flat storage of such cloths. As there is no hardware, the apron and under-side of the drawer are cut away for ease in opening. EDG

141 The enormous quantity of punch bowls, punch pots, punch strainers and ladles, tankards, tumblers, wine glasses, and decanters in the Museum collection denotes the importance of social drinking in the early home. From near Philadelphia in 1744, William Black described "a Bowl of fine lemon Punch big enough to have Swimm'd half a dozen of young Geese," and it was reputed that a ten-gallon punch bowl was placed every afternoon on the stair landing at the Otis house in Boston for the refreshment of family and friends. EDG

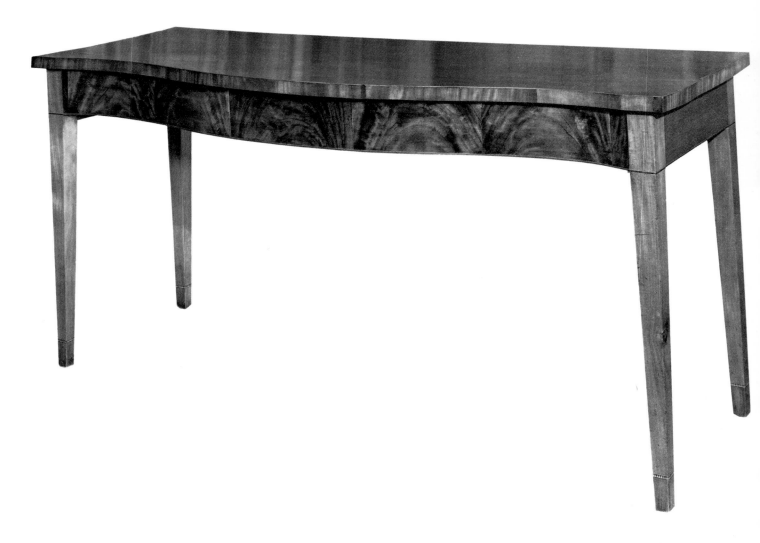

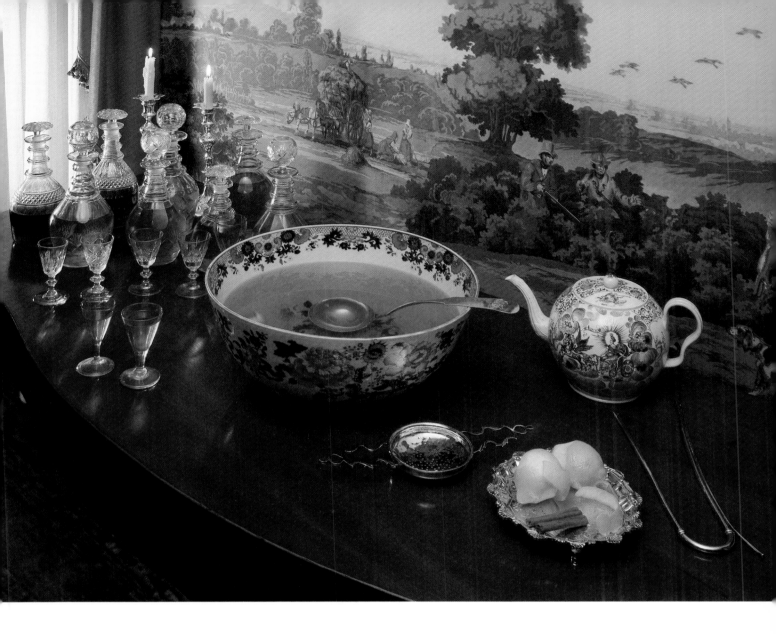

142 The two curvilinear open handles of this punch strainer, with their enlarged feathering, relate to a number of punch strainers made by Boston silversmiths in the eighteenth century. The strainer would have been suspended across the top of a punch bowl before the well-seasoned punch was poured in. This example was made by Zachariah Brigden around 1770. The handles were cast in a sand mold and finished with a fine file. The bowl section was raised from a flat sheet of silver, then perforated with a hand-held stamp. Finally, the handles were soldered to the bowl just under the lip. CMD

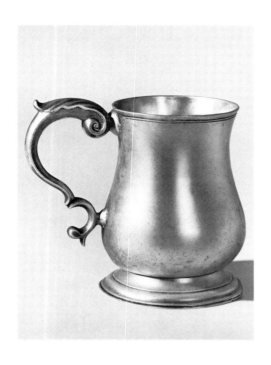

143 This cann by the Philadelphia silversmith John David descended in the Rodney family of Delaware. The pear shape of the body and the curve of the double-scroll handle with its acanthus-leaf grip had become standard elements in the design of these drinking vessels by the mid-eighteenth century and continued to be so for the next twenty years. CMD

144 The introduction of the sideboard was simultaneous with the emergence of the dining room as a specialized room to be used uniquely for dining. What made the sideboard a new form and differentiated it from the side table or sideboard-table was the addition of deep cupboards and front drawers. By 1794 George Hepplewhite had effusively endorsed the form in his *The Cabinet-Maker and Upholsterer's Guide:* "the great utility of this piece of furniture has procured it a very general reception; and the convenience it affords render a dining room incomplete without a sideboard." The sideboard offered ease in serving and provided storage space for flatware and liquor. It also furnished a display surface for the family's fine glassware and silver hollow ware. EDG

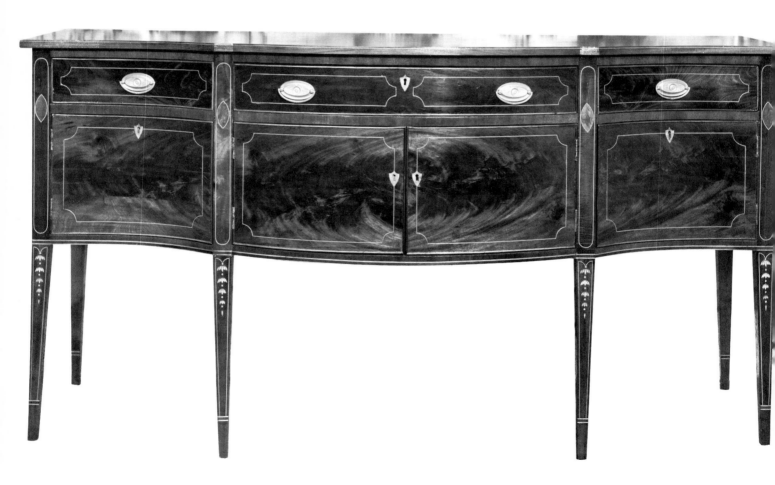

145 When Charles Carroll of Carrollton ordered this silver dish cross through his London agents in October 1798, he specified, "one genteel substantial silver cross for the table commonly called a sliding X." Edmond Milne, a goldsmith and jeweler, had also alluded to this descriptive nickname in the *Pennsylvania Journal* of November 8, 1764, offering "ex's with sliders and lamps for dish stands." Charles Carroll had appended to his order, "NB. the crest of my arms to be engraved thereon." The crest of a hawk rising is engraved on the cap and face of the spirit well. He wanted his dish cross "genteel," which is defined in the *Oxford English Dictionary* as "appropriate to persons of quality…elegant or graceful in shape or appearance… refined, delicate." And the dish cross was also to be "substantial" — serviceable and easily maintained by the absence of superfluities.

Those two adjectives could describe Carroll as well. A refined aristocrat of moneyed and landed estate, he was also solidly pragmatic. Although he ordered most of his household goods through

agents in London, the most reliable and stylish source, he also knew that "the shop keepers in London are so apt to ship off to America their refuse goods," and few of his orders are without restrictions as to form, decoration, color, measurement, or price.

This dish cross, made by the London silversmith John Moore in 1798, reveals Charles Carroll's responsible conviction that "decency is the only point to be aimed at," a maxim imparted to him by his father in 1772. A dish cross with a spirit lamp would keep food warm at table, promising pleasure to both eye and palate. Dish rings or dish crosses without lamps were useful in raising a sweating punch bowl off a mahogany surface. Joseph Anthony, a Philadelphia silversmith, offered London "Dish rings and crosses, with and without lamps," in Philadelphia in 1790. EDG

146 Filled with fresh fruits and dried sweetmeats, this silver epergne would have made a resplendent display on any eighteenth-century dining table

during the dessert course. The elegant design hints at the elaborate table settings and the care lavished on the centerpiece in the dining rooms of the wealthy classes. The epergne form was introduced into England from France in the first quarter of the eighteenth century, and was then favored among prosperous Americans by the third quarter of the century. An advertisement for "12 elegant epergnes, from 60 to 150 dollars," in a 1797 Philadelphia newspaper, is suggestive of the diversity of form and the range of ornamentation available. "Epergnes, with 7, 8, and 10 basons," were offered in that same city two years later.

This example was received with a history of ownership in the Symington family of Maryland; it was made by Thomas Pitts, a London silversmith who specialized in epergnes and pierced baskets. Pitts crafted this example in what he would have called the "French" or "Modern" style, or in what we call today the "Rococo" style. The flowing, organic configurations of this style were perfectly suited to such a branched arrangement. EDG

147 Cream-colored earthenware was produced in great quantities in the last quarter of the eighteenth century. It was inexpensive to manufacture, and its durable, lustrous glaze made it almost as appealing as porcelain. Creamware was available plain, enameled, elaborately molded or pierced in intricate openwork patterns. The four pieces illustrated provide examples of the large number of decorative rim patterns available from the potteries in Staffordshire and Yorkshire. Because they were highly decorative and less functional than solid pieces, ceramics with pierced borders were most probably intended for use with the dessert course. The lacy borders and the warm cream color provided a perfect foil for the rich tones of the jellies, fruits, and sweetmeats. GSA

148 The following recipe for "pompadour cream" suggests one of the possible uses for this covered bowl: "Take the whites of five eggs and beat them to a strong froth. Then put them in a tossing pan, with two spoonfuls of orange flower water and sugar. Stir it gently for three or four minutes, then put it into your dish, and pour melted butter over it. This is a pretty corner dish for a second course at dinner and it must be served up hot." (John Farley. *The London Art of Cookery,* London, 1785).

It was also customary to serve chilled creams as a part of the dessert course. The cream could be whipped or frozen and flavored with a variety of fruit or nut extracts. When whipped to a froth, mounded into a bowl and decorated with flower blossoms or bits of jelly, the confection required a high-domed serving container. Cream bowls were generally very decorative, to complement their contents, and were available in porcelain or in intricately-molded and pierced cream-colored earthenware. A less dramatic and more individual alternative to the cream bowl was the small covered cream or custard cup. GSA

149 Molded jellies, creams, and ice creams were popular in the eighteenth and early nineteenth centuries, as they were pleasing to both eye and palate and offered innumerable decorative possibilities. These creamware examples illustrate a swirled mold with an impressed pineapple and a tiered mold with a center fish design. The decorative pierced patternings of the fish mold allowed for the drainage of excess liquid. Ceramic molds were particularly favored for fruit jellies, as they retained the flavor of the fruit and did not alter the natural color.

Martha Washington's granddaughter, Eleanor Custis Lewis, kept a recipe for a molded "Fromage of Pine Apples" in her handwritten housekeeping book, and a compatriot, Mary Randolph, published recipes for both "Fish in Jelly" and pineapple ice cream in 1824 in her *The Virginia House-Wife.* In 1832 Lydia Maria Child advised in *The American Frugal Housewife,* "The moulds should be made thoroughly clean, and wet with cold water; the white of an egg, dropped in and shook round the moulds, will make it come out smooth and handsomely." EDG

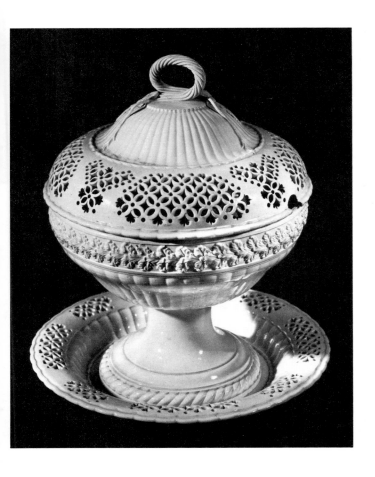

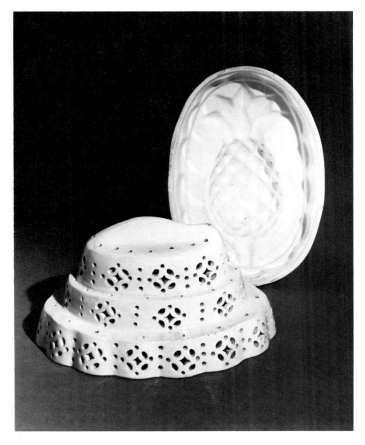

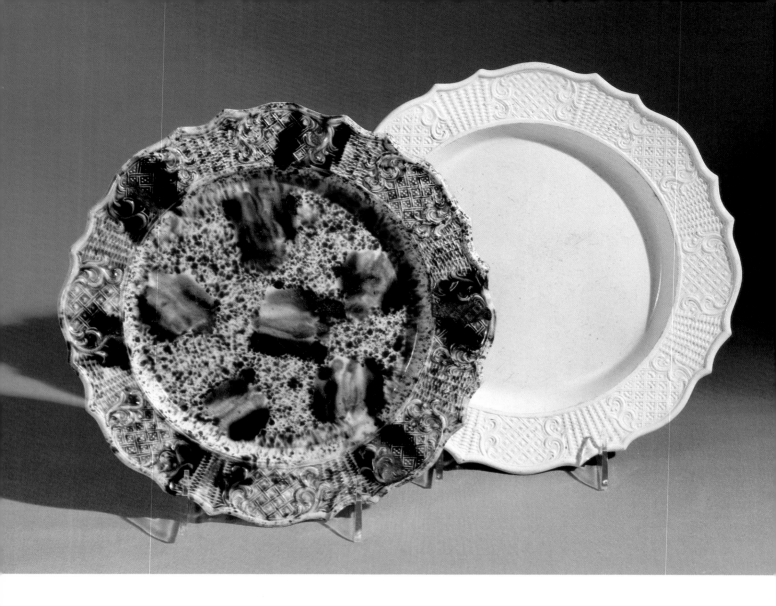

150 These two plates, one salt-glazed stoneware and the other earthenware with a tortoise-shell glaze, have similar pressed rim designs and could have come from the same mold. Eighteenth-century English potters often produced more than one type of ceramic product to keep abreast of the rapidly changing fashion in ceramic usage. Although different types of kilns were used for stone and earthenwares, the same intaglio molds could be used for several body types. When coated with a salt glaze or a lead glaze colored with metallic oxides, the end results would be strikingly different. Salt-glazed stoneware tea and tablewares were used in colonial

America in great numbers. The novel tortoise-shell ware was found less frequently. Well-stocked urban merchants, like James Houston of Annapolis, occasionally advertised both: "Just imported in the Grey-hound, Capt. Alex Stewart, from London and to be sold on board the said ship by the subscriber, either by wholesale or retail…white …and Tortise Plates and dishes plain, scallop'd and flowered" (*Maryland Gazette*, April 3, 1755). GSA

151 This sauceboat is of particular interest because its family history is known. It was originally owned by Colonel Nicholas Gilman (1731–

1783), a resident of Exeter, New Hampshire. It passed to his son Nicholas (1755–1814), who served under Washington at Yorktown, was a signer of the Constitution, and a U.S. Senator from New Hampshire. As he never married, the sauceboat passed to his sister, Elizabeth, and descended in her family.

The process of making agateware was more complex than that for other earthenwares. The variegated pattern was created by wedging together different colored clays and then pressing the mixed clay into a mold. It was finished with a clear lead glaze. Agateware was manufac-tured for a relatively short period of time. Although its novelty appealed

to the prosperous British and colonial consumer, very little has been preserved with documented family histories. GSA

152 John Morgan (1753-1812), graduate of Yale College, promoter of the "Great Bridge" across the Connecticut River at Hartford, and merchant aristocrat in that town, was independent in spirit and full of the robust flavor of an eighteenth-century gentleman. In 1869 in his *Morgan Genealogy*, Nathaniel Morgan provided documentation for these two examples of Chinese export porcelain: "In 1785 he [John] imported from Canton, China, in the first American vessel that ever entered the Chinese waters, the ship 'Empress of China'…a large quantity of China ware, among it a rich and extensive dining set, made to his own order, each piece bearing his own name and coat of arms, (a lion rampant, crest a demi griffin,) which is still preserved and now in possession of the family of Gen. John A. Dix, of New York, present minister to France. His brother Elias [1770-1812], several years later also imported another set, with his name and the same device inscribed thereon." As both these pieces are in the neoclassical style of the 1790's, it is possible that they were imported on later voyages.

Very few armorial services were made for American families, and less than two dozen of these personalized services are known. Americans who desired armorial decoration generally had to settle for a stock pseudo-armorial device —a shield with manteling—which could be customized by the addition of a cipher or initial. Nathaniel Morgan's description of John Morgan, who was a close friend of Nathaniel's father, helps to explain his predilection for a full armorial service: "His air and bearing would appear peculiar in this day, but he had several compeers in Hartford

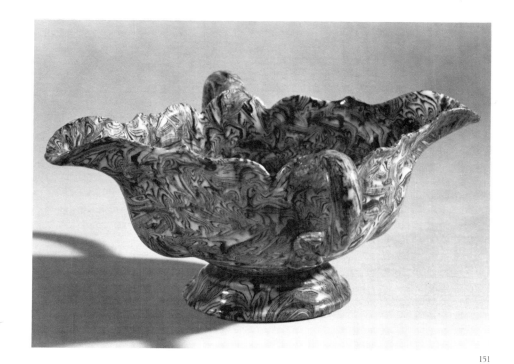

then; princely merchants of the old English school; highly educated and of polished culture; bearing themselves with all the proud dignity of lords and nobles 'to the manor born.' Common men approached them with great defer-

ence and with heads uncovered; and we boys were hushed as they passed in the streets, with their gold-headed canes, short breeches, and silver shoe-buckles. Uncle John was one of the 'last of the Plantagenets'." GSA & EDG

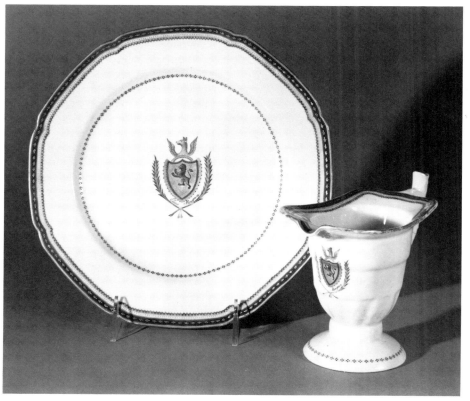

153 Sample cups and plates were decorated with a selection of borders; this custard cup has four. They were probably used by China Trade merchants and supercargoes in assisting the bewildered consumer in the selection of inner and outer, upper and lower borders for the service he might be ordering. A service could be further customized by the addition of a simple initial or a more elaborate cipher placed within a pseudo-armorial device. The merchant would relay the order to China and in more than a year's time the client would receive his wares. As the eighteenth century drew to a close, decoration on Chinese export porcelain became simpler, more restrained, and increasingly standardized. This change was in part due to the influence of neoclassicism, but it also corresponded to a general qualitative decline in Chinese export porcelain production. Specifying borders and adding initials offered the western client a personal role in selecting a more individualized product than the general mass-market wares. GSA

154 This coffee cup and saucer were once part of a personalized service made for Mary Hemphill (1779–1834) of Wilmington, Delaware, at the time of her marriage in 1808. Her cipher appears in a shield. Mary was the fourth child of the prominent Wilmington merchant William Hemphill. Hemphill had been born in Ireland and immigrated to America in 1758, settling first in New York, then Philadelphia, and eventually Wilmington. He formed a partnership with Robert Ralston of Philadelphia and successfully engaged in the shipping business. The firm's ships traded with the West Indies, France, Ireland, and China. According to family tradition, Hemphill's oldest son, James, served as supercargo on his father's ships and may have been responsible for ordering his sister's porcelain during one of his trips to China. In 1808 Mary Hemphill married another Wilmington merchant, William Jones, and the porcelain service descended in their daughter's family.

The source for the pictorial decoration was an engraving entitled "Fidelity," which was widely known at the time. The same engraving was the source for a Chinese reverse painting on glass entitled "Fidelity," which is now in a private collection. And among the "transparent paintings" on view at the Fourth of July concert and transparent-painting exhibit at Columbia Garden, opposite the Battery, in New York City in 1800 were "Fidelity under the shape of a woman, holding a basket of flowers and ears of corn, with a dog by her side." The images on Mary Hemphill's porcelain were exactingly hand painted by a Chinese copyist in a stipple and stroke-like manner to suggest the original engraving. GSA

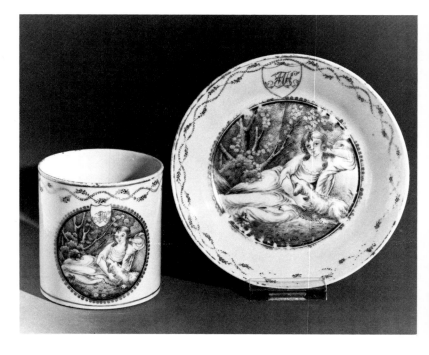

155 These four plates represent several types of tablewares which might have been found in American homes during the late eighteenth and early nineteenth centuries. Delftware, or tin-glazed earthenware (upper right), was in common use in mid-eighteenth-century America. Archaeological excavations reveal numerous fragments of blue and white tin-glazed wares, usually with Chinoiserie motifs. With its white surface and high temperature blue painting, delftware could resemble Chinese porcelain. Some examples, such as this Liverpool plate, were direct copies from Chinese prototypes. Readily available from a number of English potteries and cheaply priced at about one-quarter the cost of equivalent pieces of Chinese porcelain, delftware was used by all levels of colonial society. The incompatibility between the fragile tin glaze and the earthenware body resulted in an easily abraded surface which did not stand up to the rigors of daily use. When the durable cream-colored lead-glazed earthenwares became available in the 1760's, they gradually supplanted tin-glazed wares.

The soup plate in the lower right is from a type of dinner service which was known at the time as "Queensware." It was available with a variety of rim shapes with simple border motifs or color edges. A Queen's ware service of middling size might include two dozen soup plates, six dozen flat plates, and several serving forms. Late-eighteenth-century American newspapers are filled with advertisements for "enameled, striped, fluted, pierced and plain Queen's ware."

Anglo-American wares, or English wares with American images, were very popular in the nineteenth century, but custom-order creamware dinner services were not common. The soup plate in the lower left is decorated with the same view of Salem harbor which appeared on the certificate of the Salem Marine Society. The original impression was engraved in 1797 by Samuel Hill of Boston (w. 1789–1803). Other known pieces from this service, which is believed to have been owned by the prominent Derby family of Salem, are transfer printed with views of "Boston Harbor" and the "Town of Sherbourne" (Nantucket).

Mass-market Chinese porcelains (upper left) were readily available to the American consumer after the United States entered the China trade in 1784. Large quantities of porcelain were brought back in the holds of ships, where they served as a buffer layer for perishable silk textiles and dried teas and herbs.
GSA

156 Eighteenth-century residents of coastal North America were able to order fashionable tablewares directly from England through their factors or agents in exchange for tobacco or other market crops. In the larger colonial towns a selection of British imports was also available through local merchants. Numerous newspaper accounts from the second half of the eighteenth century list table and beverage wares made from a variety of materials and available in increasingly diverse shapes for specialized functions. Expanded technology in the ceramic industry, coinciding with increased consumer demand, resulted in the production of a diversity of tablewares in new, lustrous, and exciting ceramic forms. Plates were now designated for breakfast, dinner, or dessert use. Sauces for meat or dessert courses could be served out of one- or two-handled vessels or small covered tureens. Soup was ladled into soup plates from large, sometimes extravagantly modeled, covered dishes or tureens, and butter was kept firm and cool in its own specially ventilated container.

Along with the increase in use of ceramic tablewares came a growing demand for utensils with which to consume the food. Individual knives and forks supplemented communal or individual spoons. By using implements rather than hands for spearing and cutting food, dining became considerably neater and more refined. An elegant table now could be set with glistening silver flatware, gleaming ceramic containers, and sparkling glass drinking vessels. GSA

157 French porcelains, especially those with gilt decoration on luminous white grounds, were immensely popular in the United States during the first half of the nineteenth century. When William Ellis Tucker opened a porcelain factory in Philadelphia in 1826, his wares were heavily influenced by these French porcelains. In addition to the fashionable white and gilt wares, he also produced a number of pieces with well-painted polychrome floral decoration. Although Tucker was one of the very few American porcelain manufacturers, he could not make his business a financial success. Heavy competition came from the French porcelain he tried so hard to imitate. Because of the absence of adequate tariffs to protect home manufactures, French porcelain could be imported and sold at lower prices. After several attempts to attract investors and to bring additional funds into the business, the Tucker Porcelain Factory closed in 1838. GSA

158

159

158 This group of early tablewares illustrates the variety of forms available for purchase from American silversmiths. Porringers were used in a number of ways by young and old alike. Most were fashioned with one handle, as is this early example by John Allen and John Edwards of Boston. Casters were used for sugar and a variety of dried spices. The diminutive handled pepperbox by John Burt of Boston was probably used exclusively for that spice, while Bilious Ward's tall caster would have functioned in a more diverse manner.

Sauces were an important condiment. Most frequently used on meats, sauces were either very mild to neutralize strong-flavored meats, or very spicy to compensate for bland meat. This sauceboat was made by Thomas Edwards in Boston around 1746. That more sauceboats have not survived suggests that perhaps other forms such as the porringer fulfilled the sauceboat's role in many households.

The silver tumbler was made by Paul Revere in 1795 for the wealthy Salem merchant Elias Hasket Derby. In that year Derby commissioned Revere to make a set of eight cups modeled after a set of four by the French silversmith Denis Colombier, which he had purchased in Paris in 1789. A 1799 inventory of the Derby estate lists the twelve cups. This Revere cup, together with a Colombier cup, descended in the Derby family and are still together at the DAR Museum. A second pair is owned by the Metropolitan Museum of Art.

The two salts, the one on the left by Samuel Burt of Boston and the one on the right by Charles Oliver Bruff of New York City, illustrate the eighteenth-century fashion of an individual salt for each diner. Many salts were fitted with clear or cobalt crystal liners which protected the silver from the destructive and disfiguring effects of salt. The four bright-cut teaspoons were made by Isaac Hutton of Albany, New York, around 1790. CMD

159 Porringers were commonly used in this country from the seventeenth century through the early years of the nineteenth, attesting to the conservative taste of the American consumer, who was more willing to perpetuate a time-tested form than to adopt a novel one. Porringers, on occasion fitted with covers, were available in a variety of sizes and an assortment of mediums, such as earthenware, silver, pewter, and cast iron. Dr. Lawrence Dolhande bemoaned the theft of his "Six large Silver Porringers, Some holding a Pint and Some more," in a Boston newspaper in 1734, and pewterer John Skinner offered "Porringers of five different sizes" in the *Boston News-Letter* in 1763. George Washington ordered two ceramic Queensware porringers in 1769, but the metal forms were much more common.

This particular silver example was made by the Boston silversmiths John Allen and John Edwards, between 1699 and 1707. The engraved monogram CMR on the face of the bowl was added in the second half of the eighteenth century by Christopher and Rachel Marshall (see pl. 14 and 31) after they had inherited it.

Porringers were often used as bowls for warm liquids. Samuel Johnson, in his 1785 *Dictionary of the English Language,* defined the porringer as "a vessel in which broth is eaten." While taking care of an invalid aunt, Lucy Larcom "added a few sticks to the smouldering fire, and placed a pewter porringer of balm tea on the embers....the herb tea was boiling when Aunt Suzy woke up." The porringer handle would have provided a place for the user to grip the bowl firmly, and the handle piercings would have allowed the heat to disseminate, in addition to being decorative. EDG

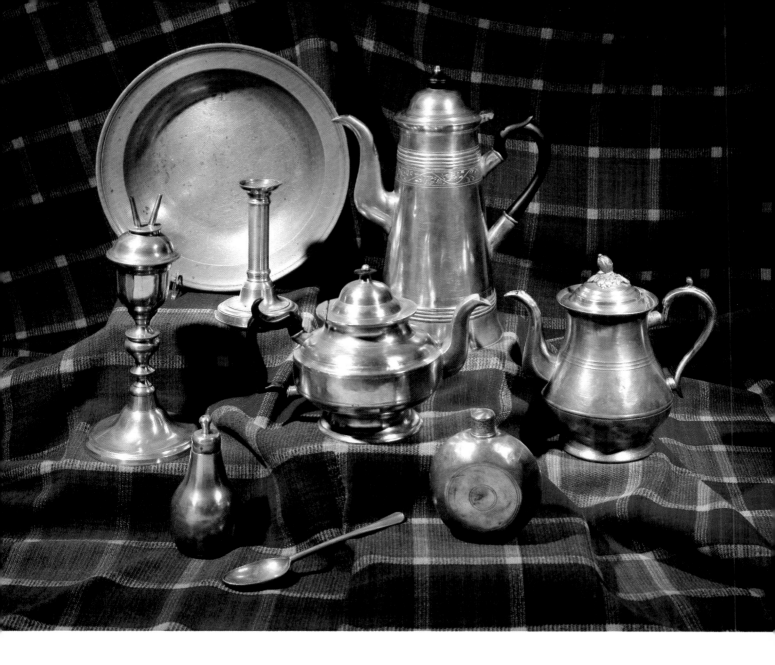

160 Pewter, an alloy of tin with varying amounts of copper, antimony, bismuth, and lead, was popular in the American colonies, as is evident in eighteenth-century probate inventories listing household objects. Though pewter was not inexpensive, it cost approximately one-tenth the price of silver. Pewter was also reusable. Unlike pottery, pewter could be melted down and recast into new forms. In fact, the livelihood of most American pewterers depended upon patrons bringing in old pewter to be redesigned. Cornelius Bradford advertised on October 7, 1756, that "All persons may have Pewter Mended at a Reasonable price, and Ready Money given for old Pewter, or exchange for new" (*Pennsylvania Journal*). The absence of tin mines in America, coupled with English laws forbidding the export of mined tin to the British colonies, constrained American pewterers and gave the mother country the advantage in the pewter trade. By the late eighteenth century the demand for pewter had begun to dwindle as inexpensive ceramics imported from England usurped the pewter market. Pewterers made an attempt to recapture the American consumer with a harder, lighter, thinner, less expensive metal called britannia.

The tall straight-sided coffeepot with Israel Trask's touchmark and the two teapots by Josiah Danforth (w. 1821-c. 1843) and Thomas and Sherman Boardman (w. 1810-1850) are examples of early nineteenth-century britannia produced in Connecticut. By 1850, the process of electroplating made inexpensive silver-coated wares available. Pewter would never regain its popularity. SMD

161 Domestic manufactures began to flourish during the Revolutionary War out of necessity, and with the cessation of hostilities certain industries, such as utilitarian pottery, continued to expand. Domestic production of stone and earthenwares was encouraged by the availability of local materials, the relatively low cost of manufacture, and the high cost of transporting heavy pieces long distances. Newspapers frequently advertised for trained craftsmen or cited the advantages of forming new industries: "Stoneware is now scarce and dear amongst us, as the housewife knows. This is owing to its great bulk and low value, that scarcely affords to pay the freight on measure. It is this circumstance that renders the manufacturing these wares an object, to our enterprising people, peculiarly promising of profit and permanent advantage. It is indeed becoming more and more necessary to the calls of the country that stone and Earthen Ware be made and improved on at home" (*Pennsylvania Mercury,* February 4, 1785).

Merchants such as Alexander Bartram of Philadelphia customarily sold refined table and beverage wares imported from England and the Orient in conjunction with the coarser domestic "pottery ware, made at his pot house, equal in quality, and as cheap as any made" (*Pennsylvania Chronicle,* September 26, 1772). After the Revolutionary War, Hugh Smith, an Alexandria, Virginia merchant, advertised earthenwares and china from Liverpool along with "a general assortment of excellent stone ware, made by [local potter] John Swann" (*Daily National Intelligencer,* May 1, 1823).

The stoneware vessels illustrated here range in date from 1815 to 1877. The flask with a painted flower-pot motif in the front center is incised as well as painted in a manner typical of earlier stoneware decoration. It bears the interesting inscription, "Jemsons/ White Clay/ D. 28 1815". The large storage jar is stamped by Hugh Charles Smith, who sold the wares of a number of Alexandria potters, thus continuing the family business. The pitcher from the Shenandoah Valley was stamped by William Lehew's pottery and may have been decorated by his sixteen-year-old son, Jackson A. Lehew, who painted "JAL 1877" on the side. GSA

162 Utilitarian vessels of the eighteenth and nineteenth centuries were frequently made from red earthenware or widely available common red clay. A number of American pot makers, working in the ceramic traditions of Europe and England, produced wares which closely resembled those of their homeland. These domestic "Potters Wares" competed favorably with imported, unrefined earthenwares. Estate inventories from the early nineteenth century are replete with references to earthenware pans, jars, dishes, and other forms for food storage, preparation, or consumption. Red and other earthenwares were customarily fashioned by draping a slab of clay over a mold, or in the case of hollowares, by throwing on a wheel. After firing at a low temperature, the vessels were decorated with slip, incised lines, or metallic oxides and then glazed in the areas that would come in contact with food or liquids.

The process of lead glazing was unwholesome at best. The application was hazardous to the pot maker, and the use of poorly or thinly glazed vessels was dangerous. A commentary in the February 4, 1785, edition of the *Pennsylvania Mercury* warned that "the Mischievous effect of it [glaze], fall chiefly on the country people....Even when it is firm enough so as not to scale off, it is yet imperceptibly eaten away by every acid matter: and mixing with the drinks and meats of the people, becomes a slow but sure poison, chiefly affecting the nerves, that enfeebles the constitution, and produces paleness, tremors, gripes, palsies & sometimes to whole families." In spite of such dire warnings, lead-glazed earthenwares continued to be produced in vast quantities, suffering competition only from the increased production of American stonewares. GSA

163 This ominous-looking mouse-trap once operated on the guillo-tine principle, offering a maximum quarry of four mice, one on each side of the square trap. A sharp blade can be propped into ready position by a thin iron rig which rests upon the wire from which the food scrap is hung. A tug upon the food triggers a chain reaction — each rig jolts the next, resulting ultimately in the rodent's decapita-tion. Only one trap retains its com-plete works, with "S. SANDERS" stamped on the blade. Pest control was a genuine concern in early America. SMD

164 In the early American home bouquets were customarily small and compactly arranged, and the vase or vases were placed in a safe and secure location where they were not likely to be tipped over. One type of container used in the eighteenth century was the wall pocket or "cornucopia," such as this English tin-glazed earthenware example, made around 1760. They were designed to be hung on the wall in pairs, with the "horn" of one cornucopia curving inward toward that of the other. This paired arrangement repeated the symmet-rical emphasis of the other room furnishings.

The mantel shelf was also favored for a balanced arrangement of flowers. On the drawing-room mantel at Mount Vernon in February 1799 were "marble jars and blue china ones in which were placed some blue and red bache-lor's buttons." Preparing for an evening party at their Boston home on April 21, 1819, Eliza Susan Quincy recorded that her family "sent to the Botanic garden for flowers, with which we decorated our drawing rooms, — placing them in vases on the mantelpieces, and in glass vases over the folding doors which were surmounted by a fan light."

Botanical gardens were not generally available to families, so bouquets were more typically gathered from gardens and fields. Sarah Connell Ayer noted in her diary on May 28, 1807, while attending the academy in Andover, Massachusetts, "After tea, we walk'd out and cull'd a variety of flowers for a nosegay," perhaps some of the same varieties that Betsy Lewis painted in this copybook while attending The Ladies Academy in Dorchester. Although schoolgirls usually copied from print sources, she, in all likelihood, recorded these from nature. EDG

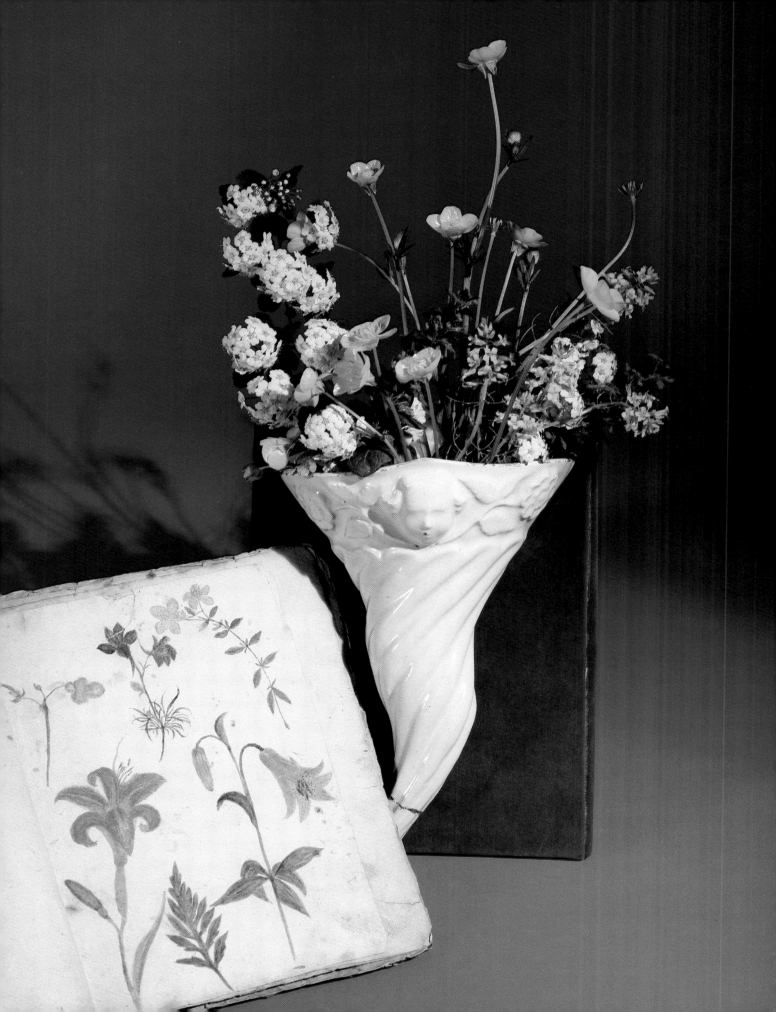

165

166

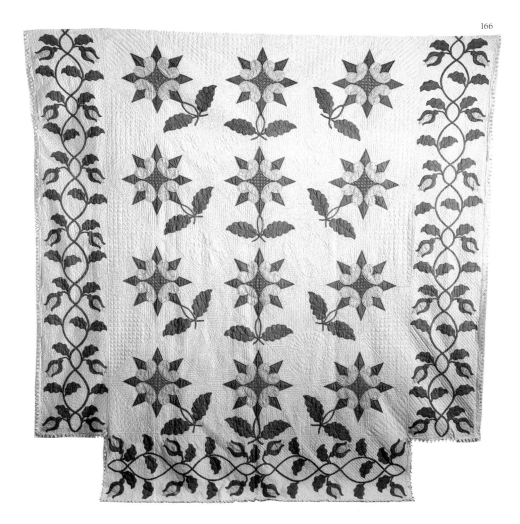

165 Eight-year-old Martha Gray of Gray's Ferry, Philadelphia, worked this summer-time bouquet in tent and cross-stitches, arranging the flowers in a two-handled cup which closely approximates a silver form. Dated June 7, 1779, the sampler is an ironically tranquil work to emerge from Revolutionary Philadelphia where both her mother and father were involved in the patriot cause. Her mother, Martha Ibbetson Gray, nursed wounded American soldiers at the time of the British occupation of Philadelphia in 1777. Her father, George Gray, was the author of the *Treason Resolvtions*, and served as the Speaker of the Pennsylvania Assembly, a member of the Pennsylvania Committee of Safety, and a member and chairman of the Board of War.

In their book, *American Samplers*, Ethel Bolton and Eva Coe list and describe a slightly larger sampler worked in "petit-point and cross-stitch" by Elizabeth Coultas Gray which displayed a "bunch of flowers in basket, fills entire sampler." Elizabeth was Martha's older sister and probably worked her piece around 1770. From the description of Elizabeth's now unlocated sampler, it would appear that Martha simply copied her sibling's needlework. The Revolution undoubtedly left little time in this family to design a new sampler for the younger sister. EDG

167

166 Lucy Howland Bassett (1803–1894) was born in Lee, Massachusetts, the daughter of Gershom and Abigail Howland Bassett. On August 5, 1822, she married Crocker Thatcher, also of Lee. They settled there, but later moved to Connecticut. The bed cover descended in the family of the maker until it was given to the Museum by her great granddaughter. The unusual "full blown poppy" design of this quilt may have been her own invention. Although templates and other patterning devices were available for purchase by quilters, this floral arrangement appears to be unique. Working in the mid-nineteenth-century tradition of quilts made from predominately red and green textiles, Lucy Thatcher probably purchased red, pink and green "vermiculate"— to use in her quilt. After carefully appliquéing her motifs to the pieced ground cloth, she finely stitched the blank spaces in diamond, diagonal or sunburst quilting. As a final touch she edged three sides with a folded tape border. Explicit instructions in quilt making and the art of tape trimming could be found in such leading periodicals as *Peterson's Magazine,* founded in Philadelphia in 1842. A January 1871 issue offered just such instructions for folded tape trimming concluding, "This is quite a simple pattern if carefully followed." GSA

167 Mary Ann Barringer (1811–1845) was the daughter of General Paul Barringer and Elizabeth Brandon Barringer of Poplar Creek, Cabarrus County, North Carolina. Her brothers all achieved prominence: Daniel Moreau became Minister to Spain under President Pierce, Victor became Judge at the International Court of Appeals in Alexandria, Egypt, and Rufus became a Brigadier General in the Confederate Army. On July 1, 1828, Mary Ann was married to Dr. Charles Wilson Harris at the Barringer homestead, and the quilt was probably made in anticipation of the event.

For her design she used English textiles, possibly imported through the ports of Charleston, South Carolina, or Wilmington, North Carolina. Her central floral medallion may have been cut from a large, patterned, furnishing cloth, or it may have been from a textile designed specifically for quilt centers. Her borders were probably cut from border textiles, where several borders, printed side by side, could be cut apart to use in trimming textile furnishings. After positioning her cut-out motifs on her cotton quilt top, Mary Ann set in her borders and then outlined all the elements of the floral medallion and corner motifs with a very fine buttonhole stitch. She finished her quilt by stitching through the layers in a diagonal or diamond quilting pattern. GSA

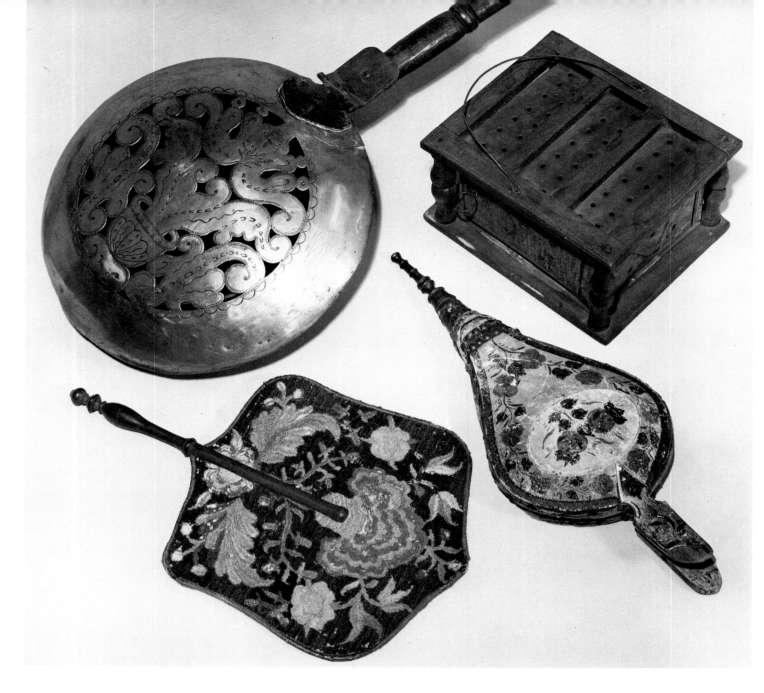

168 In the hearth-warmed houses of early America heating was a major problem. "All through the long severe winter we were cold as a matter of course," recalled Marianne Silsbee of Salem, Massachusetts, "excepting the side next to the glowing wood fire and that was scorched: the entries and sleeping rooms were probably at freezing point, ice on the water-pitchers, unmelting frost on the windows." Fire screens, such as this crewel-embroidered example, helped to shield the "scorched" side, and bellows, bed warmers, and footstoves attempted to augment and distribute the fireplace heat.

Annie Crowninshield of that same Massachusetts port town detailed the use of footstoves in the 1820's: "At that time there was no way of warming the houses except with wood-fires in the rooms and stoves in the halls; so it was the custom to have foot-stoves made of tin, like a box with holes in the top, and set in a wooden frame. Then a little door opened on the side to put in a pan of red-hot coals from the wood-fires."

The winter cold imposed a geographic constriction on the household, forcing everyone to gather around the central heat source, and many families closed off sections of the house, living in only the "winter quarters." Caroline King remembered, "People lived and moved and had their being in one room in winter then." Under these confining conditions family cohesion and accord were requisite. EDG

169 This three-hundred-pound, sandcast-iron fireback was cast at the Marlboro Furnace in Frederick County, Virginia, around 1770. Sand still adheres to the back from the casting. The ironmaster and owner of the Marlboro Furnace was General Isaac Zane, Jr., "a fiery Patriot" and Quaker from Philadelphia who served in the Virginia militia during the Revolution and later became a general. Characterizing himself as a "Quaker for the Times," Zane was an example of the dynamic and diversified Quaker merchants of the eighteenth century. Working through his brother-in-law, John Pemberton of Philadelphia, Isaac Zane was able to obtain the carved pattern for this fireback from the noted specialist carvers of Philadelphia Nicholas

Bernard and Martin Jugiez. A receipt now filed in the Pemberton Papers at the Historical Society of Pennsylvania, reads: "Rec^d 12 mo^th 20th 1770 of John Pemberton Eight pounds for the carving the Arms of Earl of Fairfax for a Pattern for the Back of Chimney sent Isaac Zane jr. Bernard & jugiez." The Coat of Arms of Thomas, sixth Lord Fairfax (1693–1781), appears on the face of the fireback.

Thomas Fairfax, sixth Lord Fairfax of Cameron and proprietor of the Northern Neck of Virginia, was born at Leeds Castle, in Kent, England. His mother, Catherine, was the heiress of Lord Culpeper, who had served as governor-general of Virginia under Charles II. The coat of arms first appears on a map by John Warner, published in London

in 1745, "A SURVEY of the NORTHERN NECK of VIRGINIA...," which was commissioned by Lord Fairfax to confirm his claim to over 5,200,000 acres of prime Virginia land.

At least eight of these Fairfax firebacks are known to exist; all have been found near Winchester and close to the site of the foundry. A casting flaw in this example cuts diagonally across the lion's legs and obscures part of the inscription which reads, "FARE FAC/ ZANE MARLBRO." Zane himself referred to the Marlboro Furnace as "Marlbro Old Furnace" in a description of his estate. The purpose of a fireback is to increase the efficiency of the fireplace and to protect the bricks at the back from the damaging heat of the fire. JM

171 Molly Lothrop probably made this bed cover, or bed "rugg" as they were called in early American household inventories, around 1779 in New London County, Connecticut. Although the rugg at first appears to have been hooked, it was actually needleworked in a running stitch with a wide variety of brown crewels on a light brown woven wool foundation. The pile was left uncut. Eighteenth-century bed ruggs appear to be indigenous to New England, with most examples originating in Connecticut, many within New London County.

This rugg was received with a tradition of having been made by Mrs. John (Molly) Stark of Derryfield (now Manchester), New Hampshire, for her niece Mary (Molly) Stark Lothrop. It seems more probable that Molly Lothrop worked it herself. Preliminary research suggests that she was from Lebanon or Norwich, Connecticut. On January 21, 1779, she married James Lothrop (Lathrop) who had served in the Revolution as a private in Captain Huntington's Company from Norwich. The rugg descended in the family through their daughter Polly.

Molly Lothrop's rugg and two other extant examples from New London County—the Metcalf and Hyde family ruggs from Lebanon and Norwich—indicate a common design source or pattern was known to the needleworkers. The ultimate design source for the central tree-of-life motif with its branched trunk, scrolled leaves, and blossoms of multifarious botanical species, was the English-inspired and Indian-made painted and dyed cotton palampores so favored by the wealthy in the early eighteenth century. Many of these

170 In genteel circles great emphasis was placed on the comfort of the diners, and dining room furnishings were adjusted according to the season. In winter, well-kept fires, fire screens, dish crosses with spirit lamps, chafing dishes, and plate warmers contributed to the warmth of diner and dinner alike. Robert Roberts counseled house servants in 1827, "if in cold weather, and [there are] some hot dishes, your plates must be warm. And keep good fires, that the company may be all comfortable." Thirteen years later Eliza Leslie instructed, "In winter first see that the fire is good, and the hearth clean, and the plates set before it in the plate-warmer." This tripod-base brass plate warmer was made in England in the eighteenth century and holds four Chinese export soup plates. EDG

palampores were designed as bed covers for the Western market, so that the tree-of-life motif had long been associated with bedchamber furnishings.

The thickness and weight of the wool bed rugg would have contributed significantly to the warmth of the hibernal slumberer. That such a cover was often necessary is suggested by Governor James Glen's description of his first experience with the bitter cold winter nights in mid-eighteenth-century South Carolina: "The first instance of intense Cold that I shall mention, relates to a healthy young Person in my Family, who at the Time was Two or Three and Twenty Years of Age, and usually slept in a Room without a Fire: That Person carried Two Quart Bottles of hot Water to Bed, which was of Down and covered with English Blankets; the Bottles were between the Sheets; but in the Morning they were both split to Pieces, and the Water solid Lumps of Ice." EDG

small community.

Such a weaver may have been working in the village of Bridgehampton, Suffolk County, Long Island. The Museum's coverlet has a long family history of use in the Fordham family of that town. This detail photograph shows a cow

motif which is repeated in both corners of the foot border and which appears on several other coverlets. It is believed to be the trademark of an as-yet-unidentified Long Island weaver who produced coverlets, and probably other textiles, in the 1820's. GSA

172 With the spread of industrialization into the British textile industry at the end of the eighteenth century, hand weavers emigrated to the United States in order to pursue their craft. Many of these weavers, particularly those of Scottish or Irish descent, settled in eastern New York State. Using a draw loom, a patent carpet loom, or a loom with a Jacquard attachment, professional male weavers could weave coverlets, floor coverings, and damask table linens, in addition to broadcloth and sheeting. Working steadily, one weaver could take care of the textile needs of a

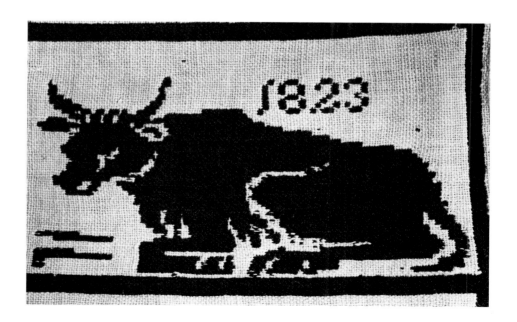

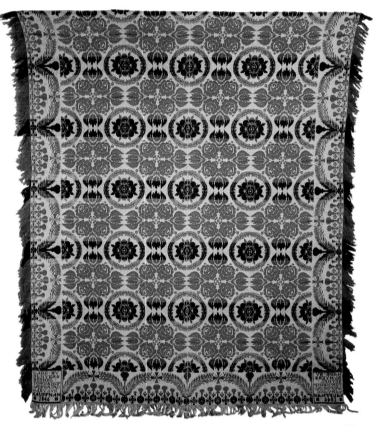

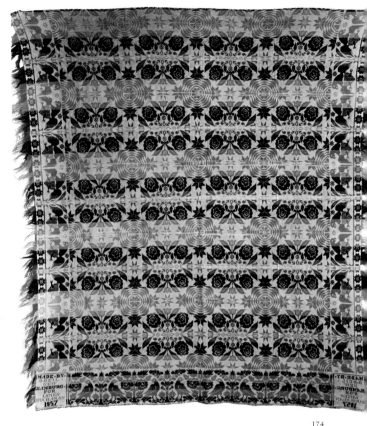

173

174

173 The recipient of this coverlet, Mary Ann Kauffman, was born in Montgomery County, Ohio, in 1827, where her parents, Christian and Esther Witmer Kauffman, had moved from Lancaster, Pennsylvania. On December 19, 1847, Mary Ann married Henry Strohm in Dayton. He, too, had been a resident of the German community in Lancaster. Following the westward migration, the Strohms moved to Iowa City, Iowa, where their children were born. The coverlet descended in the family.

Mary Ann Kauffman or her parents probably commissioned the coverlet as part of her dowry. It was woven in 1846, a year before her marriage. Jacquard coverlets were frequently woven with the names of young girls and dated within a year

or two of their marriages. This double-rose pattern with bands of multicolor wool is typical of coverlets woven by weavers of German ancestry in Pennsylvania and Ohio. Daniel Myers wove coverlets in Bethel Township, Clark County, between 1839 and 1852. By 1850 his business had expanded so that he was annually producing fifty coverlets and three hundred yards of carpeting with the aid of only one assistant. GSA

174 In 1857 James Buchanan (1791–1868) took office as the fifteenth President of the United States. This coverlet was probably woven by David Beil for Buchanan in honor of his election and as a souvenir of his home state, Penn-

sylvania. Although James Buchanan was a resident of Franklin and Lancaster counties in the southeastern part of the state, he had several connections with western Pennsylvania, especially Crawford County, which is tangent to Mercer County, where Beil had his weaving shop. Buchanan's sister, Maria Yates, lived in Meadville, Crawford County. In addition to visiting his sister, Buchanan also stayed with the Brawley family of Meadville, as the Honorable James Porter Brawley and Buchanan had served together in the Pennsylvania legislature. It is not known if Buchanan ever received the coverlet. It descended in the Brawley family. David Beil resided in New Hamburg, Mercer County, and wove coverlets from the 1840's to the 1860's. GSA

175 It is difficult for us today to imagine a world without adequate lighting; we are so accustomed to an electrified world. However, to eighteenth-century man, unsatisfactory lighting was a problem faced daily. Throughout the eighteenth century attempts were made to perfect a clean, odorless, bright, and low-cost light. A group of early lighting devices widely used by Americans would include rushlights, crusie lamps, and betty lamps. Commonly, these lights were wrought from iron with few decorative elements.

The plier-like rushlight burned a dried and fatted rush stalk. This example is mounted in a block of wood and also has a candle socket. The iron crusie lamp and the brass betty lamp both burned grease extracted from animal fat, a fuel which was readily available in the household. The betty lamp with a cover and a spout fashioned as a wick support was an improvement on the crusie design, which had a shallow, open pan and no wick support. Candles were of primary importance in lighting the early home, although their expense ensured economy in their use. This mid-eighteenth-century brass candlestick and the mid-nineteenth-century pressed glass dolphin stick attest to the lengthy popularity of that lighting device.

By 1830 many Americans were using a variety of oil lamps to light their homes, and American glass companies manufactured lamps of diverse shape. Many had metal screw-top burners for the rag wick, those with double wicks offering more than twice as much light as the single-wick examples. Americans living in the second half of the nineteenth century witnessed an incredible development in illumination from candles to oil lamps, to gas light and kerosene, and ultimately to electric incandescents. SMD

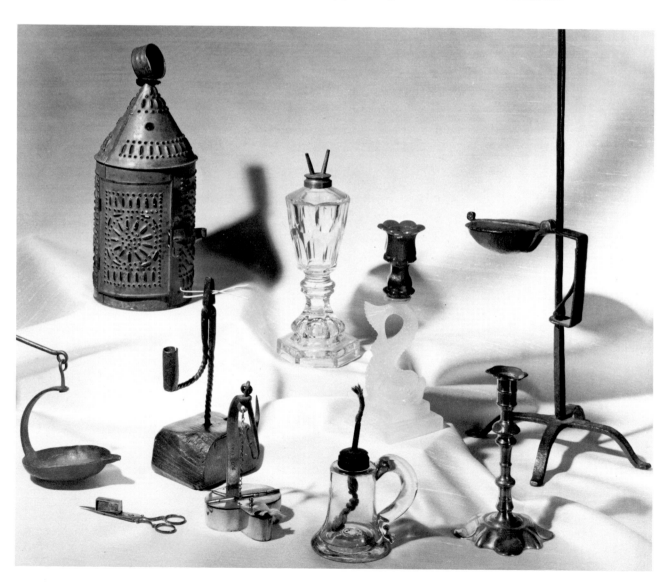

George on his pet Goat.
Published by B. Bramell, 572 N. Second Street, Philadelphia.

176 *George on his pet Goat* was published in Philadelphia around 1820, and is the kind of colorful, inexpensive, appealing print that could have hung on the walls of many simple, domestic interiors. The stained pine frame is original and quite possibly homemade. The small scale of the print facilitated distribution, and the simple lines encouraged copying. The Museum of Fine Arts, Boston, owns a watercolor by the primitive watercolorist Mary Ann Willson (w. 1800–1825) of Greenville, New York, which is a direct copy of this print. She undoubtedly entitled her rendition *Henry on his pet Goat* in deference to the child for whom it was intended. In light of this obvious borrowing, a description of Mary Ann Willson's *oeuvre* by an acquaintence is particularly amusing: "[Mary Ann] *Made pictures* which she sold to the farmers and others as rare and unique 'works of art.'" EDG

177 This cotton doll with its painted face and hair appears to be a homemade imitation of the Emma E. Adams rag dolls which were produced in Oswego, New York, between 1891 and 1900. Today, this type of rag doll with a painted face is often referred to as a Columbian Doll, in reference to the fact that similar dolls were exhibited at the 1893 Columbian Exposition in Chicago. The doll's underclothing includes a chemise, a pair of drawers, two cotton petti-coats and one flannel one. The dapple grey sports a mane and tail of real horsehair and a padded leather saddle. The hooked rug is contemporary with the horse and its rider. SMD

Rooms for Many

URING the early years of this century several state DAR societies helped to defray the costs of constructing and maintaining their national headquarters, Memorial Continental Hall, by purchasing and furnishing a room in the building. The earliest State Room, that of New Jersey, had been finished and outfitted by the time of the completion of Memorial Continental Hall in 1909 and has not changed significantly since. Carved and crafted from the oak timbers and iron elements of the British vessel *Augusta,* which sank on October 23, 1777, after leading the attack against Commodore Hazelwood's fleet defending Fort Mercer on the Delaware, it is a unique expression of the patriotic veneration for historical relics which was so much alive in the early years of the DAR Society. Most of the State Rooms were initially equipped for office use and other functional purposes, but in subsequent years many have been redecorated to evoke the feeling of the early American home. Furnishings have been progressively improved and room settings updated by recent scholarship to suggest more accurately the arrangements of the early home. In recent years an increasing emphasis has been placed on including furnishings of regional pertinence.

A synthesis of Museum staff expertise and state membership support, the thirty-four State Rooms at the DAR Museum offer a pleasing diversity. Although many states do not maintain a room, each state society has generously contributed to the success and distinction of the DAR Museum and its State Rooms.

178 Detail from a salt-glazed-stoneware teapot, Staffordshire, England, c. 1745.

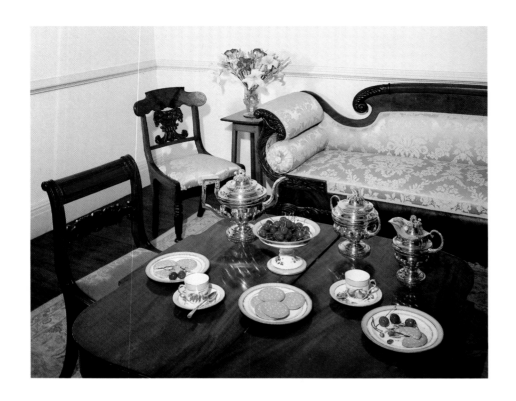

179 The Alabama Room was given in 1911 as a reception room for the President General and served in that capacity until World War II, when it was used as an office by the American Red Cross. In 1946 it was redecorated in the Empire style of the 1830's and 1840's. The handsomely-carved mahogany sofa dates from around 1830. The bounteous basket of fruit carved in the splat of the mahogany side chair in the background speaks of American abundance. Upon the open gaming table is set another bounty of fruit. This time it appears on a French porcelain dessert service with an apricot-colored border enclosing a fruit or flower design. The silver tea service was made by the South Carolina silversmith John Ewan between 1825 and 1830. JM

180 The decoration of the California State Room was suggested by a room in a whaling station in Monterey, California. The white-washed walls and exposed ceiling beams are suggestive of the adobe architecture prevalent in Monterey in the 1860's. Most of the furnishings can be associated with the eastern states, for much furniture made its way to the California coast by sea around Cape Horn, or by wagon across the Western Plains. The Connecticut mantel clock and the Pittsburgh glass are indicative of the household amenities which were made available to all in the second half of the nineteenth century. On the table is a nineteenth-century lace-making pillow complete with parchment lace patterns and spools. SMD

181 The Colorado Room serves as a conference room for the office of the Curator General. Frequently used by the Museum staff for teaching or research, the room is also available to visiting scholars who wish to examine objects from the Museum's collections. The framed Navaho rug is a reminder of Colorado's native heritage. SMD

182 The Connecticut Board Room (1904–1906) is the room in which the NSDAR Board of Management meets. A reliance on the classical principles of architecture, an emphasis on symmetry, and an elaborate stucco relief decoration highlighted with gilding identify this room as an example of early twentieth-century Beaux-Arts architecture. SMD

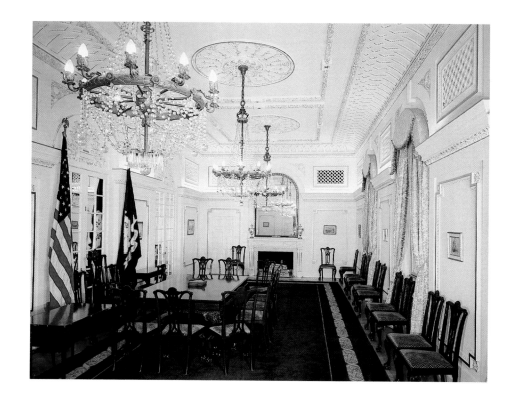

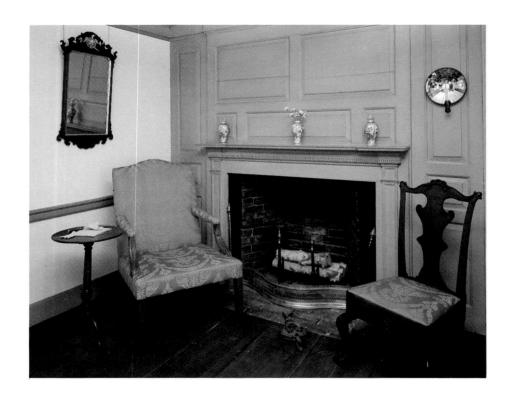

183 The Delaware State Room was installed in 1956. The mid-eighteenth-century end paneling came from the Goodwin House in Stratford, Connecticut, and the wide-board flooring, hearth bricks, nails, and hardware came from an early nineteenth-century home in Ware, Massachusetts. The upholstered-back mahogany armchair was made by John Janvier Sr., and is believed to be of Delaware origin, as is the walnut side chair. Above the side chair hangs a mirrored candle sconce which would have reflected light about the room, greatly augmenting the illumination of one small candle. JM

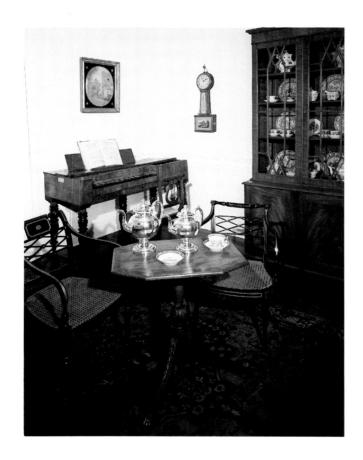

184 The District of Columbia State Room displays several pieces of regional interest. The painted maple armchair to the left of the table is thought to have been part of the original furnishings of Colonel John Tayloe's Washington townhouse, The Octagon, designed by the celebrated architect Dr. William Thornton in 1798. The needlework picture hanging over the piano was at one time backed with a piece of a Georgetown newspaper dated 1813. Although the silver tea and coffee pots were probably made in Pennsylvania, Seraphim Masi, a District of Columbia retailer of silver, fine jewelry, and fancy goods, impressed them with his stamp before selling them locally. CMD

185 The tavern held a prominent place in early American life, serving both the local community and the transient population; the Georgia State Room is based on Peter Tondee's Tavern in Savannah, Georgia. Although the Tondee Tavern no longer stands, the room is furnished as suggested by Peter Tondee's 1775 estate inventory. His furnishings included twelve windsor chairs, a quantity of pewter and creamware, several pieces of china, and a delft punch bowl. The delft punch bowl in this view dates from the mid-eighteenth century. Of particular interest are the New England windsor chairs, which were serviceable and inexpensive and were frequently shipped from New England to a number of southern ports. The pewter is of both New England and British manufacture and the pottery is English. Despite political antagonisms, British goods remained in great demand in America. GSA

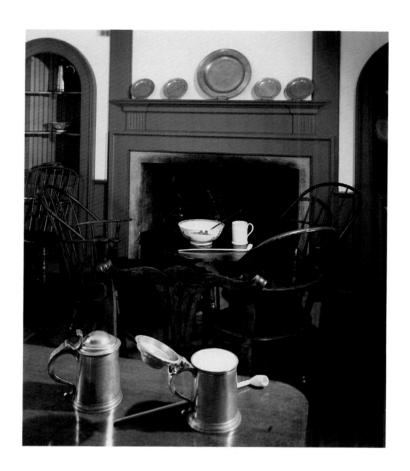

186 The spider-leg table in the Illinois Room is set with a pitcher, strawberry diamond and fan-cut lemonade cups, and a sugar dish of Pittsburgh glass. These are complemented by Chinese export porcelain dishes. The five-fingered flower holder, filled with fresh lavender, was made in England at the end of the eighteenth century. The adjustable firescreen would have been necessary in the winter months to shield one's face from the blazing fire. Frequently the screen was embroidered by the housewife. At candle-lighting time a stand or table, such as this tripod-base example, would have been pulled up to a chair and a candle placed on it, enabling one to finish the last of the long day's tasks. JM

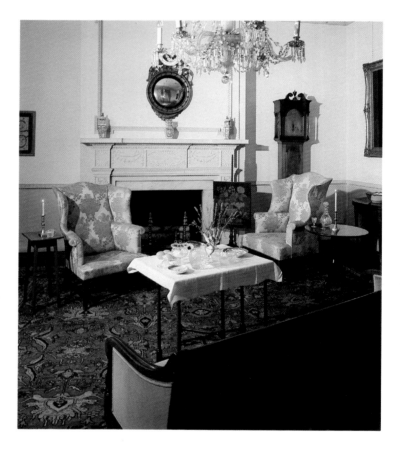

187 The tall secretary bookcase in the Indiana Room was made in North Carolina in the late eighteenth or early nineteenth century and retains its original blue/grey painted interior. Beside it is an English bookpress. The pastel portrait depicts William von Covenhoven, a New Jersey resident who fought in the American Revolution and is believed to have moved west to Indiana. On the table in the background are a pair of terrestrial globes made by Kirkwood & Son in Edinburgh, Scotland, around 1800, and a walnut perspective glass stamped "T. FLOYD." A perspective glass was for amusement and enabled a viewer to look through the lens at a print and get a feeling of perspective or space relationship. GSA

188 A handsome early nineteenth-century corner cupboard with skillful detailing highlights this corner of the Iowa State Room. It is flanked by an important early walnut dressing table, possibly made in Virginia, and an English settee. The English doll also dates from the eighteenth century, although her painted face and costume have been updated. Above her hangs a portrait of Mrs. William Young. This portrait and its pendant of Mr. Young, which also hangs in the room, were painted in Geneva, New York, and carried to Iowa in the nineteenth century by a descendant of the sitters. To the right hangs a likeness of Oliver Blanchard, who is believed to have been an American sea captain. SMD

189 The Kansas Chapel is a scaled-down re-creation of the Sargent Chapel in the Congregational Church in Topeka, Kansas. The stained-glass windows were removed from the 1911 Carnegie Library in Witchita before it was torn down. The sunflower, which grows wild on the Kansas prairies, was adopted as the official state flower in 1903. Its image suggests the agrarian economy of the state and the religious spirit of its people. Religion played an important role in the lives of many early pioneers. This was especially true of the settlers of Kansas, who quickly established churches and religious schools and strongly supported such moral issues as the abolition of slavery and the prohibition of the sale of alcohol. GSA

190 It is appropriate that two engravings by John James Audubon (1782–1851) hang in the Kentucky State Room, for Audubon resided briefly in Louisville as a retail merchant, and Henry Clay Jr. was among the eighty Americans who subscribed in 1832 to London publisher Robert Havell for a complete set of Audubon's *Birds of America*. The two aquatint engravings pictured, "Towhe Bunting" and "Yellow Redpoll Warbler," are from that set. Audubon had drawn birds from childhood, and when he met Alexander Wilson, a weaver and pioneer ornithologist, in Louisville in 1810, his interest in birds was renewed. Wilson inspired Audubon to travel the country painting North American species. The portrait of George Rogers Clark (1752–1818) was painted in 1910 by J.A. Michelbaur after the original by Matthew Harris Jouett. The English wing chair, and the American slab-top pier table and sofa were all crafted of mahogany in the first half of the nineteenth century. SMD

191 The Louisiana Room is unique among the State Rooms at the DAR Museum in that it is arranged like a gallery. Among the objects on display in that gallery which have a distinctly Louisiana feeling are this armoire and blanket chest. The armoire was a storage piece of French derivation and has survived in greater number than any other furniture form used in lower Louisiana during the late eighteenth and the early nineteenth centuries. This example is crafted of cherry which is indigenous to the lower Mississippi Valley region. In the nineteenth century, simple turned legs such as these supplanted the S-curved cabriole legs of earlier armoires. The paneled blanket chest of southern yellow pine and tulip was also a useful piece for storage and would undoubtedly have been painted originally. CMD

192 The large needlework family register in the Maine State Room records the life dates of members of the John Flint family. John Flint was a trader in Bath, Maine, but the sampler was probably worked by a daughter while away at school in Portland. The 1823 portrait of a Maine woman has been attributed to John Brewster Jr., who painted in Maine, Massachusetts, Connecticut, and eastern New York State. On the mantel is a shelf clock made by Seth Thomas in Plymouth Hollow, Connecticut. CMD

193 By the close of the Revolution, Baltimore was the principal Maryland port and the new prosperity resulting from this increased commercial activity was reflected in the home furnishings of Baltimore residents. Exotic goods imported directly from China or England were used side by side with objects shipped down from the northern states and products of local manufacture. Among the latter is the secretary bookcase which belonged to the Bond family of Baltimore. The style is characteristic of Baltimore cabinetwork, and the extensive use of tulip as the secondary wood strengthens this attribution. The chest of drawers might also be a Baltimore product. The pair of mahogany side chairs against the back wall resemble others made in Williamsburg and a number of other areas in the Chesapeake region. GSA

194 The Massachusetts bedchamber was one of the earliest State Rooms to be furnished in Memorial Continental Hall, and was designed after a room in the Hancock-Clarke home in Concord, Massachusetts. The maple bed has been made up with a woolen sheet woven by Elizabeth Hayward, who was born in Plymouth, Massachusetts, in 1809, and a bed rug made in Connecticut around 1779. The crewel-embroidered table cover in the foreground was worked by Zermiah Washburn Hayward of Bridgewater, Massachusetts. Hanging over the Massachusetts chest from the Northampton region is a stumpwork picture depicting the marriage of Charles I, King of England. It is worked in silk thread, metal bits, wool, and silk metallic purl. JM

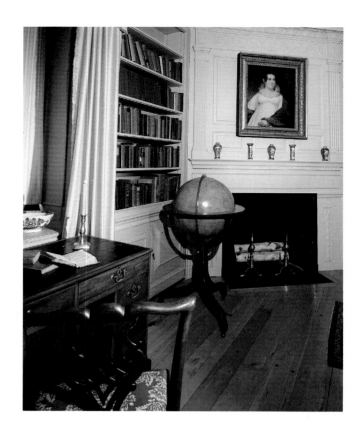

195 Over the fireplace in the Michigan State Room hangs the lovely portrait of Sarah Humes Porter painted in 1819 by Jacob Eichholtz. Her husband, George Bryan Porter, whose portrait also hangs in the room, was named Governor of the Michigan Territory in 1831, and the portraits traveled out to Michigan with the couple. Also from Pennsylvania, though less visible, is an important iron fireback in the fireplace, cast at the Mary Ann (Mary An) Furnace in York in 1763. English furniture, an English tin-glazed earthenware bowl, and a Chinese export mantel garniture enhance the setting. SMD

196 The Missouri Room represents a Victorian parlor in the second half of the nineteenth century, and the furnishings create an atmosphere of ease and luxury. The fashionable gas-lit chandelier, the Aubusson carpet, the imported marble fireplace surround with its ornate overmantel looking glass, the amply-upholstered seating furniture, the elaborately-carved sofa table, the multi-tiered display table laden with decorative objects, all suggest a knowledge of current fashion and a desire to own and display it. GSA

197 On June 26, 1928, the New Hampshire State Society voted to purchase a room in Memorial Continental Hall. Then called the "nursery," the name was changed in 1930 to the "Children's Attic" to better describe its decoration as an attic playroom. Wallace Nutting, the noted antiquarian, artist, author, and cabinetmaker from Massachusetts, was hired to design the room. Planning it around an over-mantel painting from a house in Piermont, New Hampshire, Nutting decided that the room "be done in panel work of the period 1770." In addition to this fireplace wall, he supplied two corner cupboards with glass doors "in which china or dolls furniture can be exhibited," and the six-branched chandelier. EDG

198 The New Jersey State Room is a unique and important embodiment of the antiquarian spirit which gave birth to the DAR Museum in 1890. The paneling and furniture for the room were carved from the oak timbers of the British ship *Augusta*, which had aided the British land forces in the capture of Philadelphia during the Revolutionary War. The *Augusta* sank in battle in 1777 but was raised and towed to Gloucester City, New Jersey, in 1869. Two New Jersey Daughters, Ellen Mecum and Ellen Matlock, devised the idea of salvaging the timbers and installing this room in Memorial Continental Hall which was then being built. The stained-glass windows depict scenes from the Revolution and were made by d'Ascenzo Studios in Philadelphia around 1925. CMD

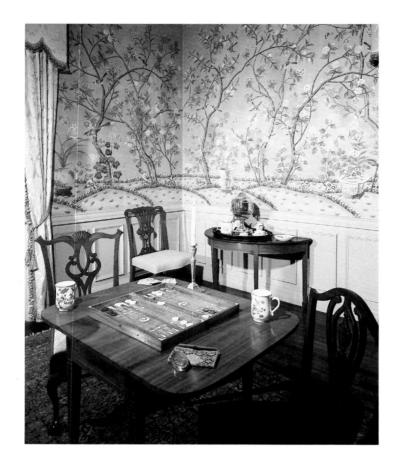

199 Because of the overwhelming importance of the China trade to the economy and culture of New York City, a number of accessories in The New York Room are Chinese in origin. When the *Empress of China* sailed into New York Harbor in 1785, she carried a quantity of Chinese porcelains as well as other exotic goods. The tea wares illustrated here are examples of porcelains made for the New York market and are painted with the coat of arms of New York, which was adopted in 1778. The enameled porcelain mugs on the gaming table are also Chinese and date from around 1770. The wallpaper, handpainted in the traditional manner, was made in Hong Kong in the twentieth century, but is suggestive of eighteenth-century papers and reinforces the importance of the China trade in New York history. GSA

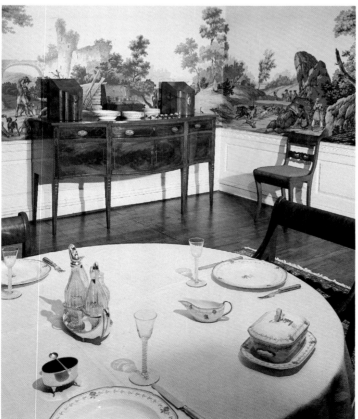

200 The North Carolina State Room is furnished as a dining room in an early nineteenth-century home. The English cream-ware dinner service numbers many pieces and is representative of the large sets which were being imported from England and China by the closing years of the eighteenth century. It is decorated with armorial devices and a floral border. The silver-and-glass caster stand is also English and was made by William Taylor and John Wakelin around 1783. On the southern sideboard are a pair of knife boxes and a bottle case, conventional sideboard accessories in the early nineteenth century. The wallpaper is a later version of "The Hunt," a scenic paper first printed by Zuber and Co., in Alsace, in 1831, and adds much to the color and beauty of the North Carolina Room. EDG

201 Ohio is represented by furnishings of the first half of the nineteenth century. Following the War of 1812, Ohio's population surged, and trade, industry, and agriculture expanded rapidly. This new prosperity, combined with the development of local manufactories and the greater availability of goods from the East, meant that homes could be supplied with necessities and many of the luxuries not formerly available. The beautifully grained tiger maple work table was made by a skilled, but not yet identified, cabinetmaker probably working in Portage County, Ohio. It was owned by Almon and Mary Babcock of Rootstown. The portrait of little Mary Denny of Mikkleton, is probably also of Ohio origin. The pier table has an Ohio history and is a type which could have been made by any number of cabinetmakers working in the Cincinnati region. GSA

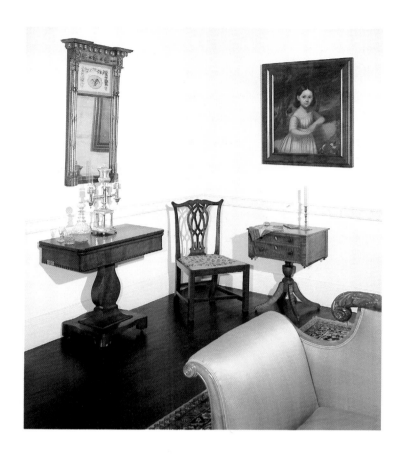

202 The Oklahoma Kitchen was completed in 1931, soon after the crane and brickbats had been purchased from an old house on Providence Road near Media, Pennsylvania. The apple pie would have been baked first in the heated oven to take advantage of the high temperature, and the oven would have been successively filled with foods requiring less heat. On the table are assembled the implements and ingredients necessary to make such a pie. Fresh apples fill the yellow-ware colander and the slip-decorated dish. Pieces of sugar cut from a sugar cone with nippers, cinnamon sticks, a nutmeg and its grater, a glass rolling pin, and an hour glass would all have been used. Filled with useful domestic and cooking accessories from North to South, from Maine to Oklahoma, the Oklahoma Kitchen represents that colonial room where so many activities centered around the great open hearth. JM

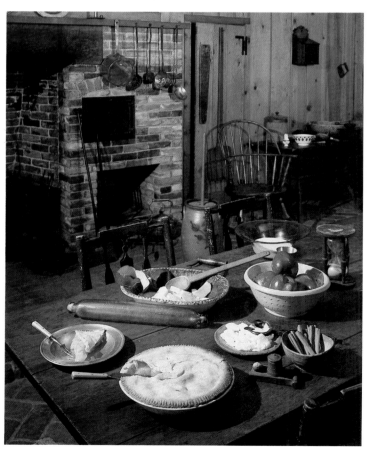

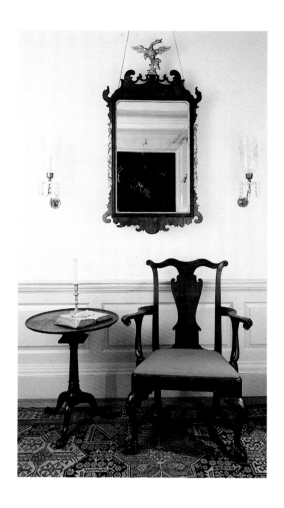

203 The Pennslyvania Alcove offers a sampling of the furniture which distinguished Pennsylvania craftsmen in the second half of the eighteenth century, a period when Philadelphia was the recognized cultural and artistic center of the nation. SMD

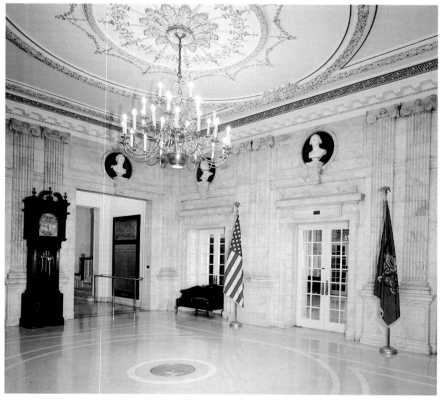

204 The Pennsylvania Foyer in Memorial Continental Hall once served as the entrance hall to the National Society's main auditorium, a room which now houses the extensive Genealogical Library. The elaborate architectural detailing reflects the Beaux-Arts training of the building's architect, Edward Pearce Casey (1864–1940). Ten bust portraits of famous Americans by George Attilio and Furio Piccirilli were sculpted around 1910 to encircle this entrance foyer. SMD

205 A needlework mourning picture embroidered by Martha Noyes of Westerly, Rhode Island, in memory of her mother, who died when Martha was seven years old, hangs on the wall of the Rhode Island Room. The banjo clock, also made in Rhode Island, is by David Williams of Newport and Providence. On the Grecian sofa is a rosewood and ivory flute marked "Firth, Hall & Pond, Franklin Sq^e N-York." It was made in New York in the 1830's. The harp is a simple, homemade piece with gut strings and no pedal. Made around 1830, it is sturdily constructed and simply painted. The tripod-base music stand, in contrast, is richly inlaid with marquetry flowers and musical instruments. JM

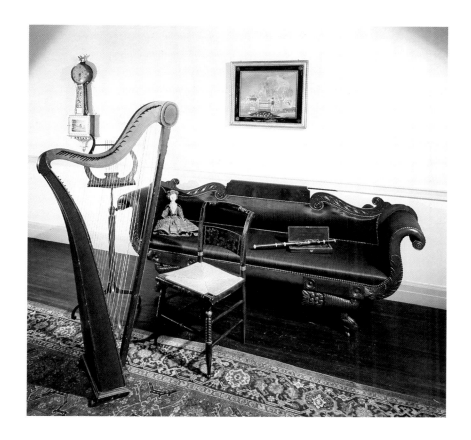

206 The installation of the South Carolina State Room has been carefully researched to suggest an early nineteenth-century southern bedchamber. The pine fireplace surround was taken from the Carwile-McClentocky House in Edgefield, South Carolina. According to family tradition the mantel was carved sometime between 1807 and 1817. The mahogany and white pine bedstead, with its fluted and rice-carved footposts, relates to other beds made in South Carolina in the opening years of the nineteenth century. During the mosquito-plagued summer months, it was necessary to enswathe the bed in mosquito netting to ensure a restful sleep. SMD

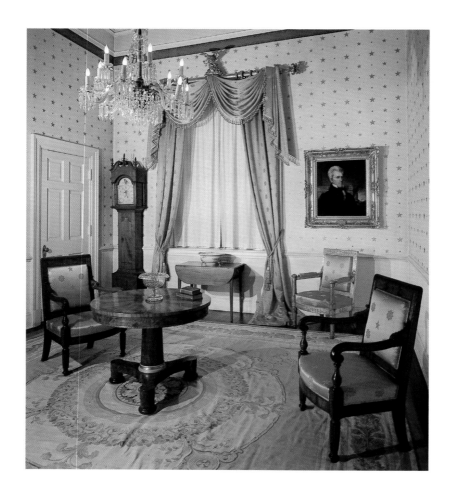

207 Several objects in the Tennessee State Room relate to the history of the White House. The portrait of Andrew Jackson, the state's most celebrated hero, was painted by his artist friend, Ralph E.W. Earl. The likeness was perhaps taken while Jackson was President, for it shows him seated in one of the chairs ordered by President Monroe from the French cabinetmaker Pierre Antoine Bellangé in 1817 for the Oval (now the Blue) Room in the White House. Displayed below the portrait is one of the gilded armchairs from that set. The pair of mahogany armchairs by the Georgetown cabinetmaker William King Jr., are from a set of twenty-four chairs and four sofas commissioned by Monroe that same year for the East Room. The early nineteenth-century New York pedestal table is positioned over the central medallion of an exquisitely-woven and nicely-preserved Aubusson carpet. EDG

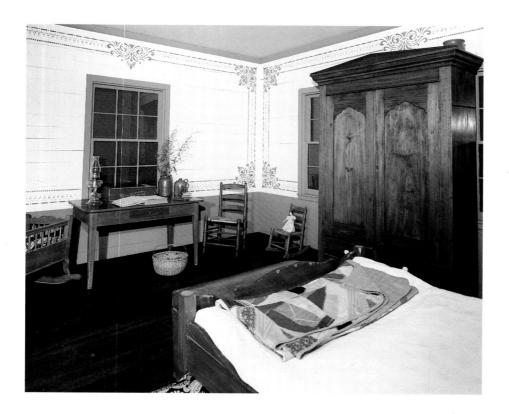

208 The Texas Bedroom suggests a Texas interior in the German immigrant style of around 1850 to 1880. The inspiration for its decoration came from a bedroom in an extant house located in Alleyton, outside of Columbus, Texas. The wall stenciling was done by artists who specialized in traditional Texas stenciling, and the furnishings are all either of Texas origin or have a history of having been used in the region. Of particular interest is the wardrobe or *kleiderschrank,* an essential element in the closet-less bedroom. Most of the furniture, including this wardrobe, are made of pine, and the chair has the special Texas feature of a rawhide seat. The ceramic jar in the background is impressed "I SUTTLES/LAVERNIA," and the jug is also of local manufacture. GSA

209 The sitters in the portraits which hang in the Vermont Room, Samuel and Lydia (Dyer) Townsend, were married in 1789. They lived in Hancock, Massachusetts, until 1809, when they moved to Wallingford, Vermont; it was here, in 1832, that they sat for James Whitehorne, a portrait and miniature painter working in that town. The cherry desk and bookcase may also be of Vermont origin and came into the collection with a history of ownership in that state. The desk interior is attractively fitted with stepped drawers, shaped pigeonholes, and column-faced document drawers. The cherry tall-case clock is believed to have been originally owned by Noah Jones, who settled in Shoreham, Vermont, in 1786. The side chairs exemplify the simple, ubiquitous side chairs of many rural interiors. Lightweight and easily portable, they were used throughout the house. CMD

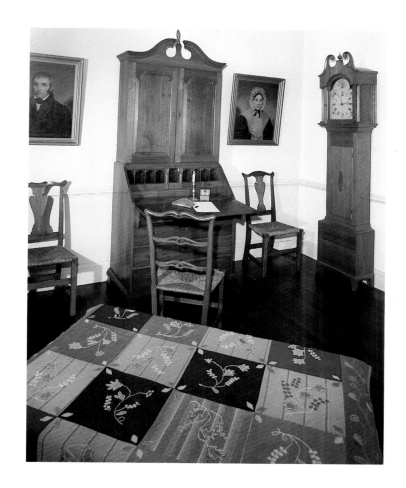

210 The mahogany dining table and set of six side chairs in the Virginia State Room were made in the South, possibly Baltimore, in the Federal period. In the established practice of that time, the tablecloth has been removed for a final course of fruits and nuts, thus displaying the polished and lively-grained table surface. The pearlware basketweave plates and baskets were made at the Wedgwood Porcelain Works in Staffordshire, England, around 1785. Inside the fireplace is a cast-iron fireback which reads "1734 AWM" and which was owned by George Washington's parents, Augustine and Mary Washington, at their home at Ferry Point near Fredericksburg, Virginia. The early date of the fireback suggests that it was made with iron from the Accokeek furnace. EDG

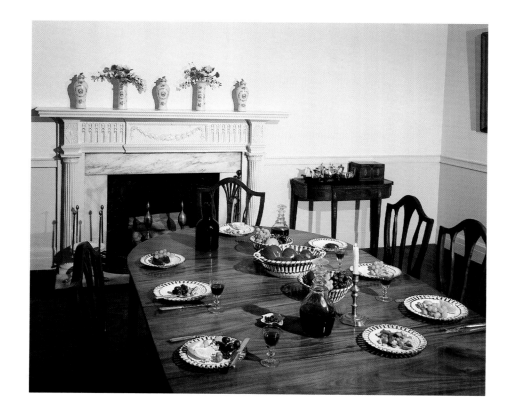

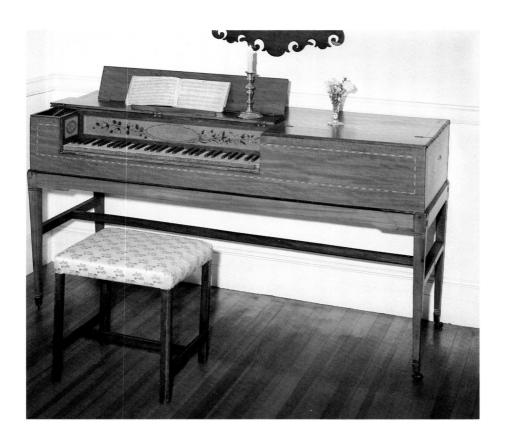

211 The West Virginia Room contains one of the finest musical instruments in the collection. The pianoforte was made by Charles Taws of Philadelphia between 1794 and 1800. According to donor history, Henley Chapman purchased the piano in Philadelphia and transported it to his home, Mount Prospect, overlooking the New River in Giles County, Virginia. Giles County is in the southwestern part of Virginia and borders the land that was set aside as West Virginia after the Civil War. Charles Taws, a native of Aberdeen, Scotland, achieved prominence as a maker of fine keyboard instruments as well as a merchandiser of London and Dublin instruments. Taws supplemented his income by making available to the public musical instruments to "let out by the month or quarter." He also "tuned and repaired in the best manner." GSA

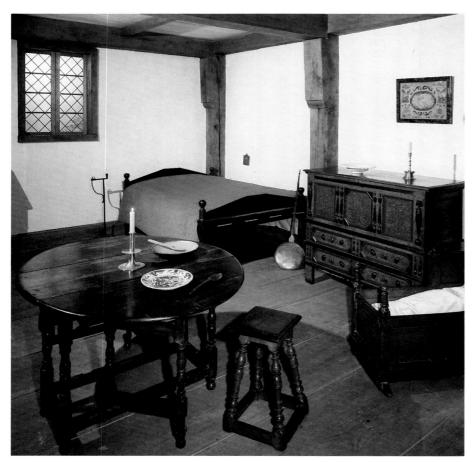

212 The Wisconsin State Room represents a hall or all-purpose room in a seventeenth-century New England home. Depending upon the time of day and the needs of the family, a hall might be used as a kitchen, dining room, sitting-room, bedroom, nursery, office, or school-room. Chests, such as this oak and pine "sunflower" chest from the Hartford, Connecticut, region, would have held and helped preserve the family linens. The same rectangular joined construction can be seen in this detail of a seventeenth-century English cradle. Adults would have shared a bed similar to this simple but nicely-detailed example, which is high enough off the floor to have allowed for the storage of a trundle bed beneath it. The turned oak joint stool could be moved about the room with ease, and the walnut gateleg table could be folded and stored against the wall, thus providing additional space for family activities. JM

Notes

Columbia's Daughters

1. Quoted in Mollie Somerville, *In Washington* (Washington, 1965), p. 17.
2. *Ibid.*
3. "The Continental Memorial Hall," a circular mailed to the DAR membership (1899), n.p.
4. *Ibid.*
5. Quoted in Elisabeth Donaghy, "Your Museum and The Bicentennial," *The Daughters of the American Revolution Magazine,* vol. 107, no. 4 (April 1973), p. 294.
6. "The Continental Memorial Hall"
7. *Ibid.*
8. Quoted in Mollie Somerville, *Washington Landmark* (Washington, 1976), p. 13.

Under This We Prosper

1. Alexis De Tocqueville, *Democracy in America,* ed. Phillips Bradley (New York, 1980), vol. 2, p. 73.
2. James Fenimore Cooper, *Notions of the Americans* (1828; New York, 1963), vol. 1, p. 144.
3. Quoted in Betty-Bright P. Low, "The Youth of 1812, More Excerpts from the Letters of Josephine du Pont and Margaret Manigault," *Winterthur Portfolio 11* (Charlottesville, Va., 1976), p. 196.
4. Thomas Low Nichols, *Forty Years of American Life 1821–1861* (New York, 1937), p. 37.
5. Quoted in Russel Blaine Nye, *The Cultural Life of the New Nation, 1776–1830* (New York, 1960), p. 101.
6. *Forty Years of American Life,* p. 64.
7. Quoted in *A Russian Looks at America, The Journey of Aleksandr Borisovich Lakier in 1857,* ed. Arnold Schrier and Joyce Story (Chicago, 1979), p. 64.
8. *Forty Years of America Life,* p. 38.
9. *Adams Family Correspondence,* ed. L. H. Butterfield (Cambridge, Mass., 1963), vol. 2, p. 225.
10. Quoted in Anne Home Shippen Livingston, *Nancy Shippen Her Journal Book* (Philadelphia, 1935), p. 43.
11. *Favorite Poems of Henry Wadsworth Longfellow* (New York, 1947), p. 385.

Faces of the Family

1. Francis J. Grund, *The Americans in Their Moral, Social and Political Relations* (1837; New York, 1971), vol. 1, p. 27.
2. Quoted in *The Cultural Life of the New Nation, 1776–1830,* p. 277.
3. Quoted in Neil Harris, *The Artist in American Society, The Formative Years 1790–1860* (New York, 1966), p. 61.
4. Quoted in Jules David Prown, *John Singleton Copley* (Cambridge, Mass., 1966), vol. 1, p. 17.
5. Quoted in Richard C. Nylander, "Joseph Badger, American Portrait Painter," unpublished master's thesis (State University of New York College at Oneonta, 1972), p. 14.
6. *The Americans in Their Moral, Social and Political Relations,* vol. 1, p. 136.
7. Chester Harding, *My Egotistigraphy* (Cambridge, Mass., 1866), pp. 26-27.
8. Quoted in Nancy E. Richards, "A Most Perfect Resemblance at Moderate Prices: The Miniatures of David Boudon," *Winterthur Portfolio 9* (Charlottesville, Va., 1974), p. 84.
9. Quoted in Rita Susswein Gottesman, *The Arts and Crafts in New York, 1777–1799* (New York, 1954), p. 10.
10. *The Cultural Life of the New Nation 1776–1830,* p. 108.
11. Quoted in Wendell D. Garrett, "John Adams and the Limited Role of the Fine Arts," *Winterthur Portfolio One* (Winterthur, Del., 1964), p. 254.
12. Quoted in Abbott Lowell Cummings, *Rural Household Inventories 1675–1775* (Boston, 1964), p. xxxiv.
13. Sarah Anna Emery, *Reminiscences of a Nonagenarian* (Newburyport, Mass., 1879), p. 245.

14. *The Selected Papers of Charles Willson Peale and His Family,* ed. Lillian B. Miller (New Haven, Ct., 1983), vol. 1, p. 201.
15. Quoted in *The Cary Letters,* ed. C. G. C. (Cambridge, Mass., 1891), p. 93.
16. Quoted in Avrahm Yarmolinsky, *Picturesque United States of America 1811, 1812, 1813, A Memoir on Paul Svinin* (New York, 1930), p. 35.
17. Quoted in *The Artist in American Society,* p. 66.
18. Quoted in *American Folk Portraits,* ed. Beatrix T. Rumford (Boston, 1981), p.19.
19. Frances Trollope, *Domestic Manners of the Americans* (1832; New York, 1949), p. 268.
20. Alfred Coxe Prime, *The Arts and Crafts in Philadelphia, Maryland and South Carolina 1786–1800* (The Walpole Society, 1932), p. 18.
21. *Ibid,* p. 11.
22. Quoted in *American Folk Portraits,* p. 176.
23. *The Arts and Crafts in New York, 1777–1799,* p. 4.
24. [Anne Grant], *Memoirs of an American Lady* (London, 1808), vol. 1, p. 172.
25. Quoted in *Nancy Shippen Her Journal Book,* p. 305.
26. Caroline Cowles Richards, *Village Life in America 1852–1872: As Told in the Diary of a School-Girl.* (1913; Williamstown, Mass., 1972), pp. 84-85.

Cycles of Life

1. Quoted in *The South Carolina Historical and Genealogical Magazine,* vol. 28, no. 2 (April 1927), p. 132.
2. Clare Jervey, *Inscriptions on the Tablets and Gravestones in St. Michael's Church and Churchyard, Charleston, S.C.* (Columbia, S.C., 1906), pp. 73-75.
3. *The Diary of Colonel Landon Carter of Sabine Hall,* ed. Jack P. Greene (Charlottesville, Va., 1965), vol. 1, p. 221.

4. Quoted in Sarah N. Randolph, *The Domestic Life of Thomas Jefferson* (Charlottesville, Va., 1947), p. 259.
5. Quoted in *The Cary Letters*, p. 63.
6. Lucy Larcom, *A New England Girlhood Outlined from Memory* (Williamstown, Mass., 1977), p. 259.
7. Quoted in Bernard Farber, *Guardians of Virtue, Salem Families in 1800* (New York, 1972), p. 161.
8. Quoted in *The Letters of Benjamin Franklin & Jane Mecom*, ed. Carl Van Doren (Princeton, N.J., 1950), p. 98.
9. Bethuel Merritt Newcomb, *Andrew Newcomb 1616–1686 And His Descendants* (New Haven, 1923), p. 122.
10. *Favorite Poems of Henry Wadsworth Longfellow*, pp. 327–328.
11. J. P. Brissot de Warville, *New Travels in the United States of America 1788*, ed. Durand Echeverria (Cambridge, Mass., 1964), p. 163. Emily R. Barnes, *Narratives, Traditions and Personal Reminiscences* (Boston, 1888), p. 160. The Prince de Broglie quoted in *The Pennsylvania Magazine of History and Biography*, vol. 2, no. 2 (1878), p. 166. Caroline King, *When I Lived in Salem* (Brattleboro, Vt., 1937), p. 75.
12. *New Travels in the United States of America*, p. 86.
13. *Ibid.*, p. 111.
14. *Ibid.*, p. 162.
15. Quoted in *The Domestic Life of Thomas Jefferson*, p. 69.
16. Timothy Dwight, *Travels in New England and New York*, ed. Barbara Miller Solomon (Cambridge, Mass., 1969), vol. 4, p. 335.
17. *A New England Girlhood Outlined from Memory*, pp. 190–191.

Tangible Comforts

1. *The Diary and Letters of Gouverneur Morris*, ed. Anne Cary Morris (New York, 1888), vol. 1, p. 271.
2. Quoted in Susan Gray Detweiler, *George Washington's Chinaware* (New York, 1982), p. 212.
3. Edward Everett Hale, *A New England Boyhood* (1893; New York, 1927), p. 4.
4. "Inventory & appraisement of the goods, chattels & personal Estate of Phebe Reich," *Frederick County, Maryland Inventories*, Maryland Hall of Records, vol. 9, no. 11 (1842), pp. 550–551.
5. Emily R. Barnes, *Narratives, Traditions and Personal Reminiscences*, p. 268.
6. Quoted in the *Pennsylvania Magazine of History and Biography*, vol. 27, no. 1 (1903), p. 123.
7. Quoted in Susan Burrows Swan, *Plain & Fancy, American Women and Their Needlework, 1700–1850* (New York, 1977), p. 91.
8. Quoted in John A. Kouwenhoven, *The Arts in Modern American Civilization* (New York, 1967), p. 7.
9. *A New England Girlhood Outlined from Memory*, p. 117.
10. Sarah Anna Emery, *Three Generations* (Boston, 1872), p. 119.
11. Quoted in *The Journal of Esther Edwards Burr 1754–1757*, ed. Carol F. Karlsen and Laurie Crumpacker (New Haven, 1984), p. 170.
12. *Ibid.*, p. 126.
13. Quoted in Gertrude Z. Thomas, *Richer than Spices* (New York, 1965), p. 139.
14. Quoted in the Museum of Fine Arts, Boston, *Paul Revere's Boston: 1735–1818* (Boston, 1975), p. 53.
15. Quoted in Charles H. Sherrill, *French Memories of Eighteenth-Century America* (New York, 1915), p. 133.
16. Quoted in Ann C. Van Devanter, *"Anywhere So Long As There Be Freedom;" Charles Carroll of Carrollton, His Family & His Maryland* (Baltimore, 1975), pp. 278, 280.
17. *Ibid.*, pp. 280–281.
18. *Ibid.*, p. 278.
19. *New Travels in the United States of America 1788*, p. 118.
20. Quoted in *Letters & Recollections of George Washington* (New York, 1932), p. 278.
21. Quoted in *The Native Muse*, ed. Richard Ruland (New York, 1976), p. 10.
22. George Francis Dow, *The Arts & Crafts in New England, 1704–1775* (Topsfield, Mass., 1927), p. 22.
23. Quoted in *French Memories of Eighteenth-Century America*, p. 55.
24. Dean A. Fales, Jr., "The Open Switch: Branch Lines for Collectors," *The Walpole Society Notebook, 1975* (The Walpole Society, 1976), p. 64.

Catalogue of Objects Illustrated

Frontispiece through Plate 178

Frontispiece
Needlework picture, *Liberty. In the form of the Goddess of Youth; giving Support to the Bald Eagle.*
1800–1815 • New Jersey or New York • Silk, watercolor, sequins, and mica on silk • 26¾ by 29⅜ inches (in frame) • Gift of the New Jersey State Society • Acc. 64.87

Facing Contents Page
The Capture of Major André (detail): See no. 15, below

1 Needlework picture, *Emblem of America*
Eliza Camp • 1810 • Connecticut • Silk, silk chenille, and watercolor on silk • 18 by 16 inches • Gift of the Stephen Decatur Chapter • Acc. Ill 82.44

2 *Memorial Continental Hall*
Edward Pearce Casey • c. 1904 • New York, New York • Watercolor on paper • 28 by 47⅜ inches

3 Pineapple finial from stairwell in Memorial Continental Hall
1904–1910 • American • Cut glass • H. 4½ inches Diam. 4½ inches

4 Photograph of the DAR Museum, South Gallery, Memorial Continental Hall, c. 1940. Courtesy Office of the Historian General.

5 Quilt
Ann Pamela Cunningham (1816–1875) • c. 1840 • Rosemont Plantation, Laurens County, South Carolina • Cotton • 105 by 98 inches • Gift of Mrs. F. Cunningham Burney and the Ann Pamela Cunningham Chapter • Acc. 54.160

Looking glass
Nineteenth century • American • Walnut, pine, glass • 16 by 8¼ inches • Gift of Mrs. Stephen Bonsal • Acc. NH 6819

Fashion doll
L. Repose • 1880–1890 • France • Bisque, porcelain, kid, cloth • H. 15 inches • Gift of Miss Mabel A. Clark • Acc. NH 4120

6 Painting, *Eagle*
Henry Inman (1801–1846) • 1833 • Signed and dated in the lower left corner, "H. Inman/ 1833" • Philadelphia, Pennsylvania • Oil on board • 10 by 7¾ inches • Gift

of Colonel Theodore Barnes • Acc. 61.50.1

7 Jacquard-type coverlet (detail): See no. 26, below

8 Bed cover
1790–1830 • China • Silk embroidery on silk, hand-knotted fringe on four sides • 111 by 92 inches • Gift of George W. King • Acc. 73.34

Tea cup and saucer
1790–1810 • China, for the Western market • Porcelain with enamel decoration • H. cup 2¼ inches Diam. saucer 5⅜ inches • Gift of Miss Lydia M. Cooke • Acc. RI 5510.7,.8

Folding fan
1800–1850 • China • Watercolor and opaque paint on mulberry leaf paper, ivory • L. 11⅜ inches Span 20 inches • Gift of Julia Grant, Princess Cantacuzene • Acc. 62.208

Painting, *Hong Kong Harbor*
Yeuqua • c. 1860 • Hong Kong • Oil on canvas, original frame • 29¼ by 22¾ inches • Gift of Mr. John Sprague • Acc. 67.61

Plate
c. 1800 • England • Cream colored earthenware with transfer print, "THE ABIGAIL SHUBAEL PINKHAM," and enamel decoration • Diam. 9⅝ inches • Gift of the DAR Museum Docent Committee • Acc. 79.15

Jug
1815–1820 • England • Cream colored earthenware with transfer print, "WILLIAM & JANE OF NEW BEDFORD," and enamel decoration • H. 9½ inches • Gift of Mrs. Edna Dugan Culberton • Acc. 65.102

9 Sauce tureen and lid and stand
1810–1820 • China, for the Western market • Porcelain with sepia enamel and gilt decoration • Tureen H. 6 inches L. 7½ inches; stand L. 7½ inches • Gift of Mrs. F. C. Getchell • Acc. 1530

10 Teapot
Paul Revere (1735–1818) • c. 1800 • Boston, Massachusetts • Silver • H. 7¾ inches L. 5⅛ inches • Friends of the Museum

Purchase • Acc. 61.148

11 Friendship book
Elizabeth Margaret Chandler (1807–1834) • 1824–1830 • Philadelphia, Pennsylvania • Paper, watercolor, ink • 10 by 8 inches • Gift of Mrs. Erwin L. Broecker • Acc. 83.8.2

Short gown
1790–1820 • American • Inner neck band stamped "John Guest & Co." • Resist, block, and roller-printed cottons • L. 16 inches Circum. 48 inches • Gift of Mrs. Erwin L. Broecker • Acc. 82.138.6

Rain bonnet
1820–1830 • American, possibly Maine • Yellow silk • H. front 10 inches, back 8 inches; brim 6⅜ inches • Gift of Mrs. Jonathan A. Schwab • Acc. 2465

Petticoat
1740–1760 • American • Quilted silk and glazed wool with wool stuffing • L. 34 inches W. 96 inches • Gift of Mrs. Erwin L. Broecker • Acc. 82.138.11

Sampler
Martha Woodnutt • 1814 • Westtown Boarding School, Chester County, Pennsylvania • Cotton on linsey-woolsey • 9¾ by 10½ inches • Friends of the Museum Purchase • Acc. 81.9

Slippers
c. 1800 • American • Leather and kid with linen lining • L. 10 inches • Gift of Mrs. Erwin L. Broecker • Acc. 82.138.12

Dress
c. 1840 • American • Roller-printed cotton • L. 52 inches • Gift of J. Frederick and Lars Cain • Acc. 84.12

Corset
1800–1830 • American • Cotton • Circum. 33 inches • Gift of Mrs. Erwin L. Broecker • Acc. 82.138.4

Busk
1800–1850 • Middle Atlantic states • White pine with chip carved decoration • H. 11½ inches W. 3½ inches • Friends of the Museum Purchase • Acc. 81.89.6

12 Left: Drawstring bag
1820-1830 • probably England • Silk,

transfer-printed • 8 by 8 inches • Gift of Mrs. Erwin L. Broecker • Acc. 82.137.2

Right: Drawstring bag
1820–1830 • probably England • Silk, transfer-printed • Diam. 9 inches • Gift of Mrs. Erwin L. Broecker • Acc. 82.137.1

Pin holder
1820–1830 • probably England • Silk, transfer-printed, paper, pins • Diam. 2 inches • Gift of Mrs. Erwin L. Broecker • Acc. 82.137.3

Cameo Medallion
Wedgwood Porcelain Works; impressed "WEDGWOOD" on reverse • 1790's • Staffordshire, England • Solid white Jasper with black basalt relief • H. 1⅛ inches W. 1 inch • Friends of the Museum Purchase • Acc. 82.52

13 Coverlet
c. 1825 • Dutchess County, New York • Cotton and wool double weave • 86½ by 73½ inches • Gift of Mrs. Edna J. McFerson • Acc. 75.25

Left: Masonic apron
c. 1825 • American • Silk on linen with free-hand painted decoration • History of ownership by Samuel Reade Rucker (1794–1862) of Tennessee • L. 17½ inches W. 16 inches • Gift of Mrs. Albert Boyd Whitley • Acc. 65.184

Center back: Masonic apron
1832 • American • Silk on linen with engraved and satin appliquéd decoration • L. 24½ inches Waist 18¾ inches • Gift of Mrs. Mary R. Moore • Acc. 2281

Front: Masonic apron
1830–1840 • probably American • Silk on linen with stenciled decoration • L. 16 inches W. 13½ inches • Acc. 74.38

Punch pot and lid
c. 1800 • China, for the Western market • Porcelain with enamel and gilt decoration • H. 11 inches • Friends of the Museum Purchase • Acc. 77.77

Decanter and stopper
c. 1790 • Germany or Bohemia • Blown non-lead glass with engraved decoration • H. 10⅝ inches • Gift of Dr. and Mrs. Albert R. Miller, Jr. • Acc. 74.1

Firing glass
1785–1795 • English or Continental • Blown non-lead glass with engraved decoration • H. 4 inches • Gift of Mrs. William D. Lippincott • Acc. 72.46

Watch key
c. 1808 • American • Silver • H. 2¼ inches • Bequest of Miss Grace E. Dexter • Acc. 68.121

Watch key
1826 • probably American • Gold • Engraved, "George B. Brua, Charity Lodge/ No. 111/Harper's Ferry, Jefferson Co./ Virginia/May the 5th 1826" • H. 2½ inches W. 1 inch • Gift of Miss Henrietta Briscoe • Acc. 50.32

Ring
c. 1782 • Gold, paper, moonstone • Diam. ⅞ inch • Gift of Mrs. Harry Dunstan Hazard • Acc. 1799

Presentation jug
1800–1810 • English • Pearlware • H. 13½ inches • Friends of the Museum Purchase • Acc. 57.68

14 Portrait of Christopher Marshall (1743–1804)
c. 1790 • Boston, Massachusetts • Oil on canvas • Original frame stamped S.WADE • 29½ by 24⅜ inches • Gift of Mrs. Franklin E. Campbell • Acc. 76.80.2

Coat
1790–1810 • American • Wool with brass buttons • L. 39 inches • Gift of Mrs. John L. Mosher • Acc. 48.48

Gorget
1775–1783 • England • Silver • Engraved with the arms of George III and the mottoes "HONI SOIT QUI MAL Y PENSE" and "DIEU ET MON DROIT" • W. 4 inches • Friends of the Museum Purchase • Acc. 59.164

Drum
1865–1880 • American • Oak, hide and paint • Diam. 24 inches • Acc. 84.73

Canteen
Eighteenth century • American • Oak • Diam. 7¼ inches • Acc. 74.196

Fife
Eighteenth century • American • Cherry and brass • L. 14 inches • Acc. RI 5524.3

Toy cannons
Nineteenth century • American • Brass • H. 1½ inches L. 3 inches • Gift of Miss Frances G. Smith • Acc. 2885

Powder flask
American Flask & Cap Company • 1857–1870 • Waterbury, Connecticut • Brass • W. 3 inches L. 6½ inches • Acc. 51.17

Powder horn
1777 • American • Horn and oak • Engraved with a masonic compass, and square with the letter G, and the inscriptions, "J. McKEE. HIS HORN/ 1777" and "THE RED COAT WHO STEALS THE HORN —WILL/ GO TO HELL FROM WHENCE HE'S BORN" • L. 11½ inches • Gift of Mrs. Benjamin Catchings • Acc. 7218.2

15 The Capture of Major André
Attributed to Thomas Birch (1779–1851) • 1831 • Philadelphia, Pennsylvania • Oil on canvas • 31½ by 46 inches • Gift of Mrs. Charles Wesley Bassett • Acc. 72.23

16 Painting, allegorical scene
Henry Inman (1801–1846) • 1833 • Signed and dated in the lower left corner, "H. Inman/ 1833" • Philadelphia, Pennsylvania • Oil on board • 10 by 7¾ inches • Gift of Colonel Theodore Barnes • Acc. 61.50.2

17 Appliquéd quilt (detail)
Carmelia Everhart (b. 1835) • 1857–1859, 1907 • Manchester, Carroll County, Maryland • Polychrome roller-printed and dyed cottons • 81 by 79 inches • Gift of Dr. Kate I. Leatherman • Acc. 7045

18 Appliquéd and reverse-appliquéd quilt (detail)
Anna Catherine Hummel Markey (1773–1860) • c. 1815 • Frederick, Maryland • Polychrome roller-printed cottons • 92 by 90⅛ inches • Gift of Mrs. Stephen J. Buynitsky • Acc. 74.282

19 Papyrotamia eagle
1830–1850 • American • Paper with ink and watercolor • 12½ by 7¾ inches • Gift of Mrs. William H. McGlauflain • Acc. 64.146.11

20 Appliquéd quilt (detail):
See no. 17, above

21 Engraving, LIBERTY. In the form of the Goddess of Youth; giving Support to the Bald Eagle.
Printed and engraved by Edward Savage (1761–1817) • Published June 11, 1796 • Philadelphia, Pennsylvania • Ink on paper • 23 by 14½ inches • Friends of the Museum Purchase • Acc. 82.28

22 Papyrotamia Washington memorial
1820–1830 • American • Paper, mirror • 14⅝ by 12¼ inches (in frame) • Acc. 73.28

23 Handkerchief, "The Death of General Washington"
1800–1830 • English or American • Sepia printed on white cotton • 19 by 20½ inches • Gift of Mrs. Edwin A. Farnell • Acc. 63.43

Portrait bust of George Washington
Clark Mills (1810–1883) • 1849 • Muirkirk, Maryland • Bronze • H. 18½ inches • Gift of The Lida R. and Charles H. Tompkins Foundation • Acc. 67.116

Shelf clock
c. 1815–1820 • Probably France • Gilt bronze and bronze • H. 18 inches W. 7¾ inches • Gift of Mrs. Henry Fay • Acc. RI 72.17

Jug
Richard Hall & Son • 1825–1832 • Staffordshire, England • Pearlware, transfer printed in black • H. 8 inches • Gift of Miss Lois A. Bliss • Acc. 63.166

Jug
1800–1820 • Liverpool, England • Cream colored earthenware, transfer printed in black • H. 9½ inches • Gift of Roy D. Hyndman • Acc. 2710

Plaque
c. 1800 • Attributed to the Herculaneum Pottery, Liverpool, England • Cream colored earthenware, transfer printed in black • H. 4⅞ inches W. 4 inches • Gift of Mrs. Clarence G. Willcox • Acc. 55.40

Whiskey flask
c. 1828 • Attributed to the Keene Glass Works, Keene, New Hampshire • Blown molded amber glass • H. 7 inches • Gift of Miss Mattie Wagg Emerson • Acc. 926

Medallion tumbler
Bakewell, Page and Bakewell • 1824–1825 • Pittsburgh, Pennsylvania • Clear lead glass • H. 3½ inches Diam. 2⅞ inches • Gift of Miss Bertha Rodney Twells • Acc. 1916

Copybook
Betsy Lewis (1786–1818) • 1800–1803 • Dorchester, Massachusetts • Paper, ink and watercolor • H. 8½ inches W. 6½ inches • Gift of Mrs. J. Gene Edwards • Acc. 79.14

24 *Washington at the Farm*
Attributed to David L. Donaldson (b.c. 1809) • c. 1840 • Media-Philadelphia, Pennsylvania • Oil on canvas • 30 by 39⅝ inches • Gift of Margaret Marshall and Percy Owens • Acc. 6538

25 Portrait of George Washington as commander in chief
1790–1810 • Possibly French • Oil on canvas • 8½ by 6⅞ inches • Gift of the Virginia State Society • Acc. VA 73.139

26 Jacquard-type coverlet (detail)
James Cunningham • 1841 • New Hartford, New York • Double weave, natural cotton, blue wool • L. 93 inches W. 71¾ inches (two loom widths joined) • Gift of Robert P. Brodie • Acc. 76.99

27 Furnishing textile, "America Presenting at the Altar of Liberty Medallions of her Illustrious Sons"
c. 1785 • England • Cotton, copperplate printed in red • L. 92 inches W. 95 inches • Gift of Miss Margaret Luther • Acc. 62.28

Bowl
Possibly Herculaneum Pottery • 1806–

1810 • Liverpool, England • Cream colored earthenware with overglaze transfer-printed decoration • Diam. 10½ inches • Gift of Mrs. Elizabeth J. Hansen • Acc. 71.80

Portrait medallion
Jean Baptiste Nini (1717–1786) • 1777 • Signed and dated on the tranche of the shoulder, "NINI/F/ 1777" • Glass and pottery works of Jacques Donatien le Ray de Chaumont, France • Terracotta • Diam. 3⅝ inches • Friends of the Museum Purchase • Acc. 82.51

Watch seal with intaglios of George Washington and the Washington shield
1805–1825 • Probably England • Gold; carnelian and moonstone intaglios • 2¼ by 1½ inches • Friends of the Museum Purchase • Acc. 67.266

Watch seal with intaglio of Benjamin Franklin
c. 1806 • Probably France • Gold, opal • 1 by 1 inch • Acc. 84.39

28 Engraving of Benjamin Franklin
Louis Charles Ruotte (1754–1806) after a drawing by Charles Nicholas Cochin (1715–1790) • 1780–1800 • Probably England • Ink on paper with watercolor wash • 10⅛ by 8⅜ inches • Gift of Mrs. Kate Gilbert Wells • Acc. 5047

29 Portrait of Mary Lightfoot (1750–1789)
John Wollaston (w. 1736–1767) • c. 1757 • Charles City County, Virginia • Oil on canvas • 29¾ inches by 25 inches • Gift of Herbert Lee Pratt • Acc. 4725

30 Portrait of Rebeckah Barrett (1757–1765)
Joseph Badger (1707/8–1765) • c. 1765 • Boston, Massachusetts • Oil on canvas • 36 by 28¼ inches • Gift of Kenneth H. Wood • Acc. 76.83

31 Portrait of Rachel Marshall (1743–1829)
c. 1790 • Boston, Massachusetts • Oil on canvas • Original frame stamped, S.WADE • 29 by 23½ inches • Gift of Mrs. Franklin E. Campbell • Acc. 76.80.1

32 Portrait of Humphrey Courtney
James Earl (1761–1796) • 1794–1796 • Charleston, South Carolina • Oil on canvas • 47½ by 37½ inches • Gift of Louise Tompkins Smith • Acc. 71.226

33 Portrait of James Courtney (1747–1809)
James Earl • 1794–1796 • Charleston, South Carolina • Oil on canvas • 36½ by 29 inches • Gift of The Lida R. and Charles H. Tompkins Foundation • Acc. 71.99

34 Portrait of Elizabeth Coburn Courtney (1752–1813)
James Earl • 1794–1796 • Charleston,

South Carolina • Oil on canvas • 37 by 29½ inches • Gift of The Lida R. and Charles H. Tompkins Foundation • Acc. 71.100

35 Portrait of Hannah Morgan Stillman (1737–1821)
Christian Gullager (1759–1826) • c. 1789 • Boston, Massachusetts • Oil on canvas • 30 by 25 inches • Friends of the Museum Purchase • Acc. 76.35

36 Top row
Left: Ralph Izard, Jr. (1785–1824)
Attributed to Edward Greene Malbone (1777–1807) • c. 1800 • Charleston, South Carolina • Watercolor on ivory • 4 by 5 inches in the frame • Friends of the Museum Purchase • Acc. 82.144

Middle: Alice DeLancey Izard (1746–1832)
George Engleheart (1750/3–1829) • 1775–1777 • London, England • Watercolor on ivory • 2 by 1½ inches in the frame • Friends of the Museum Purchase • Acc. 82.143

Right: Commodore Joshua Barney (1759–1818)
Attributed to Jean Baptiste Isabey (1767–1855) • c. 1800 • Paris, France • Watercolor on ivory • 3 inch diameter in the frame • Gift of Richard H. Thompson • Acc. 670

Middle row
Gentleman of the Carter family of Virginia
Attributed to Philippe Abraham Peticolas (1760–1841) • 1804–1811 • Richmond, Virginia • Oil on ivory • 2⅞ by 1⅞ inches • Gift of Miss Frances F. Hayes • Acc. 78.351

Bottom row
Left: Martha Van Swearingen Shafer (1805–1887)
Artist unknown • c. 1824 • Washington County, Maryland • Watercolor on ivory • 3 by 2 inches • Gift of Mrs. John Martin Green • Acc. 3702

Middle: John Van Swearingen (1778–1849)
David Boudon (1748–1816) • 1813 • Washington County, Maryland • Silverpoint and watercolor on vellum • 2½ by 2 inches • Gift of Mrs. John Martin Green • Acc. 3704

Right: Enoch Huntington (1767–1826)
artist unknown • 1795–1800 • Watercolor on paper • 2⅞ by 2¼ inches • Gift of the Faith Trumbull Chapter • Acc. 63.199

37 Portrait of Mary Lisle Gamble
Attributed to the Peale family, possibly Charles Willson Peale (1741–1827) •

1808–1816 • Philadelphia • Oil on paper mounted on canvas • 27½ by 22⅛ inches • Gift of Mrs. Festus Caruthers • Acc. 72.50

38 Portrait of Sarah Humes Porter (1796–1867)
Jacob Eichholtz (1776–1842) • 1819 • Lancaster, Pennsylvania • Oil on canvas • 29½ by 24 inches • Gift of the Michigan State Society • Acc. MI 72.10.2

39 Portrait of George Bryan Porter (1791–1834)
Jacob Eichholtz • 1819 • Lancaster, Pennsylvania • Oil on canvas • 29¼ by 24 inches • Gift of the Michigan State Society • Acc. MI 72.10.1

40 Portrait of Samuel Humes (1754–1836)
Attributed to Jacob Eichholtz • c. 1810 • Lancaster, Pennsylvania • Oil on mahogany panel • 28¾ by 23¼ inches • Gift of Colonel Theodore Barnes • Acc. 70.348.1

41 Portrait of Mrs. Samuel Humes (1759–1822)
Attributed to Jacob Eichholtz • c. 1810 • Lancaster, Pennsylvania • Oil on canvas • 29⅛ by 24 inches • Gift of Colonel Theodore Barnes • Acc. 70.348.2

42 Portrait of Andrew Jackson (1767–1845)
Attributed to Ralph E.W. Earl (c. 1788–1838) • c. 1830 • Oil on canvas • 30 by 25 inches • Friends of the Museum Purchase • Acc. 59.202

43 Portrait of Joseph Knowlton (b. 1804)
Ruth Henshaw Bascom (1772–1848) • March, 1830 • Phillipston, Massachusetts • Pastel and pencil on paper • 19½ by 13½ inches • Friends of the Museum Purchase • Acc. 84.35.1

44 Portrait of Frances Knowlton (1808–1885)
Ruth Henshaw Bascom • March, 1830 • Phillipston, Massachusetts • Pastel and pencil on paper, cut out and pasted to a background sheet • 19½ by 14½ inches • Friends of the Museum Purchase • Acc. 84.35.2

45 Portrait of Chloe Wood Cushing
Reuben Rowley (w. 1825–1835) • January, 1826 • Ithaca, New York • Oil on canvas • 25¹³⁄₁₆ by 21¾ inches • Gift of Mrs. James A. Vaughan • Acc. 72.48.2

46 Portrait of Lucas Cushing (1802–1876)
Reuben Rowley • January, 1826 • Ithaca, New York • Oil on canvas • 25¹³⁄₁₆ by 21¾ inches • Gift of Mrs. James A. Vaughan • Acc. 72.48.1

47 Portrait of an unidentified Maine woman
Attributed to John Brewster Jr. (1766–1854) • 1823 • Maine • Oil on canvas • 29¾ by 23¾ inches • Gift of Dr. and Mrs. John Hashim • Acc. 81.109

48 Portrait of Phebe Steiner Reich (1774–1842)
Alexander Simpson • 1821 • Frederick, Maryland • Oil on canvas • 30 by 24½ inches • Gift of Helen Gaines and Phoebe Gaines Sadler • Acc. 79.44.2

49 Portrait of Benjamin Stone
1810–1820 • New England, possibly Maine • Oil on paper • 10¼ by 8½ inches • Gift of the Maine State Society • Acc. ME 72.13

50 Overmantel painting, Two Little Girls in a River Landscape
1830–1840 • Removed from the French homestead, Piermont, New Hampshire • Oil on pine boards • 31 by 58¾ inches • Gift of Mrs. Leslie P. Snow • Acc. NH 72.71

51 Portrait of Josephine, Horace, Charles and George Emery
c. 1854 • New York State • Oil on canvas • 65 by 49 inches • Gift of Mrs. G. Stewart Emery • Acc. 71.90

52 Mourning embroidery
Caroline Litchfield Newcomb (1799–1850) • 1817 • Sarah Pierce's Litchfield Female Academy, Litchfield, Connecticut • Silk and watercolor on silk • 25⅞ by 31¾ inches • Gift of Mrs. John H. Bruns • Acc. 64.129

Copybook
Elizabeth Margaret Chandler (1807–1834) • c. 1830 • Philadelphia, Pennsylvania, or the Michigan Territory • Paper and ink • 12½ by 8¹⁄₁₆ inches • Gift of Mrs. Erwin L. Broecker • Acc. 83.8.1

Mourning pendant in memory of Charles William Carter (d. 1794)
c. 1794 • American, possibly Virginia • Gold, glass, oil on ivory, hair • H. 1⅞ inches W. 1½ inches • Gift of Miss Frances Hayes • Acc. 78.35.2

Mourning pendant in memory of Commodore Brooke (d. 1798)
Labeled by Samuel Folwell (1764–1813) • 1798–1800 • Philadelphia or Baltimore • Gold, glass, oil on ivory • 2³⁄₁₆ by 2⅜ inches • Friends of the Museum Purchase • Acc. 64.116

Mourning pin in memory of Dorothea Dandridge (d. 1778)
1790–1800 • American • Gold, glass, enamel, oil on ivory, hair • 1⅞ by 1½ inches • Gift of Mrs. D.F. Clark • Acc. 1803

Mourning pendant in memory of Winifred T. Carter (d. 1798)
1798–1800 • American, possibly Virginia • Gold, glass, oil on ivory • 1¹⁄₁₆ by 1⅛ inches • Gift of Miss Frances Hayes • Acc. 78.35.3

Mourning ring in memory of George Hext (d. 1786)
1786–1800 • Possibly Charleston, South Carolina • Gold, glass, watercolor on ivory • H. 1¹⁄₁₆ inches Diam. ¾ inch • Friends of the Museum Purchase • Acc. 82.35

Mourning bracelet in memory of Robert Wormely Carter (d. 1797)
1797–1800 • American, possibly Virginia • Gold, glass, oil on ivory; velvet band • H. of miniature: 1¹⁄₁₆ inches • Gift of Miss Frances Hayes • Acc. 78.35.4

53 Needlework memorial
Designed by Samuel Folwell (1764–1813) • c. 1810 • Philadelphia, Pennsylvania • Silk embroidery, watercolor, and paper on satin • 12½ by 10½ inches • Friends of the Museum Purchase • Acc. 82.40

54 Watercolor memorial
Attributed to Sally F. Cheever (1806–1831) • c. 1821 • Possibly Danvers, Massachusetts • Watercolor and applied engraving on paper • 20 by 24½ inches • Friends of the Museum Purchase • Acc. 64.223

55 Needlework family record
Sarah Stevens • 1822 • Greater Boston region, Massachusetts • Silk on linen • 21¾ by 29¼ inches • Gift of Sarah E. Caldwell • Acc. 55.111

56 Needlework family register
Attributed to Caroline Childs (1790–1811) • c. 1805 • Deerfield, Massachusetts • Silk on linen • 17½ by 16½ inches • Gift of the Illinois State Society • Acc. 79.26

57 Sampler
Ann West • 1787 • Philadelphia • Silk on linen • 17 by 16⅜ inches • Gift of Marion Terhune • Acc. 47.158

58 Family record
Lucretia Bright (1807–1828) • c. 1820 • Middlesex County, Massachusetts • Silk on linen • 20½ by 20½ inches • Acc. 73.96

59 Cradle
Nineteenth century • probably New England • Pine, stained red • H. 9¾ inches L. 12½ inches • Gift of Mrs. Stephen Bonsal • Acc. 6804

Coral and bells
Francis Clark • c. 1836 • Birmingham, England • Silver, coral • L. 5 inches • Acc. 73.151

Pewter "sucking bottle"
c. 1800·American·Pewter·Circum. 9³⁄₁₆ inches·Gift of Mrs. Allyn M. Smith· Acc. 52.38.a

Infant's shirt
c. 1810·American·Linen with cotton crochet·H. 8⅜ inches W. 10⅞ inches· Gift of Mrs. George Ripley·Acc. 6696

Infant's cap
c. 1796·American·Linen on linen with cutwork lace·W. 5½ inches·Gift of Mrs. Edward M. Blake·Acc. 6879

Silver nipple and tube
Edward and Samuel Rockwell (w. 1815–1847)·First half of the nineteenth century·New York City·Silver·L. 7½ inches·Friends of the Museum Purchase·Acc. 66.196

Glass nipple shell
Nineteenth century·Possibly American· Blown clear glass·Diam. 3¼ inches· Acc. 84.71

Pap boat
Harvey Lewis (c. 1811–1825)·c. 1811–1825·Philadelphia, Pennsylvania·Silver ·H. 1¼ inches W. 3¹⁄₁₆ inches D. 5¾ inches·Friends of the Museum Purchase·Acc. 66.186

Glass nursing bottle
Nineteenth century·Possibly American· Blown clear glass·L. 7½ inches W. 3 inches·Gift of Mrs. Allen Collier· Acc. 47.108

Quilted petticoat
1770–1800·American·Changeable silk; brown linen and glazed blue cotton lining·L. 39¼ inches·Gift of Mrs. Samuel T. Bolton·Acc. 64.140

60, 61 Pincushion
July, 1786·Boston, Massachusetts·Silk satin cushion with silk quilled ribbon border and four corner tassels; hand-wrought pins·L. 7 inches W. 5⅛ inches ·Gift of Miss Ada Augusta Rhodes· Acc. 1887

62 Miniature portrait of Charles Wesley Fenton (1815–1882)
Attributed to Jacob Frymire·c. 1819· Possibly New Jersey·Watercolor on paper·4¾ by 3¼ inches·Gift of Miss Ella Luckett·Acc. 58.170

63 Sampler
Elizabeth Shrupp·1805·Frederick, Maryland·Silk on linen·2¼ by 8⅜ inches·Gift of Phoebe Ann Roos· Acc. 4026

Pull-out book, "The New Alphabet Of The Nations"
A. Phelps·1810–1820·Greenfield, Mas-

sachusetts·Paper and ink·3½ by 3 inches L. (open) 64½ inches·Gift of Mrs. Harriet Gruley·Acc. 4218

Double slate board
1830–1870·American·Slate and wood· L. 9½ inches W. 12 inches·Gift of Mrs. Henry Matthews Parker·Acc. 61.52

Cards, "Multiplication Merrily Matched"
C.S. Francis & Co.·c. 1840·New York City·Paper and ink·L. 2 inches W. 2¾ inches·Acc. NH 51.11

64 Alphabet blocks
c. 1880·American·Color lithographed paper on wood·H. 7 inches decreasing by ½ inch measurements·Gift of Mrs. Fred C. Hahn·Acc. 70.44.1-7

Board game, "The Mansion of Happiness"
W. & S.B. Ives·1843·Salem, Massachusetts·Color lithographed paper on cardboard·Gift of Mrs. Leslie P. Snow· Acc. NH 47.19

Marble board and marbles
Late nineteenth or early twentieth century·American·Wood and glass·Diam. 10 inches·Acc. 77.61.1-33

Sulphide marble
Late nineteenth century·American· Glass·Diam. 1½ inches·Gift of Mrs. Fred Gwynn·Acc. 6909

Spinning top
Late nineteenth century·American· Wood and paint·L. 5⅝ inches·Gift of Miss Grace Crosby·Acc. NH 4388

Doll
Second half of the nineteenth century· Possibly German·Porcelain and cloth· H. 8 inches·Acc. 84.54

Wooden building blocks
Late nineteenth century·American· Pine·Acc. 84.55

65 Sampler
Julia Ann Crowley·1813·Washington, D.C.·Silk and silk chenille on green linsey-woolsey·23½ by 22 inches·Gift of Mrs. W.W. Brothers·Acc. 63.11

Copybook
Betsy Lewis (1786–1818)·1803·The Ladies Academy, Dorchester, Massachusetts·Paper, ink, and watercolor·8½ by 6½ inches·Gift of Mrs. J. Gene Edwards·Acc. 79.14

Child's presentation mug
1820–1840·England·Earthenware with transfer printed designs and pink luster glaze·H. 2½ inches Diam. 2½ inches· Gift of Mrs. Leslie P. Snow· Acc. NH 4708

Rear: Reward of merit
Printed and sold by John F. Brown· c. 1850·Concord, New Hampshire· Paper and ink·6¼ by 2¾ inches·Gift of Mrs. Leslie P. Snow·Acc. NH 47.7d

Center: Reward of merit
1815–1825·American·Paper and ink· 3⅞ by 2½ inches·Gift of Mrs. Rufus K. Noyes·Acc. 7280a

Front: Reward of merit
c. 1850·American·Paper and ink·5 by 4½ inches·Gift of Mrs. E.W.C. Fernald· Acc. 3679a

Merit medallion
1825–1830·American·Engraved on face "Merit;" on reverse "E.V."·Belonged to Elizabeth Viles (b. 1816) of Waltham, Massachusetts·Silver·L. 1¼ inches W. 1⅜ inches·Gift of Mrs. James Peabody· Acc. 2844

Merit medallion
1827·American·Engraved on face with a view of school building and "CENTRAL ACADEMY;" on reverse "to/ C. Drake/ for/ early regular/ attendance good/ behavior and close/ application by/ John McLeod May 1827"·Silver·Diam. 1¼ inches·Gift of Miss Alice Ely Colt· Acc. 54.121

66 Dresden type and drawn-work sampler
Susannah Razor·1783·Philadelphia· Cotton on cotton; silk quilled-ribbon edging·16¾ by 14⅜ inches·Gift of Juliet Thorp Whitehead·Acc. 67.155

67 Sampler, view of the Baptist Meeting House. Alstead, N.H.
Bia Hale (1792–1874)·c. 1802·Alstead, New Hampshire·Silk on linen·7½ by 6¹⁄₁₆ inches·Gift of Miss Maybelle H. Still·Acc. 64.44

68 Sampler
Anna Hale Smith (1818–1841)·1830· Alstead region, New Hampshire·Silk on linen·16⅜ by 17⅛ inches·Gift of Miss Maybelle H. Still·Acc. 61.90

69 Sampler
Anna Lyford (1793–1862)·1806· South central New Hampshire·Silk on linen·17³⁄₁₆ by 17 inches·Gift of Ella J. Morrison·Acc. 2462

70 Sampler
Cassandanna Hetzel (b. 1802)·1823· Mrs. Leah Meguier's School, Harrisburg, Pennsylvania·Silk on muslin·17 by 17⅜ inches·Bequest of Mrs. Margaret Riviere Hetzel Pendleton·Acc. 4503

71 Needlework picture, Charity
Sarah Marshall·1806·Miss Patten's painting and embroidery school· Hartford, Connecticut·Silk, silk che-

nille, gold metallic thread, sequins, and watercolor on silk • 19⅛ by 16½ inches • Gift of Miss Sarah Richardson • Acc. 67.160

72 Mezzotint, *Charity*
Published by P. Stampa • 1802 • London, England • Ink on paper • 11 by 9 inches • Friends of the Museum Purchase • Acc. 77.45

73 Needlework picture, *View Near Exeter*
Rebecca Rooker (1793–1862) • c. 1810 • England or America • Watercolor and silk chenille on silk • 26 by 33¼ inches (in frame) • Friends of the Museum Purchase • Acc. 64.44.2

74 Colored engraving, *View Near Exeter*
Engraved by William Cartwright after a painting by Thomas Walmsley • c. 1800 • England • Colored engraving • 11 by 16½ inches • Friends of the Museum Purchase • Acc. 64.44.1

75 Left: Bag or purse
Hannah Gilman (b. 1807) • c. 1820 • Exeter, New Hampshire • Cotton with pen and ink inscriptions; cotton tassels and drawstring • L. 7½ inches W. 5½ inches • Gift of Mrs. Claire Murphy • Acc. 84.34.2

Right: Bag or purse
Caroline Odlin (1790–1817) • c. 1810 • Exeter, New Hampshire • Cotton with pen and ink inscription and vignette; cotton fringe and drawstring • L. 9½ inches W. 7¾ inches • Gift of Mrs. Claire Murphy • Acc. 84.34.3

76 Needlework picture, "South East View of the Episcopal Church & ACADEMY at Newcastle, Del."
Hannah Fox Budd (1791–1871) • 1806 • Burlington Academy, Burlington, New Jersey • Silk and watercolor on silk • 16 by 20 inches • Gift of Mrs. Fred W. Holt • Acc. 56.6

77 Terrestrial globe
Edith B. Stockton • 1822 • Westtown School, Westtown, Pennsylvania • Silk and ink on silk; canvas • Circum. 18 inches • Gift of Mrs. A. A. Birney • Acc. 2267.1

Puzzle
William Darton • 1824 • London • Printed paper on mahogany; original painted pine box • Box: 3 by 3 inches • Gift of Miss Frances G. Smith • Acc. 2886.1,2

78 Sampler
Virginia Kramer (1828–1870) • 1840 • Pittsburgh, Pennsylvania • Wool on wool • 18⅞ by 21⅛ inches • Gift of Mrs. Raymond D. MacCart • Acc. 66.261.1

79 Theorem painting
1820–1850 • Probably New England • Paint on velvet • 14 by 18 inches • Friends of the Museum Purchase • Acc. 84.35.3

80 Sampler
Martha Ann Smith (b. 1806) • 1824 • King George County, Virginia • Silk on linen • 15½ inches by 15½ inches • Gift of Mrs. Martha Waugh Smith Boyle • Acc. 56.20

81 Teapot, "The Fortune Teller"
Transfer prints by William Greatbatch (1735–1813) • c. 1780 • Probably Leeds, England • Creamware with transfer prints and polychrome enamel decoration • H. 5¼ inches • Friends of the Museum Purchase • Acc. 64.246 a,b

82 Clothespin
Captain Philip Nye • c. 1820 • Probably New England, possibly Fairhaven, Massachusetts • Whale bone • L. 5⅜ inches • Gift of Elizabeth Winslow Nye • Acc. 74.197

Clothespin
1800–1850 • American • Walnut • L. 6¾ inches • Gift of Mrs. Joseph M. Raidy • Acc. 74.198

Handkerchief
c. 1810 • New England • Homespun linen in blue and natural plaid • 18½ by 18½ • Gift of Mrs. Bert C. Thomas • Acc. 60.201

Handkerchief
1800–1850 • American • Homespun linen in a tan and natural plaid • 22½ by 22¾ inches • Acc. 80.53

Towel
1800–1850 • American • Linen • 35½ by 19 inches • Gift of Miss Jean E. Treadwell • Acc. 62.189

83 Embroidered and drawn-work hand towel
Margetha Minsen • 1797 • Probably Pennsylvania • Cotton on linen • L. 39⅜ inches exclusive of fringe W. 14⅝ inches • Gift of Mrs. Allyn K. Ford • Acc. 62.212

Embroidered and drawn-work hand towel
Anna Rutt • June, 1820 • Probably Pennsylvania • Cotton on linen • L. 55¾ inches exclusive of fringe W. 18½ inches • Gift of Mrs. Allyn K. Ford • Acc. 62.213

84 Crewel work strip, possibly a petticoat boarder
Elizabeth Gorton (1738–1818) • 1764 • Kent County, Rhode Island • "ELIZABETH GORTON 1764" worked in cross-stitch along the top • Crewel on linen •

L. 91 inches W. 5½ inches • Gift of Mrs. Albert E. Congdon • Acc. 57.90

Pinball
c. 1790 • Probably Rhode Island • Silk on canvas, silver • Circum. 7⅛ inches • Gift of Miss May Arnold Husted • Acc. 1832

Chatelaine
Walter Cornell (w. Providence c. 1780–1801) • c. 1790 • Providence, Rhode Island • Silver • L. of clip 1⅝ inches L. longest chain 14⅞ inches • Gift of Miss May Arnold Husted • Acc. 1832

Needle holder
1791 • American • Silver • L. 2 inches W. 1¼ inches • Gift of Miss Wilmuth Gary • Acc. 6667

Bible and needlework cover
Cover worked by Elizabeth Peyton Patterson • Bible 1783; cover c. 1790 • Bible printed in Oxford, England; cover probably worked in Virginia • Embroidered, "E. Patterson" on front; "G. Patterson" on reverse; "HOLY BIBLE" on spine • Crewel on canvas, paper • H. 5⅝ inches W. 3⅜ inches D. 2¼ inches • Gift of Mrs. Lewis Halsey • Acc. 542

Worktable: See no. 85, below

85 Worktable
1795–1815 • Possibly Philadelphia • 1795–1815 • Mahogany, mahogany veneer, pine, and tulip • H. 29 inches W. 23½ inches D. 12¾ inches • Gift of Mrs. Sylvanus E. Johnson • Acc. DC 4834

86 Worktable
1814–1825 • Ohio • Tiger maple and tulip • H. 28¼ inches W. 22¼ inches D. 17¼ inches • Gift of Miss Hazel E. Clark • Acc. OH 74.15

87 Hanging wall pocket; or folding purse, "housewife"
c. 1780 • Possibly France • Silk, etched mirror glass, glass beads, silvered wire • L. 14¹¹⁄₁₆ inches W. 4 inches • Acc. 2521

88 Left rear: Pocket
1770–1800 • American • Crewel on linen; lined and backed in blue and ecru striped handwoven linen; printed linen edging • H. 16¼ inches W. 15⅜ inches • Acc. 74.176

Right rear: Pocket
c. 1780 • Probably Vermont • History of ownership by Lydia Laughton of Dummerston, Vt. • Crewel on linen; printed chintz border around part of body and opening • H. 14½ inches W. at top 7 inches, at base 12 inches • Gift of Mrs. Annie S. Talbot • Acc. 2623

Front: Pocket
1780–1800 • American • Crewel on natu-

ral linen; green silk back and edging • H. 16¼ inches W. at top 6½ inches, at base 11½ inches • Friends of the Museum Purchase • Acc. 61.53

Section of a petticoat
1780–1800 • Probably Burlington, New Jersey • Gold silk; blue and natural striped homespun back • H. 29½ inches L. 57 inches • Gift of Mrs. Robert M. Weber • Acc. 3622

89 Clockwise from upper right:
Irish stitch single pocketbook
Mary Wright Alsop (1739/40–1829) • 1773 • Connecticut • Cross-stitch inscription "RICHARD ALSOP 1773 M.A." • Wool, canvas • 4½ by 7⅝ inches • Gift of Miss Julia Rogers • Acc. 961

Letter
E. Bridgens Lt., Bridgen & Wallen, London, to Charles Caldwell, Hartford, Connecticut • September 29, 1783 • London, England • Paper and ink • Americana collection • Americana 395

One dollar, Continental currency
Hall & Sellers, printers • 1775 • Philadelphia, Pennsylvania • Paper and ink • Americana collection • Americana 2980

One Sixth of a dollar, Continental currency
Hall & Sellers, printers • 1776 • Philadelphia, Pennsylvania • Paper and ink • Americana collection • Americana 2980

Irish stitch double pocketbook
1770–1790 • Probably Pennsylvania • Owned by Christopher Keatley (1752–1831) • Wool, canvas • 4 by 7⅛ inches • Gift of Miss Marie Keatley • Acc. 75.192

Crewel-embroidered single pocketbook
1770–1800 • New England • Owned by John Orr • Wool, linen • 4¾ inches by 8 inches • Gift of Miss Alice M. Robertson • Acc. 2279

Irish stitch double pocketbook
1776 • Probably Virginia • Cross-stitch inscription "ROBERT CHEW 1776" • Owned by Robert Chew (1750–1814) • Wool, canvas • 4¼ by 7 inches • Gift of Mrs. Walter Zane • Acc. 60.5

Pair of shoe buckles
Myer Myers (1723–1795) • 1780–1790 • Philadelphia or New York City • Silver, brass, iron • L. 3⁷⁄₁₆ W. 1¹³⁄₁₆ inches • Friends of the Museum Purchase • Acc. 62.142

One-piece bed quilt
Possibly Mary Polly Pillsbury (b. 1796) • wool lining • 84 by 83½ inches • Gift of

Miss Arianna M. Tasker • Acc. 3921

90 Hand-done Marseilles work dressing table cover
c. 1815 • New England • cotton • 40¼ by 21½ inches • Acc. 84.86

91 Embroidered and tufted table cover
1811 • American • Cotton on cotton • 39 by 29 inches • Gift of Mrs. Albert Stabler and Mrs. Gertrude J. McPherson • Acc. 4031

Lady's workbag, pincushion, and needle holder
1780–1800 • American • Silk embroidery on silk, metallic thread • L. 6½ inches W. 4 inches • Gift of Mr. Richard H. Thompson • Acc. 727

Gold bead necklace
1775–1820 • Possibly American • Gold • L. 14¼ inches • Gift of Mr. and Mrs. Ralph L. Longley • Acc. 65.33

Brooch
c. 1836 • New England, possibly Brunswick, Maine • Gold, hair, glass • Owned by Caroline Kent Newman of Brunswick, Maine • W. 1¾ inches • Gift of the Misses Caroline and Mary Pond • Acc. 46.116

Pair of drop earrings
1820–1850 • Possibly American • Gold, hair, glass • L. 1¾ inches • Acc. 84.72

92 Teakettle holder
c. 1800 • Possibly Essex County, Massachusetts • Wool on linen • 6½ by 6¼ inches • Friends of the Museum Purchase • Acc. 82.43

Teakettle
1770–1840 • Possibly southeastern Pennsylvania • Copper • H. 12½ inches W. 12 inches • Gift of Miss Frances E. Peters • Acc. 82.90.1

93 Hand-held fire screen
1750–1790 • American, probably New England • Crewel wools on canvas, cardboard, green silk, green silk tape, mahogany handle • H. 15⅝ inches W. 9⁹⁄₁₆ inches • Gift of Mrs. Charlotte Boyer Robbins • Acc. 2229

94 Table cover
1820–1850 • New England • Wool with wool and satin appliqué; wool and cotton threads; printed cotton backing; wool tape • 42¼ by 49 inches • Acc. 84.56

95 Petticoat (detail)
1780–1800 • Probably Burlington. New Jersey • Gold silk; blue and natural

striped homespun lining • H. 29½ inches L. 57 inches • Gift of Mrs. Robert M. Weber • Acc. 3622

96 Appliquéd quilt (detail)
Laura Whitcher (Whicher) Adye (1801–1875) • 1850–1875 • Indiana or Iowa • Polychrome roller-printed and dyed cottons; polychrome roller-printed backing • 80 by 69 inches • Gift of Mrs. Ellen Adaye Cochran Gates • Acc. 3715

97 Pieced quilt
1830–1840 • Mountville, Loudoun County, Virginia • Roller-printed cottons on cotton ground • 97½ by 91 inches • Gift of Mrs. John Porter Sawyer • Acc. 81.16

98 Appliquéd quilt
Emma Maria Fish (b.1825) • 1842–1844 • Trenton, New Jersey • Roller-printed cottons on cotton ground, cotton fringe on three sides • 101 by 104 inches • Gift of Mrs. C. Edward Murray • Acc. 5254

99 Pieced quilt
Possibly made by Martha Lee • 1850–1851 • Berks County, Pennsylvania • Roller-printed cottons, glazed cotton, silk • 96 by 96 inches • Gift of J. Frederick and Lars Cain • Acc. 84.11

100 Sampler
Eliza Woodrow • c. 1808 • Culpeper County, Virginia • Silk on muslin • 8⅜ by 7⅜ inches • Gift of Mrs. Mary S. Perry • Acc. 2459

101 Bandbox
Daniel S. Gladding (1786–1847) • c. 1835 • New Haven, Connecticut • Cardboard and paper • H.13¾ inches W. 15 inches L. 18¾ inches • Gift of Daniel H. Gladding • Acc. 46.105

Bandbox
Lid by Joseph L. Freeman • c. 1835 • New Bedford, Massachusetts • Cardboard and paper • H. 11 inches W. 13 inches L. 16½ inches • Gift of Mary A. Rand • Acc. 4180

Comb Box
c. 1830 • Possibly Massachusetts • Cardboard and paper • H. 10 inches W. 4 inches • Gift of Ella May Lewis • Acc. 62.196

Hair Comb
Attributed to John Evans Jones • c. 1830 • Roxbury, Massachusetts • Tortoise shell • History of ownership by Dolley Madison (1768–1849) • H. 9 inches W. 9 inches • Gift of Mrs. Charlotte Niese Shanklin and Miss Harriet E. Niese • Acc. 54.131

Milliner's Model
c. 1830 • American • Papier-mâché and paint • H. 15 inches • Acc. 788

Calash
1840–1850 • American • Silk, cane, cotton netting • H. 9 inches • Gift of Mrs. Erwin L. Broecker • Acc. 83.4.4

102 Looking glass
1790–1795 • England or Philadelphia • Labeled by John Eliot & Son, 60 South Front Street, Philadelphia • Mahogany • 37½ by 21½ inches • Gift of the Iowa State Society • Acc. IO 70.52

Chest of drawers
1780–1800 • Pennsylvania • Mahogany, tulip, white pine, oak • H. 33⅞ inches w. 41¼ inches D. 22½ inches • Gift of the Iowa State Society • Acc. IO 72.108

Table cover
c. 1820 • American • Damask • L. 34¾ inches W. 36⅜ inches • Gift of Miss Agnes Storer • Acc. 6748

Waistcoat
1825–1845 • American • Cotton, linen • H. 17¼ inches • Gift of the Misses Catharine and Matilda Carson • Acc. 1937

Guglet
1750–1770 • Staffordshire or Yorkshire, England • Saltglaze stoneware • H. 9 inches Diam. base 3½ inches • Friends of the Museum Purchase • Acc. 63.88

Shaving bowl
c. 1770 • Leeds, England • Creamware • Diam. 11 inches • Friends of the Museum Purchase • Acc. 62.247

Shoe buckles
William Mannerback • 1820–1835 • Redding, Pennsylvania • Silver, steel • L. 3 inches W. 2¼ inches • Acc. 84.90

Portrait
English or American • c. 1800 • Pastel • 16 by 8 inches • Gift of the Iowa State Society • Acc. IO 70.49

103 Plate
1737–1750 • Bristol or Liverpool, England • Tin-glazed earthenware with manganese border • Diam. 9 inches • Gift of Miss Mary Knox Meeker • Acc. 48.67

Cann
c. 1765 • Possibly Boston • Silver • H. 5⅜ inches • Gift of Mrs. Franklin E. Campbell • Acc. 76.79

Letter
Edward Jeffrey to Ichabod Stodard, Groton • September 26, 1788 • Probably Connecticut • Paper and ink • Americana collection • Americana 23

104 Double tea canister
1740–1750 • Staffordshire, England • Salt-glazed stoneware with molded decoration • H. 4 inches L. 5 inches • Friends of the Museum Purchase • Acc. 64.73

Teapot
1735–1745 • Staffordshire, England • Salt-glazed stoneware with stamped, applied ornament • H. 4¾ inches • Gift of Mr. and Mrs. John R. Williams • Acc. 75.190

Tea dishes
1750–1760 • Staffordshire, England • Salt-glazed stoneware with scratch blue decoration • H. 1½ inches Diam. 3 inches • Gift of Miss Cordelia Jackson • Acc. 2375.1,2

Tea caddy spoon or "tea shell"
John Adam (w. 1755–1798) • c. 1780 • Alexandria, Virginia • Silver • L. 3½ inches • Gift of Mrs. B. F. Wilson • Acc. 2081

Teaspoon
Isaac Hutton (1766–1855) • 1790–1800 • Albany, New York • Silver with bright cut engraving • L. 5½ inches • Gift of Miss Katherine Batcheller • Acc. 3185.2

Table cover
c. 1800 • American • Silk on linen • 20 by 26 inches • Gift of Mrs. David M. McCathie • Acc. 56.43

105 Left rear: Teapot and lid
Attributed to the Leeds Pottery • 1760–1770 • Yorkshire, England • Cream colored earthenware with enamel decoration • H. 4⅜ inches • Friends of the Museum Purchase • Acc. 65.97

Right rear: Teapot and lid
1760–1770 • Staffordshire, England • Salt-glazed stoneware with enamel decoration • H. 4 inches • Friends of the Museum Purchase • Acc. 77.9

Center: Teapot and lid
c. 1750 • Staffordshire, England • Agate-ware • H. 5⅛ inches • Friends of the Museum Purchase • Acc. 66.8

Left foreground: Teapot and lid
c. 1760 • Staffordshire, England • Cream colored earthenware with tortoise-shell glaze • H. 3¾ inches • Friends of the Museum Purchase • Acc. 77.9

Right foreground: Teapot and lid
1745–1750 • Staffordshire, England • Red earthenware with applied pipe clay and clear lead glaze • H. 3⅞ inches • Friends of the Museum Purchase • Acc. 79.33

106 Teapot and lid
1750–1755 • Staffordshire, England • Red

earthenware body with lustrous black glaze • H. 5¼ inches • Gift of Mrs. David B. Kraybill • Acc. 66.281

107 Coffeepot and lid
1750–1760 • Staffordshire, England • Unglazed red stoneware • H. 8½ inches • Friends of the Museum Purchase • Acc. 62.250

108 Right: Teapot and lid
Decoration attributed to the "Tulip Painter" • 1774–1776 • Lowestoft Porcelain Factory, Suffolk, England • Soft paste porcelain with painted enamel decoration • H. 5⅜ inches • Friends of the Museum Purchase • Acc. 78.55

Left: Teapot and lid
Decoration attributed to James Giles • 1760–1770 • China and England • Hard paste porcelain with painted enamel decoration • H. 5¾ inches • Gift of the Texas State Society • Acc. 52.110.1

109 Rear: Teapot
Josiah Wedgwood, Ivy House Works • 1760–1765 • Burslem, Staffordshire, England • Cream colored earthenware with lead glaze • H. 6 inches L. 7 inches • Friends of the Museum Purchase • Acc. 62.248

Left rear: Tea canister or tea jar
1760–1770 • Staffordshire or Yorkshire, England • Cream colored earthenware with lead glaze • H. 4 inches L. 3½ inches • Friends of the Museum Purchase • Acc. 66.5

Right foreground: Coffeepot
c. 1760 • Staffordshire or Yorkshire, England • Cream colored earthenware with lead glaze • H. 9¾ inches L. 4½ inches • Friends of the Museum Purchase • Acc. 80.5

Left foreground: Tea canister or tea jar
1760–1770 • Staffordshire or Yorkshire, England • Cream colored earthenware with lead glaze • H. 4 inches L. 2⅞ inches D. 2¼ inches • Friends of the Museum Purchase • Acc. 66.147

Foreground: Cream pot
1760–1770 • Staffordshire or Yorkshire, England • Cream colored earthenware with lead glaze • H. 5½ inches L. 4 inches • Friends of the Museum Purchase • Acc. 64.75

110 Child's tea set
c. 1790 • China, for the Western market • Porcelain with painted enamel decoration • H. teapot 3¼ inches • Gift of Mrs. Franklin E. Campbell • Acc. 76.71.1–9

111 Doll
Ludwig Greiner • c. 1858 • American •

Papier- mâché and cloth • H. 28 inches • Gift of Mrs. Garland P. Ferrell • Acc. 6646

Child's windsor chair
1791–1810 • Pennsylvania or New Jersey • Pine, hickory, maple and paint • H. 26 inches W. 12 inches D. 15 inches • Gift of Mrs. Fred W. Holt • Acc. 56.4

Child's spatterware tea set
1830–1850 • England • Earthenware with painted decoration • H. teapot 3 inches Diam. cup 2 inches • Acc. 84.53

112 Clockwise from lower right
Cream pot
Samuel Casey (c. 1724–c. 1780) • 1745–1750 • South Kingstown, Rhode Island • Silver • H. 3⅜ inches • Acc. L. 68.62

Cream pot
John Heath (w.c. 1761–1770) • c. 1765 • New York City • Silver • H. 4¼ inches • Friends of the Museum Purchase • Acc. 80.22

Cream pot
James Duffel (1761–1835) • 1790–1800 • Georgetown, South Carolina • Silver • H. 7 inches • Gift of Mrs. Pauline Brundidge Feinberg and Miss Louise Brundidge • Acc. 81.28.2

Cream pot
Thomas Boyle Campbell and James Meredith • 1815–1822 • Winchester, Virginia • Silver • H. 6⅜ inches • Friends of the Museum Purchase • Acc. 67.119

Cream pot
John McMullin (w.c. 1791–1841) • 1800–1810 • Philadelphia, Pennsylvania • Silver • H. 7¾ inches • Gift of Mrs. John R. Silver • Acc. 4434

Cream pot
Anthony Rasch (w.c. 1807–1820) • 1815–1820 • Philadelphia, Pennsylvania • Silver • H. 6¹/₁₆ inches • Friends of the Museum Purchase • Acc. 83.69

113 Clockwise from center front
Covered sugar dish
John McMullin (w.c. 1795–1841) • 1815–1825 • Philadelphia, Pennsylvania • Silver • H. 7¹⁵/₁₆ inches L. 7¾ inches • Gift of Dr. Helen Bush • Acc. 74.98

Covered sugar dish
Joseph Richardson Jr. (1752–1831) • 1791–1805 • Philadelphia, Pennsylvania • Silver • H. 9⅞ inches • Gift of Mrs. Clarence C. Wagner • Acc. 71.2

Covered sugar dish
Robert Sheppard and William Boyd (w. 1806–1830) • 1806–1815 • Albany, New York • Silver • H. 5¹⁵/₁₆ inches L. 7½ inches • Gift of Dr. Helen Bush • Acc. 74.103

Covered sugar dish
Christian Wiltberger (w. 1791–1819) • 1793–1819 • Philadelphia, Pennsylvania • Silver • H. 7½ inches • Gift of Mrs. Eliot Callender Lovett • Acc. MD 73.10

114 Left: Sugar bowl and lid
Attributed to Bakewell and Page • 1820–1830 • Pittsburgh, Pennsylvania • Blown and cut colorless lead glass • H. 8⅛ inches • Friends of the Museum Purchase • Acc. 83.1

Middle: Sugar bowl and lid
Attributed to the Boston and Sandwich Glass Co. • 1840–1860 • Boston, Massachusetts • Pressed colorless lead glass • H. 5½ inches • Gift of Mrs. James A. Vaughan • Acc. 59.89

Right: Sugar bowl and lid
Attributed to Thomas Caines, South Boston Crown Glass Company or Phoenix Glass Works • 1820–1835 • Boston, Massachusetts • Blown colorless lead glass • H. 5¾ inches • Gift of the DAR Museum Docent Committee • Acc. 81.2

115 Card table
John Budd • c. 1817 • New York City, New York • Mahogany, mahogany veneer, white pine • H. 29⅜ inches W. 35⅝ inches D. closed 17¾ inches • Gift of the Texas State Society • Acc. TX 74.18

116 Engraved label of John Budd
1817 • New York City, New York • Ink on paper • 2½ by 4 inches

117 Card table
1800–1815 • Boston-Salem region • Mahogany, pine and maple with veneers of mahogany, maple and satinwood • H. 30⅜ inches W. 36½ inches D. (closed) 16¾ inches • Gift of Katherine Beeman Berry and Edith Louise Beeman • Acc. ME 6913

118 Card table
1790–1810 • Philadelphia-Maryland region • Mahogany, tulip, white pine and oak with mahogany and maple veneer • H. 37 inches W. 36 inches D. (closed) 18½ inches • Gift of Mrs. John H. Bruns • Acc NY 64.289

119 Dressing table
1730–1760 • Virginia or Pennsylvania • Walnut, burl walnut, tulip, cedar • H. 29⁷/₁₆ inches W. 35¼ inches D. 19½ inches • Friends of the Museum Purchase • Acc. 63.209

120 Washstand
1790–1810 • American • Mahogany, white pine, tulip with brass inlays • H. 32 inches W. 15¹/₁₆ inches D. 15 inches • Gift of Mrs. Viola Ayre Hodson • Acc. DC 55.139

121 Side chair
c. 1757 • Boston region, Massachusetts • Walnut, maple • H. 40⅜ inches W. 21 inches D. 17⅛ inches • Gift of Mrs. Earle M. Pease • Acc. 67.153

122 Armchair
c. 1760 • Philadelphia region • Walnut, white pine, and tulip • H. 40½ inches W. 23½ inches D. 17½ inches • Friends of the Museum Purchase • Acc. 61.132

123 Side chair
1770–1795 • Massachusetts • Mahogany, curly mahogany, maple, white pine • H. 37⅛ inches W. 23½ inches D. 19 inches • Gift of the Sequoyah District Chapters, Tennessee, and Friends of the Museum Purchase • Acc. 71.224

124 Side chair
Attributed to Eliphalet Chapin (1741–1807) • 1780–1807 • East Windsor, Connecticut • Mahogany, cherry, pine • H. 38½ inches W. 21⅜ inches D. 16⅞ inches • Gift of Miss Harriette Folger • Acc. NY 53.113

125 Armchair
c. 1770 • Williamsburg, Virginia • Walnut with yellow pine and walnut • Impressed "VIRGᴬ" on rear seat rail • H. 36⅝ inches W. 23¼ inches D. 18⅝ inches • Friends of the Museum Purchase • Acc. 72.24

126 Clockwise from left:
Chippendale armchair
1780–1830 • Probably Massachusetts • Maple, rush seat • H. 38½ inches W. 21½ inches D. 17 inches • Acc. 6507

Bannister back side chair
1730–1800 • Possibly Massachusetts • Painted maple, rush seat • H. 43 inches W. 18 inches D. 13½ inches • Gift of Mrs. Marion L. Ells • Acc. 68.153

Queen Anne side chair
1730–1770 • New England • Maple, ash, rush seat • H. 42½ inches W. 19 inches D. 14 inches • Gift of the Warren and Prescott Chapter • Acc. MA 5920

Slat-back armchair
1800–1830 • Possibly Connecticut • Maple, woven seat • H. 44½ inches W. 25½ inches D. 15 inches • Gift of Mrs. Bertha Cady Propson • Acc. 61.11

127 Sofa
1770–1790 • Philadelphia, Pennsylvania • Mahogany, white pine • History of ownership by Thomas McKean (1734–1817) • H. 39¾ inches W. 90¾ inches • Gift of the Mary Washington Chapter • Acc. 2004

191

128 Upholstered-back armchair or elbow chair
c. 1770 • New York City • Mahogany, beech, black gum • H. 37½ inches W. 26½ inches D. 23¾ inches • Gift of Elizabeth M. Newton • Acc. NY 5682

129 Pair of armchairs
William King Jr. (w.c. 1806–c. 1834) • 1817–1818 • Georgetown, D.C. • Mahogany and mahogany veneer • H. 39 inches W. 25½ and 25 inches D. 21 and 20 inches • Friends of the Museum Purchase • Acc. 61.133.1,2

130 Desk-on-frame
1740–1770 • Mid-Atlantic states • Maple with white pine, tulip, and white cedar • H. 45 inches W. 37¼ inches D. 20¼ inches • Gift of Mrs. Harry Clark Boden • Acc. DE 74.28

131 Bookcase
1770–1800 • Northeastern North Carolina • Walnut, yellow pine • H. 107⅞ inches W. 52 inches D. 17½ inches • Gift of Mrs. Edmund Burke Ball • Acc. IN 5801

132 Tall-case clock
Works by David Shoemaker • 1810–1817 • Mount Holly, New Jersey; case possibly Philadelphia • Mahogany and pine with lightwood inlays • H. 104 inches • Gift of Miss Mildred Getty • Acc. 71.179

133 Tall-case clock
Works by Humphrey Griffith (1791–1870) • 1825–1836 • Indianapolis, Indiana • Cherry • H. 99 inches • Gift of Mrs. John Newman Carey • Acc. 5803

134 Chest
1700–1716 • Northampton, Massachusetts • Oak and white pine • H. 32½ inches W. 44¼ inches D. 18 inches • Gift of Mrs. Carlos E. Pitkin • Acc. 47.1

135 Doll
Jumeau • c. 1880 • Paris, France • Bisque and composition • H. 17½ inches • Gift of Mrs. Miriam C. Chaney • Acc. 69.65

Doll's bed
1860–1870 • American • Walnut and burl walnut • H. 12 inches L. 25 inches W. 14 inches • Gift of Miss Theodora McCurdy • Acc. NH 4139

Doll's chest of drawers
Late nineteenth century • American • Walnut • H. 12½ inches W. 10½ inches D. 5¾ inches • Acc. 84.51

Doll's traveling trunk
c. 1840 • American • Wallpaper, wood • H. 2⅝ inches W. 5¼ inches D. 2⅞ inches • Gift of Miss Abby Harlan Jerret • Acc. 987

136 Card table
1820–1829 • Baltimore, Maryland • Mahogany and tulip; wood painted green with Pompeian red and gilt freehand and stenciled decoration • H. 28 inches W. 36 inches • Friends of the Museum Purchase • Acc. 78.36

137 Fancy chair
1820–1830 • Baltimore, Maryland • Tulip and maple with painted decoration • H. 31½ inches W. 18½ inches D. 16 inches • Gift of Mrs. Martha Maddox Key • Acc. MD 5147

138 Painted side chair and armchair
c. 1820 • New York State • Maple with painted decoration • Armchair: H. 34 inches W. 18½ inches D. 16 inches side chair: H. 34 inches W. 18 inches D. 16 inches • Gift of Mrs. Edward D. Conley • Acc. 73.4.1,2

139 Center table
1805–1820 • New York City • Mahogany, mahogany veneer, chestnut, and pine • H. 29⅛ inches Diam. top 36⅛ inches • Gift of Frank E. Klapthor • Acc. 64.280

140 Hunt board or sideboard-table
1770–1800 • Maryland • Mahogany, mahogany veneer, yellow pine, and tulip • H. 36 inches W. 75 inches D. 28¾ inches • Gift of Nicholas Jones • Acc. 6458

141 Punch bowl
1770–1800 • China for the Western market • Porcelain with polychrome enamel decoration • H. 6½ inches Diam. 16 inches • Friends of the Museum Purchase • Acc. 67.124

Ladle
Edward Francis • c. 1830 • Leesburg, Virginia • Silver • L. 14⅜ inches • Gift of Mrs. Marian H. Detwiler • Acc. 77.71

Punch strainer: See no. 142, below

Wine siphon
C.F. • 1800–1850 • American • Silver • L. 12¾ inches • Friends of the Museum Purchase • Acc. 67.124

Salver
Gerardus Boyce (1795–1880) • c. 1820 • New York City • Silver • Diam. 7¾ inches • Gift of Dr. Helen Bush • Acc. 74.85

Punch pot, "Aurora"
Attributed to The Leeds Pottery; transfer printed decoration after William Greatbatch (1735–1813) • c. 1780 • Staffordshire, England • Creamware with multicolor transfer decoration • H. 7¼ inches • Gift of Mrs. William A. Sutherland • Acc. 58.120

142 Punch strainer
Zachariah Brigden (1734–1787) • c. 1770 • Boston, Massachusetts • Silver • L. 11¹⁵⁄₁₆ inches • Gift of the South Dakota State Society • Acc. 52.31

143 Cann
John David (1736–1794) • 1763–1793 • Philadelphia, Pennsylvania • Silver • H. 3¹⁵⁄₁₆ inches • Gift of Miss Wilmuth Gary and Mrs. Victoria Anderson • Acc. 6666

144 Sideboard
1790–1810 • Southern United States • Mahogany, cedar, yellow pine, with satinwood inlays • H. 38¾ inches W. 72 inches D. 26 inches • Gift of the North Carolina State Society • Acc. NC 64.57

145 Dish cross
John Moore • 1798 • London, England • Silver • History of ownership by Charles Carroll of Carrollton • H. 3⅞ inches W. 12½ inches • Gift of the Illinois State Society • Acc. IL 73.61

146 Epergne
Thomas Pitts • 1770–1771 • London, England • Silver • H. 19½ inches W. 25⅞ inches • Friends of the Museum Purchase • Acc. 71.231

147 Left to right:
Dessert plate
c. 1780 • Staffordshire or Yorkshire, England • Cream colored earthenware • Diam. 9½ inches • Friends of the Museum Purchase • Acc. 65.98

Dessert dish
Attributed to the Leeds Pottery • c. 1770 • Yorkshire, England • Cream colored earthenware • L. 10¼ inches W. 8 inches • Friends of the Museum Purchase • Acc. 63.49

Dessert plate
Attributed to the Leeds Pottery • c. 1780 • Staffordshire or Yorkshire, England • Cream colored earthenware • Diam. 7½ inches • Friends of the Museum Purchase • Acc. 63.42

Dessert plate
c. 1770 • Staffordshire or Yorkshire, England • Cream colored earthenware • Diam. 6½ inches • Friends of the Museum Purchase • Acc. 63.41

148 Cream bowl and cover with stand
c. 1790 • Staffordshire or Yorkshire, England • Cream colored earthenware • H. 11¾ inches Diam. of stand 9½ inches • Friends of the Museum Purchase • Acc. 58.120

149 Oval jelly mold
1760–1790 • Staffordshire or Yorkshire,

England•Cream colored earthenware•
L. 7 inches H. 2¼ inches•Gift of
Mrs. Grey R. Smith•Acc. 53.26

Fish mold
Attributed to the Leeds Pottery•
c. 1770•Staffordshire, England•
Cream colored earthenware•L. 6½
inches H. 4 inches•Friends of the
Museum Purchase•Acc. 63.35

150 Plate
c. 1760•Staffordshire, England•
Cream colored earthenware with
tortoise-shell lead glaze•Diam. 9⅛
inches•Friends of the Museum Pur-
chase•Acc. 65.85

Plate
c. 1760•Staffordshire, England•
Salt-glazed stoneware•Diam. 9¼
inches•Gift of Mr. and Mrs. John R.
Williams•Acc. 75.190

151 Sauceboat
1750-1760•Staffordshire, England•
Agateware•H. 3 inches L. 7 inches
•Friends of the Museum Purchase•
Acc. 84.35.4

152 Plate
1790-1800•China, for the Western
market•Porcelain with gilt and blue,
green and black overglaze enamel dec-
oration•Made for Elias Morgan
(1770-1812)•Diam. 9 inches•Friends of
the Museum Purchase•Acc. 56.105

Cream pot
1790-1800•China, for the Western
market•Porcelain with gilt and blue,
green and black overglaze enamel dec-
oration•Made for John Morgan
(1753-1812)•H. 4½ inches•
Gift of Major and Mrs. James Glover
Charles•Acc. 83.71.1

153 "Sample" custard cup and lid
1790-1810•China, for the Western
market•Porcelain with enamel and gilt
decoration•H. 3¼ inches•Friends of
the Museum Purchase•Acc. 68.168

154 Coffee cup and saucer
c. 1808•China, for the Western
market•Porcelain with sepia and brown
enamel decoration•Made for Mary
Hemphill (1779-1834)•H. cup 2⅝
inches Diam. saucer 5⅜ inches•Friends
of the Museum Purchase•Acc. 78.1

155 Upper left: Plate
1800-1810•China, for the Western
market•Hard paste porcelain with blue
enamel and gilt decoration•Diam. 9
inches•Gift of Sylvia Paliner Bennett•
Acc. 1660

Upper right: Plate
c. 1760•Liverpool, England•Tin-glazed

earthenware with underglaze blue
decoration•Diam. 9 inches•Friends of
the Museum Purchase•Acc. 82.109

Lower left: Soup plate
c. 1820•Staffordshire or Yorkshire, Eng-
land•Cream colored earthenware with
black transfer printed and blue-green
enamel decoration•Diam. 10 inches•
Friends of the Museum Purchase•
Acc. 80.81

Lower right: Soup plate
Wedgwood•1770-1780•Impressed
WEDGWOOD on underside•Stafford-
shire, England•Cream colored ear-
thenware with sepia enamel decoration
•Diam. 9½ inches•Gift of Byron and
Elaine Born•Acc. 83.59

156 Left rear: Sauceboat
c. 1755•Staffordshire, England•
Salt-glazed stoneware with enamel deo-
cration•H. 3¼ inches L. 6⅜ inches•-
Friends of the Museum Purchase•
Acc. 77.16

Right rear: Tureen and lid
1760-1770•Staffordshire, England•
Salt-glazed stoneware, molded in relief
with seed ornament•H. 8 inches L. 10
inches•Friends of the Museum Pur-
chase•Acc.64.51

Left center: Sauceboat
The Worcester Porcelain Factory•
c.1755•Worcester, England•Soft paste
porcelain with underglaze blue decora-
tion•H. 3¼ inches L. 8 inches•Gift of
Frank E. Klapthor•Acc. 57.71

Center: Butter tub and lid
Molded decoration attributed to James
Hughes, Lowestoft Factory•1760-1768•
Suffolk, England•Soft paste porcelain
with underglaze blue decoration•H. 4⅜
inches L. 5½ inches•Gift of Mrs.
William A. Sutherland•Acc. 60.136.1,2

Center right: Sauce tureen and lid with
stand
1769-1790•Staffordshire, England•
Cream colored earthenware•H. 6
inches L. 8 inches•Friends of the
Museum Purchase•Acc. 63.34

Foreground: Butter tub and lid with
stand
1750-1770•Staffordshire, England•Salt-
glazed stoneware•Gift of Mr. and
Mrs. John R. Williams•Acc. 75.190.3

Two knives and one fork
1740-1770•England•Silver•Knives: L.
10¾ inches, fork: L. 8¼ inches•Gift
of Miss Caroline Loughboro•
Acc. 54.224

157 Left rear: Plate
Tucker Porcelain Factory•1826-1838•

Philadelphia•Porcelain with polychrome
enamel and gilt decoration•Diam. 7¾
inches•Friends of the Museum Purchase
•Acc. 82.108.2

Right rear: Pitcher
Tucker Porcelain Factory•1826-1838•
Philadelphia•Porcelain with polychrome
enamel and gilt decoration•H. 9½
inches•Friends of the Museum
Purchase•Acc. 58.39

Center: Pitcher
Tucker Porcelain Factory•1826-1838•
Philadelphia•Porcelain with sepia
decoration•H. 9 inches•Friends of the
Museum Purchase• Acc. 79.29.2

Center right: Plate
Tucker Porcelain Factory•1826-1838•
Philadelphia•Porcelain with sepia
decoration•Diam. 6 inches•Friends of
the Museum Purchase•Acc. 62.175

Left front: Plate
Tucker Porcelain Factory•1826-1838•
Philadelphia•Porcelain with enamel
and gilt decoration•Diam. 6 inches•
Gift of Mrs. William White•Acc. 2533

Right front: Cup
Tucker Porcelain Factory•1826-1838
•Philadelphia•Porcelain with gilt
decoration•H. 2¾ inches Diam. 3¼
inches•Friends of the Museum Pur-
chase•Acc. 79.29

Right front, beneath cup: Plate
Tucker Porcelain Factory•1826-1838
•Philadelphia•Porcelain with gilt
decoration•Diam. 6¼ inches•Friends
of the Museum Purchase•Acc. 58.40.1

158 Porringer: See no. 159, below

Caster
Bilious Ward (1729-1777)•c. 1750•
Guilford, Connecticut•Silver•H. 2⅞
inches•Gift of Miss Florence Lee•
Acc. 59.185

Pepperbox
John Burt (1692/3-1745/6)•1730-
1740•Boston, Massachusetts•Silver•H.
3½ inches•Friends of the Museum Pur-
chase•Acc. 81.55

Sauceboat
Thomas Edwards (1701-1755)•c.
1746•Boston, Massachusetts•Silver•
H. 4⅝ inches L. 6 inches•Gift of Mrs.
Franklin E. Campbell•Acc. 76.76

Left: Salt
Samuel Burt (1724-1754)•1745-
1750•Boston, Massachusetts•Silver•
Diam. 2¼ inches•Gift of Mrs. Franklin
E. Campbell•Acc. 76.77

Right: Salt
Charles Oliver Bruff (w.c. 1765-

1783 in New York•New York City or
Elizabethtown, New Jersey•Silver•
Diam. 2⁷/₁₆ inches•Gift of the District
of Columbia State Society•Acc. 4028

Cup
Paul Revere (1735–1818)•1795•
Boston, Massachusetts•Silver•H. 2¾
inches•Gift of Miss Katherine Matthies•
Acc. 66.294

Four teaspoons
Isaac Hutton (1767–1855)•c. 1790•
Albany, New York•Silver•L. 5⅛ inches•
Gift of Miss Katherine Batcheller•
Acc. 3185.1–4

159 Porringer
John Allen (1671/2–1760) and John
Edwards (1671–1746)•c. 1699–1707•
Boston, Massachusetts•Silver•H. 1¹/₁₆
inches Diam. 4⅞ inches•Gift of
Mrs. Franklin E. Campbell•Acc. 76.70

160 Dish
Thomas and Townsend Compton,
(w.1801–1817)•1801–1817•London,
England•Pewter•Diam. 8³/₁₆ inches
•Gift of Mrs. Willis Harnden•Acc. 2822

Coffeepot
Israel Trask (w.c. 1815–1856)•
1825–1850•Beverly, Massachusetts•
Britannia•H. 13 inches•Gift of the Mary
Ishem Keith Chapter•Acc. 3817

Candlestick
Circa 1820•Probably American•Pewter•
H. 6½ inches•Gift of Mr. and
Mrs. Frank A. Hodson•Acc. 55.50

Twin burner oil lamp
1830–1860•Probably American•
Britannia•H. 11 inches•Gift of the
Oklahoma State Society•Acc. OK 73.70

Center: Teapot
Josiah Danforth (w. 1821–ca. 1843)•
1830–1843•Middletown, Connecticut•
Britannia•H. 7 inches•Gift of
Mrs. Walter S. Edgar•Acc. 73.53

Right: Teapot
Thomas Danforth Boardman and
Sherman Boardman (w. 1810–1850)•
1830–1850•Hartford, Connecticut•
Britannia•H. 8¾ inches•Gift of Mrs.
Mabelle Amelia Dowd•Acc. 7299

Nursing or "sucking" bottle
Circa 1820•Probably American•Pewter•
H. 5½ inches•Gift of Mrs. Allyn M.
Smith•Acc. 52.58

Tablespoon
Eighteenth century•Possibly Amer-
ican•Pewter•L. 7½ inches•
Acc. NH 4372a

Canteen or round pint container
1780–1830•Possibly American•Pewter•
H. 5⅛ inches Diam. 4½ inches•
Acc. 6328

Blanket
1830–1850•American•Wool•
L. 77¼ inches W. 68 inches•Gift of
Berneice Johnson•Acc. 67.48.2

161 Pitcher
W. H. Lehew & Co.•1877•Strasburg,
Virginia•Salt-glazed stoneware with
cobalt slip decoration•H. 9 inches•Gift
of Mrs. Margaret Spinks Thomas•
Acc. 62.172

Jar
Sold by H. C. Smith•1831–1846•
Alexandria, D.C.•Salt-glazed stoneware
with cobalt slip decoration•H. 10
inches•Gift of Mrs. Earl Wiley•
Acc. 63.75

Flask
c. 1815•New York or northeast
Pennsylvania•Salt-glazed stoneware
with incised and cobalt slip decoration
•H. 7⅝ inches•Friends of the
Museum Purchase•Acc. 61.136.1

Flask
Nineteenth century•American•Salt-
glazed stoneware with cobalt slip deco-
ration•H. 8⅞ inches•Friends of the
Museum Purchase•Acc. 61.136.2

Blanket
Nineteenth century•American•Plain
weave natural and blue wool, weft
patterned stripe•L. 83 inches W. 57½
inches (2 panels joined)•Gift of Mrs.
Paul V. Bretz•Acc. 64.174

162 Left front: Pie plate
Nineteenth century•American, possibly
Connecticut•Red earthenware with slip
decoration and lead glaze•Diam. 10
inches•Friends of the Museum
Purchase•Acc. 79.32

Left rear: Oval dish
c. 1850•Probably England•Red
earthenware with combed slip decora-
tion and lead glaze•L. 13¾ inches W.
11 inches•Friends of the Museum
Purchase•59.132

Right rear: Pie plate
Early nineteenth century•American or
English•Red earthenware with slip
decoration and lead glaze•Diam. 11
inches•Gift of Mrs. Martha G. Downs•
Acc. 2253

Jar and cover
Nineteenth century•American or Euro-
pean•Red earthenware with manganese-
oxide decoration and lead glaze•H. 13½
inches Diam. 9½ inches•Acc. 84.60

Mold
1820–1850•American•Red earthenware
with lead glaze interior•H. 2½ inches
Diam. 7½ inches•Gift of Mrs. Henry
Matthews Parker•Acc. 61.52.13

163 Mousetrap
Blade stamped S.SANDERS•Nineteenth
century•Possibly American•Pine
and iron•H. 1½ inches W. 4 inches L. 4
inches•Gift of Miss Sarah Marion
Chase•Acc. 2094

164 Wall pocket or cornucopia
c. 1760•Perhaps Liverpool, England•
Tin-glazed earthenware•L. 7½ inches•
Gift of Mary Beale Brainerd Wahoske•
Acc. 58.127

Copybook
Betsy Lewis (1786–1818)•1803•The
Ladies Academy, Dorchester, Massa-
chusetts•Paper, ink, and watercol-
or•8½ by 6½ inches•Gift of Mrs. J.
Gene Edwards•Acc. 79.14

165 Sampler
Martha Gray (1771–1868)•1779•
Philadelphia, Pennsylvania•Wool on
linen•7 by 9½ inches•Gift of Mrs. C.
Edward Murray•Acc. 3976

166 Appliquéd and pieced quilt
Lucy Bassett Thatcher (1803–1894)•
c. 1860•Connecticut or
Massachusetts•Roller-printed cottons
with linen tape on cotton ground•98½
by 93½ inches•Gift of Mrs. Herbert
Thatcher, Miss Marion Lee Thatcher,
and Mrs. Henry W. Schorer•Acc. 3825

167 Appliquéd quilt
Mary Ann Barringer (1811–1845)•
c. 1828•Cabarrus County, North
Carolina•Roller-printed glazed cottons
on cotton ground•97 by 97 inches•
Gift of Mrs. Theodore W. Gunn•
Acc. 55.38

168 Bedwarmer
Eighteenth century•Probably Con-
tinental•Brass, wood•L. 48½ inches
Diam. of pan 13 inches•Gift of Mrs. G.
C. Spillers•Acc. OK 66.305

Foot stove
1820–1850•American, possibly Massa-
chusetts•Wood, tin•W. 9 inches Depth
8 inches•Gift of Mrs. John L. Mosher
•Acc. 50.21

Bellows
c. 1820•American•Painted pine, brass,
leather•L. 17¾ inches•Gift of the
General John Stark Chapter•
Acc. 67.121

Hand-held fire screen: See no. 93,
above

169 Fireback with the Fairfax coat of arms
Isaac Zane Jr., Marlboro Furnace•
c. 1770•Frederick County, Virginia•
Iron•33½ by 31¼ inches•Gift of
Colonel and Mrs. Frank M. Boberek•
Acc. 83.76

170 Plate warmer
c. 1770•American•Brass•H. 22¼
inches•Acc. 84.85

Four soup plates
1780–1810•China, for the Western
market•Porcelain with blue enamel and
gilt decoration•Diam. 9⁷/₁₆ inches•Gift
of Mrs. Jefferson Patterson•
Acc. 84.5.18.1–4

171 Bed rugg
Molly Stark Lothrop (b. 1755)•
c. 1780•New London County, Connec-
ticut•Natural wool foundation, tabby
weave; uncut pile•73 by 83½ inches•-
Gift of Mrs. Belle Case•Acc. 1173

172 Jacquard-type coverlet
1823•Suffolk County, New York•
Double weave, blue wool and natural
cotton warp and weft•L. 91 inches W.
82 inches (2 loom widths joined)•Gift
of Mrs. John P. Bramer•Acc. 56.1

173 Jacquard coverlet
Daniel L. Myers•1846•Bethel Town-
ship, Clark County, Ohio•Natural
cotton warp with blue, green and red
wool and natural cotton weft; self warp
fringe on foot end and self weft fringe
on sides•L. 92 inches W. 73 inches (2
loom widths joined)•Gift of Mrs. Henry
S. Lewis•Acc. 77.18

174 Jacquard coverlet
David Beil•1857•New Hamburg,
Mercer County, Pennsylvania•Natural
and light blue cotton warp with blue,
gold and red wool and natural cotton
weft; self weft fringe at sides, self warp
fringe at foot•L. 92 inches W. 76
inches (two loom widths joined)•Gift
of Miss Jean Crosby•Acc. 82.140

175 Clockwise from upper left:
Pierced tin lantern
c. 1830•American•Tin•H. 14 inches•
Acc. 84.50

Pressed glass lamp with double burner
1835–1850•American•Glass and
pewter•H. 11½ inches•Gift of Mrs. W.
C. Badger•Acc. 1491

Pressed glass dolphin candlestick
Attributed to the Boston and Sandwich
Glass Company•c. 1840•Sandwich,
Massachusetts•Glass•H. 10½ inches•
Gift of Mrs. James A. Vaughan•
Acc. 78.17a

Sliding crusie lamp
c. 1830•Possibly American•Iron•H.
30¼ inches•Gift of the Oklahoma State
Society•Acc. OK 61.147

Candlestick
1750–1775•Probably English•Brass•
H. 8 inches•Friends of the Museum
Purchase•Acc. 70.55

Fluid lamp
1830–1850•American•Free blown glass,
pewter•H. 6 inches•Gift of Mrs.
Kearney A. Meeker•Acc. 47.85

Betty lamp
Peter Derr•1843•Reading, Berks
County, Pennsylvania•Iron and brass•
H. 11 inches•Gift of Mrs. Richard
Anderson•Acc. 46.140

Rushlight with candle socket
1750–1850•Possibly American•Iron and
wood•H. 10¼ inches•Gift of Mrs.
Charles Leas Eshlemen•Acc. 3474

Crusie lamp
1750–1850•Possibly American•
Iron•H. 13½ inches•Acc. 73.80

176 *George on his pet Goat*
Published by B. Bramell•c. 1820•
Philadelphia, Pennsylvania•Colored
woodcut•7⅛ by 6⅜ inches (in frame)-
•Gift of Katherine Steyker•Acc. 47.77

177 Columbian doll
1891–1900•American•Cotton muslin
and paint•H. 29 inches•Gift of Mrs.
Henry Erwin•Acc. 66.212

Rocking horse
1850–1880•American•Wood, paint,
horsehair, leather•H. 24 inches•Gift of
Mrs. Tronia Mattison•Acc. NH 4130

Bonnet
1840–1880•American•Cotton•
Diam. 10 inches•Acc. 4539

Hooked rug
1850–1880•American•Wool and cot-
ton•36 by 24 inches•Acc. 80.35

178 Teapot (detail)
c. 1745•Staffordshire, England•Salt-
glazed stoneware•H. 5½ inches•Friends
of the Museum Purchase•Acc. 63.36

Selected Bibliography

Affleck, Diane L. Fagan. "The Betsy Lewis Copybook: A New England Girl's Education." *Daughters of the American Revolution Magazine* (March 1980): 268-273.

Allen, Gloria Seaman. "China Trade Consumables." *Washington, D.C., Antiques Show Catalogue* (1982): 67-69.

———. "Delftware Usage: A Study of Probate Records from Kent County, Maryland, 1740 to 1780." *Daughters of the American Revolution Museum Antiques Show Catalogue* (1982): 14-17.

Beal, Rebecca J. *Jacob Eichholtz, 1776-1842.* Philadelphia, 1969.

Belden, Louise Conway. *The Festive Tradition; Table Decoration and Desserts in America, 1650-1900.* New York, 1983.

———. *Marks of American Silversmiths in the Ineson-Bissell Collection.* Charlottesville, Va., 1980.

Belknap, Waldron Phoenix, Jr. *American Colonial Painting.* Cambridge, Mass., 1959.

[The William Benton Museum of Art.] *The American Earls: Ralph Earl, James Earl, R.E.W. Earl.* Meriden, Ct., 1972.

Berry, Michael W. "Castles on the Ellipse: Ceramics at the DAR Museum." *Nineteenth Century* (Spring 1984): 6-7.

———. "'Drawn Upon Sattin and Ivory'; Mourning Designs of Samuel Folwell, 1793 to 1813." *Washington, D.C., Antiques Show Catalogue* (1983): 74-75.

———. "Tin-Glazed Earthenwares at the DAR Museum: A Genealogical Perspective." *Daughters of the American Revolution Antiques Show Catalogue* (1982): 11-13.

Bingham, Robert Warwick. "George Washington in Liverpool Ware." *The Magazine Antiques* (July 1927): 32-35.

Bishop, Robert and Carleton L. Safford. *American Quilts and Coverlets.* New York, 1972.

Bivins, John Jr. "Decorative cast iron on the Virginia frontier." *The Magazine Antiques* (March 1972): 535-539.

Bolton, Ethel Stanwood and Eva Johnston Coe. *American Samplers.* 1921. Reprint. Princeton, N.J.: Pyne Press, 1973.

Bradfield, Nancy. *Costume in Detail, 1730-1790.* London, 1968.

Brant, Sandra and Elissa Cullman. *Small Folk: A Celebration of Childhood in American.* New York, 1980.

Buhler, Kathryn C. *American Silver, 1655-1825, in the Museum of Fine Arts Boston.* 2 vols. Boston, 1972.

———. and Graham Hood. *American Silver, Garvan and Other Collections in the Yale University Art Gallery.* 2 vols. New Haven, Ct., 1970.

Callister, J. Herbert. *Bed Ruggs: 1722-1833.* Hartford, Ct., 1972.

Clinton, Catherine. *The Plantation Mistress: Woman's World in the Old South.* New York, 1982.

Coleman, Dorothy S. *The Collector's Encyclopedia of Dolls.* New York, 1968.

Collins, Herbert Ridgeway. *Threads of History.* Washington, D.C., 1979.

Comstock, Helen, *American Furniture: Seventeenth, Eighteenth, and Nineteenth Century Styles.* New York, 1962.

Cook, Clarence. *The House Beautiful: Essays on Beds and Tables, Stools and Candlesticks.* 1878. Reprint. New York: North River Press, 1980.

Cooke, Lawrence S., ed. *Lighting in America; From Colonial Rushlights to Victorian Chandeliers.* Pittstown, N.J., 1984.

Cooper, Wendy A. *In Praise of America: American Decorative Arts, 1650-1830.* New York, 1980.

Cotterell, Howard Herschel. *Old Pewter: Its Makers and Marks.* Rutland, Vt., 1963.

Craig, James H. *The Arts and Crafts in North Carolina, 1699-1840.* Winston-Salem, N.C., 1965.

Crossman, Carl L. *The China Trade: Export Paintings, Furniture, Silver and Other Objects.* Princeton, N.J., 1972.

Crumpacker, Laurie and Carol F. Karlsen, eds. *The Journal of Esther Edwards Burr 1754-1757.* New Haven, Ct., 1984.

Cullman, Elissa and Sandra Brant. *Small Folk: A Celebration of Childhood in America.* New York, 1980.

Cummings, Abbott Lowell. *Rural Household Inventories, 1675-1775.* Boston, 1964.

Cushion, John P. *Pottery and Porcelain Tablewares.* New York, 1976.

Davis, John D. *English Silver at Williamsburg.* Williamsburg, Va., 1976.

Davison, Mildred and Christa C. Mayer-Thurman. *Coverlets.* Chicago, 1973.

De Pauw, Linda Grant and Conover Hunt. *Remember the Ladies, Women in America: 1750-1815.* New York, 1976.

Detweiler, Susan Gray. *George Washington's Chinaware.* New York, 1982.

Deutsch, Davida Tenenbaum. "Samuel Folwell of Philadelphia: an artist for the needleworker." *The Magazine Antiques* (February 1981): 420-423.

———. and Betty Ring. "Homage to Washington in needlework and prints." *The Magazine Antiques* (February 1981): 402-419.

Donaghy, Elisabeth. "French and English Decorative Arts in the Service of Seven 'American Kings'." *Washington, D.C., Antiques Show Catalogue* (1973): 55-59.

———. "Paintings at the Daughters of the American Revolution Museum." *The Magazine Antiques* (March 1973): 510-519.

Dow, George Francis. *The Arts and Crafts in New England, 1704-1775.* Topsfield, Mass., 1927.

Downs, Joseph. *American Furniture in the Henry Francis du Pont Winterthur Museum: Queen Anne and Chippendale Periods.* New York, 1952.

Elder, William Voss. *Baltimore Painted Furniture, 1800-1840.* Baltimore, 1972.

Emery, Irene. *The Primary Structure of Fabrics.* Washington, D.C., 1966.

Fales, Dean A., Jr. *American Painted Furniture, 1660-1880.* New York, 1972.

Fales. Martha Gandy. *Early American Silver for the Cautious Collector.* New York, 1970.

———. *Joseph Richardson and Family, Philadelphia Silversmiths.* Middletown, Ct., 1974.

———— and Henry N. Flint. *The Heritage Foundation Collection of Silver With Biographical Sketches of New England Silversmiths, 1625–1825.* Old Deerfield, Mass., 1968.

Federico, Jean Taylor. "China Trade Porcelain From the DAR Museum." *Washington, D.C., Antiques Show Catalogue* (1982): 57–59.

————, ed. *The Decorative Arts in America at 1776.* Washington, D.C., 1976.

————. "Eighteenth-century ceramics at the DAR Museum." *The Magazine Antiques* (April 1976): 750–759.

————. "Two Revolutionary Boston Families and Their Silver." *Daughters of the American Revolution Magazine* (March 1977): 204–207.

————. "An Unfinished Tale of Three Cities: Late Neoclassical Domestic Silver." *Washington, D.C., Antiques Show Catalogue* (1980): 87–90.

Fennelly, Catherine. *Textiles in New England, 1790–1840.* Sturbridge, Mass., 1961.

Fitzgerald, Oscar P. *Three Centuries of American Furniture.* Englewood Cliffs, N.J., 1982.

Fleming, E. McClung. "From Indian Princess to Greek Goddess: The American Image, 1783–1815." *Winterthur Portfolio III* (1967): 37–66.

Flynt, Henry N. and Martha Gandy Fales. *The Heritage Foundation Collection of Silver With Biographical Sketches of New England Silversmiths, 1625–1825.* Old Deerfield, Mass., 1968.

Garrett, Elisabeth Donaghy. "American furniture in the DAR Museum." *The Magazine Antiques* (April 1976): 750–759.

————. "The American home, Part I: 'Centre and circumference': the American domestic scene in the age of the Enlightenment." *The Magazine Antiques* (January 1983): 214–225.

————. "The American home, Part II: Lighting devices and practices." *The Magazine Antiques* (February 1983): 408–417.

————. "The American home, Part III: The bedchamber." *The Magazine Antiques* (March 1983): 612–625.

————. "The American home, Part IV: The dining room." *The Magazine Antiques* (October 1984): 910–921.

————. "American samplers and needlework pictures in the DAR Museum, Part I: 1739–1806." *The Magazine Antiques* (February 1974): 356–364.

————. "American samplers and needlework pictures in the DAR Museum, Part II: 1806–1840." *The Magazine Antiques* (April 1975): 688–701.

————. "A Century of Samplers from the Daughters of the American Revolution Collections." *The Decorator* (Fall 1973): 6–22.

Garrett, Wendell D. "John Adams and the Limited Role of the Fine Arts." *Winterthur Portfolio One* (1964): 242–255.

Golovin, Anne Castrodale. "Cabinetmakers and chairmakers of Washington, D.C., 1791–1840." *The Magazine Antiques* (May 1975): 898–922.

Gottesman, Rita Susswein. *The Arts and Crafts in New York 1777–1799.* New York, 1954.

————. *The Arts and Crafts in New York 1800–1804.* New York, 1965.

Goyne, Nancy A. "Britannia in America: The Introduction of a New Alloy and a New Industry." *Winterthur Portfolio II* (1965): 160–196.

Greenstein, Blanche and Thomas K. Woodard. *Crib Quilts and Other Small Wonders.* New York, 1981.

Gusler, Wallace B. *Furniture of Williamsburg and Eastern Virginia, 1710–1790.* Richmond, Va., 1979.

Harris, Neil. *The Artist in American Society; The Formative Years, 1790–1860.* New York, 1966.

Hashim, Debra A. "American Silver at the DAR Museum." *The Magazine Antiques* (March 1980): 634–641.

Heatherington, Avis B. "Nineteenth Century Childhood Toys." *The Decorator* (Fall 1975): 19–25.

Heisey, John. *A Checklist of American Coverlet Weavers.* Williamsburg, Va., 1978.

Hewitt, Benjamin A., et. al. *The Work of Many Hands: Card Tables in Federal America, 1790–1820.* New Haven, Ct., 1982.

Hood, Graham and Kathryn C. Buhler. *American Silver, Garvan and Other Collections in the Yale University Art Gallery.* 2 vols. New Haven, Ct., 1970.

Howard, David Sanctuary. *New York and the China Trade.* New York, 1984.

Hunt, Conover and Linda Grant De Pauw. *Remember the Ladies, Women in America: 1750–1815.* New York, 1976.

Innes, Lowell. *Pittsburgh Glass, 1797–1891: A History and Guide for Collectors.* Boston, 1976.

Jacobs, Phoebe Lloyd. "John James Barralet and the Apotheosis of George Washington." *Winterthur Portfolio 12* (1977): 115–137.

Jones, Louis C. "Liberty and considerable license." *The Magazine Antiques* (July 1958): 40–43.

Kane, Patricia E. *300 Years of American Seating Furniture: Chairs and Beds from the Mabel Brady Garvan and Other Collections at Yale University.* Boston, 1976.

Karlsen, Carol F. and Laurie Crumpacker, eds. *The Journal of Esther Edwards Burr, 1754–1757.* New Haven, Ct., 1984.

Katzenberg, Dena S. *Baltimore Album Quilts.* Baltimore, 1981.

Kidwell, Claudia. "Shortgowns." *Dress, 4* (1978): 30–65.

Kirk, John T. *American Chairs: Queen Anne and Chippendale.* New York, 1972.

Klapthor, Margaret and Howard Alexander Morrison. *G. Washington: A Figure Upon The Stage.* Washington, D.C., 1982.

Krueger, Glee. *New England Samplers to 1840.* Sturbridge, Mass., 1978.

Larcom, Lucy. *A New England Girlhood Outlined from Memory.* 1889. Reprint. Williamstown, Mass., 1977.

Lipman, Jean and Alice Winchester. *The Flowering of American Folk Art.* New York, 1974.

Little, Nina Fletcher. *Neat and Tidy; Boxes and Their Contents Used in Early American Households.* New York, 1980.

McCauley, Robert H. *Liverpool Transfer Designs on Anglo-American Pottery.* Portland, Me., 1942.

McClinton, Katharine Morrison. *Antiques of American Childhood.* New York, 1970.

McKearin, Helen and George S. *Two Hundred Years of American Blown Glass.* New York, 1950.

Mayer-Thurman, Christa C. and Mildred Davison. *Coverlets.* Chicago, 1973.

Miller, Lillian B. *In the Minds and Hearts of the People.* Greenwich, Ct., 1974.

Montgomery, Charles F. *American Furniture in the Henry Francis du Pont Winterthur Museum: The Federal Period.* New York, 1966.

————. *A History of American Pewter.* New York, 1973.

Montgomery, Florence M. *Printed Textiles; English and American Cottons and Linens, 1700–1850.* New York, 1970.

————. *Textiles in America, 1650–1870.* New York, 1984.

Morrison, Howard Alexander and Margaret Klapthor. *G. Washington: A Figure Upon The Stage.* Washington, D.C., 1982.

Mountford, Arnold R. *Stafffordshire Salt-glazed Stoneware.* London, 1971.

Mudge, Jean McClure. *Chinese Export Porcelain for the American Trade, 1785–1835.* Newark, Del., 1962.

Nelson, Christina H. "Transfer-printed Creamware and Pearlware for the American Market." *Winterthur Portfolio 15* (1980): 93–115.

[New-York Historical Society.] *The Arts and Crafts in New York, 1726–1776.* New York, 1938.

Nye, Russel Blaine. *The Cultural Life of the New Nation, 1776–1830.* New York, 1960.

Nylander, Jane C. "Some print sources of New England schoolgirl art." *The Magazine Antiques* (August 1976): 292–301.

Palmer, Arlene M. *A Winterthur Guide to Chinese Export Porcelain.* New York, 1976.

[Philadelphia Museum of Art.] *Three Centuries of American Art.* Philadelphia, 1976.

Poesch, Jessie J. *The Art of the Old South.* New York, 1983.

Prime, Alfred Coxe. *The Arts and Crafts in Philadelphia, Maryland and South Carolina, 1721–1785.* The Walpole Society: 1929.

———. *The Arts and Crafts in Philadelphia, Maryland and South Carolina, 1786–1800.* The Walpole Society: 1932.

Richards, Caroline Cowles. *Village Life in America, 1852–1872: As Told in the Diary of a School-Girl.* 1913. Reprint. Williamstown, Mass., 1972.

Richards, Nancy E. "A Most Perfect Resemblance at Moderate Prices: The Miniatures of David Boudon." *Winterthur Portfolio* 9 (1974): 77–101.

Ring, Betty. "Mrs Saunders' and Miss Beach's Academy, Dorchester." *The Magazine Antiques* (August 1976): 302–312.

———. and Davida Tenenbaum Deutsch. "Homage to Washington in needlework and prints." *The Magazine Antiques* (February 1981): 402–419.

Robertson, Niente Ingersoll. "The American China Trade: 1784–1850." *Washington, D.C., Antiques Show Catalogue* (1982): 34–36.

Roth, Rodris. "Tea Drinking in 18th-Century America: Its Etiquette and Equipage." *United States National Museum Bulletin 225.* Washington, D.C., 1961.

Rumford, Beatrix T., ed. *American Folk Portraits; Paintings and Drawings from the Abby Aldrich Rockefeller Folk Art Center.* Boston, 1981.

Sadik, Marvin. *Christian Gullager, Portrait Painter to Federal America.* Washington, D.C., 1976.

Safford, Carleton L. and Robert Bishop. *American Quilts and Coverlets.* New York, 1972.

Schermerhorn, Gene. *Letters to Phil; Memories of a New York Boyhood, 1848–1856.* New York, 1982.

Schiffer, Herbert, Peter, and Nancy. *China for America.* Exton, Pa., 1980.

Schiffer, Margaret B. *Historical Needlework of Pennsylvania.* New York, 1958.

Schmidt, Patricia Brady, ed. *Nelly Custis Lewis's Housekeeping Book.* New Orleans, 1982.

Smith, Alan. *The Illustrated Guide to Liverpool Herculaneum Pottery.* New York, 1970.

Somerville, Mollie. *In Washington.* Washington, D.C., 1965.

———. *Washington Landmark.* Washington, D.C., 1976.

Sprigg, June. *Domestick Beings.* New York, 1984.

Swan, Susan B. *Plain & Fancy: American Women and Their Needlework, 1700–1850.* New York, 1977.

———. *A Winterthur Guide to American Needlework.* New York, 1976.

———. "Worked pocketbooks." *The Magazine Antiques* (February 1975): 298–303.

Stewart, Robert G. *A Nineteenth Century Gallery of Distinguished Americans.* Washington, D.C., 1969.

Sweeney, John A. H. "Lafayette in the decorative arts." *The Magazine Antiques* (August 1957): 136–140.

Towner, Donald. *The Leeds Pottery.* London, 1963.

Van Devanter, Ann C. *"Anywhere So Long As There Be Freedom;" Charles Carroll of Carrollton, His Family & His Maryland.* Baltimore, 1975.

Walton, Peter. *Creamware and Other English Pottery at Temple Newsam House, Leeds.* London, 1976.

Wehle, Harry B. *American Miniatures: 1730–1850.* New York, 1970.

Wick, Wendy. *George Washington: An American Icon.* Washington, D.C., 1982.

Winchester, Alice and Jean Lipman. *The Flowering of American Folk Art.* New York, 1974.

Woodard, Thomas K. and Blanche Greenstein. *Crib Quilts and Other Small Wonders.* New York, 1981.

Index

Page numbers in italics refer to illustrations.